P9-DNJ-521

Places of Delight
THE PASTORAL LANDSCAPE

Places

of Delight

THE PASTORAL LANDSCAPE

Robert C. Cafritz
Lawrence Gowing
David Rosand

The Phillips Collection
in association with the
National Gallery of Art
Washington, D.C.

Grants from Ford Motor Company and
the Morris and Gwendolyn Cafritz Foundation
made possible the exhibition that inspired this book.

Additional assistance was received from the L.J. and Mary C. Skaggs Foundation.

The exhibition was also supported by an indemnity from the
Federal Council on the Arts and the Humanities.

Copyright ©1988 The Phillips Collection, Washington, D.C.
All rights reserved. No part of this publication
may be reproduced without the written permission of
The Phillips Collection, 1600 21st Street, Northwest, Washington, D.C. 20009

This book was produced by The Phillips Collection on the occasion of the exhibition,
The Pastoral Landscape: The Legacy of Venice and The Modern Vision,
jointly presented in two parts by the National Gallery of Art and The Phillips Collection,
November 6, 1988–January 22, 1989.

Research for the exhibition and publication was coordinated by Jan Lancaster.

The hardcover edition of this book was copublished in the United States and Canada by
The Phillips Collection and Clarkson N. Potter, Inc./Publishers
and is distributed by Crown Publishers, Inc., 225 Park Avenue South, New York, NY 10003

Library of Congress Cataloging-in-Publication Data

Cafritz, Robert.
 Places of delight.

 Bibliography: p.
 Includes index.
 1. Landscape painting—Exhibitions. 2. Painting,
Italian—Italy—Venice—Influence—Exhibitions.
3. Painting, Renaissance—Italy—Venice—Influence—
Exhibitions. I. Gowing, Lawrence. II. Rosand, David.
III. Phillips Collection. IV. Title.
ND1349.C34 1988 760'.04436'094 88-18028
ISBN 0-517-56979-5 (Potter : cloth)
ISBN 0-943044-12-X (Phillips Collection : pbk.)

The hardcover edition of *Places of Delight* is available in the British Commonwealth
excluding Canada from Weidenfeld & Nicolson Ltd , London.

Details of the following works appear on the pages indicated.
The complete image is reproduced later in the book.

Jacket and cover:
FRONT: Fig. 7, **Giorgione** or **Titian**, *Concert champêtre*
BACK: Fig. 226, **Henri Matisse**, *Luxe, calme et volupté*

pp. 2–3: Fig. 83, **Annibale Carracci**, *Landscape*

pp. 4–5: Fig. 101, **Claude Gellée**, *Pastoral Landscape*

pp. 6–7: Fig. 120, **Peter Paul Rubens**, *Shepherds and Shepherdesses in a Rainbow Landscape*

pp. 10–11: Fig. 157, **Jean Antoine Watteau**, *Pilgrimage to the Island of Cythera*

Contents

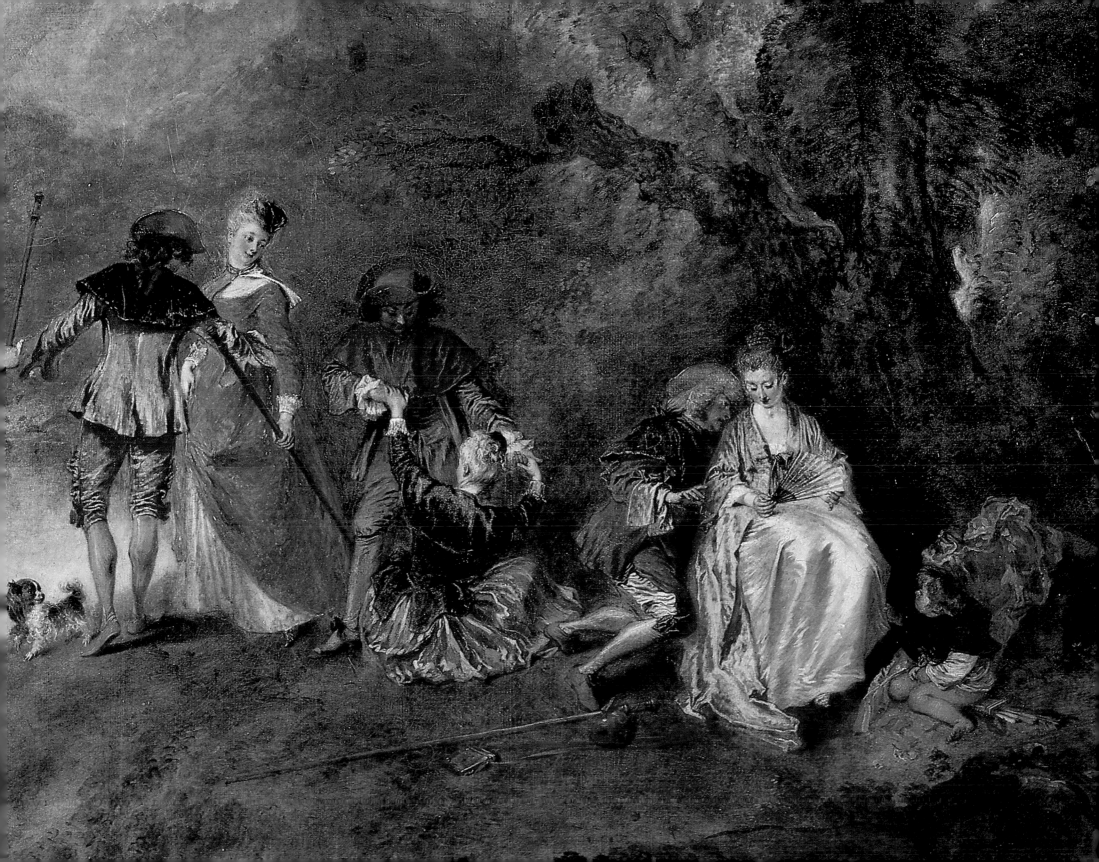

Directors' Foreword

The publication of this book coincides with an unprecedented two-part exhibition, *The Pastoral Landscape: The Legacy of Venice and The Modern Vision,* undertaken by the National Gallery of Art and The Phillips Collection. This joint venture explores one of the more fascinating subjects in Western painting: the tradition of the pastoral landscape from Giorgione to the present day.

Pastoral dreams have long been a part of the psychic life of those who live in crowded cities. Just as the Bible had its land of milk and honey, the classical world articulated; first in its poetry and subsequently in its painting, the image of man living in sweet and simple harmony with a benevolent nature. These Arcadian conceits were not central to medieval culture, and their visual expression lay dormant for more than a millennium. It was not until the sixteenth century that a pictorial tradition reemerged to exploit the vistas of rustic escape. This extraordinary step was taken in Venice, the birthplace of an artistic spirit that was perhaps the most free and most spontaneous in all of Renaissance Europe. *The Legacy of Venice,* shown at the National Gallery, traces the development of this genre from its appearance in the art of Giorgione and Titian through its adoption in the seventeenth and eighteenth centuries by such masters as Rembrandt and Watteau. For the first time, sixteenth-century Venetian prints and drawings are juxtaposed with the northern European works they inspired. In one example, Rembrandt actually sketched over an earlier work attributed to the Venetian draftsman Domenico Campagnola.

The Phillips Collection's presentation of *The Modern Vision* explores how, in its more recent aspects, the pastoral ideal gave rise to a rich new vocabulary of images. A blend of the old masters' idealism and modern naturalism typified nineteenth-century pastoral landscapes, as in the contemporary idylls of Constable, Inness, and Eakins.

◁ Detail of Fig. 127 **Rembrandt van Rijn** *The Flute Player*

However, by incorporating new concerns, such as the psychological tensions found in Cézanne's nymphs and satyrs, the modern pastoral landscape could also become more conflicted and complex in tone. Matisse evoked the classical Arcadian tradition in the course of some of the early twentieth century's most innovative painting, while in Bonnard's work the more romantic vision of pastoral escape reappeared.

The two sections of *The Pastoral Landscape* bring together a sumptuous feast for the eye that truly transports the viewer to "places of delight." It owes its vision to an organizing committee composed of Beverly Louise Brown, Robert C. Cafritz, Sir Lawrence Gowing, and David Rosand. We are deeply grateful to the Ford Motor Company and the Morris and Gwendolyn Cafritz Foundation for their generous grants, which have made this two-part exhibition possible, and to the L. J. and Mary C. Skaggs Foundation for an additional grant to the exhibition. The exhibition is also supported by an indemnity from the Federal Council on the Arts and the Humanities.

J. CARTER BROWN
Director
National Gallery of Art

LAUGHLIN PHILLIPS
Director
The Phillips Collection

Detail of Fig. 226 Henri Matisse *Luxe, calme et volupté* ▷

Introduction

by Robert C. Cafritz

The Renaissance rediscovery of nature raised the primal question of man's relationship to Mother Earth, and Renaissance society revived the ancient theme of pastoral landscape as its most explicit way of affirming the sympathy between the human and natural realms. Both classical and contemporary humanistic poetry and art theory, modeled on ancient sources, inspired distinctly urbane and nostalgic fantasies about human life in harmony with nature. Intimate scenes, which share the basic scheme of an idealized natural setting that contains such bucolic figures as the amorous shepherd or the industrious peasant (who personified virtue), epitomized rustic serenity and typified visual expression of pastoral ideals. This book introduces the ways in which Venetian Renaissance artists first visualized pastoral ideals and how this Venetian imagery has shaped, in turn, the pastoral dreams of some of the greatest artists for almost five centuries.

From the rise of the pastoral landscape as an independent visual theme in High Renaissance Venice to the present day, pastoral landscapists have relied on the natural settings depicted in their works to transport viewers to an idealized realm, evoking ancient poets' descriptions of the fresh, green comforts of the *locus amoenus*, or pleasance, representative of nature's intimate "places of delight." Because the landscape setting plays such a prominent role in conveying a sense of harmony between man and nature, the pastoral theme brought the expressive resources peculiar to the painter's art into the vanguard of thinking about pictures. Critical considerations of composition, color, and description of natural effects take precedence over allegorical and narrative concerns, which dominate conceptions of more official kinds of imagery, for example, didactic history painting and altarpieces. When it arose as an independent theme in early sixteenth-century Venetian art, pastoral landscape

◁ Detail of Fig. 209 **Jan de Bisschop** *Concert champêtre*

was the first type of imagery based on poetics that were primarily sensuous and evocative in spirit rather than discursive and intellectual.

The original Venetian ways of rendering man's relationship to nature rang true for an impressive succession of later masters, including the Carracci, Rubens, Rembrandt, Watteau and—then modernized—continued to resound in the work of Manet, Cézanne, and Matisse. These painters almost invariably visualized the pastoral ideal in ways reflecting Giorgione and Titian's original expression of it in the early sixteenth century.

The leaders of the Venetian High Renaissance filled the same exemplary role in the evolution of later pastoral painters as the Ancients, Theocritus and Virgil, did in the genesis of later pastoral poets. The models, methods, and history of the rise and diffusion of the Venetian pastoral tradition are the subjects of the essays that follow.

In the first essay, David Rosand introduces the basic models that became the legacy of Venice to the history of art. He describes the literary impetus to the emergence of pastoral landscape as a major theme in the circle of Giorgione, which included Titian, Giulio Campagnola, and Campagnola's nephew, Domenico. Rosand not only shows how the pastoral landscape aesthetic could be incorporated in other genres, including religious and mythological art, but also how it provided a framework for aesthetic appreciation of the natural world, apart from significant figural content.

In subsequent essays the present writer shows how later old masters exploited the legacy of Giorgione and Titian, beginning with Annibale Carracci's creation of the "ideal" landscape in early seventeenth-century Rome. This great reformer rigorously intellectualized Venetian style according to the classical rules of "papal" aesthetics. Discussion of the influence of Venetian models

on later art does not, however, imply a strict, linear evolution of the pastoral vision of nature. Claude may have been, as Kenneth Clark wrote, the spiritual heir of Giorgione and the Venetians, but, historically, Claude benefited more directly from the Carraccis' determined, classical revision of the Venetian tradition than he did from the firsthand knowledge of sixteenth-century Venetian sources his own work occasionally betrays. In the context of the Venetian pastoral tradition's evolution, Claude is important because he refined the "ideal" transformation of Venetian pastoral that Annibale Carracci had shared in Rome with his close follower, Domenichino. In the larger context of the later evolution of the pastoral tradition, however, Claude's importance is even greater. His freshness of vision, based on an essentially northern European detailed rendering of natural effects, reinvigorated the classical, Roman form of the Venetian tradition. Claude's vital enhancement of the classical, Roman pastoral ideal gave the Roman tradition an international, historical momentum distinct from that of the legacy of Venice.

In the next three sections, I discuss the steady northward flow of Venetian prints and drawings and how this fed the prestige of Titian and his followers as landscapists in seventeenth- and eighteenth-century northern Europe. Northern masters made characteristic uses of this Venetian material. On special occasions both Rubens and van Dyck seasoned their native, Netherlandish taste for landscape with the humanistic flavor of Venetian sources. In the process of studying sixteenth-century Venetian landscape designs, Rembrandt refined his varied manners of graphically expressing the organic sympathies between the human and natural realms.

Rubens and Rembrandt maintained the momentum of the Venetian tradition through the seventeenth century and set the stage for their

French followers' restoration of Venetian pastoral landscapes during the early eighteenth century. Watteau was one of the most highly motivated connoisseurs of sixteenth-century Venetian landscapes active in his time. He acquired intimate knowledge of the rich Parisian collections of Venetian landscape designs by faithfully copying over one hundred of them. Once Watteau began to use his updated impressions of these Venetian sources in the composition of his fêtes galantes—painterly glorifications of the Parisian elite's romantic, escapist ethos—they were accepted by his professional colleagues as a serious art form.

In the final essay of this book Lawrence Gowing surveys representative examples of the pastoral landscape tradition in nineteenth- and twentieth-century art. He describes the insights into the inherent poetry of pictorial effects and rendering of natural forms that modern artists may gain through contemplation of High Renaissance Venetian landscapes. Gowing also discusses such earnest revivals of the pastoral genre as those of William Blake and his followers and the authority of Claude's naturalistic vision as a model for major English and American nineteenth-century painters. Gowing sheds light on how the modern sophistication of Manet, Cézanne and Matisse colored their revolutionary evocations of the Venetian pastoral tradition.

Specific links to sixteenth-century Venetian sources characterized most of the historical revivals of the pastoral landscape tradition discussed in this book. But the vision of Giorgione and Titian has also been preserved in more elusive ways. Examples selected from recent art, such as paintings by Milton Avery and Howard Hodgkin, suggest that the Venetian pastoral landscape tradition lingers as the subliminal model of the modern humanist's nostalgic attitude toward nature.

Giorgione, Venice, and the Pastoral Vision

David Rosand

...woodland songs carved on the rugged barks of beeches no less delight the one who reads them than do learned verses written on the smooth pages of gilded books. And the wax-bound reeds of shepherds proffer amid the flower-laden valleys perhaps more pleasurable sound than do through proud chambers the polished and costly boxwood instruments of the musicians. And who has any doubt that a fountain that issues naturally from the living rock, surrounded by green growth, is more pleasing to the human mind than all the others made by art of whitest marble, resplendent with much gold?

—Jacopo Sannazaro[1]

T he Italians," wrote Jakob Burckhardt, "are the first among modern peoples by whom the outward world was seen and felt as something beautiful."[2] Central to Burckhardt's grand conception of the Italian Renaissance was the notion of "the discovery of the world and of man." Our own sense of the history of Renaissance art continues to acknowledge the importance of landscape — the visual exploration of the natural world — as a major pictorial theme, albeit secondary to the thematic dominance of the human figure.

Early fifteenth-century humanists delighted in testing their literary skills against the natural bounty of painted landscapes. Guarino of Verona, for example, praised the variety of Pisanello's painting (Fig. 1):

...you equal Nature's works, whether you are depicting birds or beasts, perilous straits and calm seas; we would swear we saw the spray gleaming and heard the breakers roar. I put out a hand to wipe the sweat from the brow of the labouring peasant....When you paint a nocturnal scene you make the night-birds flit about and not one of the

◁ Detail of Fig. 22 **Giulio** and **Domenico Campagnola** *Shepherds in a Landscape*

Fig. 1
Antonio Pisano, called **Pisanello** (living 1395–1455)
The Vision of Saint Eustace(?) c. 1435
oil on wood panel
21½ x 25¾ inches (54.6 x 65.4 cm.)
The National Gallery, London
1436

birds of the day is to be seen; you pick out the stars, the moon's sphere, the sunless darkness. If you paint a winter scene everything bristles with frost and the leafless trees grate in the wind. If you set the action in spring, varied flowers smile in the green meadows, the old brilliance returns to the trees, and the hills bloom; here the air quivers with the songs of birds.[3]

Such dialogue between painting and literature served to encourage the pictorial description of nature's spectacle, and literary convention played a critical role in enabling landscape to emerge as an independent genre in painting.

Later in the century the natural curiosity that animated the painting of artists like Pisanello (living 1395, d. 1455?) yielded to more systematic and sustained investigation. Leonardo da Vinci (1452–1519), above all, sharpened his powers of observation on nature's panoramic sweep (Fig. 2) as well as on the details of its individual forms, studying and rendering the atmospheric expanse along the horizon, its mountain ranges and distant harbors, as well as the flowers and pebbles in the foreground. It was in Venice, however, that landscape painting assumed a particularly poetic tone. There, in the late Quattrocento, the study of nature's space and forms was motivated less by Leonardo's kind of scientific curiosity about the world than by a desire to create a proper setting for the holy persons and events of religious imagery. And there the adoption of the oil medium—whose potential had been so dramatically demonstrated by Jan van Eyck and the Netherlandish tradition—bathed that setting in a new luminosity, transfiguring the material forms of nature, investing them with a spiritual aura. Saint Francis's communion with the divine in nature becomes possible in painting because Giovanni Bellini (ca. 1433–1516), the first pictorial genius of the Venetian Renaissance, is able to imagine the saint as truly part of a natural world, a world made pal-

pable through the very light that suffuses it (Fig. 3). Essentially religious in tone and meaning, Bellini's landscape would be secularized by his radical follower of the next generation, the painter whose name became synonymous with the pastoral mode: Giorgione (1477/78–1510) (Fig. 4).[4]

Questions of Genre

Landscape is not discussed in the first Renaissance treatise on the art of painting, Leon Battista Alberti's three books *On Painting* (1435). Alberti's first concern is to establish the principles and practice of mathematical perspective, the essential foundation of painting's mimesis, the representational system used to construct the spatial envelope of the narrative subject. Significant human action, Alberti tacitly assumes, is commensurable only with the classical forms of an architectural setting. The irregularity of the natural landscape, its refusal to submit to the rules of geometry, disqualified it as a preferred stage. Nonetheless, it is through architecture that landscape is first acknowledged as a valid theme in Renaissance art theory, in another of Alberti's treatises, his *Ten Books on Architecture* (ca. 1452). Discussing appropriate subjects for painted decoration of private houses and villas, he accords landscape full recognition as a genre:

> ...the subjects both of Poetry and Painting are various, some expressing the memorable actions of great men, others representing the manners of private persons, others describing the life of rustics: The former, as the most majestic, should be applied to public works and the buildings of princes; and the latter, as the more cheerful, should be set apart for pleasure-houses and gardens. Our Minds are delighted in a particular manner with the pictures of pleasant landscapes, of havens, of fishing, hunting, swimming, country sports, of flowery fields and thick groves.[5]

The passage is modeled on the ancient Roman treatise of Vitruvius, in which landscape murals are recommended as decoration: "In these

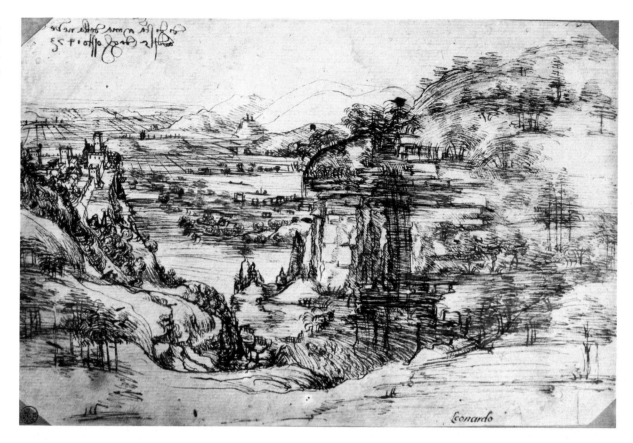

Fig. 2
Leonardo da Vinci (1452–1519)
Landscape with View of the Arno Valley 1473
pen and ink on paper
7½ x 11¼ inches (19 x 28.5 cm.)
Gabinetto Disegni e Stampe degli Uffizi, Florence

paintings there are harbours, promontories, seashores, rivers, fountains, straits, fanes, groves, mountains, flocks, shepherds...."[6] The authority of classical texts, of Pliny as well as Vitruvius, lent legitimacy to landscape repesentation for Renaissance artists. It was generally within the framework of architecture that the genre found its most explicit development in Italian painting, in palace and villa decoration—that is, in the service of another art. Although Leonardo would make the strongest case for landscape as one of the great glories of the painter, the representational arena in which he

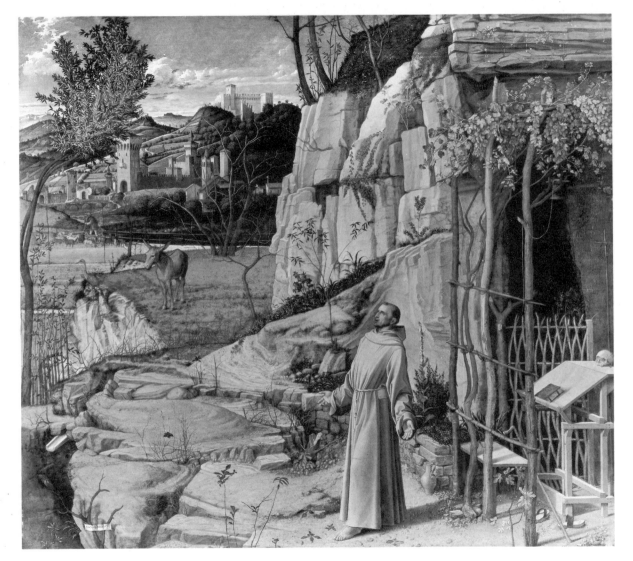

Fig. 3
Giovanni Bellini (c. 1433–1516)
Saint Francis in Ecstasy c. 1479–85
tempera and oil on poplar panel
49 x 55⅞ inches (124.4 x 141.9 cm.)
Copyright The Frick Collection, New York

could create a universe to rival that of the Creator, Italian art theory of the Renaissance tended to relegate it to a relatively low position on any scale of genres. Unlike the heroic human figure, whose proportions most closely approximate divine design, the visible beauties of the natural world were considered essentially superficial, the merely sensible allure of colors as opposed to the intellectual appeal of measure.

Renaissance theorizing on art, however, was based on modal distinctions; it sought to identify categories appropriate to the various aspects of its subject. Thus, no matter how low it fell on the scale, landscape nonetheless found a place in the scheme of things. Once again, Vitruvius offered an important model: the three modes of theater.[7] The proper settings for tragedy and comedy were architectural, distinguished by their respective social status; the third scenic type, the satyr play, was to be "decorated with trees, caverns, mountains, and other rustic objects delineated in a landscape style" (see Fig. 70). Alberti had followed this model in distinguishing the pictorial types appropriate for the decoration of houses. Below the heroic grandeur of tragedy (presenting the noble deeds of great men) and the domestic activities of comedy (describing the habits of private citizens) was the natural world of the peasant and the shepherd. There, on the lowest rung of the generic ladder, landscape found its place.[8]

If in the fifteenth century the genre received its classical sanction through the texts of architectural theory, toward 1500 the literary imagination suggested other expressive dimensions for landscape painting. The highly self-conscious revival of pastoral poetry created a cultural climate particularly receptive to the possibilities of secular meaning and affect in the natural scene.

The *Idylls* of Theocritus established the pastoral poem, a deliberately modest alternative to the

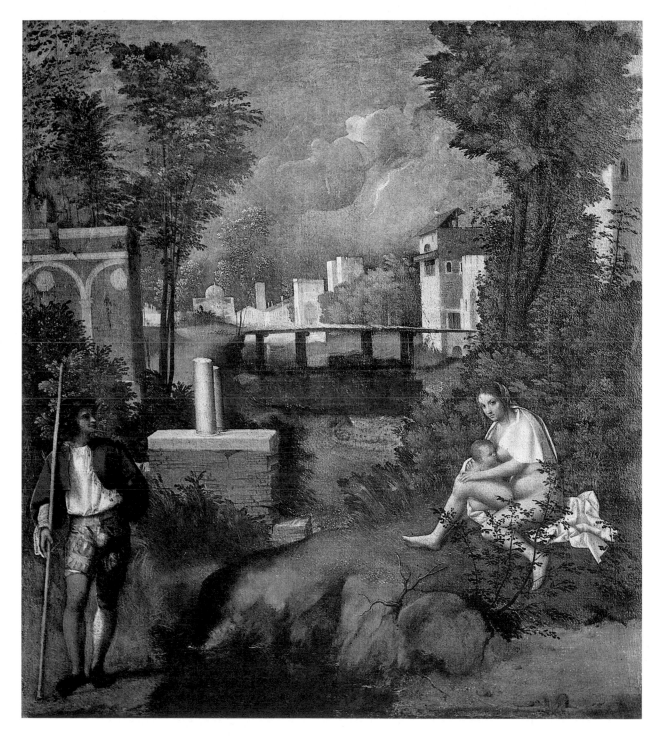

Fig. 4
Giorgione (c. 1477/78–1510)
Tempest c. 1505–10
oil on canvas
32¾ x 28¾ inches (83 x 73 cm.)
Gallerie dell'Accademia, Venice

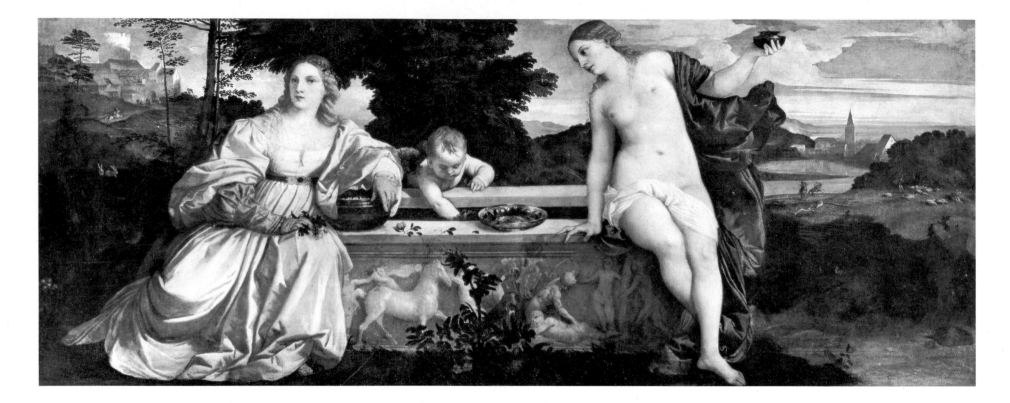

Fig. 5
Titian (c. 1488–1576)
Sacred and Profane Love c. 1514
oil on canvas
46½ x 109⅞ inches (118 x 279 cm.)
Galleria Borghese, Rome

more heroic modes of older Greek poetry, as an independent literary genre in classical antiquity. The poems of Theocritus, set in the hills and groves of his native Sicily, were peopled by shepherds and goatherds, individually named and yet nearly anonymous. Mixing the realms of the real and the ideal, Theocritus created a world of deeply felt yet artfully controlled passion that is at once distant and accessible. Virgil translated the pastoral from Greek to Latin in his *Eclogues*, and he translated its setting from Sicily to an imagined Arcadia. Its protagonists—never really rude rustics but rather natural artists given to expressing themselves in poetry and music—found their natural setting in some shady grove; escaping the noonday sun, they give themselves over to their feelings and their art. Singing of their loves, usually lost, they celebrate the very songs of their passion. Socializing the natural landscape, they enjoy their leisure and their flocks, aware (especially in Virgil) of their distance from the commerce and the politics of a more urban world.[9]

Throughout the postclassical world the pastoral tradition continued to be a source of poetic inspiration. It found new life in the Renaissance, especially with the publication in the opening years of the sixteenth century of Jacopo Sannazaro's *Arcadia*, written in Italian and therefore accessible to a large audience.[10] And the pastoral aesthetic found absolutely new pictorial expression in the

 DAVID ROSAND

Fig. 6
Andrea Previtali (c. 1470–1528)
Four Scenes from an Eclogue of Tebaldeo c. 1505
oil on wood panels
2 panels, each 17⅞ x 7⅞ inches (45.3 x 20 cm.)
each image, 7¾ x 7¼ inches (19.7 x 18.4 cm.)
The National Gallery, London
4884

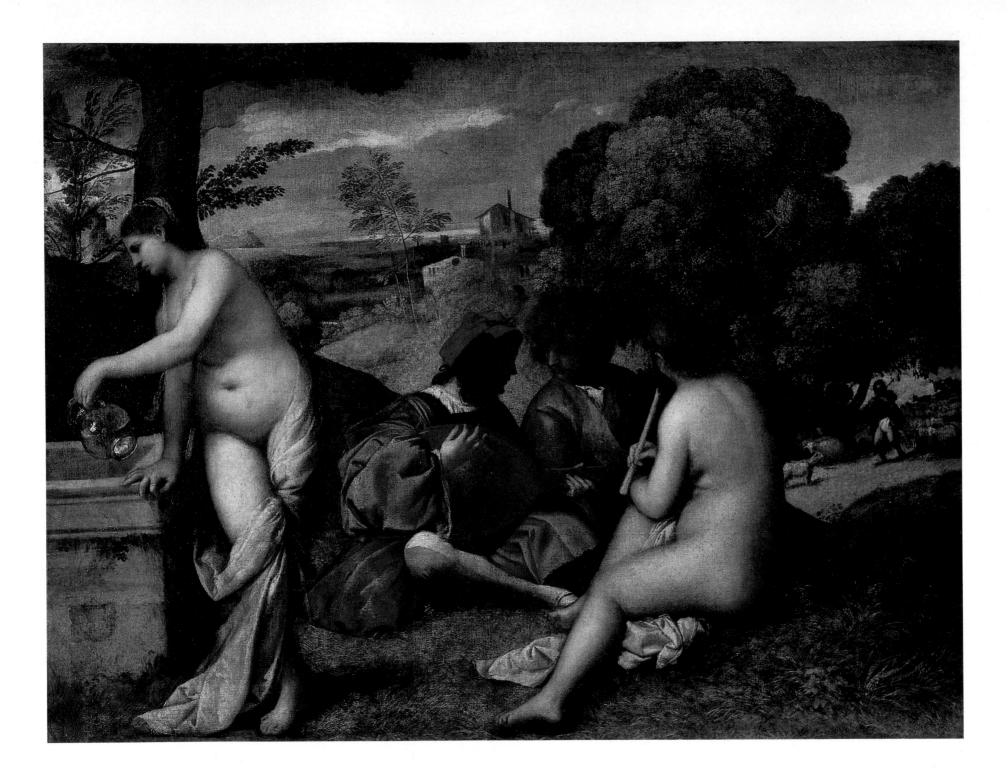

DAVID ROSAND

Fig. 9
Circle of Titian
Young Man Playing a Viol da Gamba and Woman in a Landscape
pen and ink on paper
8¹³/₁₆ x 8¹⁵/₁₆ inches (22.4 x 22.6 cm.)
Trustees of the British Museum, London

Fig. 8
Titian (c. 1488–1576)
Three Ages of Man c. 1512–15
oil on canvas
35½ x 59½ inches (90.2 x 151.2 cm.)
Duke of Sutherland Collection
On loan to the National Gallery of Scotland, Edinburgh

◁ **Fig. 7**
Giorgione (c. 1477/78–1510) or
Titian (c. 1488–1576)
Concert champêtre c. 1510
oil on canvas
42⅞ x 53¹⁵/₁₆ inches (109 x 137 cm.)
Musée du Louvre, Paris
71

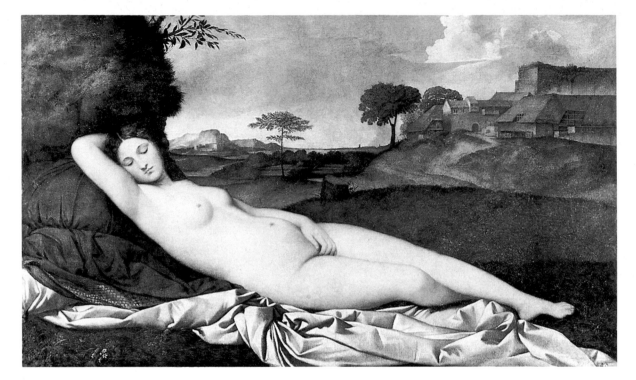

painting we have come to associate with the name of Giorgione.[11]

The Pastoral Concert

"All art constantly aspires towards the condition of music." Walter Pater's aesthetic dictum found precise expression, appropriately, in his essay "The School of Giorgione" (1877). Rather than analyzing specific pictures in that essay, Pater addressed the idea of Giorgione. His vision of that painter's art and the aesthetic embodied in it remains both satisfying and persuasive: "in the school of Giorgione, the perfect moments of music itself, the making or hearing of music, song or its accompaniment, are themselves prominent as subject."[12] Recalling Giorgione's reputation as an admirable musician, Pater gave new articulation to a theme that has generally informed the appreciation of this painter's art, "this pictorial poetry":

> ...music at the pool-side..., or mingled with the sound of the pitcher in the well, or heard across running water, or among the flocks; the tuning of instruments; people with intense faces, as if listening...to detect the smallest interval of musical sound, the smallest undulation in the air, or feeling for music in thought on a stringless instrument, ear and fingers refining themselves infinitely, in the appetite for sweet sound; a momentary touch of an instrument in the twilight....[13]

The image summoned by this evocative passage is the canvas in the Louvre known since the early nineteenth century as the *Concert champêtre* (Fig. 7). In the late seventeenth century, when the picture is first mentioned in an inventory of the collection of Louis XIV, it was called a *pastorale*, and this generic label is probably more useful in that it suggests the rich tradition to which the image belongs.[14]

Assembled in the shade of a tree near a well, an unlikely quartet dominates the foreground: two

Fig. 10
Giorgione (c. 1477/78–1510)
Sleeping Venus c. 1507–10
oil on canvas
42½ x 68⅞ inches (108 x 175 cm.)
Gemäldegalerie Alte Meister
Staatliche Kunstsammlungen Dresden
185

Fig. 11 (opposite)
Giorgione (c. 1477/78–1510)
The Three Philosophers c. 1508–10
oil on canvas
48½ x 56⅞ inches (123.3 x 144.5 cm.)
Kunsthistorisches Museum, Vienna

DAVID ROSAND

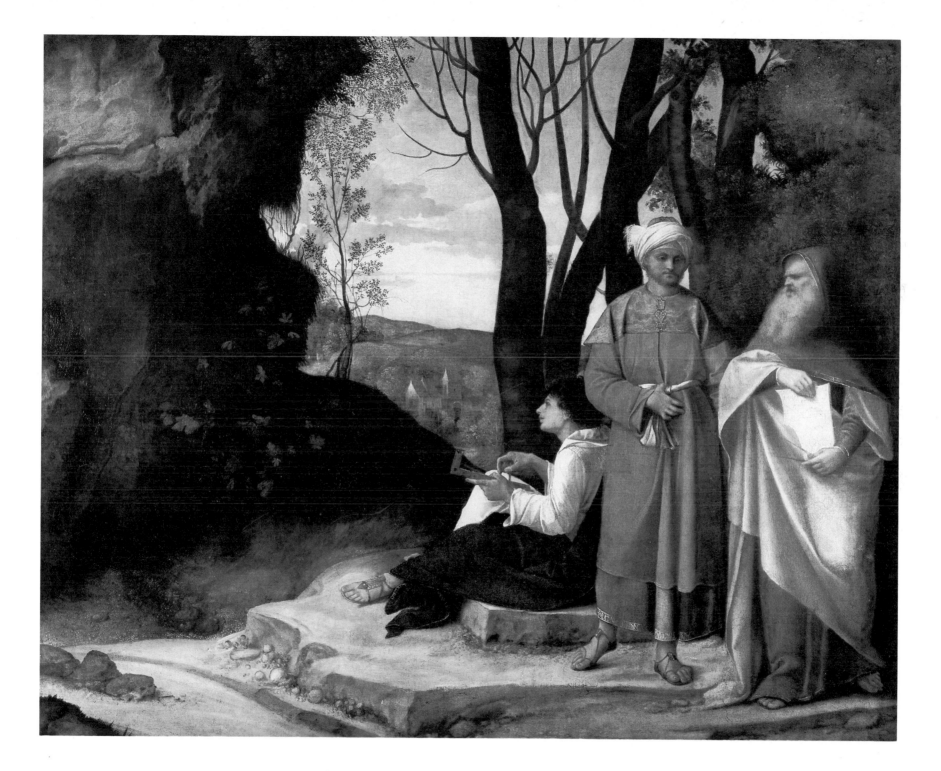

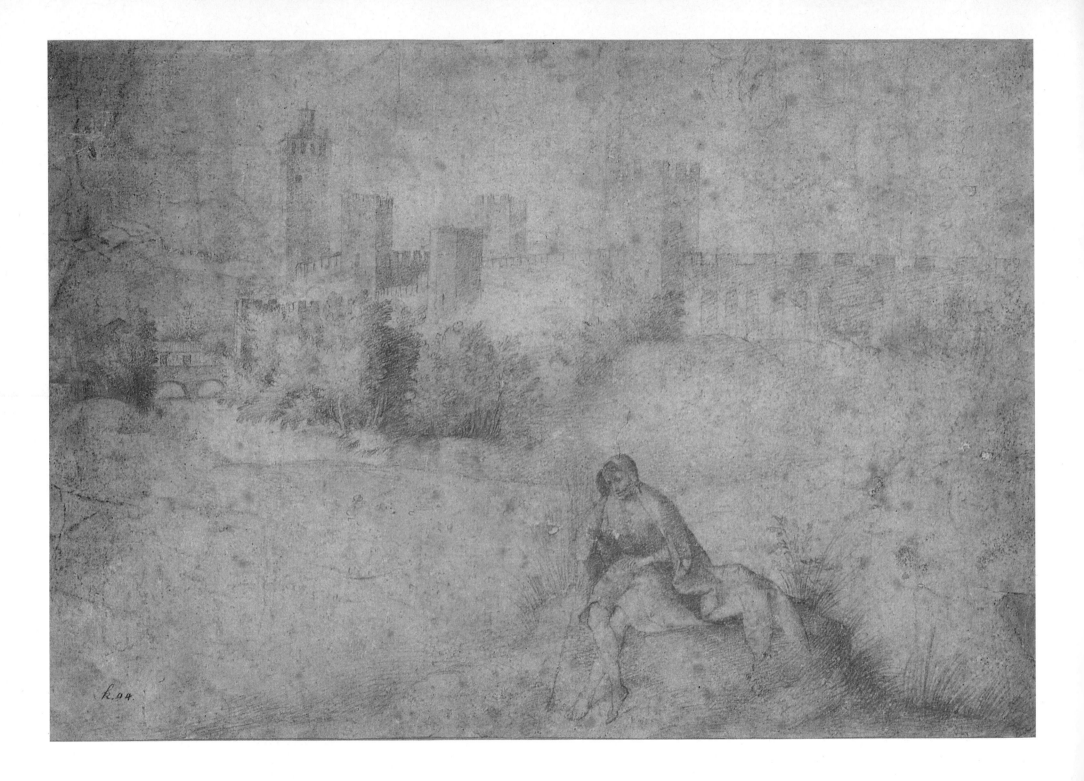

DAVID ROSAND

Fig. 13 (No. 5)
Attributed to **Giorgione**
Saint John the Baptist Preaching in the Wilderness
c. 1510
oil on wood panel
13½ x 10¹⁵⁄₁₆ inches (34.3 x 27.9 cm.)
Piero Corsini, New York

◁ **Fig. 12** (No. 4)
Giorgione (c. 1477/78–1510)
Castel San Zeno di Montagnana (formerly *View of Castelfranco*)
red chalk on paper
8 x 11⅜ inches (20.3 x 29 cm.)
Museum Boymans-van Beuningen, Rotterdam

Fig. 14
Giorgione (c. 1477/78–1510)
*Sunset Landscape with Saint Roch(?), Saint George(?)
and Saint Anthony Abbot* c. 1505–10
oil on canvas
28⅞ x 36 inches (73.3 x 91.5 cm.)
The National Gallery, London
6307

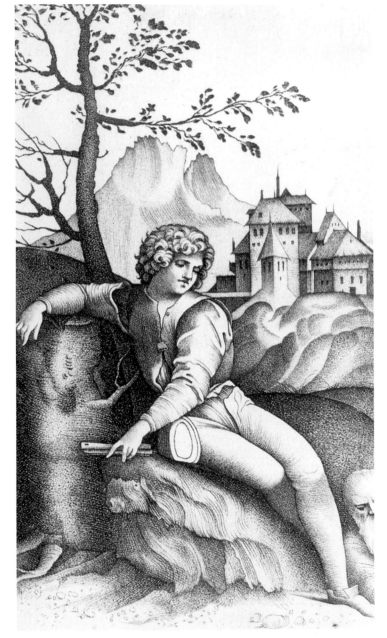

Fig. 16 (No. 28)
Giulio Campagnola (c. 1482–after 1515)
The Old Shepherd
engraving
plate, 3⅛ x 5⁵⁄₁₆ inches (7.9 x 13.5 cm.)
The Metropolitan Museum of Art, New York
Harris Brisbane Dick Fund, 1937
37.3.11, Hind 5, no. 8 II

Fig. 15 (No. 27)
Giulio Campagnola (c. 1482–after 1515)
The Young Shepherd c. 1509
engraving
5³⁄₁₆ x 3¹⁄₁₆ inches (13.2 x 7.8 cm.)
Cincinnati Art Museum
Bequest of Herbert Greer French
1943.88, Hind 5, no. 10 II

young men bracketed by a pair of nude women, set apart from and yet very definitely within the larger landscape that is the world of the picture. One of the youths, dressed quite fashionably, is clearly an urban visitor; his tousled rustic companion, just as evidently, is native to this bucolic region. Beyond their shaded retreat, in the middleground, a shepherd leads his flock of sheep and a goat in sunlight past another grove. In the distance, buildings interrupt the horizon, architectural signs of civilization, a man-made world on the fringes of—and yet somehow finally containing—the natural landscape in which this gathering takes place.

Three of the four figures in the group, those seated on the ground, are joined in apparent concert, their common focus on the lingering notes just

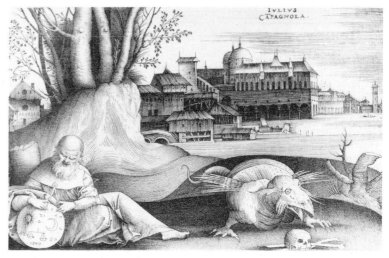

Fig. 17 (No. 9)
Circle of Giorgione
Saint Theodore about to Slay the Dragon
oil on canvas
29½ x 33¾ inches (75 x 85.7 cm.)
Private Collection

Fig. 18 (No. 25) (top)
Giulio Campagnola (c. 1482–after 1515)
Three Philosophers Consulting a Globe in a Landscape
pen and brown ink on brownish-toned paper
7³⁄₁₆ x 10¹³⁄₁₆ inches (18.3 x 27.4 cm.)
Fondation Custodia, Collection F. Lugt
Institut Néerlandais, Paris
1978–T.21

Fig. 19 (No. 29)
Giulio Campagnola (c. 1482–after 1515)
The Astrologer c. 1509
engraving
3¾ x 6¹⁄₁₆ inches (9.6 x 15.4 cm.)
Cincinnati Art Museum
Bequest of Herbert Greer French
1943.90, Hind 5, no. 9 II

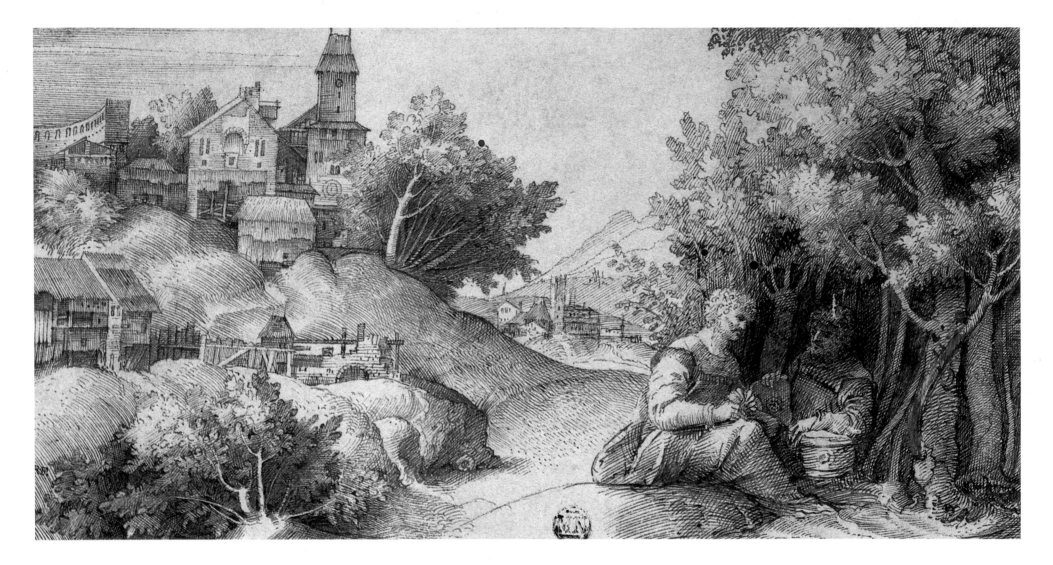

Fig. 20 (No. 24)
Giulio Campagnola (c. 1482–after 1515)
Landscape with Two Philosophers
pen and brown ink on paper, partially pricked for transfer
5¼ x 10⅛ inches (13.3 x 25.7 cm.)
Musée du Louvre, Paris
Département des Arts Graphiques
4868

Fig. 21 (No. 20)
Titian (c. 1488–1576)
Group of Trees c. 1514
pen and brown ink, traces of grey printer's ink at lower
right, on beige paper
8⁹⁄₁₆ x 12⁹⁄₁₆ inches (21.8 x 31.9 cm.)
The Metropolitan Museum of Art, New York
Rogers Fund, 1908.
08.227.38

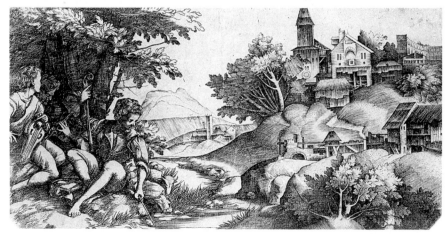

Fig. 22 (No. 30)
Giulio (c. 1482–after 1515) and **Domenico
Campagnola** (1500–64)
Shepherds in a Landscape c. 1517
engraving
5¼ x 10¹⁄₁₆ inches (13.3 x 25.5 cm.)
National Gallery of Art, Washington, D.C.
Rosenwald Collection
1943.3.2697, Hind 5, no. 6

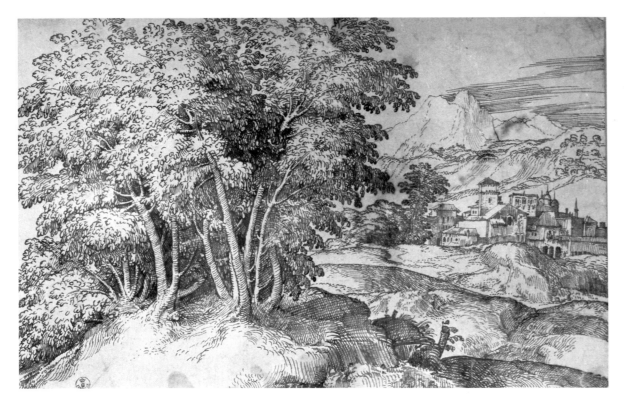

Fig. 23 (No. 33) (left)
Domenico Campagnola (1500–64)
Landscape with Wooded Slope and Buildings
pen and brown ink on paper
8⅞ x 13¾ inches (22.5 x 35 cm.)
Gabinetto Disegni e Stampe degli Uffizi, Florence
1406E

Fig. 24 (No. 21) (right)
Titian (c. 1488–1576)
Group of Trees
pen and brown ink on paper
9 9/16 x 8⅛ inches (24.3 x 20.7 cm.)
Private Collection

sounded. To the left, the standing nude turns her attention to the well, into which with grave languor she pours water from a crystal pitcher. As surely as their clothes distinguish the two youths from one another, so the two women are distinguished from them by their nudity—as well as by gender. Nudity is their natural state, for they have not disrobed. Nudity signifies their higher spiritual status: they are divinities, nymphs of this *locus amoenus*, the "pleasant place" that is the requisite site of such pastoral encounters.[15] This is indeed the world of the pastoral tradition of antiquity, with its nymphs and shepherds, its music and poetry, its natural and unforced eroticism. The voice is that of the civilized urban poet celebrating a more natural existence.

Within the order of its natural environment, the painting joins contrasting elements into an overall harmony. Two of those elements, personified by the urban and rustic youths, are extended in several ways. The architecture in the background, so deliberately set above their heads, may reflect their cultural division: a more nobly articulated structure, punctuated by oculus and arcade, is juxtaposed to a sagging-roofed wooden construction. More significantly, however, the instruments associated with the protagonists carry different connotations. The lute, stringed and able to accompany the poetry of song, is the modern exemplar of ancient Apollo's lyre and represents music's highest cultural ambition, union with the word and the hu-

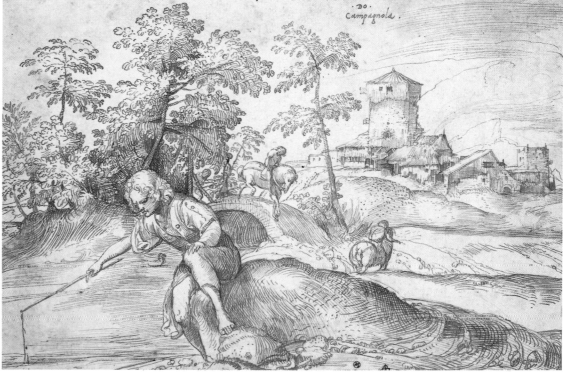

man voice. The wooden flute or recorder is a wind instrument, distant relative to the pipes of half-bestial Pan; it precludes the musician's singing, yet remains the natural voice of passion, eloquent but inarticulate. Mediating these extremes, participating in both worlds, are the nymphs, who might in this context be called muses, inspiring companions to these mortal singers.[16]

The lowly pipes are the instruments of the pastoral mode. In the epilogue to Sannazaro's *Arcadia* the plaintive poet, his song now ended, addresses his "rustic and rural *sampogna* [panpipes], worthy because of your lowness to be sounded by a shepherd not more cultured, but more fortunate, than I." Music was a central

component of the classical traditions of pastoral poetry: "Arcadians alone know how to sing," declared Virgil (*Eclogue* X). The musical contest was an occasion that often elicited such poetry, singing matches between goatherds and shepherds, witnessed and recorded by the urban visitor to the countryside. The songs of these country poets most often deal with love, poignantly and longingly. The *Concert Champêtre* probably represents no particular dialogue between an imagined Lycidas and Simichidas (Theocritus, *Idyll* VII), or Meliboeus and Corydon (Virgil, *Eclogue* VII), or Logisto and Elpino (Sannazaro, *Arcadia*, eclogue IV)—the typical shepherd protagonists of such poetry. Rather, the painting embodies the general ethos of the pas-

Fig. 26 (No. 34) (right)
Domenico Campagnola (1500–64)
Landscape with Boy Fishing c. 1520
pen and brown ink on laid paper
6⁷/₁₆ x 9¾ inches (16.4 x 24.7 cm.)
National Gallery of Art, Washington, D.C.
Rosenwald Collection
1950.20.1

Fig. 25 (No. 31) (left)
Domenico Campagnola (1500–64)
Two Boys Kneeling in a Landscape
pen and brown ink on paper
9⁵/₁₆ x 8⅜ inches (23.6 x 21.3 cm.)
Graphische Sammlung Albertina, Vienna
24364

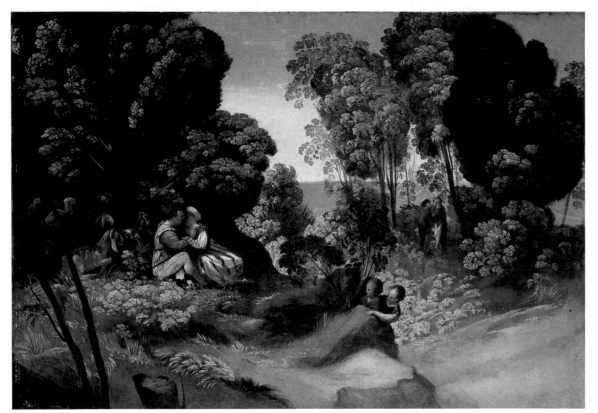

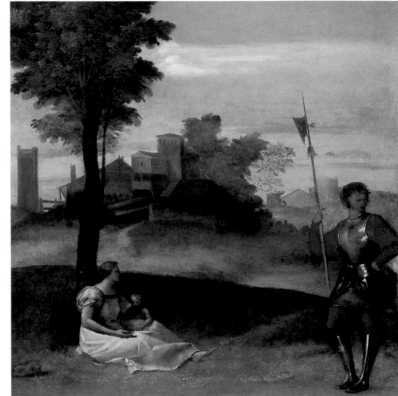

Fig. 27 (No. 13)
Giovanni de Lutero, called **Dosso Dossi** (c. 1479–1542)
The Three Ages of Man c. 1520–25
oil on canvas
30½ x 44 inches (77.5 x 111.8 cm.)
The Metropolitan Museum of Art, New York
Maria DeWitt Jesup Fund, 1926.
26.83

Fig. 28 (No. 16)
Attributed to **Titian**
An Idyll: A Mother and a Halberdier in a Wooded Landscape
oil on wood panel
18¼ x 17¼ inches (46.4 x 43.8 cm.)
Private Collection, New York

toral, its typical dramatis personae, its structures of communication, and, above all, its natural setting.

By the end of the fifteenth century Giovanni Bellini had established an essentially sacred poetry of landscape. In the opening years of the sixteenth century Giorgione secularized that poetic sensibility. Venturing into landscape to discover and gratify other, more personal and poetic needs, he created a realm of pictorial experience that responded to a new kind of aestheticism and a new kind of patronage, which sought delectation as much as edification in imagery. In paintings like the *Concert champêtre* the new patron—young, noble, and culturally refined—found a new kind of picture, in which a certain condition of private, secular meditation offered the basis for a new kind of aesthetic response, the evocation of a poetry in which his own sensibility could delight. The painter himself, moreover, participated fully in this world. Taking pleasure in culturally sanctioned amorous dalliance (*le cose d'amore*), Giorgione played the lute so marvelously and sang so beautifully that he was a favorite guest at the gatherings of those noble aesthetes.[17]

All this is reported in Giorgio Vasari's biography of Giorgione. Vasari had honored the Venetian painter by placing him second only to Leonardo da Vinci among the innovators of the modern style in painting.[18] Speaking for the critical public of the sixteenth century, the biographer recognized that both Leonardo and Giorgione had introduced new qualities of softness and relief, of enveloping shadow and tonal unity, which gave to painting a heightened mimetic conviction. Insisting that in nature there were no outlines, both painters softened the contours of their forms, permitting objects to exist in a space that, blending with those shadowed edges, itself assumed a tangible presence. In this art, shadow emerged as a most significant expressive factor; concealing information, it in-

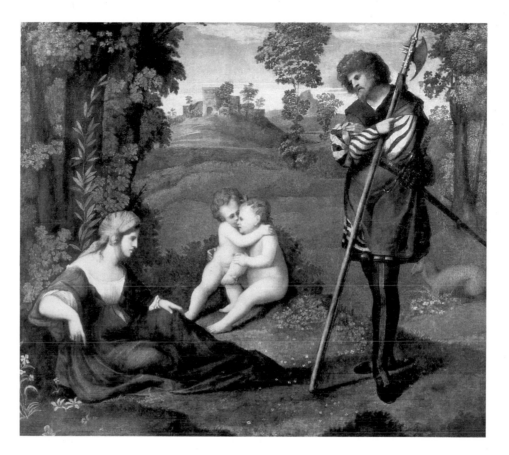

Fig. 29
Jacopo Palma, Il Vecchio (c. 1480–1528)
Halberdier Watching Woman Seated in a Meadow with Two Infants
oil on canvas
21⅝ x 24 inches (55 x 61 cm.)
Philadelphia Museum of Art
W. P. Wilstach Collection
W.22–1–2

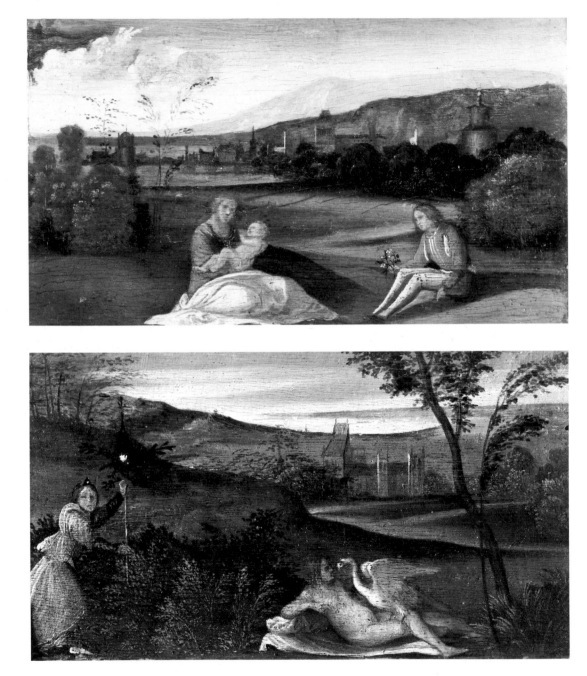

vited the imagination of the viewer to enter ever deeper into the fiction of the image. Giorgione in particular exploited the poetic potential of this phenomenon and nowhere more eloquently than in the faces of the two young men in the *Concert champêtre*. As we strain to discern their features, our very effort expands to encompass their music: we try as well—like Pater—to imagine the sounds of voices and instruments.

So little is actually given, however. The music of this painting is, of course, all in our imagination, in the eye and ear of the mind. Presented with a pictorial configuration, we have willingly entered into an active exchange with the picture; following its suggestions, we bring to the image our own experience, answering its invitation to participate.

Vasari had complained that it was not possible to discover any meaning in Giorgione's fresco decorations on the façade of the Fondaco de' Tedeschi, the great German warehouse in Venice, and he concluded that the artist's intention was not to convey such significance but merely and essentially to offer a demonstration of the power of his art.[19] A similar dilemma confronts the modern critic who would interpret Giorgione's imagery. The *Tempest* (Fig. 4), for example, continues to defy definitive interpretation.[20] It is not likely that such a picture is in fact without a subject (as has occasionally been suggested), but our difficulty in locating a theme with any precision may indeed reflect the kind of evocative poetry that Giorgione's contemporaries evidently found so appealing in his work.

The pictorial poetry of Giorgione's naturalism depended also upon his radical technical innovations, for, as Vasari recognized, he revolutionized the art of oil painting. That revolution, following by nearly a century the first development of the medium by Jan van Eyck, depended upon the Venetian

adoption of canvas as a support and corollary changes in ground and paint structure. Reversing the light to dark sequence of traditional practice in panel painting, the new technique built toward light on a darker ground; instead of the smooth gesso surface, the woven texture of cloth interacting with the substance of a more impasto medium yielded new expressive possibilities. In Giorgione's art light emerges from dark, and brushwork begins to be broken up, the individual stroke assuming a greater visual and expressive weight. The surface of a painting by Giorgione, particularly in his later work on canvas, is vibrant and open, the touches of the brush creating a loose atmospheric network that invites the eye of the viewer to bring forms into focus. Even on this essentially formal level, then, Giorgione's art insists on active engagement. Its invitation, by suggestion, implicates the viewer in its poetry.

The Tuscan Vasari lamented that in developing this technique the Venetian painter abandoned the practice of elaborating his compositions in a series of preparatory drawings. Deliberately rejecting such cautious graphic preparation, Giorgione is said to have declared that working directly on the canvas with the brush, imitating nature with colors alone, was the true path to imitation. Decisions were made on the canvas itself and, if later repented, were easily painted over. Indeed, X-ray investigation of many of Giorgione's paintings has confirmed such changes, some quite radical and affecting the entire composition, others only a single figure—such as the standing nude in the *Concert champêtre*, whose pose was originally more frontal and open, her head turned in the opposite direction and her left arm extended toward the central trio.[21]

Although it entered the recorded history of art as the work of Giorgione, the *Concert champêtre*—like so much of this master's work—

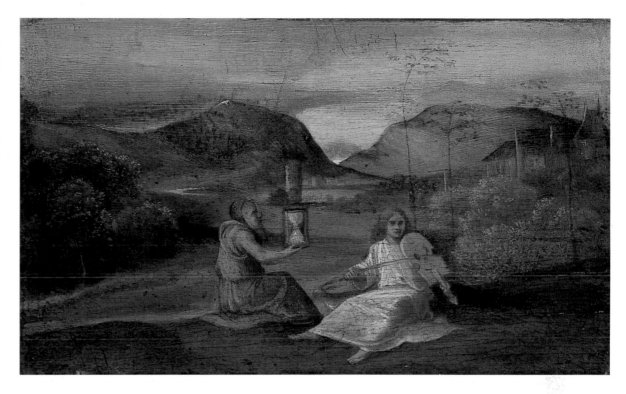

Fig. 32 (No. 6)
Circle of Giorgione
The Hour Glass
oil on wood panel
4¾ x 7½ inches (12 x 19 cm.)
The Phillips Collection, Washington, D.C.

Opposite
Fig. 30 (top)
School of Giorgione
Rustic Idyll
oil on wood panel
4¾ x 7½ inches (12 x 19 cm.)
Museo Civico, Padua

Fig. 31
School of Giorgione
Leda and the Swan
oil on wood panel
4¾ x 7½ inches (12 x 19 cm.)
Museo Civico, Padua

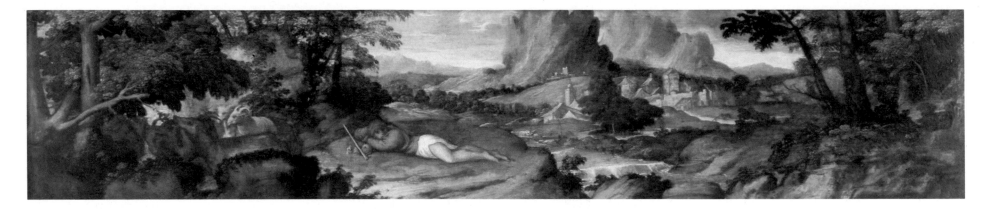

Fig. 33
School of Titian
Shepherd in a Landscape (*Endymion?*) c. 1520
oil on wood panel
11 x 50 inches (28 x 127 cm.)
The Barnes Foundation, Merion, Pennsylvania

has, since the nineteenth century, been subject to a number of alternative attributions, most significantly to Titian. And yet the pictorial poetry of the canvas is not that of Giorgione's younger contemporary and eventual successor. Titian's comparable images with amorous iconography are fundamentally different in conception and realization, more classically structured in composition, insistently respectful of the picture plane. Titian's early palette is chromatically clearer, his forms more crisply drawn, illuminated by a brighter sunlight. Nor are these paintings—the *Three Ages of Man*, for example (Fig. 8)—conceived in a pastoral mode; their compositional structures correspond rather to an allegorical function, in which clarity of form is essential for the equations of meaning.

The differences between the two styles may be epitomized in the contrast between the standing nude of the *Concert champêtre* and the comparable figure, also leaning against a fountain, in Titian's *Sacred and Profane Love* (Fig. 5). Even within the construction of a single figure, the style of the *Concert champêtre* is predicated on volume rather than mass, a quality characteristic of Giorgione's twilight naturalism; the softened modeling of the round forms of the torso, inviting touch

yet offering no guarantee of tactile satisfaction, the slow fusing of body and space at the disappearing contours—all this the figure shares with the landscape's hills, trees, and clouds in the painting. The long, unbroken contour of Titian's nude bespeaks a different style: its precisely controlled undulation offers a sinuous poetry of its own, and its frontality addresses the picture plane with the same kind of subtly inflected precision. Such comparisons may be extended to the full composition, for clouds, trees, or larger spatial constructs reveal the same contrasts: Titian's articulation is cleaner, his surfaces firmer, his spaces more deliberately layered; his art sounds a poetic note quite distinct in its clarity and solid realism from the veiled invitation that remains for us the culmination of Giorgione's achievement.

Not until much later in his long career, in the broad and open style of free brushwork that extended the example of his predecessor, did Titian create, albeit on a different scale, a pastoral art in painting comparable to—indeed, inspired by—Giorgione's invention (Fig. 78).

Giorgione died young, at the age of thirty-three, a victim of the plague in 1510. His vision and technique begin the long tradition of modern oil

painting. The *Concert champêtre*, once it entered public awareness in the eighteenth century, challenged the poetic sensibilities of Watteau and, a century later, the technical curiosity and ambitions of Delacroix; most infamously, it would provide a basis for Manet's shocking communion of modern dressed male and unclothed female in the park (Fig. 208).[22] Even in its own time, however undocumented its provenance, the picture evidently inspired Giorgione's contemporaries and followers—its anonymous seated nude continued to invite pastoral partners to make music (Fig. 9).[23]

Pastoral Structures

Other paintings of the early Cinquecento from the circle of Giorgione are more explicitly tied to Renaissance pastoral poetry. A series of four small images ascribed to Andrea Previtali (Fig. 6), for example, illustrates scenes from an eclogue by the Ferrarese poet Antonio Tebaldeo. They narrate events in the sad tale of the shepherd Damon: (1) Damon laments his unrequited love for Amaryllis; (2) his friend Thyrsis asks the cause of his sorrow; (3) Damon kills himself; (4) Thyrsis discovers the body of the shepherd. Before his suicide, in Tebaldeo's poem, Damon breaks his cithara so that it may never be sounded by other hands; the shepherd's music is destroyed with his love. The Renaissance poet realizes a theme whose potential had only been hinted at in classical models: no one actually dies for love—on stage, as it were—in Theocritus or in Virgil's *Eclogues*. These panels were probably intended to decorate some piece of furniture. Their very modesty, as much as their actual subject, contributes to their pastoral status; their pathos is nonheroic.[24]

Such explicit pastoral narratives, with nameable personae, are rare. Most of the figures that populate the pastoral landscapes of the early sixteenth century cannot be identified; they are ge-

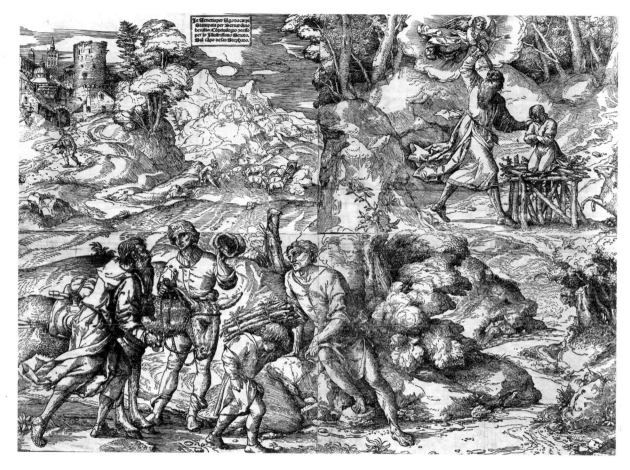

Fig. 34
Titian (c. 1488–1576) design
Ugo da Carpi (1450–c. 1525) cutter
The Sacrifice of Abraham c. 1514–15
woodcut
c. 31½ x 41¹⁵⁄₁₆ inches (80 x 106.5 cm.)
Kupferstichkabinett und Sammlungen der Zeichnungen
Staatliche Museen, East Berlin
868–100

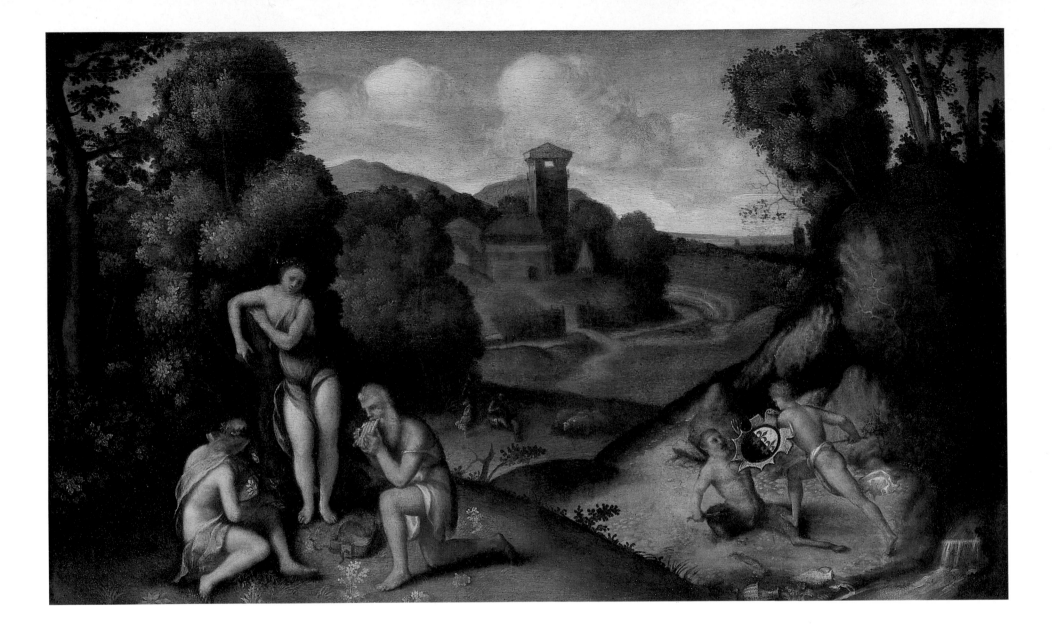

Fig. 35 (No. 10)
Circle of Giorgione
Allegory c. 1506–10
oil on wood panel
17 x 27½ inches (43.1 x 69.8 cm.)
Sarah Campbell Blaffer Foundation
Houston

DAVID ROSAND

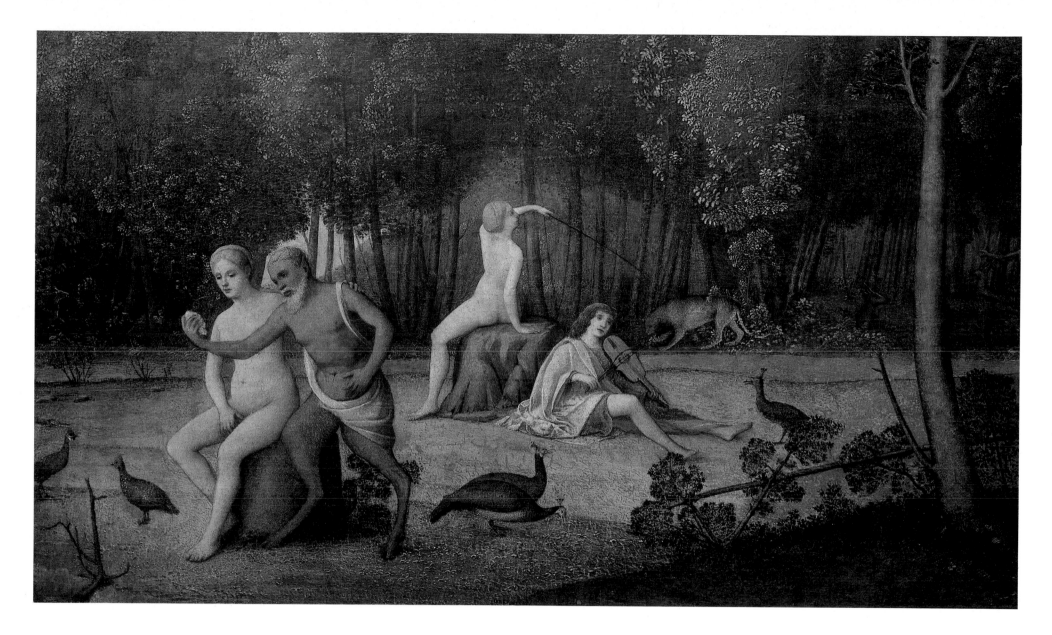

Fig. 36 (No. 1)
Giovanni Bellini (c. 1433–1516)
Orpheus c. 1515
oil on canvas, transferred from panel
18⅝ x 32 inches (39.5 x 81 cm.)
National Gallery of Art, Washington, D.C.
Widener Collection
1942.9.2

distance, the buildings of a town or village serve as foil to the natural setting, defining its character of escape, confirming its difference. These are qualities shared by a large body of landscape images created by Venetian artists of the first decade of the sixteenth century, artists grouped, for want of more precise attributions, under the heading of the "circle of Giorgione."

Giorgione is the name that we have come to associate most immediately with pictorial pastoral. The relatively few paintings that are his legacy to the history of art establish the basic models for the several ramifications of the genre. The *Concert champêtre* visually realizes the world of the eclogue, the world of shepherds and nymphs, of music, poetry, and, implicitly, love, a world shaded from the sun, refreshed by the sound of a spring. In other paintings, however, Giorgione extended the limits and possibilities of the genre. Both *Three Philosophers* (Fig. 11) and the *Sleeping Venus* (Fig. 10) initiate a new kind of image, elaborating the type and role of figures in a landscape. Even the enigmatic *Tempest* shares in the structure of pastoral: its protagonists, whatever their identities, are located along the banks of a stream, far from the distant city. And the famous red chalk drawing of a shepherd in a landscape with the crenellated walls of a city in the background is the epitome of that essential pastoral situation (Fig. 12).[25]

On the example of Giorgione's art, landscape confirmed its role as both setting and protagonist in painting. Especially on the intimate scale of small images, landscape presented a field for special delectation, often transcending the interest of whatever narrative it hosted. Even as it served to locate figures and action, landscape offered its own visual satisfaction, the fiction of its spatial invitation and integrity (Figs. 13, 17).

From within the circle of Giorgione a few individual artists emerged to develop aspects of the

Fig. 37 (No. 7)
Circle of Giorgione
Venus and Cupid in a Landscape
oil on wood panel
4⅜ x 8 inches (11 x 20 cm.)
National Gallery of Art, Washington, D.C.
Samuel H. Kress Collection
1939.1.142

neric types, anonymous shepherds who might be called Daphnis or Lycidas, Mopsus or Corydon, Selvaggio or Ergasto or, the persona of Sannazaro himself, Sincero. Nor do they do anything, except make music or love, or contemplate their surroundings; their very existence affirms their pastoral credentials. And just as the figures participate in situations that can be called pastoral, the landscapes themselves share certain structural characteristics that establish a comparable generic identity.

The pastoral landscape tends to be more intimate than panoramic, to feature a dominant grove as either immediate setting for or backdrop to the figures, and a stream is likely to run through its gentle hills. These are essential components of the *locus amoenus*, the scene for pastoral inaction, for the leisure that is essential to the genre. In the

DAVID ROSAND

Fig. 38
Giovanni Bellini (c. 1433–1516)
Feast of the Gods 1514
oil on canvas
67 x 74 inches (170 x 188 cm.)
National Gallery of Art,
Washington, D.C.
Widener Collection
1942.9.1

Fig. 39
School of Giorgione
Birth of Adonis
oil on wood panel
13¾ x 63¾ inches (35 x 162 cm.)
Museo Civico, Padua

pastoral. Among them, Giulio Campagnola (ca. 1482–after 1515) is perhaps the most significant. Best known to us as a printmaker, he was extremely well educated—credited with a knowledge of Hebrew as well as Greek and Latin. Like Giorgione, he too was praised as a musician, a singer and lutenist. A familiar of both humanists and courtiers, he brought to his art a refined literary background.[26] His elaboration of the pastoral genre, however, was not illustrative or narrative in any obvious way; it was essentially pictorial. And because he worked in prints, his vision was open to a broader dissemination. The small scale of his images, as well as the details of execution, invited a special intimacy of response. Indeed, the particular techniques and qualities that Giulio explored in engraving are closely related to the pastoral aesthetic. The stippling technique he invented was a graphic equivalent to the tonalism of Giorgione's painting, a soft shadowing of modeled form and ambient atmosphere. Giulio's pastoral designs present either single figures or groups in the foreground of a landscape that rolls away beyond bowers and hills to a horizon of architecture: by the very structure of the composition, the dialogue between town and country remains implicit in the situation.

Giulio's shepherds, like those of Giorgione, evoke the dramatis personae of pastoral poetry. His young shepherd (Fig. 15)—who may well relate to a Giorgionesque model, known in painting through the so-called *Sunset Landscape* (Fig. 14)—is paired with an older one, suggesting the dialogue between youth and age that is a theme in the pastoral literature.[27] And, as though in response to his own imagery, Giulio engraved another, older shepherd: reclining against a saddle, he sounds his pipe before his sheep and goat (Fig. 16). We, presumably like Campagnola's audience, might well think of Virgil's "lucky old man" (*fortunate senex*), the shepherd Tityrus who plays "woodland musings upon a delicate reed" (*Eclogue* I).[28] Later (in *Eclogue* V), Menalcas encourages the younger Mopsus to song, urging him to begin and "let Tityrus watch the grazing kids." Single lines and single images, states of being rather than full narrative situations, define the character of Giulio's inventions.

Sannazaro's imagined Arcadia, unlike Virgil's, is punctuated by monuments—temples, altars, tombs. It is a more particularized landscape, demanding a more particular response of its inhabitants—and, by extension, the reader. The

DAVID ROSAND

existence of Sannazaro's shepherds becomes complicated by rituals of initiation and interpretation, by a more active presence of the deities. In a similar vein, the artists expanded the range of pastoral possibilities. They populated their landscapes with characters calculated to introduce a nonpastoral note of the hermetic and enigmatic: philosophers and seers, astrologers and priests evoke exotic dimensions of culture and extensions of geography. Once again, a painting by Giorgione seems to epitomize this development, the *Three Philosophers* (Fig. 11). Campagnola, too, elaborates upon this basic theme in drawings and prints (Figs. 18, 19). The shaded grove of pastoral becomes more like Dante's *selva oscura*, a dark wood of more ominous meaning. Such thematic modulations are reversible, however; the exotic and enigmatic could be translated back to a purer pastoral mode. Giulio's drawing of landscape with two philosophers (Fig. 20) was intended to serve as the model for an engraving. He actually began work on the plate but evidently abandoned it—possibly the project was interrupted by his death. His adopted son Domenico brought the plate to completion, but not according to Giulio's design (Fig. 22). Instead, he substituted for the two older enigmatic figures a quartet of younger musicians, adding the requisite sheep, and thereby returning the image to its pastoral origins.

Domenico Campagnola (1500–64), although a painter of some importance in Padua, is also best known as a professional graphic artist, a printmaker and draftsman. Above all, his landscape imagery was sought after by collectors and, in evident response to demand, he produced both drawings and their replication as woodcuts, that is, both *disegni a mano* and *disegni a stampa*. His earlier inventions in particular found their ideal basis in the fundamental structures of pastoral (Figs. 25, 26).[29]

A third artist who came out of the circle of Giorgione is the master who dominated Venetian painting for most of the century, Titian (ca. 1488–1576). From the beginning, however, Titian demonstrates a sensibility not obviously suited to the pastoral genre. His ambition seems essentially heroic, his style more determined and, as we have suggested, tectonic. A theme such as the three ages of man, which might indeed have lent itself to pastoral development, is treated instead with an insistent clarity of presentation in his painting in Edinburgh (Fig. 8).[30] The gentle eroticism of the young lovers, its musical expression, and their position within a landscape setting might suggest the pastoral mood, but the firmly classical structure of the composition resists the tonal suggestiveness of Giorgione's pastoral vision. Titian's stronger formal language does not accommodate that softer mood. Only as his painterly manner loosens, later in his career, does he find his own pastoral voice.

Nonetheless, Titian does participate in the pictorial development of pastoral motifs in the opening decades of the sixteenth century. Indeed, through the special power of his vision, certain of those motifs achieve a new grandeur: the grove, for example (Figs. 21, 24).[31] If both Giulio and Domenico Campagnola rendered natural forms as much on the basis of their study of other art—the graphic art of Albrecht Dürer in particular—as of nature itself (Fig. 23), Titian transcended whatever models he may have known to impose his own graphic will upon nature. The result is that conviction of style, the organic integrity of technique and form, that transfers to the object rendered. Titian's trees seem to be rooted in the ground and to grow organically from the ground. Although his concern with groves and bowers may relate to pastoral themes, Titian's use of these motifs is of a different order. While they may serve as comfortable *loci* for shepherds (Fig. 33), they are as likely to set off a

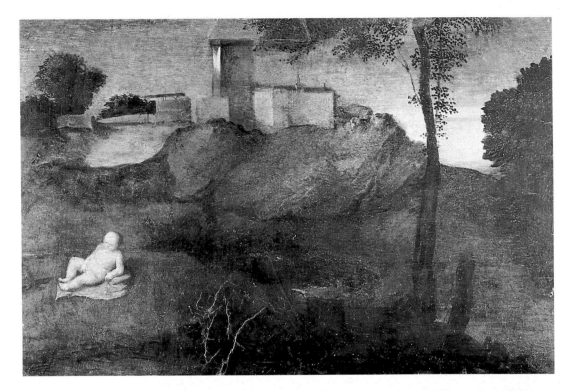

more tragic pathos—such as Abraham's sacrifice of his son (Fig. 34).[32] For Titian, natural setting, like human action, generally belongs to a heroic mode.

Courtly Pastoral

In the course of the Renaissance, the idealized pathos of the ancient shepherd merged with the ideals of the chivalric lover, creating new possibilities in painting as well as poetry. Courtly behavior itself ennobled the pastoral pleasance, transforming it at times into a more crafted garden; on other occasions, however, the rustic grove continued to stand as a symbol of the natural alternative. Most famously, in Pietro Bembo's celebration of the court of Caterina Cornaro at Asolo, *Gli Asolani*, the several dialogues on love are deliberately staged away from the court proper, in the *locus amoenus* of a garden of "surpassing charm and beauty." Following the pastoral model, Bembo's courtiers, like the shepherds of antiquity, organize their discourse around song. The court of the displaced Queen of Cyprus was indeed a center of cultural activity, and tradition, without explicit documentation, has associated the musical Giorgione himself with that center. Typically, the courtier-musicians gather in a landscape setting outside the confines of the town.

Within the narrative of *Gli Asolani*, however, there is a further dimension of escape, beyond the cultivated garden. Lavinello, the purest of Bembo's protagonists and the one who resolves the debate as the voice of the author himself, recounts his experience:

> ...early this morning, when I had parted from my friends and left the castle in order to pursue my thoughts alone, taking a path which climbs the slope behind us, without knowing where I went, I reached the little grove which crowns the charming mountaintop as if it has been planted there by careful measurement. The scene did not displease me; nay, forgetting love while I stopped to

DAVID ROSAND

admire the beauty of that plantation from without, I was tempted by its silvan quietude and shade to enter it and finally chose an almost invisible trail which after branching from the pathway, led my steps within; nor did I stop before the slender track had brought me to a little clearing. At one of its corners, I became aware, a hut was built, and not far off there slowly moved among the trees a solitary figure, a bearded, white-haired man clothed in a material like the bark of the young oaks surrounding him.[33]

Lavinello's encounter with the hermit recalls the familiar images of various old men, of presumed wisdom, at the edge of a wood. More precisely, it seems to enact a situation like that in the background of Dosso Dossi's pastoral *Three Ages of Man* (Fig. 27).[34]

Pure pastoral defines the left side of Dosso's composition: a pair of lovers embracing in the shade of a bower, accompanied by a flock of goats. Paired lovers in the pastoral landscape were not always responsible for such flocks, however. For the shepherd and his staff were substituted the courtly musician with his instrument or the soldier with his spear or pike. Giorgione's *Tempest* offers the clearest model of a certain type: the grouping of female with child, usually seated, with standing soldier (Figs. 28, 29). These enigmatic encounters—almost secular variations on the Rest on the Flight into Egypt—defy ready interpretation. Although they lend themselves to such allegorical categories as Charity and Fortitude, the very popularity of the juxtaposition of female and male suggests that its appeal was less consciously moralizing.[35]

In a similar vein, the motif of lovers in the shadows assumed an independent existence; as an element of the landscape it signaled in a most general but nonetheless explicit way the amorous invitation of the natural setting (Fig. 125).[36]

The Pastoral Epyllion

The groves of the pastoral landscape were hardly

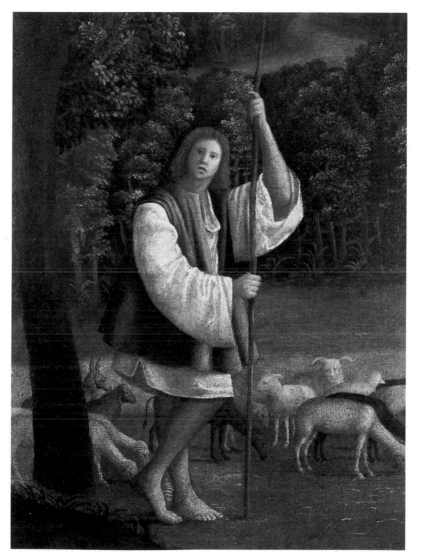

Opposite
Fig. 40 (No. 8) (top)
Circle of Giorgione
Paris Exposed on Mount Ida
oil on wood panel
14¹⁵/₁₆ x 22⁷/₁₆ inches (38 x 57 cm.)
The Art Museum, Princeton University
Gift of Frank Jewett Mather, Jr.

Fig. 41 (bottom)
Paris Bordone(?) (1500–71)
Apollo and Daphne c. 1525
oil on wood panel
25¼ x 51¼ inches (64 x 130 cm.)
Pinacoteca Manfrediniana e Raccolte
del Seminario Patriarcale, Venice

Fig. 42 (No. 2)
Andrea Previtali (c. 1470–1528)
David the Shepherd c. 1500
oil on canvas
26 x 19⅝ inches (66 x 49.9 cm.)
Gift of Michael Straight
Herbert F. Johnson Museum of Art
Cornell University, Ithaca, New York

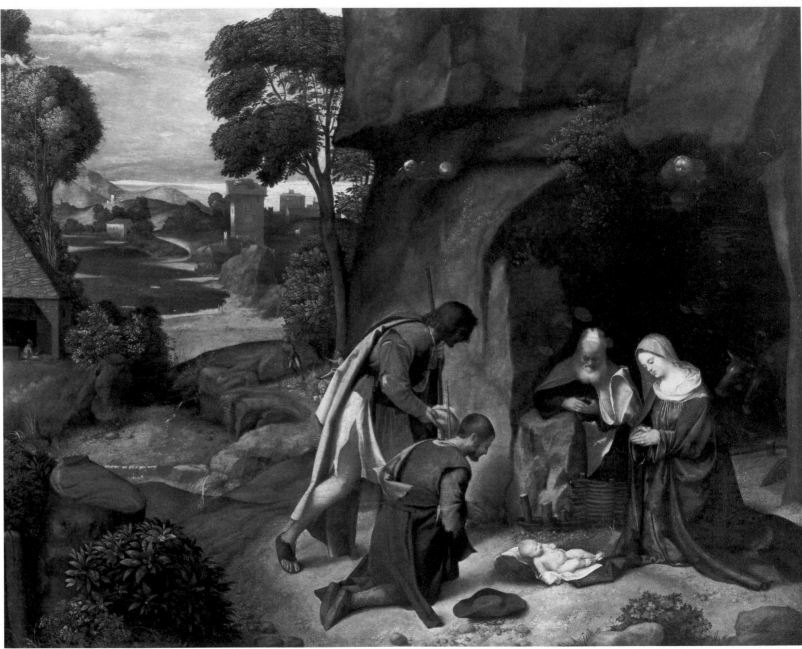

Fig. 43 (No. 3)
Giorgione(?) (c. 1477/78–1510)
The Adoration of the Shepherds c. 1505–10
oil on wood panel
35¾ x 43½ inches (91 x 111 cm.)
National Gallery of Art, Washington, D.C.
Samuel H. Kress Collection
1939.1.289

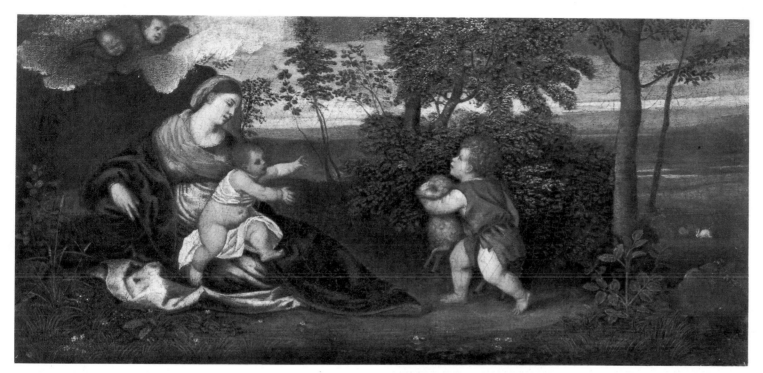

Fig. 44 (No. 39)
Polidoro Lanzani (1515–65)
*Madonna and Child and the Infant Saint John
in a Landscape*
c. 1540–50
oil on canvas
11 x 22¾ inches (27.9 x 57.8 cm.)
National Gallery of Art, Washington, D.C.
Andrew W. Mellon Collection
1937.1.36

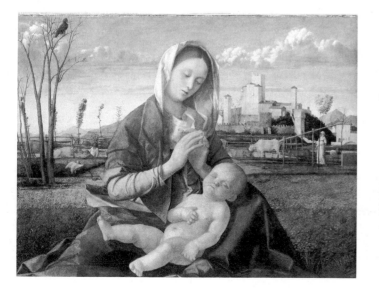

Fig. 45 (left)
Giovanni Bellini (c. 1433–1516)
Madonna of the Meadow
oil on board, transferred from wood panel
26½ x 34 inches (67.3 x 86.4 cm.)
The National Gallery, London
599

Fig. 46
Titian (c. 1488–1576)
*Madonna and Child with Saints John the Baptist
and Catherine of Alexandria*
oil on canvas
39⅝ x 56 inches (100.6 x 142.2 cm.)
The National Gallery, London
635

neutral settings. They were charged with mythic memories, recollections of a past when gods and mortals mixed. These are Ovidian woods, in which any particular tree or plant has an heroic or, more usually, a pathetic etiology. Describing a special grove in his "pastoral Arcadia," Sannazaro introduces the poplar: "And there with shorter leaf is the tree with which Hercules was wont to be crowned, into whose trunk the wretched daughters of Clymene were transformed."[37] The woods themselves are inspirited by their own deities, populated by nymphs and satyrs. It is perfectly appropriate, then, that this landscape should serve as the setting for a range of Ovidian narratives and allegories figured in the shapes of the pagan gods.

Unlike Giovanni Bellini's *Feast of the Gods* (Fig. 38), many of these mythological paintings are of very modest dimensions, some undoubtedly intended as furniture decoration, and the figures themselves are correspondingly modest in scale. This very modesty is a part of the pastoral aesthetic. Its aheroic stature is confirmed by the small size of the actors and dominance of the landscape. Indeed, the landscape setting in this kind of imagery seems almost to serve as a ground for, an invitation to, figural invention. We recognize the typological pairings—of Venus and Cupid (Fig. 37) or astrologer and musician (Fig. 32) or lovers in a rustic idyll (Fig. 30)—as part of the larger pictorial context of pastoral; the social situation of pastoral is here extended to imply meanings of greater complexity and precision, however elusive they remain. In other cases more or less recognizable figure types—Apollo and Marsyas (Fig. 35) or Orpheus and Circe (Fig. 36)—suggest narrative dimensions to the gathering in the grove.

The pastoral operates through indirection. Implication and suggestion are its important means in painting as well as poetry. The evocation of a distant world, a golden age of greater simplicity than

Fig. 47 (No. 23)
After **Titian**
Saint Jerome in the Wilderness c. 1525–30
woodcut
15⅛ x 20⅝ inches (38.5 x 52.5 cm.)
National Gallery of Art, Washington, D.C.
Rosenwald Collection
1964.8.373

Fig. 48 (No. 38) (opposite)
Paris Bordone (1500–71)
Saint Jerome in the Desert c. 1535–40
oil on canvas
27⅝ x 34¼ inches (70.2 x 87 cm.)
John G. Johnson Collection of Philadelphia

DAVID ROSAND

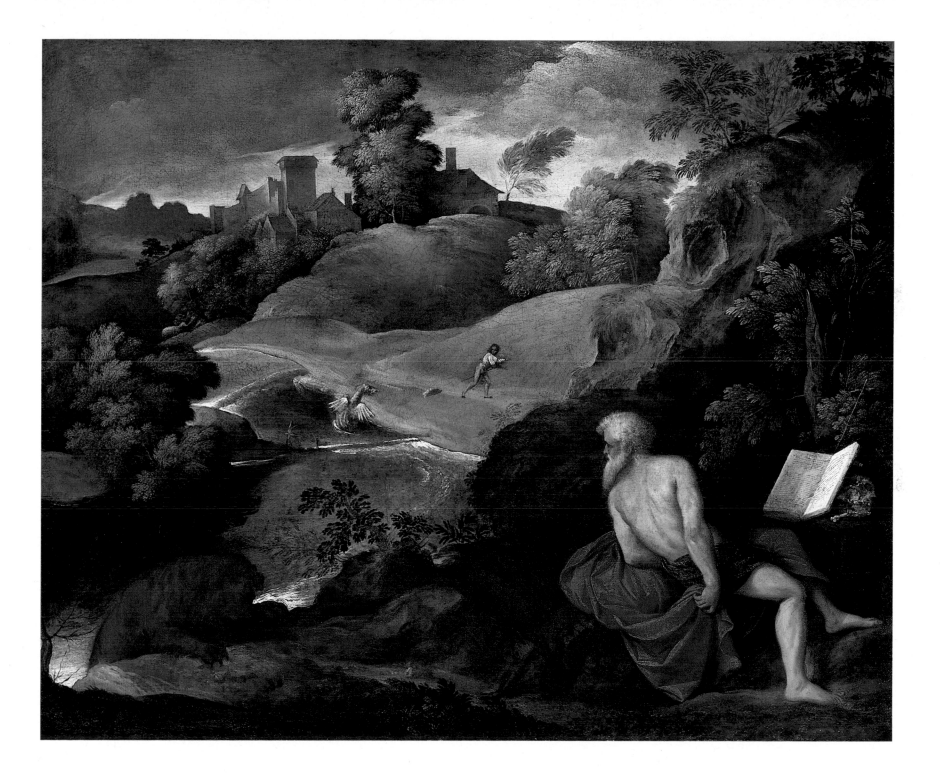

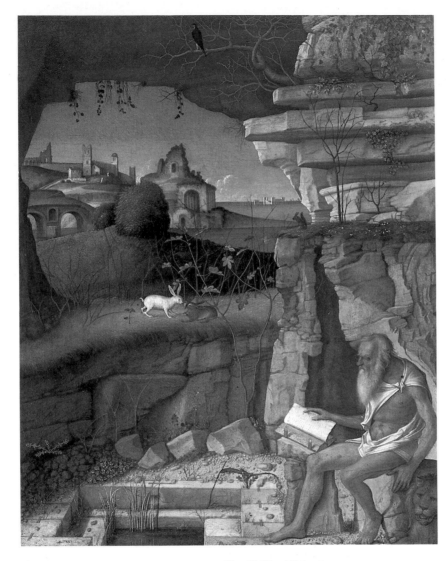

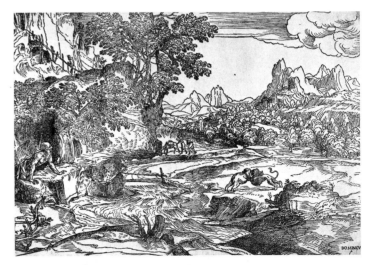

Fig. 49
Giovanni Bellini (c. 1433–1516)
Saint Jerome Reading c. 1480–90
oil on wood panel
19¼ x 15½ inches (48.9 x 39.4 cm.)
National Gallery of Art, Washington, D.C.
Samuel H. Kress Collection
1939.1.217

Fig. 50 (No. 11) (top)
Circle of Giorgione
Landscape with an Old Nude Man Seated (Saint Jerome?) c. 1505
pen and brown ink and wash on brownish paper
7⁷⁄₁₆ x 10⅛ inches (18.9 x 25.8 cm.)
The Ian Woodner Family Collection, Inc., New York

Fig. 51 (No. 36)
Domenico Campagnola (1500–64)
Saint Jerome with the Fighting Lions c. 1530–35
woodcut
11⁵⁄₁₆ x 16⁷⁄₁₆ inches (28.7 x 41.8 cm.)
The Cleveland Museum of Art
Dudley P. Allen Fund
52.271

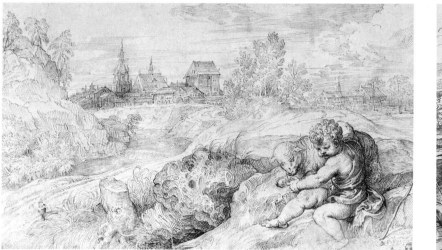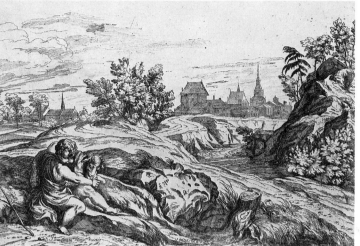

the modern, is achieved by appeal to the imagination of the viewer: we are invited to read our own dreams into the shadowed eyes of Giorgione's musicians. Renaissance invention, however, was not purely subjective fantasy. Painters created new themes on the supporting foundations of a rich heritage. They worked with and within the conventions of their art and their culture. The creation of a pastoral mode in painting depended in part upon the isolation of that mode in literature. Once established in painting, however, the pastoral mode itself became the basis for new developments, affecting a broader thematic range.

Pastoral settings were adapted to accommodate narrative structures, as in Giorgione's *Sunset Landscape* (Fig. 14), which hosts Saint George's battle with the dragon, the retreat of Saint Anthony Abbott, and (possibly) the healing of Saint Roch. A group of pictures generally ascribed to the school of Giorgione, sometimes to Titian himself, tell their Ovidian tales within the controlling realm of landscape: among others, tales of the birth of Adonis (Fig. 39), Leda and the swan (Fig. 31), the birth of Paris (Fig. 40), Apollo and Daphne (Fig. 41).[38] The figural action is not merely an excuse for painting a landscape; rather, the narrative reference awakens possibilities latent in the natural setting—the very possibilities that had inspired Ovid's own *Metamorphoses* and the mythology that lies behind it. Set into these paintings, the tales articulate the landscape, give it special meaning, as surely as the presence of shepherds had in other contexts. Without the heroic ambition of monumental figure painting, the narrative itself is inflected by being part of nature—in a poetic rather than a philosophical sense, its resonance human rather than cosmic. Not epic, these little paintings are like *epyllia*, small-scale narrations that reduce the great mythic tales to more intimate proportions, stressing the amorous over the heroic.

Religious Pastoral

If classical precedent affords the essential background and impetus for the development of the

Fig. 52 (No. 32) (left)
Domenico Campagnola (1500–64)
Landscape with Infant Saint John the Baptist c. 1530
pen and brown ink with traces of black chalk on paper
9 x 14⅝ inches (22.8 x 37.1 cm.)
Gabinetto Disegni e Stampe degli Uffizi, Florence
1405E

Fig. 53 (No. 69) (right)
Valentin LeFebre (c. 1642–80)
Landscape with Infant Saint John the Baptist, after Titian, published 1682
etching
11⁹⁄₁₆ x 15¹¹⁄₁₆ inches (29.3 x 39.8 cm)
Fondation Custodia, Collection F. Lugt
Institut Néerlandais, Paris
7620/27

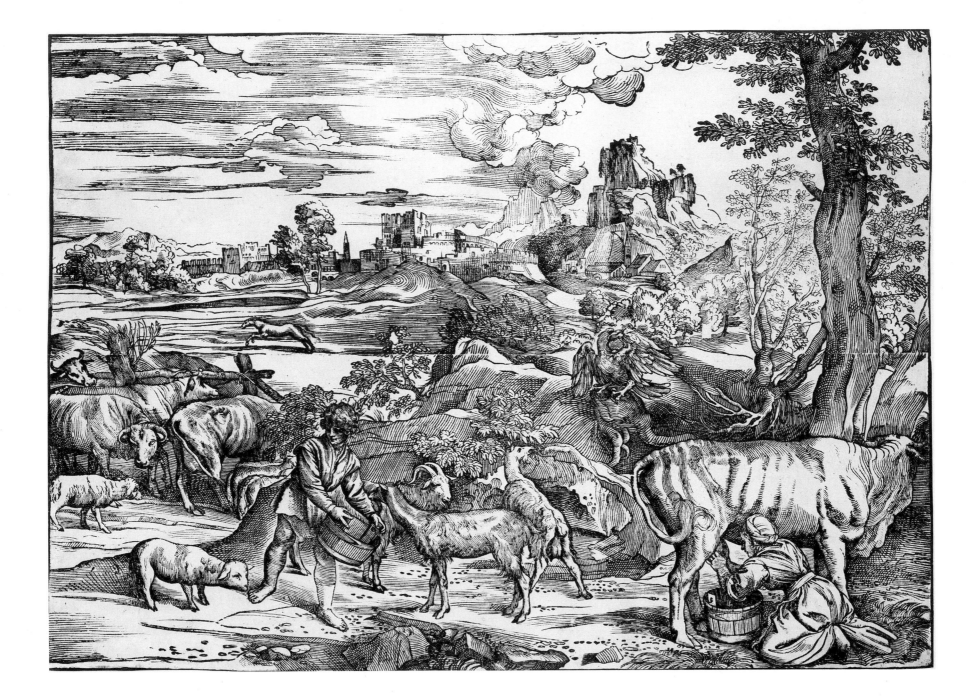

DAVID ROSAND

Fig. 55
Jacopo da Ponte, called **Jacopo Bassano** (1510–92)
The Parable of the Sower c. 1560
oil on canvas
54¾ x 50¾ inches (139 x 129 cm.)
Thyssen-Bornemisza Foundation, Lugano

◁ **Fig. 54** (No. 22)
After **Titian**
Landscape with Milkmaid c. 1520–25
woodcut
14¹³⁄₁₆ x 17¹⁄₁₆ inches (37.6 x 43.3 cm.)
National Gallery of Art, Washington, D.C.
Rosenwald Collection
1964.8.372

Fig. 56 (No. 18)
Titian (c. 1488–1576)
Landscape with Milkmaid
pen and brush and brown ink, washed, on faded, brownish paper
14⁹⁄₁₆ x 20¹³⁄₁₆ inches (37 x 52.8 cm.)
Musée du Louvre, Paris
Département des Arts Graphiques
5573

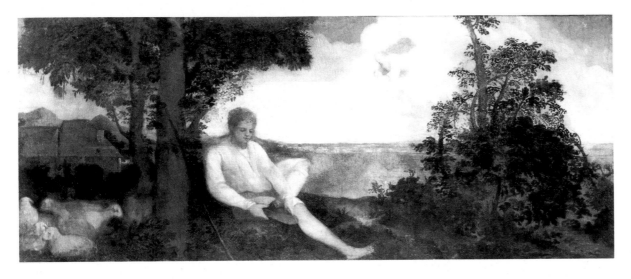

pastoral in Renaissance literature and art, it was reinforced and even guided in part by another tradition. Holy Scripture, more than Theocritus or Virgil, shaped the fundamental and determining values of a Christian culture. In both the Old and New Testaments the poetic imagination could find nonpagan pastoral models—from David the shepherd (Fig. 42) and musician to Christ as both good shepherd and lamb of God. The story of the Nativity, especially as narrated in the Gospel of Saint Luke (2:6–20) with its emphasis on humility, is cast in essentially pastoral terms. Luke recounts that the Child was born in a manger and the heavenly announcement of the "good tidings of great joy" made first to shepherds:

> And there were in the same country shepherds abiding in the field, keeping watch over their flock by night.
> And, lo, the angel of the Lord came upon them, and the glory of the Lord shone round them....

After Mary and her husband Joseph, shepherds were the first witnesses of the birth of the Savior, "the babe wrapped in swaddling clothes, lying in a manger... And the shepherds returned, glorifying and praising God for all the things that they had heard and seen, as it was told unto them."

The pastoral implications of the situation are more fully realized pictorially when the Nativity takes place, following Byzantine tradition, in a cave rather than in a manger, that is, a landscape proper. In the National Gallery's *Adoration of the Shepherds*, a painting now generally attributed to Giorgione (Fig. 43), the rustics adore the Child in the middleground; behind, another pair of shepherds with their sheep resting beneath the shade of a large tree before a grove, receives the heavenly announcement. The grouping creates a motif of pure pastoral ease. In a more modest painting by Polidoro Lanzani (1515–65), the infant Saint John in all innocence brings a present to the Child, a

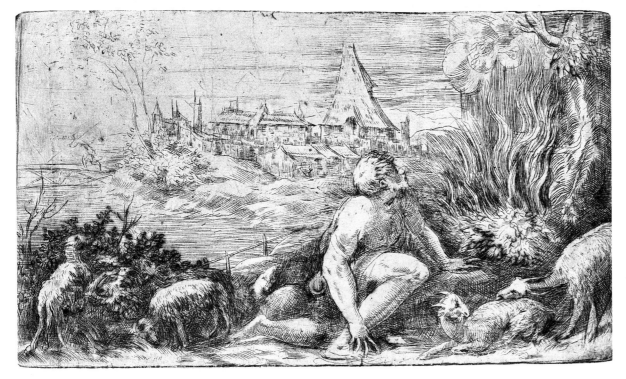

DAVID ROSAND

lamb symbolizing the sacrifice (Fig. 44); his gesture recalls the gift giving of shepherds in Theocritus.

The degree to which the pastoral imagination could appropriate the Christian story can be gauged in another of Jacopo Sannazaro's poems, *De Partu Virginis* (On the Virgin Birth, 1526). In his most ambitious effort, the Renaissance poet, writing now in Latin, took Virgil as his model and his challenge. Narrating the story and declaring the theology of his Christian theme, Sannazaro quite naturally reaches out to his classical sources. The pastoral character of the Nativity is renewed as he calls the blessed shepherds Lycidas and Aegon, names taken straight from the *Eclogues* of Virgil. Translating the values of the classical pastoral to a new realm and era, the pagan shepherds in attendance upon the Child bear special and poignant witness to the fulfillment of the prophecy. Their song, now resounding to His praise, actually paraphrases Virgil's *Eclogue* IV, which had always been read by Christians as foretelling the coming of Christ.[39]

Although the iconography of the Nativity lent itself explicitly to pastoral depiction, a more fundamental and pictorially important development involved landscape itself, its signifying role in religious imagery. Pastoral imagery could be invoked to give added resonance to the basic image of the Madonna and Child, as in Giovanni Bellini's *Madonna of the Meadow* (Fig. 45). The bucolic background of this painting, although redolent with natural symbolism, functions as much through its peaceful tone—established by the articulation of the distance between the sanctified meadow and the far-off town, the tranquility of the cowherd in repose, and the very stillness of the animals.[40] Here and in other compositions, Bellini sets a model for a type of religious image in the pastoral mode—holy figures within a landscape—that would be developed by the next generation of

Opposite
Fig. 57 (top)
Circle of Titian
Moses and the Burning Bush
oil on canvas
23⅝ x 61⅜ inches (60 x 155.9 cm.)
Courtauld Institute Galleries, London
Lee Collection

Fig. 58 (bottom)
Andrea Meldolla, called **Schiavone** (1510/15–63)
Moses and the Burning Bush
etching
4¹⁵⁄₁₆ x 8⁹⁄₁₆ inches (12.5 x 21.7 cm.)
Graphische Sammlung Albertina, Vienna
B.XVI, p. 41, no. 3

Fig. 59
Giuseppe Porta, called **Salviati**(?) (c. 1520–75)
Landscape with a Ploughman c. 1550–60
woodcut
11⅜ x 15¹⁵⁄₁₆ inches (29 x 40.5 cm.)
The Trustees of the British Museum, London
1860.4.14.149

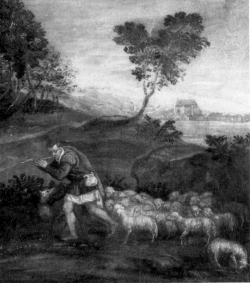

Fig. 60 (No. 19) (left)
Titian (c. 1488–1576)
Landscape with Flute-playing Shepherd
pen and brown ink on yellowed paper
11⅞ x 17¹⁄₁₆ inches (30.2 x 43.4 cm.)
Graphische Sammlung Albertina, Vienna
1477

Fig. 61 (right)
Domenico Brusasorci (1516–67)
Shepherd and His Flock
oil on canvas
17¹¹⁄₁₆ x 15⅜ inches (45 x 39 cm.)
The John G. Johnson Collection of Philadephia

Opposite
Fig. 62 (left)
Hieronymous Cock (1510–70)
Ruins on the Palatine, with a Panoramic Landscape
from his series of *Views of Roman Ruins* 1550
etching
8⅛ x 11⅛ inches (20.6 x 28.2 cm.)
Graphische Sammlung Albertina, Vienna
1957.339.13, Holl. 34

Fig. 63 (right)
Paolo Veronese (1528–88)
Landscape Mural, 1561–62
fresco
Sala dell'Olimpo, Villa Barbaro-Volpi, Maser

Venetian painters. Titian's *Madonna and Child with Saints John the Baptist and Catherine of Alexandria* is a striking example (Fig. 46); the annunciate shepherds in the background confirm the pastoral mode of the image.[41] An important aspect of this type is its horizontal format, which accords a dominant role to the landscape. The degree to which composition in such pictures acknowledges landscape as a guiding construct, not merely a backdrop, reinforces their pastoral identity.

In certain subjects, especially the retreats of saints, landscape played a major role. Bellini's great panel *Saint Francis in Ecstasy* (Fig. 3) offers the most satisfying image of the saint who, more than any other, identified with the natural world. In his own poetry Francis had sung the praises of God in all his creation, detailing in his *Canticle of Created Things* a litany of natural forces and forms—from "brother sun" and "sister moon" to "mother earth who maintains and governs us and puts forth different fruits with colored flowers and grass." His retreat to Mount Alverna, site of his stigmatization, was an escape into the desert landscape, and strong iconographic tradition has confirmed Francis's identification with that natural setting. The complexity of Bellini's landscape—including the gazing shepherd with his flock in the background—has inspired several, often competing, interpretations.[42] Here, Bellini established the basic configuration of the saint in nature: his isolation and envelopment, his communing with the light, his distance from the city, the rustic bower of his cave, the stillness. Hardly relevant in this context is the poetry of the classical eclogue. Rather the structures of pictorial composition and the degree to which they establish the mode of an image associate Bellini's Saint Francis with the notion of religious pastoral.

DAVID ROSAND

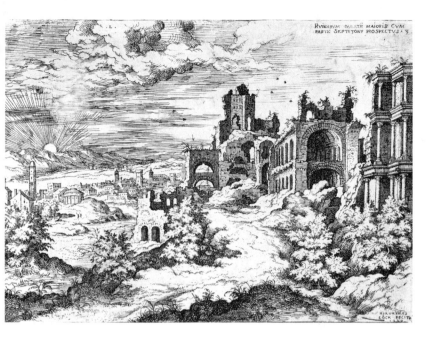

The life and legend of another saint, however, more deliberately encourage the comparison between pagan and Christian pastoral. Jerome, too, finds a natural home in the landscape, to which he escaped in penitence. This saint's description of his desert retreat reads like a deliberate perversion of the pastoral instinct: "Filled with stiff anger against myself, I would make my way alone into the desert; and when I came upon some hollow valley or rough mountain or precipitous cliff, there would I set up my oratory, and make that spot a place of torture for my unhappy flesh."[43] From Jerome's own words Renaissance painters created an image of the saint in the wilderness that seems to reverse the soft and inviting values of pastoral, replacing them with a landscape of repelling hardness (Fig. 49). Yet, by locating the lonely saint in a more familiar and accessible setting, Venetian artists not only domesticated that wilderness but thereby reaffirmed its

pastoral situation (Fig. 50). On a grander scale, Titian composed one of his most impressive graphic landscapes to accommodate Jerome and his "oratory" (Fig. 47), and this woodcut served as inspiration for another, by Domenico Campagnola (Fig. 51). Clearly the theme appealed to artists in search of landscape compositions and, as indicated by its dissemination in prints, to a broader audience as well (Fig. 48).

That Jerome's desert retreat is legitimately compared with pastoral is confirmed by the saint himself in another letter, in which he celebrates the country life. Having suffered the tempests and shipwrecks of fortune, he writes,

> let us take this first chance and make for the haven of a rural retreat. Let us live there on coarse bread and on the greenstuff that we water with our own hands, and on milk, country delicacies, cheap and harmless. If thus we spend our days, sleep will not call us away from prayer, nor overfeeding from study. In summer the shade of a tree will give us privacy. In autumn the mild air and the leaves beneath our feet point out a place for rest. In spring the fields are gay with flowers, and the birds' plaintive notes will make our psalms sound all the sweeter. When the cold weather comes with winter's snows, I shall not need to buy wood: whether I keep vigil or lie asleep, I shall be warmer there, and certainly as far as I know, I shall escape the cold at a cheaper rate. Let Rome keep her bustle for herself, the fury of the arena, the madness of the circus, the profligacy of the theatre....[44]

The rhetorically trained Jerome must have found it quite natural to adapt the models of pagan poetry to serve Christian ends. In similar fashion, Renaissance painters moved easily between the cultures. The shepherd in the landscape and the saint shared a common pictorial foundation. Sometimes the two protagonists could be equated, as in Domenico Campagnola's design of the infant Saint John the Baptist hugging the lamb (Fig. 52). Or, returning to the Old Testamant, Moses before the burning bush could be conceived in an entirely pas-

Fig. 64
Domenico Campagnola (1500–64)
Landscape with Wandering Family
woodcut
11⁵/₁₆ x 16⁷/₁₆ inches (28.7 x 41.8 cm.)
The Metropolitan Museum of Art, New York
Harris Brisbane Dick Fund and Rogers Fund,
by exchange, 1967
67.770

Fig. 65 (No. 41) (opposite)
Girolamo Muziano (1532–92)
Landscape with Saint Giving a Sermon
pen and black pencil on paper
19¼ x 14⅜ inches (49 x 36.5 cm.)
Gabinetto Disegni e Stampe degli Uffizi, Florence
522P

DAVID ROSAND

toral way—as in a painting from the circle of Titian (Fig. 57) or an etching by Andrea Schiavone (1510/15?–1563) (Fig. 58). In each case, the horizontal format of the field acknowledges the significance of landscape in determining pictorial structure—and therefore meaning.

The Georgic: Hard Pastoral and Beyond

> What makes the crops joyous, beneath what star, Maecenas, it is well to turn the soil, and wed vines to elms, what tending the kine need, what care the herd in breeding, what skill the thrifty bees—hence shall I begin my song.[45]

Thus does Virgil open the first book of his *Georgics*. This didactic poem dedicated to the arts of agriculture—tilling and planting, raising cattle, and keeping bees—sounds a different note regarding the natural world, one decidedly not pastoral. The central distinction involves work, the antithesis of the ease that is prerequisite to the poetics of pastoral. The inhabitants of the pastoral landscape are the beneficiaries of a bountiful and generous nature. Those of the georgic, farmers rather than shepherds, must work to reap that bounty; their husbandry transforms nature, and what they enjoy are the fruits of their labor.[46]

Titian, whose inclination was to energize the landscape, took a leading and influential role in transposing pastoral into georgic, particularly in his woodcut design of *Landscape with a Milkmaid* (Figs. 54, 56).[47] This print, possibly inspired by an engraving by Lucas van Leyden, established a repertory of motifs that received wide dissemination and served as model for subsequent artists—most notably Rubens, who probably owned an impression; Van Dyck, who copied parts of it; and Watteau, who recreated it as a painting in his signboard for Gersaint.[48] The basic structure of this landscape, with its distance between foreground figures and the fortified town on the horizon, may evoke

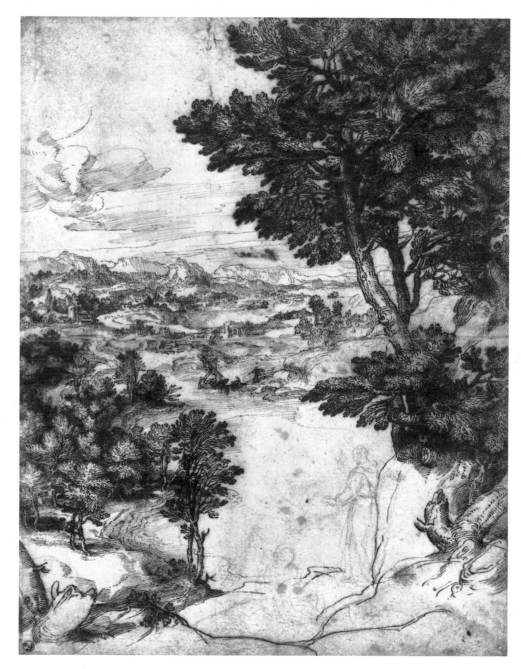

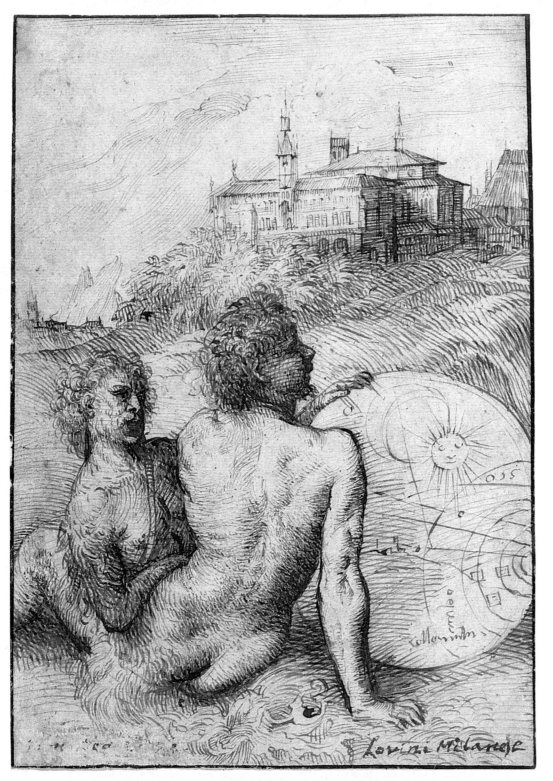

Opposite
Fig. 67 (No. 14) (left)
Lorenzo Lotto (c. 1480–1556)
A Maiden's Dream c. 1505
oil on wood panel
16⅞ x 13¼ inches (43 x 34 cm.)
National Gallery of Art, Washington, D.C.
Samuel H. Kress Collection
1939.1.147

Fig. 68 (No. 15) (center)
Lorenzo Lotto (c. 1480–1556)
Allegory 1505
oil on wood panel
22¼ x 16⅝ inches (56.5 x 42.2 cm.)
National Gallery of Art, Washington, D.C.
Samuel H. Kress Collection
1939.1.156

Fig. 66 (No. 17)
Titian (c. 1488–1576)
Two Satyrs in a Landscape
pen and bistre ink on paper
8½ x 5¹⁵⁄₁₆ inches (21.6 x 15.2 cm.)
Private Collection

certain pastoral values, but the figures themselves hardly have time to enjoy any escape from the cares of life: no idyllic nostalgia here, no music, no love. This couple—rather, family—must tend the flocks and cattle, feed the goats and milk the cows.

Whatever escape from urban care may continue to inform the georgic landscape, it assumes the form of a practical alternative: labor in the country. Jacopo Bassano (1510–92) and his studio made a specialty of catering to the growing urban taste for such imagery (Fig. 55).[49] When such labor is freely chosen, however, that freedom assigns work a very positive value indeed. Ever since the ancient Roman culture of the villa, country life had

offered just such an alternative. "O fortunatos nimium," sings Virgil (*Georgics*, II.458), celebrating the life of the husbandman. "Beatus ille," begins Horace's influential second epode: "Happy is the man who far from the cares of business, like the ancient generations of man, works his ancestral fields with his own oxen, free of all usury."[50] These sentiments echo through the literature on country life—in poetry or in letters like those of Pliny the Younger on his Tuscan villa—nearly always measuring it against the trials of the city. From Alberti to Poliziano to Alvise Cornaro, Renaissance writers extolling life in the country have, understandably, been men of the city.

Fig. 69 (No. 40)
Attributed to **Pietro degli Ingannati**
(mentioned 1529–48)
Allegory c. 1530
oil on wood panel
17 x 15⅜ inches (43 x 39.2 cm.)
National Gallery of Art, Washington, D.C.
Gift of Dr. and Mrs. G. H. Alexander Clowes
1948.17.1

Fig. 70
Sebastiano Serlio (1475–1554)
The Satyric Scene
woodcut illustration from *Il Primo (secondo) Libro
d'Architettura di Sebastiano Serlio, Bolognese.* (Paris:
J. Barbé, 1545)
image, 7½ x 7⅞ inches (19.5 x 20 cm.)
National Gallery of Art, Washington, D.C.
Mark J. Millard Architectural Collection
1983.49.106

Beatus ille might be an appropriate title for another woodcut, traditionally ascribed to Titian but more likely the design of an artist like Giuseppe Porta Salviati (ca. 1520–ca. 1575) (Fig. 59). Tilling his own soil, the ploughman has created out of this larger landscape a rustic *locus amoenus*. The presence of his family behind him, set within a kind of rustic bower, confirms the sense of well-being and self-sufficiency that was a traditional theme of georgic discourse.[51]

In other designs more convincingly associated with Titian and his circle, the shepherds themselves are transformed into workers (Figs. 60, 61). No longer lounging or taking their ease in the shade, they now assume practical responsibility for their flocks, moving them down from the background groves to the water. Even such appropriate labor locates this imagery at the limits of the pastoral poetic.

One aspect of the shift from pastoral toward georgic involved opening up the landscape, extending its spaces toward a more panoramic vista, and this in turn invited a greater variety of form. Stretching away to more distant horizons, articulated by rocky mountain peaks beyond the architecture, the land more deliberately leads away from the trees or groves of the foreground. Above, sweeping clouds—inspired above all by Titian's cumulus inventions—further carry the impetus, graphic as well as spatial. Domenico Campagnola especially is responsible for this development of the panoramic landscape, in his drawings and his prints. Whatever the pastoral implications of his foreground couple in *Landscape with a Hurdy-gurdy Player and a Girl* (Fig. 104), implications both amorous and musical, they are effectively dissipated by the sweep of the landscape beyond.

The invitation of these deep landscape structures is different from that of the more intimate pastoral. Not only is the viewer's eye drawn to the

DAVID ROSAND

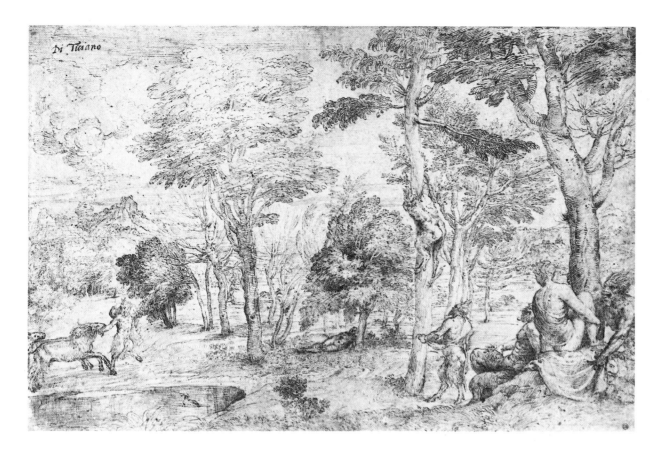

Fig. 71
Titian (c. 1488–1576)
Landscape with Nymphs and Satyrs c. 1535
pen and brown ink on paper
10 7/16 x 16⅛ inches (26.5 x 41 cm.)
Musée Bonnat, Bayonne
150

Fig. 72 (No. 49) (top)
Adam Elsheimer (1578–1610)
Satyr Playing the Flute, Surrounded by Other Satyrs
etching
3⁵⁄₁₆ x 4¼ inches (8.4 x 10.8 cm.)
The Trustees of the Chatsworth Settlement, Derbyshire
Hind 1926, no. 11

Fig. 73 (No. 50) (bottom)
Adam Elsheimer (1578–1610)
Landscape with Flute-playing Satyr and Two Nymphs
etching
2⅜ x 3¹⁵⁄₁₆ inches (6.1 x 10 cm.)
The Trustees of the Chatsworth Settlement, Derbyshire
Hind 1926, no. 12

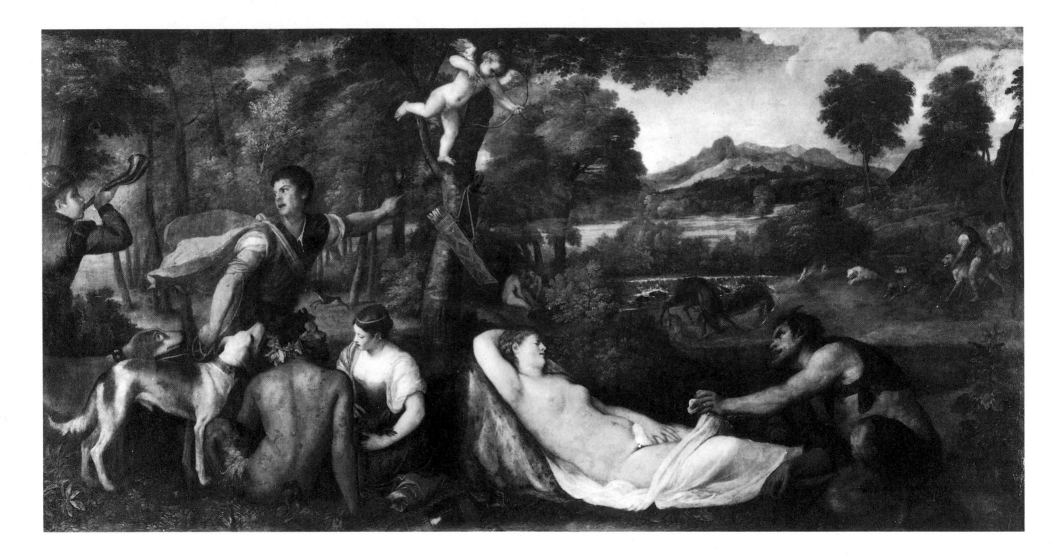

Fig. 74
Titian (c. 1488–1576)
The Pardo Venus (Jupiter and Antiope?) c. 1535–40,
retouched c. 1560
oil on canvas
77⅜ x 151⅝ inches (196 x 385 cm.)
Musée du Louvre, Paris
752

DAVID ROSAND

distances, the human figures and animals adapt to the spatial expanse, which tends to be punctuated by wandering figures, making their way toward far-off towns. Indeed, the theme of the wanderer becomes something of a leitmotif in these landscapes (Fig. 64).[52] Toward the middle of the sixteenth century this type of panoramic landscape becomes an international phenomenon. The Netherlandish printmaker and publisher Hieronymus Cock produced etchings (Fig. 62) that combined Roman ruins with graphic landscapes reminiscent of those of Campagnola (Fig. 161).[53] Pieter Bruegel (ca. 1525/30–69), too, following his trip across the Alps (in 1551 or 1552), drew landscape vistas that suggest his study of Venetian models. The twisting foreground tree in the *Landscape with the Penitence of Saint Jerome* (Fig. 103), siting the figure of the penitent saint, recalls that of Titian's woodcut (Fig. 47), and the general configuration of other designs, with their elevated foreground hills traversed by wanderers moving into the space beyond, suggests the example of Campagnola.[54]

The graphic arts were responsible for the transmission not only of images and image types but of actual formulas of rendering as well. From the penmanship of Titian, as recorded in the woodcuts, and especially that of Campagnola, from their various linear systems of representing foliage and bark, the topography of land and clouded sky, Bruegel learned to open up his forms and his views, to create an atmosphere through graphic marks. His awareness of Venetian landscape drawing technique may well have been reinforced during his stay in Rome by the further example of Girolamo Muziano (1532–92), a Brescian artist with Venetian training (Fig. 65). Prints especially continued to play a critical role in the dissemination of Venetian landscape inventions throughout Europe in the following two centuries.

Another aspect of the georgic landscape re-

calls its origins. The descriptions and recommendations of Vitruvius and Alberti, confirmed by the discovery of ancient Roman wall paintings in the course of the Renaissance, inspired the re-creation of those pictorial programs within buildings that were themselves based upon classical models: villas in the countryside (Fig. 63). Land reclamation in the Veneto, especially following the peace signed in 1530 concluding the war with the League of Cambrai, was officially encouraged by the Venetian government, and the patricians of Venice rapidly developed estates in the countryside that were to serve practical as well as recreational or cultural ends. These were working farms, part of a policy to guarantee agricultural support of the lagoon capital, but as such they were inspired by the example of classical literature.[55] Appropriately, the walls of these villas were covered with the range of pictorial possibilities set out in that literature—including Vitruvius's "harbours, promontories, seashores, rivers, fountains, straits, fanes, groves, mountains, flocks, shepherds."

The Satyric Landscape

Satyrs and nymphs, lurking spirits perhaps in the ancient idyll or eclogue, revealed themselves fully in the Renaissance pastoral—if by indirection. Perhaps the first relevant painting from the Renaissance of such a landscape never existed: the famous *ekphrasis* in Sannazaro's *Arcadia*. His shepherds climb to a holy temple where they

> saw painted above the entrance some woods and hills, very beautiful and rich in leafy trees and a thousand kinds of flowers. A number of herds could be seen walking among them, cropping the grass and straying through the green meadows, with perhaps ten dogs about them standing guard, their tracks most realistically visible in the dust. Some of the shepherds were milking, some shearing fleece, some playing the pipes, and some there were, as it seemed,

Fig. 75
Venus and Satyr
woodcut illustration from *Hypnerotomachia Poliphili* by Francesco Colonna (Venice: Aldus Manutius, 1499)
image, 6¾ x 5 inches (17.2 x 12.7 cm.)
Courtesy of the Library of Congress
Rare Book and Special Collections
Lessing J. Rosenwald Collection
340b

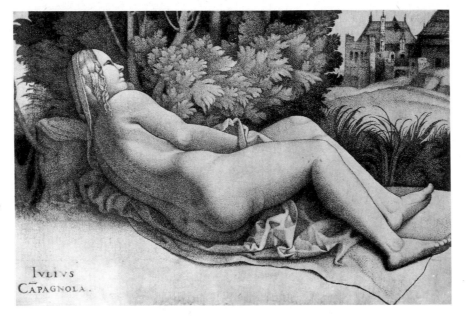

Fig. 76 (No. 26)
Giulio Campagnola
(c. 1482–after 1515)
Venus Reclining in a Landscape
c. 1508–09
engraving
4¹¹⁄₁₆ x 7³⁄₁₆ inches
(11.9 x 18.3 cm.)
The Cleveland Museum of Art
Gift of the Print Club
of Cleveland
31.205, Hind 5, no. 13

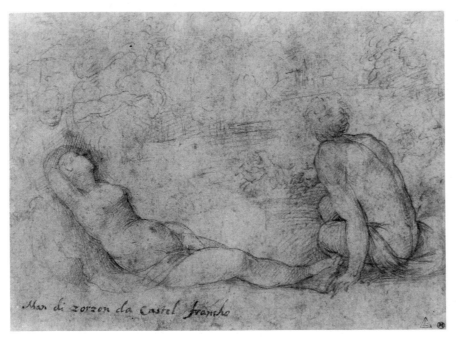

Fig. 77 (No. 12)
Anonymous Parmesan(?) Artist,
Mythological Scene c. 1520–30
red chalk on yellowish paper
5½ x 7½ inches
(13.9 x 19.1 cm.)
Hessisches Landesmuseum,
Darmstadt

who were endeavoring to match their singing with the pipers' melody.

But, the shepherd narrator Sincero continues,

what I was pleased to examine more attentively were certain naked Nymphs who were standing, half-hidden as it were, behind the trunk of a chestnut tree, laughing.... Therewith four Satyrs with horns on their heads and goatish feet were stealing very softly through a thicket of mastic trees to seize them from behind.[56]

The nymphs, followers of Diana, are dedicated virgins. Half-man, half-goat, the satyrs embody elemental lust. The sporting of these naturally opposed denizens of the woods results then in perpetual chase. Indeed, a similar situation, Pan's frustrated pursuit of Syrinx, led to the creation of the pipes that would echo through the groves of poetic tradition.[57] Inspired by the tone of the reeds that Syrinx had become, Pan created the instrument, sublimating desire in music: "And so the pipes, made of unequal reeds fitted together by a joining of wax, took and kept the name of the maiden." This is the *sampogna* that will pass down to Sannazaro as carrier of the pastoral tradition in poetry.[58] On this instrument the shepherds will continue to make their music.

Assuming their natural place in pastoral imagery, satyrs too take their ease in the landscape, as in the drawing now generally ascribed to Titian (Fig. 66). The basic structure of the design does not differ from the common type of landscape with two figures in the foreground (cf. Fig. 25), but instead of youthful shepherds we encounter the more primitive creatures of the woods.

Horned and goat-footed, the satyr lends his beastly half as well to the coloring of the landscape. His very presence quickens the setting, animates the grove with libidinous energy. Thus, in Lorenzo Lotto's so-called *A Maiden's Dream* (Fig. 67), the divinely graced nymph is surrounded by a couple of

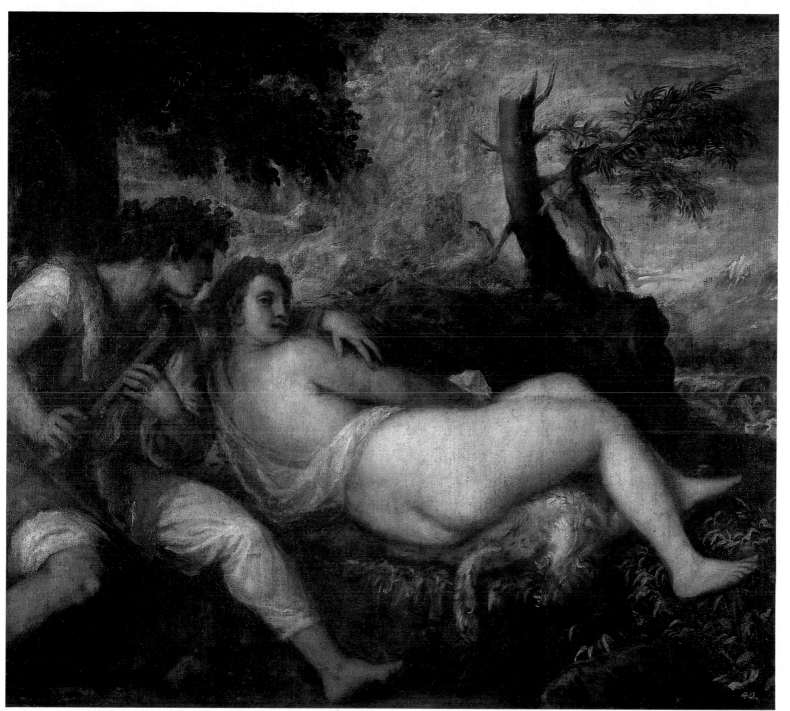

Fig. 78
Titian (c. 1488–1576)
Nymph and Shepherd c. 1570–75
oil on canvas
58⅞ x 73⅝ inches (149.6 x 187 cm.)
Kunsthistorisches Museum, Vienna

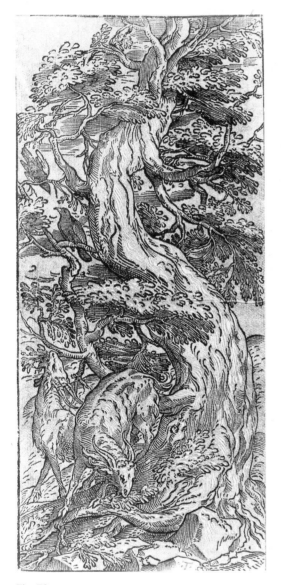

Fig. 79
Domenico Campagnola(?) (1500–64)
Two Goats at the Foot of a Tree c. 1530–35
chiaroscuro woodcut
19⅜ x 8½ inches (49.3 x 21.7 cm.)
Graphische Sammlung Albertina, Vienna

satyrs whose darker, rougher forms contrast with her luminousness. More explicitly in the allegory Lotto painted for Bernardo de' Rossi (Fig. 68) the moralized division of the landscape is articulated by the contrast between the putto of virtue and his opposite, the drunken satyr. Its moral message is still more directly, if crudely, stated in the little panel attributed to Pietro degli Ingannati (Fig. 69).

The satyric landscape had its own classical pedigree, especially as codified in Vitruvius's comments on scenic design (Fig. 70). But the fuller pictorial realization of its meaning, the convincing animation of this setting, was essentially the achievement of Titian (Fig. 71).[59] Indeed, when a sixteenth-century dialogue seeks to establish that the satyr "denotes lasciviousness," the demonstration is an image by the painter. Titian has marvelously expressed this truth, writes Lodovico Dolce, "in one of his landscapes, in which there is a seated Nymph being spied on by two Satyrs, thereby indicating that this was intended to be the land of Lasciviousness."[60] Dolce, in fact, suggests that Titian may even have been alluding to the temple painting described by Sannazaro. The Neapolitan poet's *ekphrasis* may well have provided a certain inspiration for the Venetian painter, as it did for many others. Satyrs and nymphs in a landscape became a standard theme in Western art, a mythological inflection of the basic pastoral situation— as in the etchings of Adam Elsheimer (1578– 1610), a German artist active in Rome but with something of a Venetian education (Figs. 72, 73).

In giving a new reality to poetic imaginings Titian also realized the potential of the pictorial tradition to which he was heir. The painting most often associated with Dolce's description is the so-called *Pardo Venus* (Fig. 74), which incorporates the motif of nymphs and satyrs into a larger narrative structure.[61] At its core is an invention of Giorgione, the sleeping nude in a landscape (Fig.

10). Giorgione's picture was, according to Marcantonio Michiel, completed by Titian, especially the landscape and the Cupid that was once at the feet of the nude (but lost in early restorations) and confirmed her identity as Venus.[62] But the insidious satyr unveiling the sleeping nude in Titian's *Pardo Venus* derives ultimately from another source, the antique motif of the discovery of Ariadne, which enjoyed wide currency in one of the woodcuts in the *Hypnerotomachia Poliphili*, an elaborately illustrated archaeological romance published in 1499 (Fig. 75).[63]

Giorgione's animation of the landscape by a recumbent female figure would have the greatest resonance in subsequent Venetian art and beyond. An old inscription on the red chalk drawing in Darmstadt (Fig. 77) ascribes it to Giorgione himself; although that attribution is no longer tenable, it indicates the degree to which the motif was associated with the master from Castelfranco.[64] Another of Giorgione's variations on the theme may well be reflected in Giulio Campagnola's stippled engraving of a *Venus Reclining in a Landscape* (Fig. 76), for Michiel reports seeing in the house of Pietro Bembo a miniature by Giulio of "a nude woman reclining and seen from the back" that he says was "after Giorgione." And this design in particular leads to Titian's most monumental statement of a pastoral theme, the late painting of *Nymph and Shepherd* (Fig. 78), whose reclining nude was evidently inspired by the Giorgionesque motif.[65] Here the figures now dominate the field, forcing the landscape into a subsidiary role. Nonetheless, the landscape contributes powerfully to establishing the mood of the picture, brooding with a gentle melancholy. Titian's late manner of painting, with its open brushwork and broken colors, merges figures with setting in a way that actually creates their common ambience; through the texture as well as colors of paint, figures and landscape

DAVID ROSAND

share the same natural fabric. Beyond the bower, a goat strives to reach the leaves of a reborn tree. Halfbrother to the satyr, the goat himself bridges the realms of the pastoral and the satyric, a standard member of the idyllic flock and yet known as a creature of ardent lust.[66] Like the satyr, the goat could add a contrasting note to the placid flock: along with a menacing boar and an enigmatic sleeping nude, it undermines the shaded repose of noontime in a drawing by Titian (Fig. 80).[67] The goat could also sustain development as an independent theme, a character in its own right (Fig. 79).[68]

Titian's *Nymph and Shepherd* has been interpreted by Erwin Panofsky as representing the couple Paris and Oenone: the Trojan prince in exile as a shepherd and the nymph who loved him but who foresaw her abandonment.[69] Among the subjects of the temple painting that Sannazaro's Sincero describes is the shepherd/prince carving the name of his beloved nymph in the bark of an elm— only to be interrupted by the call to the judgment for the golden apple. Oenone's abandonment is best known to us through the voice given her by Ovid: "You, now a son of Priam, were (to let respect give way to truth) a servant then; I deigned to wed a servant, I, a nymph! Amidst the flocks we often took our rest protected by a tree; and, intermixed with leaves, the grass became our bridal couch."[70] Whether or not Titian's painting actually represents these lovers reclining together in a bower on Mount Ida, lovers soon to be parted but fated to be reunited in death, the painting's mood, its tonal resonance, accommodates such an interpretation. Titian has invested the pastoral with human pathos of great magnitude, and in so doing he may have violated that very decorum which had, by its aheroic insistence, preserved its generic identity. In appropriating the conventions of the pastoral, then, Titian may have pushed it well beyond its modest limits.

Fig. 81 (No. 70)
Valentin LeFebre (c. 1642–80)
Sleeping Shepherd with Flock, after Titian, published 1682
etching
8 x 12⁹/₁₆ inches (20.4 x 31.9 cm)
Fondation Custodia, Collection F. Lugt
Institut Néerlandais, Paris
7620/30

Tiziano

DAVID ROSAND

NOTES

1. Sannazaro 1966, *Arcadia*, p. 29.

2. Burckhardt 1965, p. 178.

3. For Guarino's poem addressed to Pisanello, see Baxandall 1971, pp. 91–93 (translation), 155–57 (original text). Baxandall discusses the tradition of such rhetorical description (*ekphrasis*) and offers futher examples.

4. The most recent monograph with catalogue raisonné of this painter's work is by Pignatti 1978, with bibliography. In addition, see the papers of the several congresses held in that (presumably) quincentennial year: *Giorgione: Convegno internazionale* 1979; Pallucchini 1981; Calvesi 1981.

5. Alberti 1986, p. 192. Leoni's translation has been slightly modified here.

6. Vitruvius 1960, p. 211.

7. Vitruvius 1960, V.vi.

8. The place of landscape in Renaissance aesthetics is explored in this context by Gombrich 1966. See also Turner 1966, and the monumental survey by Pochat 1973, as well as the sensitive introduction to the subject by Clark 1949. For a highly suggestive model of the generic interpretation of landscape, see Vergara 1982.

9. On the pastoral tradition in literature, see especially Rosenmeyer 1969; Alpers 1979; as well as Curtius 1953, ch. 10, "The Ideal Landscape."

10. Although probably composed in the 1480s, Sannazaro's *Arcadia* was not officially published until 1504, two years after a pirated and unauthorized edition. See Kennedy 1983, 96–102, et passim, as well as the notes to Enrico Carrara's 1952 edition of Sannazaro's *Opere*.

11. See the synthetic essay by Wittkower 1978.

12. Pater 1980, p. 118. See also Sutton 1979, pp. 339–42.

13. Pater 1980, p. 119.

14. For basic information on the painting see Pignatti 1978, cat. no. A 43; Wethey 1975, vol. 3, cat. no. 29.

15. On the *locus amoenus*, or pleasance, see especially Curtius 1953, pp. 194–200, and Rosenmeyer 1969, pp. 179–205.

16. Two of the most rewarding studies of the painting are Fehl 1957, arguing the invisibility of the nudes as deities, and Egan 1959, focusing on the implications of the musical iconography. See also Tanner 1979, an attempt to extend the moralizing implications of the image.

17. On Giorgione's music, see Pirrotta 1979. The most recent discussion of Giorgione's patronage: Settis 1978, especially pp. 129–44, and Settis 1981, vol. 1, pp. 373–98.

18. Vasari 1906, vol. 4, p. 11 (*proemio* to the third part), 91–100 (the biography).

19. Vasari 1906, vol. 4, p. 96: "a farvi figure a sua fantasia per mostrar l'arte." The most serious attempt to confront this issue is Muraro 1975.

20. The richest discussion of the painting, although not finally persuasive in its conclusion, is by Settis 1978. The most recent efforts at interpretation have focused on a particularly political contextualism: see Howard 1985, and Kaplan 1986. For a deliberately less positivist interpretive approach, more open and avowedly Pateresque, see Barolsky and Land 1983.

21. For a review of the contradictory interpretations of the X-rays of the *Concert champêtre*, see Pignatti 1978, pp. 134ff. A survey of these examinations is offered in Mucchi 1978—to which should be added the new revelations on the *Tempesta* in *Riflettoscopia all'infrarosso computerizzata* 1984. The larger contexts of the development of oil painting in Venice are discussed in Rosand 1985, pp. 15–46, with further bibliography.

22. Haskell 1971.

23. Following its reproduction in the seventeenth century in an etching by Valentin LeFebre, the drawing has often been ascribed to Titian himself: see Oberhuber 1976, cat. no. 32, with earlier bibliography, and Pignatti 1979, pl. XIV. A similar situation surrounds the drawing in the Uffizi of a *Landscape with the Infant Saint John the Baptist* (Fig. 52), which was also reproduced by LeFebre (Fig. 53) as a design by Titian. Generally on that basis, the drawing has often been attributed to Titian despite bearing all the characteristics of Domenico Campagnola's draftsmanship. See Rearick 1976, cat. no. 20; Oberhuber 1976, cat. no. 30; Pignatti 1979, plate XXXIII. For the arguments against such an attribution, see Rosand 1981.

The etchings of Valentin LeFebre have played a significant role in the connoisseurship of Venetian drawings. His graphic records of designs by (or ascribed to) Titian and Veronese were published by Jan van Campen as *Opera selectioria quae Titianus Vecellius Cadubriensis et Paulus Calliari Veronensis inventarunt ac pinxerunt quaeque Valentinus le Febre Bruxellensis delineavit et sculpsit* (Venice: J. van Campen, 1682; see Figs. 52 and 53, 60 and 111, 80 and 81). Several of the inventions credited to Titian on these prints, however, clearly are by Domenico Campagnola: e.g., *Opera selectioria* no. 29 reproduces, in reverse, a woodcut by that master, *Landscape with a Hurdy-gurdy Player and a Girl* (Fig. 104). Although often taken as historical evidence, LeFebre's attributions can only testify to the early confusion in the connoisseurship of Venetian drawings—in which the name of Domenico

Fig. 80 (opposite)
Titian (c. 1488–1576)
Pastoral Scene c. 1565
pen and brown ink, black chalk, heightened with white gouache on paper
7¹¹/₁₆ x 11⅞ inches (19.6 x 30.1 cm.)
The J. Paul Getty Museum, Malibu, California
85.GG.98

Campagnola disappears, until it is accorded full recognition in the eighteenth century by connoisseurs like P. J. Mariette. On LeFebre's prints, see Catelli Isola 1976, nos. 179–210, and Chiari 1982, nos. 86–111.

24. The subject of the panels was identified by E. H. Gombrich and published in Clark 1937. Further on the question of attribution: Gould 1959, p. 70f., reprinted in Davies 1961, p. 453f.

25. Although it is the only one generally accepted as by Giorgione, the Rotterdam drawing manifests typical symptoms of the "Giorgione problem." The sheet boasts an impressive provenance, coming from the collection compiled by Padre Sebastiano Resta in the seventeenth century. The figure in the drawing was recognized (by Padre Resta) as Giorgione himself, as a young shepherd "either tending his flocks or drawing on the ground"—an adaptation of the Giotto legend, the legend of the youth manifesting his natural talent by drawing sheep. The architecture in the background was generally thought to represent the walls of Castelfranco, the artist's *patria*, further confirmation of the authorship (if not the identity) of Giorgione. Recently, however, those walls have been reidentified as Castel San Zeno at Montagnana, thereby undermining part of the basis for the attribution. Nonetheless, the drawing remains a key point of reference for any knowledge, however hypothetical, of Giorgione as a draftsman; its *sfumato* and its compositional structure—a figure in a landscape—still conform to our idea of Giorgione. For the most recent entry on the drawing, with full bibliography, see Aikema and Meijer 1985, cat. no. 15—although Meijer's recognition of an eagle in the sky and his consequent interpretation of the subject are not convincing.

26. On Giulio, see the essay and entries by Konrad Oberhuber in Levenson et al. 1973, pp. 390–413.

27. I owe this reading to Patricia Emison, who first adumbrated it in Emison 1985 and has further refined it in a chapter, "The Low Style: Pastoral and Petrarchan Themes in Prints," of her forthcoming book. On the general theme, see Rosenmeyer 1969, pp. 57–59; also Curtius 1953, pp. 98–101.

28. Translations of the *Eclogues* are from Alpers 1979.

29. On Domenico and his engravings, see Oberhuber in Levenson et al. 1973, pp. 414–36; on his woodcuts, see Rosand and Muraro 1976, pp. 120–37, 138f., 154–71. For the distinction—in inventories of the collection of Gabriele Vendramin—between *disegni a mano* (drawings) and *disegni a stampa* (prints), see Rosand and Muraro 1976, p. 25f., n. 37. On Domenico as a painter, see the contributions of Loredana

Olivato in *Dopo Mantegna* 1976, pp. 81–86.

30. On Titian's *Three Ages of Man*, see especially Panofsky 1969, pp. 94–96; also Wethey 1975, vol. 3, cat. no. 36, with further bibliography.

31. The exact status of the drawing in the Metropolitan Museum of Art has been put in question by Dreyer 1979. Dreyer argues that the sheet is not a drawing preparatory to the woodcut of the *Sacrifice of Abraham* (Fig. 34), but a retouched counterproof taken from the print. Dreyer's arguments have led to the official questioning of the attribution: Bean and Turčić 1982, cat. no. 249. For a defense of the integrity of the drawing, see Rosand 1981.

32. Rosand and Muraro 1976, cat. no. 3.

33. Bembo 1971, p. 169.

34. This relationship has been developed in an unpublished paper by Barbara Dodsworth of Columbia University.

35. See especially Wind 1969.

36. Two versions of this design are preserved at Chatsworth and their exact relationship has been a challenge to connoisseurship. See Oberhuber and Goldfarb 1976, cat. nos. 15 (Chatsworth no. 749B) and 16 (Chatsworth no. 749A), who cites the former as the original. In this Oberhuber is followed by Pignatti 1978, pl. IV. The originality of Chatsworth no. 749A, however, has been defended by Byam Shaw, who nonetheless accepts no. 749B as "an excellent copy, in some ways better than the original" and attributes it to none other than Rembrandt (1980, p. 390). For further comment on Rembrandt and the Venetian graphic tradition, see Cafritz, "Reverberations of Venetian Graphics" in this volume.

37. Sannazaro, *Arcadia*, prosa prima, 30f. The daughters of Clymene were the Heliades, who, lamenting the death of their brother Phaethon, were transformed into a popular grove (Ovid, *Metamorphoses*, II, 340–67).

38. Many such "favole d'Ovidio" among the works of Giorgione are recalled by Ridolfi 1914–24, p. 98f. Those in the Vendramin collection are recorded in the drawn inventory of 1627 (British Museum), while others, in the collection of Archduke Leopold Wilhelm in Brussels, are known to us through painted and graphic copies by David Teniers. See Richter 1937, pp. 21–29; Pignatti 1978, p. 157f., 163; and Anderson 1979.

39. On Sannazaro's *De Partu Virginis*, see Kennedy 1983, pp. 180–224.

40. For the symbolic significance of the background motifs, see Cast 1969. See also Battisti 1980, who stresses the more traditional Marian epithet as a key to reading the details of the landscape.

DAVID ROSAND

41. On the theological/narrative function of light in this painting, see Rosand 1978, p. 104. That function is transformed as the sky is deprived of the announcing angel and more ominously darkened in the version of the composition recently acquired by the Kimbell Art Museum in Fort Worth—published by Christiansen 1987.

42. Cf. Meiss 1964; Turner 1966, pp. 59–65; Pochat 1973, pp. 351–53; and, most recently, Fleming 1982.

43. *Saint Jerome* 1933, p. 69, Letter 22.

44. Ibid., p. 175, Letter 43. On the special position of Jerome in the Renaissance, see Rice 1985.

45. Virgil 1978, p. 81.

46. See Wilkinson 1969. For the relevance to landscape and the tradition of the country house, see Vergara 1982, pp. 154–93.

47. Rosand and Muraro 1976, cat. no. 21. For a further defense of the Louvre drawing as the cartoon for this woodcut, see Rosand 1981, p. 308, n. 31.

48. See Rosand and Muraro 1976, cat. no. 21, and, for Watteau's adaptation of the design, Dreyer 1976, pp. 271, and 1979, p. 375.

49. On the development of genre painting in the Bassano workshop, see Muraro 1982–83, especially pp. 105–20, and on their patrons, 130–34. Also Rearick 1968, and Rigon 1983.

50. Horace 1927, p. 365 (translation modified).

51. For the attribution of the woodcut, see Rosand and Muraro 1976, cat. no. 33. An etching by Dominique Vivant Denon after the woodcut, dated 1792, ascribes its design to Titian: Chiari 1982, cat. no. 179. Ruskin may have had this etching in mind when he wrote, "As in the classical landscape, nearly all rural labour is banished from the Titianesque; there is one bold etching of a landscape, with grand ploughing in the foreground, but this is only a caprice; the customary Venetian background is without sign of laborious rural life" (*Modern Painters*, Part IX, chap. III, 11).

52. Rosand and Muraro 1976, cat. no. 28.

53. For Hieronymus Cock's etching, see Oberhuber 1968(b), cat. no. 10, and Riggs 1977, p. 259, cat. no. 13.

54. For the *Landscape with the Penitence of Saint Jerome*, see most recently, Robinson in Hand et al. 1986, cat. no. 27. On the importance of Venetian models for Bruegel's landscape drawings: Arndt 1972, pp. 69–121, esp. 85–87, 114–16, and Oberhuber 1981, both with earlier bibliography. For the continuing influence of Titian's tree, see Dreyer 1985, p. 766f.

55. Study of this aspect of the development of the Venetian villa was pioneered by Michelangelo Muraro, whose work is handsomely summarized in Muraro 1986, and by James Ackerman, whose *Villa Studies* will be published shortly. For the Villa Barbaro, see especially Reist 1985. Several of the motifs articulating Veronese's landscape murals derive from the graphic tradition of Cock: see Turner 1966, pp. 205–12, and Oberhuber 1968(a).

56. Sannazaro, *Arcadia*, prosa terza, 42f. Sannazaro's imagined painting would inspire painters well into the seventeenth century: see Blunt 1967, p. 337f.

57. Ovid, *Metamorphoses*, I, 689–711.

58. Sannazaro, *Arcadia*, prosa decima, 103f., and the epilogue, "A la sampogna," 151–54.

59. On the Bayonne drawing, see, most recently, Oberhuber 1976, p. 36; Oberhuber 1978, p. 121f.; Pignatti 1979, pl. LI, with earlier literature. For the printed copies of this design, beginning with an etching now generally ascribed to Battista del Moro, see Catelli Isola 1976, cat. nos. 51, 51a, 169, and Chiari 1982, cat. nos. 28, 137.

60. Dolce 1565, 51v. The significance of this passage was first observed by Tietze-Conrat 1955.

61. On the *Pardo Venus*: Wethey 1975, vol. 3, cat. no. 21.

62. For the Dresden picture: Pignatti 1978, cat. no. 23; Wethey 1975, vol. 3, cat. no. 38. The most satisfying reading of the painting as an epithalamic image is offered by Anderson 1980.

63. For the broader implications of this motif and its development, see Meiss 1976, pp. 212–39.

64. Although the drawing has been attributed to Titian himself, the suggestion by John Gere that it is in fact a copy after the Venetian master by the young Parmigianino or a follower makes sense graphically (see Oberhuber 1976, p. 65).

65. Wethey 1975, vol. 3, cat. no. 27. The relationship of Titian's picture to the Campagnola nude was first observed by Fritz Saxl in a Warburg Institute lecture in 1935, "Titian and Pietro Aretino," reprinted in 1970, p. 84.

66. See Chastel 1978, vol. 2, pp. 121–27.

67. Pignatti 1979, pl. LIII, with further bibliography. In Valentin LeFebre's etching after this design (*Opera selectioria*, no. 15), the enigmatic sleeping nude is replaced by a more conventional sleeping shepherd (see Chiari 1982, no. 100).

68. Rosand and Muraro 1976, cat. no. 25.

69. Panofsky 1969, pp. 168–71.

70. Ovid, *Heroides*, V, 11–14.

Classical Revision
of the Pastoral Landscape

Robert C. Cafritz

Around 1600 Annibale Carracci led the classical reorganization of the pastoral vision of landscape, whose original form was a legacy of the Venetian High Renaissance.[1] Annibale Carracci's transformation of the Venetian landscape tradition, which is a relatively minor theme of his overall reformation of Italian painting, echoes his evolution as an artist in general.[2] Annibale absorbed and revised the Venetian landscape in the same determined course of study and emulation of earlier High Renaissance masters that characterized his naturalistic renovation of heroic figure painting.[3] Beginning with Carracci, almost all major advances in seventeenth-century Italian landscape painting reflect High Renaissance Venetian models in varying degrees.[4]

Most of Annibale's landscape canvases were conceived in the context of formal interior decoration. Unlike the small cabinet pictures and gallery paintings of the Venetian Renaissance, his landscapes tend to be large in scale, portable versions of the landscape frescoes that traditionally graced the walls of Renaissance villas.[5]

Landscape, usually appreciated as evocative decoration, did not have to conform to the elevated intellectual standards set for history or religious paintings: it did not have to be didactic or morally uplifting. As a branch of interior decoration, landscape painting could express private and secular experiences that officially sanctioned genres of high art did not accommodate.[6] Ancient literature established precedent for landscape as a theme that allowed for the free play of the imagination.[7] The ancient sources were echoed, in turn, in Renaissance accounts of landscape painting that included the first systematic treatise about landscape, written in 1584 by the Milanese critic Giovan Paolo Lomazzo, who characterized one kind of landscape

◁ Detail of Fig. 92 **Domenico Zampieri**, called **Domenichino**
Landscape with Fortifications

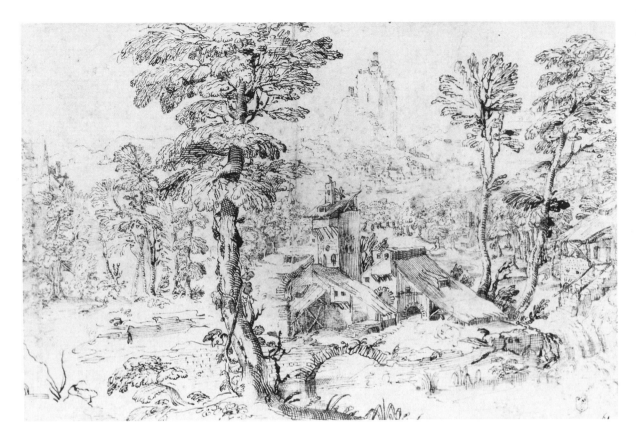

Fig. 82
Annibale Carracci (1560–1609)
An Extensive Wooded Landscape with Buildings,
a Mountain in the Distance
pen and brown ink over red chalk on paper
11³⁄₁₆ x 16¾ inches (28.4 x 42.6 cm.)
Present location unknown
Photo courtesy of Sotheby's, London

painting as the depiction of "places of delight." Lomazzo wrote that "those who have shown excellence and grace in this branch of painting...have discovered various ways of setting about it." At the beginning of his list of landscape modes, he echoed a passage on the decoration of villas from the classical author Vitruvius and included the category of landscape that shows "places of delight with fountains, fields, gardens, seas, rivers, bathing places and places for dancing."[8] Lomazzo's enumeration of such delightful settings also reflected Alberti's advice about the decoration of interiors in his *Ten Books on Architecture*, written about 1452. Alberti's comments are more interesting than Lomazzo's because he reveals the value placed on this branch of landscape painting, stressing its psychological effects: "Our minds are cheered beyond measure by the sight of paintings depicting the delightful countryside, harbours, fishing, hunting, swimming, the games of shepherds—flowers and verdure"[9] In effectively carrying out the program enunciated by Alberti, Annibale during the pre-Roman phase of his career depended chiefly on sixteenth-century Venetian sources as models and, in their less exalted subject matter, on the graphic works of Titian and Domenico Campagnola especially.

The Carraccis studied Titian's art, using it as a point of departure to restore a more organic and coherent appearance to Italian painting. In their notes to Vasari's "Life of Titian," the Carracci failed to indicate Titian as their master, specifically, with respect to landscape,[10] which is not surprising because Renaissance art theorists considered landscape among the lowest categories of artistic endeavor—the special preserve of alien painters, Northern European specialists, in particular.[11] In hindsight, the low status accorded landscape as a genre during this period, especially as compared to history painting, only exalts Annibale Carracci's

contribution as a landscapist. He, first among his contemporaries, fully comprehended the expressive potential of the classically coherent and naturalistic vision of landscape that was originally formulated by Titian. As a result of Annibale's decisive, classicizing revision of the Venetian tradition bolstered by the conservative Roman aesthetic, landscape became a more prestigious genre. It came to be respected as a subject by the most conservative Roman critics, including the seventeenth century's most outspoken proponents of classic, large-scale figure painting.[12]

Ludovico (1555–1619) and Agostino Carracci (1557–1602) produced landscapes, but from the outset of the family's professional activity, Annibale was by far the most active landscapist. The many landscape drawings that survive from Annibale's hand, which include studies of individual natural forms, designs for paintings, and many landscape drawings with figures, are evidence of his fascination with the natural world and man's pleasurable interaction with it.[13] The drawings encompass the same range of Arcadian imagery encountered in Venetian Renaissance art including the more purely pastoral varieties, religious landscapes, and rustic genre scenes. Regardless of subject, stylistically almost all of Annibale's landscape drawings reflect his knowledge of graphic designs by Titian and his followers.

Annibale's early landscape drawings, executed in Bologna and datable to around 1590, are most conspicuous in their reliance on Titianesque models.[14] The influence is most obvious in those drawings by Annibale that appear to paraphrase landscape prints or drawings by Titian or, more likely, by Domenico Campagnola, Titian's close follower. Annibale's drawing, *An Extensive Wooded Landscape with Buildings and Mountain in the Distance* (Fig. 82) seems to be a free imitation of an original by Domenico Campagnola; even

Annibale's rendering of nature in this work mimics Campagnola's style of drawing.[15] Campagnola's widely circulated works and the formulaic character of his graphic vocabulary were more accessible to students of Venetian landscape than Titian's rarer and stylistically more idiosyncratic and varied landscape prints and drawings. Annibale's imitation preserves the chief characteristics of Venetian draftsmanship: breadth of conception, openness of form, and boldness of handling. Annibale rarely transcribes the sixteenth-century Venetian style of drawing as literally as he does in this sheet, but in his renderings of landscape, both paintings and drawings, Annibale magnified and consolidated the principles of organization he first explored in such formative works.

If the relatively autonomous pen strokes of Venetian draftsmanship constitute the graphic analogue of the exuberant brushwork of Venetian painting,[16] the transparency and freedom of the brushwork in Annibale's *Landscape*, circa 1590 (Fig. 83), translates into paint the openness and fluidity of handling that characterized his landscape drawings.[17]

The National Gallery of Art's *Landscape* is Annibale's most effusive exploration of the pleasures of nature. Rarely in his landscapes is human activity so little emphasized, but the presence of the small boating party, coursing across the middleground, engages the viewer in a decidedly sybaritic experience of nature. In this work Annibale presents landscape in and of itself, but in a significantly transmuted form. He has re-created the landscape as an aesthetic organism that is structured and animated by a thrilling and all-encompassing play of light and air. The defining presence of the natural setting is otherwise observed only in Annibale's drawings. In Domenico Campagnola's prints and drawings, landscape first emerged in Italian art as a self-sufficient pictorial theme and

became established as a fully independent aesthetic category.[18] With *Landscape*, Annibale realized in painted form all that had been implied in the graphic work of Campagnola. Realizing the promise of the graphic models of the sixteenth-century Venetians, Annibale was among the first Italian artists to extend landscape's aesthetic mandate into the domain of painting.

Other landscape paintings that survive from Annibale's years in Bologna, such as a pair of landscapes in the Louvre, *Hunting* and *Fishing* (Figs. 84 and 85), executed in the mid-1580s, are characterized by a greater emphasis on human activity.[19] *Hunting* and *Fishing*, simple scenes of rustic life set against landscape backgrounds in which the relationship of figures and natural elements is balanced, recall works by earlier sixteenth-century artists, primarily those active in Emilia and the Veneto, such as the decorative painters Lambert Sustris, Paolo Fiammingo, and Niccolo dell'Abate.[20] These rustic scenes, distinguished by diffuse, panoramic vistas seen from a bird's-eye view, are in marked contrast to Annibale's more clearly structured schemes. Earlier artists rendered the natural world as an ornate spectacle and favored fanciful, all-over compositions, which give their landscapes an impersonal and remote character. The luminous and organic quality of Annibale's images make them much more emotionally accessible and compelling. Although his repertoire is similar to that of his North Italian predecessors, in his hands these subjects gained an expressive significance, a sonority that transcended their more purely decorative and superficial conceptions. In *Hunting* and *Fishing*, Annibale came very close to restoring the integrity and power of communication that characterized the Arcadian vision of nature when handled originally by the Venetians.

The *Pardo Venus* (Fig. 74) is the painting by Titian of figures in a landscape that shares most with Annibale's Louvre landscapes.[21] Both *Hunting* and the *Pardo Venus* frame close-up views of woodland settings and a colorful mixture of animated figures. The Titian canvas depicts a realm of classical myth inhabited by demi-gods, nymphs, and satyrs, in contrast to the mundane world invoked by the figures in Annibale's painting. Despite this important difference between the two images, there is a remarkable similarity in detail and, more profoundly, a spiritual correspondence based on a shared approach to the rendition of nature. In Annibale's vision the natural realm is unremittingly idealized, as unthreatening and benevolent as the innocent, playful characters who inhabit it. In adapting Titian's idyllic vision of nature, Annibale dispensed with the mythological creatures so evident in Titian's painting. Instead, Annibale's Arcadian scenes accommodate a cross-section of contemporary personages, placing Annibale's idylls in the realm of everyday experience. This content is not surprising given the critical environment in which they took shape. One writer of the time expressed a prevailing attitude toward the arts in Italy after the Council of Trent, when he complained about works that presented an excessive intellectual challenge, which were iconographically so intricate that one would need "a Sphinx" to decipher them, proclaiming, "A thing is beautiful in proportion as it is clear and evident."[22]

As "clear and evident" rustic scenes, Annibale's landscapes in the Louvre recall Titian's graphic essays on the pastoral theme more than the Venetian master's paintings. Titian's woodcut of circa 1520–25, *Landscape with Milkmaid* (Fig. 54) is an image notable for the dominant role of landscape. As in Annibale's *Hunting* and *Fishing* scenes, Titian presents an idealized landscape animated by rustic characters who might have been encountered in daily experience. Annibale made a more popu-

ROBERT C. CAFRITZ

larizing statement on the pastoral theme that Titian was only prepared to declare, fully and formally, in the graphic medium.

In their relative emphasis on the activity of the figures, *Hunting* and *Fishing* assume a commonplace or anecdotal tenor analogous to Annibale's scenes of everyday life in the city. A recently published pair of paintings by Annibale in Munich, also of about 1590, emphasizes strongly the landscape setting itself and seems to embody the principles set forth by Alberti in discussing the depiction of "the delightful countryside." The matched oval shapes of the Munich paintings (Figs. 86 and 87) suggest that most likely they originally belonged to a scheme of interior decoration.[23] But in stressing the landscapes themselves as pure "places of delight," Annibale did not relegate the human figure to the periphery of these paintings, visually or thematically. In both works the figures occupy center stage and are as much a part of the scene as the inanimate elements of the landscape: in one a group of peasants is assembled at the ford of the stream, in the other two women bathe in the widening of the river. Interest was divided between the animated foregrounds and calm backgrounds in the pair of landscapes in the Louvre, but the figures in the Munich paintings are as serene and poised as the landscapes that envelop them. Moreover, the effects of chiaroscuro that characterize the rendering of the human forms also integrate the figures into the overall structure of the picture. In the Munich works, Annibale has exploited the expressive possibilities of an essentially Venetian style of painting, revealing in these pictures, among all of Annibale's landscapes, a feeling closest to the National Gallery's *Landscape*, although that work is more vigorous and dynamic. In all three works landscape is manifestly idealized, subject to a highly integrated tonal structure. Evidently Annibale was prepared to assert nature as signifi-

cant in its own right only if it was aesthetically consecrated in this way.

River Landscape from about 1600 (Fig. 88) was painted during Annibale's early years in Rome, and in every respect—visually, compositionally, spiritually—it represents the clear division between his Bolognese and Roman styles of painting.[24] The many cavorting figures recall the engaging, heterogeneous mixture of social classes that characterized *Hunting* and *Fishing*. But the figures in *River Landscape*, as in *Landscape*, are much smaller in relation to the landscape setting, and they are distributed throughout the landscape rather than being concentrated in the foreground. In this work, Annibale conspicuously uses the figures to guide the viewer through the landscape. As directionals they could be judged "purely secondary,"[25] but the figures also give a psychological and symbolic value to the landscape, which is to be understood as the "place of delight" described by Alberti and Lomazzo. The architectural elements of *River Landscape* are much more forceful and insistent than in Annibale's earlier landscapes in which the grandeur of nature was only implied in a tonal way. In *River Landscape*, the fragile, wooden structures of the Isola Tiberina in Rome have been transformed into ponderous architectural groupings and a heavy, arched bridge stretches across the middleground.[26] This massive, stable complex is central to *River Landscape*'s compositional structure; such elements will increasingly govern Annibale's idealization of nature. Organic complexity or disequilibrium are banished and, with increasing insistence and deliberation, Annibale uses compositional procedures and imagery to emphasize the intellectual authority of man over nature. His Roman landscape paintings mirror such humanist power, but delicate sfumato effects soften the harsh lines of man-made architecture in the *River Landscape* and, in general, integrate the

composition. Annibale's vision in this painting is still dominated by lyrical effects of light and color, which are suggestively emotional rather than willfully intellectual in appeal, and are in complete accord with the nostalgic subject matter of the image.

With the exception of *River Landscape*, Annibale virtually abandoned the pastoral landscape as a pictorial theme after becoming established in Rome after 1595. Thereafter he produced paintings in which the landscapes were dominated by religious or historical subject matter. This shift in thematic focus was dramatic: Annibale now emphasized literary subject matter and exercised those aspects of his style predisposed to solemn effects of majestic formality. Even in Rome the influence of the sixteenth-century Venetian tradition on Annibale's landscapes did not immediately dissipate and became even more compelling in the small number of landscapes he produced at the beginning of his Roman period. In fact, some of the landscape paintings Annibale produced at the turn of the century reflect more clearly the High Renaissance Venetian tradition than do the landscapes he produced toward the end of his Bolognese period.[27]

Typical of Annibale's renewed awareness of Venetian prototypes is his *Landscape with the Rest on the Flight into Egypt* of about 1596–97 (Fig. 89).[28] A preparatory study for this work, in Budapest, is particularly revealing (Fig. 90).[29] The style and imagery of this drawing contains the kind of panoramic landscape typical of Domenico Campagnola's woodcuts of landscapes with saints. As in Campagnola's work, the open vista of fluidly rendered, rolling terrain dominates the image; even the Holy Family scene, characterized as a rustic genre motif, adds only anecdotal interest not spiritual significance to the landscape. In the painted version Annibale retained the same tonal fluidity and unity of the preparatory drawing.

Annibale moved to Rome in 1595 to accept with his brother Agostino a commission from Cardinal Odoardo Farnese to decorate the Sala Grande in his family palace.[30] Instead, they decorated the vault of the Farnese Gallery with grand mythological love scenes, which became the most outstanding achievement of their careers. The Farnese were allied in marriage to the Aldobrandini family, headed by Clement VIII who was pope from 1592 until 1605, and Annibale executed some of his most important work for these two powerful and conservative families. Both the Farnese and Aldobrandini retained highly educated artistic advisors who acted as liaisons between them and the artists whose services they regularly engaged to decorate both sacred and secular spaces within their palatial urban residences and country villas. These advisors were professional literati who saw themselves as guardians of tradition. They actively promoted the classical style in art and the hierarchy of values that it represented.[31] The serious challenge posed by Caravaggio's vigorous and provocative realism put proponents of classicism on the defensive, as the polemical character of their treatises reveal. One of the earliest seventeenth-century Roman essays in defense of the classical style was written by Giovanni Battista Agucchi, who was attached to the Aldobrandini household for most of his professional career as administrator and art advisor.

Agucchi's *Treatise on Painting* was written in the years immediately after Annibale completed the vault of the Farnese Gallery.[32] In decorating the Farnese Gallery, Annibale revived the grand manner of Roman painting as represented by the achievements of Michelangelo and Raphael in the Vatican Palace, and allied this classical tradition to the naturalistic illusionism that he had mastered, in part, through his study and emulation of the sixteenth-century Venetian school. Some early sources suggest that Agucchi consulted Annibale while he

ROBERT C. CAFRITZ

Fig. 83 (No. 42)
Annibale Carracci (1560–1609)
Landscape c. 1590
oil on canvas
34¾ x 58¼ inches (88.5 x 148.2 cm.)
National Gallery of Art, Washington, D.C.
Samuel H. Kress Collection
1952.5.58

Fig. 84
Annibale Carracci (1560–1609)
Hunting c. 1585
oil on canvas
53⁹⁄₁₆ x 99⁵⁄₈ inches (136 x 253 cm.)
Musée du Louvre, Paris
210

Fig. 85
Annibale Carracci (1560–1609)
Fishing c. 1585
oil on canvas
53⁹⁄₁₆ x 99⁵⁄₈ inches (136 x 253 cm.)
Musée du Louvre, Paris
209

Fig. 86
Annibale Carracci (1560–1609)
Landscape (The Ford) c. 1590
oil on canvas
39 x 59¼ inches (99 x 150.5 cm.)
Alte Pinakothek
Bayerische Staatsgemäldesammlungen, Munich
14618

Fig. 87
Annibale Carracci (1560–1609)
Landscape (Bathers) c. 1590
oil on canvas
39 x 59¼ inches (99 x 150.5 cm.)
Alte Pinakothek
Bayerische Staatsgemäldesammlungen, Munich
14617

Fig. 88
Annibale Carracci (1560–1609)
River Landscape c. 1600
oil on canvas
28¾ x 56⁵⁄₁₆ inches (73 x 143 cm.)
Gemäldegalerie
Staatliche Museen Preussischer Kulturbesitz, West Berlin
372

Fig. 90
Annibale Carracci (1560–1609)
Rest on the Flight into Egypt
pen and brown ink on paper
10⅝ x 15½ inches (27 x 39.4 cm.)
The Budapest Museum of Fine Arts
2309

Fig. 89
Annibale Carracci (1560–1609)
Landscape with the Rest on the Flight into Egypt
c. 1596–97
oil on canvas
16 x 18½ inches (40.5 x 47 cm.)
Private Collection, London

Fig. 91
Annibale Carracci (1560–1609)
Landscape with Flight into Egypt c. 1604
oil on canvas
48 x 90⁹⁄₁₆ inches (122 x 230 cm.)
Galleria Doria-Pamphilj, Rome

ROBERT C. CAFRITZ

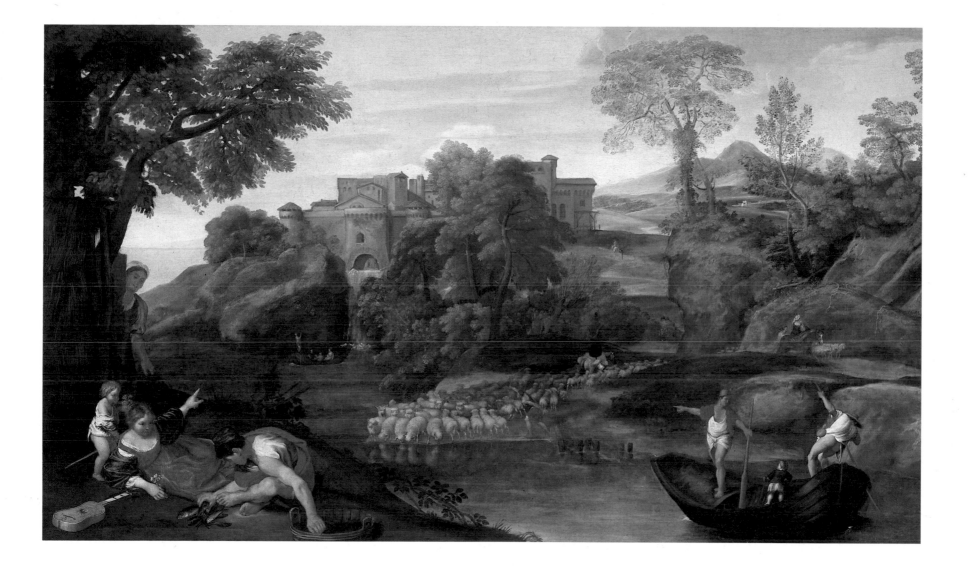

Fig. 92
Domenico Zampieri, called **Domenichino** (1581–1641)
Landscape with Fortifications c. 1634–35
oil on canvas
44 x 76 inches (112 x 193 cm.)
Sir Denis Mahon, London

Fig. 93 (No. 43)
Annibale Carracci (1560–1609)
Pastoral Landscape with Three Figures c. 1600
pen and brown ink on paper
9⅝ x 7³/₁₆ inches (24.4 x 18.3 cm.)
The Visitors of the Ashmolean Museum, Oxford
PII.165

prepared his treatise and it is clear that he wrote his treatise in close association with his protégé, Domenichino (1581–1641), Annibale's most important assistant, who later emerged as a master of the "ideal" style of painting espoused by Agucchi.[33] Agucchi's writings are especially important because they reveal the critical situation in Rome during the period in which Annibale's style of painting was dramatically transformed. Annibale's Roman style of painting and Agucchi's views on art are, in fact, perfectly compatible, and Annibale's immersion in the Roman environment is evident in both his landscapes of this period and in his monumental figural decorations.

Landscape with Flight into Egypt of about 1604 (Fig. 91), one of six lunettes commissioned to decorate the chapel of the Aldobrandini Palace (now the Galleria Doria-Pamphilj) in Rome, is the paradigm of Annibale's Roman style in his landscapes.[34] It shows how Annibale assimilated landscape as a pictorial theme with the contemporary aesthetic and philosophical environment, which is reflected in the writings of Agucchi and other proponents of classicist-idealist art theory. First of all, subject matter has changed. Earlier works, like *Landscape with the Rest on the Flight into Egypt*, represent a moment of relaxation, a pastoral oasis of somnolent tranquility; in the later work, the pastoral imagery is relegated to the background, and the biblical epic assumes priority in the foreground. In *Landscape with Flight into Egypt*, Annibale's affirmation of the primacy of human action is entirely consistent with Agucchi's Aristotelian point of view. Agucchi equated artistic significance with the representation of heroic actions and noble themes,[35] and all of Annibale's later Roman landscapes represent noble religious or mythological themes with conspicuous dramatic and narrative content. The concept of a pastoral mode of landscape did exist within Agucchi's ideal theory but it

consisted of a pastoral imagery derived from prestigious literary sources, which was manifested in the mature work of Domenichino, Annibale's follower and an artist Agucchi promoted, rather than in the more improvised rustic imagery favored by Annibale in his early years.

Agucchi wrote that painters should apply their talents to the visualization of heroic deeds and to stimulating exalted states of mind far removed from daily life. On the subject of beauty Agucchi prized, above all, the principles of lucidity and commensurability of forms, the hallmarks of divine beauty that were only partly reflected in nature. The enlightened artist studied the natural world but in his paintings recast nature as it ought to be.[36] Agucchi's views on the representation of nature recall passages in Leonardo's notebooks in which he extolled the painter's prerogative to reveal the harmony of the universe through the depiction of landscape. He stated that the painter could bring forth "whatever exists in the universe either potentially or actually or in the imagination...first in his mind and then in his hands, and these [images] are of such excellence that they present the same proportioned harmony to a single glance as belongs to the things themselves...."[37]

For the artist who aspired to depict the world as a pure and lofty reflection of divine beauty, Agucchi recommended studying ancient art and the paintings of Raphael.[38] Annibale drew on these sources to develop the monumentally ordered forms and designs that characterized his mythological figure decoration of the Farnese Gallery and, from this point in Annibale's career, all pictorial effects in his paintings were subordinated to the monumental and the ideal.

In *Landscape with Flight into Egypt*, Annibale accomplished for the Northern Italian landscape tradition what he had achieved with respect to the depiction of the human body in the

ROBERT C. CAFRITZ

Farnese Gallery. He made naturalistic landscape painting strictly accord with the grand style and rhetoric of the Roman classical aesthetic. The bold features of the landscape are geometrically precise in configuration and aligned in a rigid axial relationship to one another, so that the main vertical and horizontal lines of the composition intersect, emphasizing the central position of the Holy Family in the foreground. This heroic scheme conveys an overall impression of monumental, sculptural formality that is essentially intellectual and contemplative in appeal. The huge landscape appears absolute, immutable, static, and entirely lucid in structure; it is a declamatory reflection of a lofty, intellectual, and philosophical order of experience. Here, landscape is no longer the private, relaxed realm devoted to the exploration of worldly pleasures seen in his earlier works, even those with a religious theme, such as the *Landscape with the Rest on the Flight into Egypt*.

Although the dominant themes of Annibale's Roman landscapes were no longer pastoral or Venetian in style, his recognition that the landscape motif could be manipulated stylistically to express different orders of experience was based on the sixteenth-century Venetians' original exploitation of landscape's power of communication. Annibale did not abandon the pastoral landscape as a theme altogether once he was established in Rome, but his efforts were confined to works on paper, such as the suggestive little drawing in the Ashmolean Museum datable to around 1600 (Fig. 93).[39] In this work Annibale focuses on the pastoral ideal of innocent friendship in a purely natural setting. The motif of interlocked figures in a copse recalls similar images by the Campagnola and Titian himself, but Annibale dispensed with the contrast between urban worldliness and rustic naïvete that the Venetians rarely failed to evoke with their safely distanced architectural references to town life.[40]

Annibale has made a typical Venetian pastoral landscape structure even more elementary. He stripped the Venetian imagery of its vestigial literary overtones and distilled its existential essence. Following the Venetians, Annibale organized the landscape setting so that it echoes the arrangement of figures, thus equating the harmony of friendship with that of the natural world.

Another drawing from the circle of Annibale, attributed to Domenichino (Fig. 94), celebrates innocence in a very similar way.[41] It could be a copy after a presumably now lost work by Annibale similar to the Ashmolean's *Pastoral Landscape*. This suggests how the ongoing renewal of the Venetian pastoral vision depended on the graphic flow of imagery through later masters' studios.[42] Moreover, in contrast to the insistence on the sculptural integrity of form that characterized Annibale's Roman style of painting, Annibale, in the Ashmolean drawing, revived the more open and fluid way of rendering forms, originally learned from the Venetians, which yields a harmonic integration of man and nature.

The correlation of an essentially Venetian style with pastoral experience suggests that Annibale had come to appreciate that landscape lent itself, as readily as did the figure, to stylistic characterization of themes. Until the end of his life, Annibale used a summary language of Venetianizing form and content to explore in his landscape drawings an intimate and relaxed emotional realm. This was Annibale's private manner, which coexisted with the formal and declamatory style and subject matter of his commissioned works in Rome.

By the time Annibale completed the Aldobrandini lunettes, landscape painting had come into its own as a genre. Landscape was a subject capable of assuming an emblematic or programmatic value.[43] Giovanni Battista Agucchi's

Fig. 94 (No. 45)
Domenico Zampieri, called **Domenichino** (1581–1641)
Landscape with Two Boys
pen and brown ink on paper
10⅜ x 8¹/₁₆ inches (26.3 x 20.4 cm.)
The Trustees of the Chatsworth Settlement, Derbyshire

ROBERT C. CAFRITZ

program for Erminia and the shepherds, written in 1602, contains many of the ideas that he later elaborated and incorporated in a theory of beauty in his *Treatise on Painting*.[44] Agucchi's program consists of instructions on how a painter might illustrate the pastoral episode of Erminia and the shepherds from Tarquato Tasso's *La Gerusalemme Liberata* (1581), a peaceful interlude in an epic poem of heroic adventure. That Agucchi turned to literary sources as the inspiration for painting is consistent with his basic outlook as a classically minded humanist. He championed the ancient dictum *ut pictura poesis*, "as is poetry so is painting," which later Renaissance and Baroque classicists understood to mean that the principles enunciated by the ancient Latin author Horatio in his theory of poetry were also applicable to the art of painting. This dictum defined the noble subject matter worthy of painting; thus, intellectual prestige could be conferred on landscape painting if, for instance, it was the setting for heroic dramatic situations derived from a prescribed literary source, either ancient or contemporary.[45]

Tasso himself was an ideologue of the classic idiom. His poem, a grand drama set in the time of the Crusades, though earnest and didactic in intent, also contained several lyrical and idyllic scenes, such as the story of the beautiful pagan princess, Erminia, and her temporary retreat from the anxiety of life at court to a life with the shepherds and the pleasures of bucolic existence. For all the ideological insistence on didacticism, these escapist passages were the basis for the immediate popularity of the poem and the ones on which the painters focused as a source of imagery, beginning ten or fifteen years after the publication of the poem in 1581.[46]

In a private letter in 1602 Agucchi differentiates between works "that such men [as Annibale] are obliged to undertake," and "those of taste and

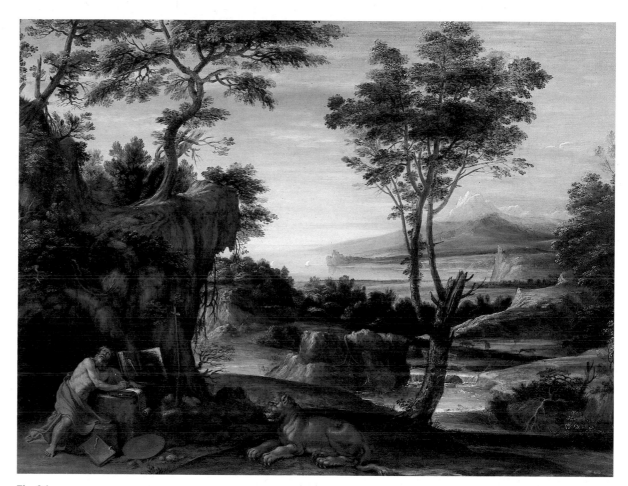

Fig. 96
Domenico Zampieri, called **Domenichino** (1581–1641)
Landscape with Saint Jerome c. 1610
oil on panel
17¼ x 23½ inches (44 x 59.8 cm.)
Glasgow Art Gallery and Museum

Fig. 95 (opposite)
Domenico Zampieri, called **Domenichino** (1581–1641)
Landscape with Erminia and the Shepherds c. 1623–25?
oil on canvas
48⁷⁄₁₆ x 71¼ inches (123 x 181 cm.)
Musée du Louvre, Paris
799

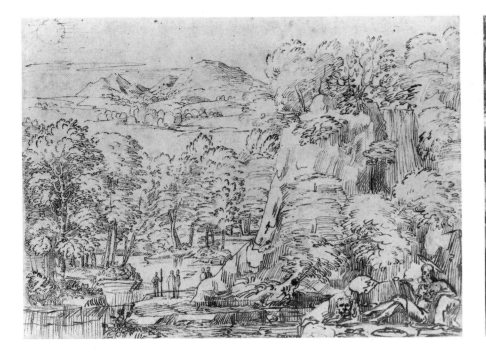

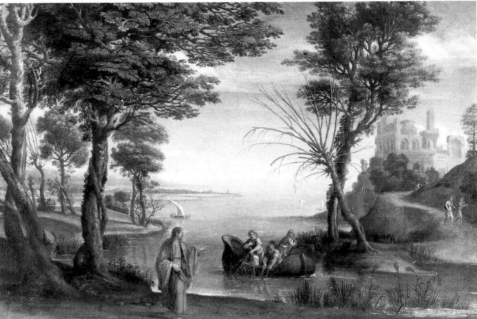

Fig. 97 (No. 46)
Domenico Zampieri, called **Domenichino** (1581–1641)
Landscape with Saint Jerome
pen and brown ink on paper
7¹³⁄₁₆ x 10⁹⁄₁₆ inches (19.9 x 26.9 cm.)
The Visitors of the Ashmolean Museum, Oxford
PII.168

Fig. 98 (No. 44)
Domenico Zampieri, called **Domenichino** (1581–1641)
Landscape with the Calling of Saints Peter, Andrew and Simon c. 1603–04
oil on canvas
14¼ x 21 inches (36.2 x 53.3 cm.)
Piero Corsini, New York

ROBERT C. CAFRITZ

judgment...for their friends." In this passage Agucchi presumably meant the contrast between large-scale public commissions by which artists established their reputations and works made for personal enjoyment, such as images of pastoral retreat, which were evidently recognized as special to the private sphere and prized as vistas of escape from the pressures of public life.[47] In his original publication of the program, Clovis Whitfield concluded on the basis of Agucchi's choice of a device to accompany the illustration of Erminia and the shepherds—a symbol of the contemplative man—that Agucchi, a busy courtier himself, saw a reflection of his own aspirations to leisure in the image of this literary heroine who sought pastoral sanctuary with the shepherds.[48]

Agucchi's program focuses as much on how the painter might depict the landscape setting as on how the artist might render the figurative protaganists of the scene. The figures must be "finely painted," but kept small in scale, so that the breadth of the vista may assume priority.[49] Agucchi provides detailed instructions regarding the individual elements to be contained in the view but, more significantly, he projects onto the view an overall psychological significance: "The whole landscape (to be) a haven of quiet, and happy Arcadia, and a fine day of the most pleasant season," that is, a *locus amoenus*, a "place of delight," as originally formulated by Virgil, on whose work Tasso based his description of the setting of Erminia and the shepherds.[50] Agucchi's concept of the landscape as "a haven of quiet" again recalls Alberti's comments regarding the suitable decoration of a villa, and like Alberti and Lomazzo before him, Agucchi emphasized especially the beneficial effects of viewing such decorations. Domenichino's *Landscape with Erminia and the Shepherds* (Fig. 95) is one painting that attains the spirit of Agucchi's program by virtue of

its "vital element of scale," which gives the figures a landscape setting rather than merely a landscape background.[51] The visual weight of the landscape is equal to, if not superior to, that of the protaganists from the narrative, who are small and arranged in the foreground just to the left and right of center, the center being dominated by the landscape vista. To a considerably greater degree than in Annibale's *Landscape with Flight into Egypt* (Fig. 91), *Landscape with Erminia and the Shepherds* is organized around the landscape setting, which is distinguished by the geometric clarification of individual forms and precise definition of their relationships. Agucchi had specified that such a rational organization of the landscape would most effectively illustrate Erminia and the shepherds, which implies that the desire to contemplate nature in such a definitively idealized condition attracted Agucchi to the scene from Tasso's poem in the first place. He placed special emphasis on the idealization of the natural setting, the breadth of the vista in contrast to the smallness of the figures, and he insisted on a "reasoned arrangement of the parts (*sitti*), of the proportions of the body, and of the whole landscape."[52] The landscape setting and the style in which it was presented were, in Agucchi's view, very important. These features were essential to the expressive potency of the image as a "place of quiet retreat and blissful Arcadia."[53]

In contemplating Domenichino's *Landscape with Erminia and the Shepherds*, the formal plan of the majestic natural setting comes to the forefront of perception, as with Annibale's *Landscape with Flight into Egypt*. The figures and all other effects are subordinate to a patently artificial and inflated compositional scheme, presumably designed according to Agucchi's formal prescriptions to induce a spirit of pastoral calm. Domenichino visualized a pastoral fantasy that relies largely on the legibly geometric structure embodied in the

Overleaf
Fig. 99 (No. 53) (left)
Claude Gellée, called **Le Lorrain** (1600–82)
The Judgment of Paris 1645–46
oil on canvas
44¼ x 58⅞ inches (112.3 x 149.5 cm.)
National Gallery of Art, Washington, D.C.
Ailsa Mellon Bruce Fund
1969.1.1

Fig. 100 (No. 52) (right)
Claude Gellée, called **Le Lorrain** (1600–82)
Landscape with Nymph and Satyr Dancing 1641
oil on canvas
39¼ x 52⅜ inches (99.7 x 133 cm.)
The Toledo Museum of Art
Gift of Edward Drummond Libbey

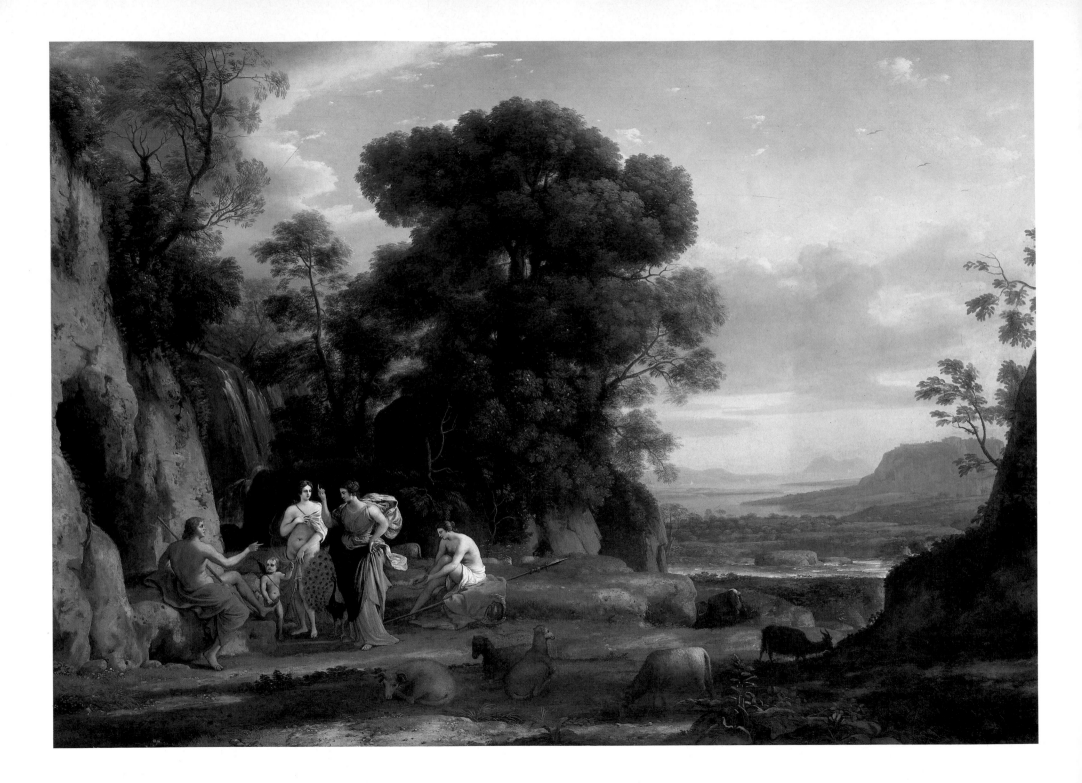

ROBERT C. CAFRITZ

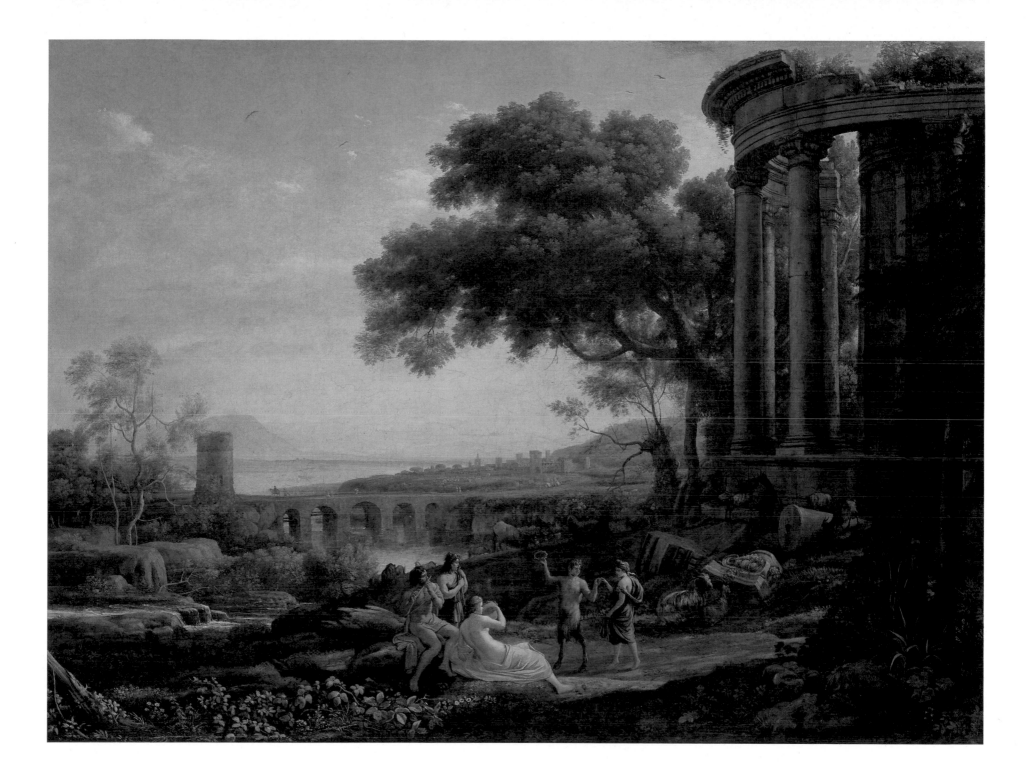

landscape for its impact. This is a distinctively intellectualized, Apollonian vision of Arcadia. Rhetorically abstract and hyperbolic, Domenichino's is a characteristically Roman image of Arcadia.[54] But the nostalgic impulse behind this painting's creation and the primary role the style and composition of natural setting play in sustaining its spiritual significance recalls Giorgione's original insight into landscape's power of expression.

Domenichino's firsthand knowledge of Venetian models is evident in his *Landscape with Saint Jerome* of about 1610 (Fig. 96), in which the lion is "a virtual quotation" from Titian's woodcut, *Saint Jerome in the Wilderness* (Fig. 47).[55] The impact of that woodcut is also felt in a drawing of the same subject (Fig. 97), formerly given to Annibale Carracci but now attributed to Domenichino.[56] If both of Domenchino's landscapes with Saint Jerome reveal his commitment to reorganizing the originally Venetian landscape with small figures along classical lines,[57] so too does his earlier work of about 1603–04, *Landscape with the Calling of Saints Peter, Andrew and Simon* (Fig. 98).[58] In this work the motif of trees cropped by the edge of the canvas, one leafless and the other verdant, together looming over the left foreground, appears to recycle the group of trees in the same position in Titian's woodcut, *Saint Jerome in the Wilderness*. More significant, however, is how Domenichino has evoked but restructured Titian's essentially dramatic conception of the landscape. In Titian's woodcut, a dramatic "swirl of clouds seems to symbolize the divine presence in the darkness of Jerome's natural 'oratory',"[59] while in the Domenichino an impressive view of the sky is central, visually and metaphorically. In the Domenichino dawn appears to be just breaking on the horizon, just as "light dawned on the dwellers in the land of death's dark shadow," when Christ repaired to Galilee, the seashore from which he summoned

his first apostles (Matt 4:16–20). Responding to Venetian religious landscapes and certainly realizing the liturgy's metaphorical invocation of the imagery of light and dark, Domenichino envisioned the natural setting here as a sacred precinct pervaded by the spirit of the Christian drama.[60] He used the landscape to bring out the spiritual essence of the narrative, universalizing the significance of the episode through his central visual play on the Bible's metaphorical invocation on the holiness of light.

Landscape with the Calling of Saints Peter, Andrew and Simon was produced during Domenichino's closest association with Agucchi.[61] Like his later work, *Landscape with Erminia and the Shepherds* (Fig. 95), this also represents a pastoral interlude in the midst of a dramatic epic. The pastoral overtones of the fisherman's life had been the basis in the Italian Renaissance for the first piscatory eclogues. In these literary works "the fisherman unlike the epic seafarer stays close to shore and the body of water to which he entrusts his safety is adjacent to human works and engulfed by natural walls."[62] Such features lend an idyllic cast to the settings of Italian piscatory eclogues, just as they do to Domenichino's painting. Moreover, the marginal social status of fishermen, "the humblest of the humble," is shared by shepherds, and Christian poets readily transformed the scene of Christ selecting his fishermen, his fishers of souls, into idyllic imagery.[63] A similar impulse may inform Domenichino's choice of theme here, particularly given the evident predilection of his mentor Agucchi for scenes that lent themselves to pastoral interpretation.

In these two landscapes by Domenichino, *The Calling of Saints Peter, Andrew and Simon* and *Landscape with Erminia and the Shepherds*, noble literary sources sanctioned the artist's exploration of landscape's expressive potential. Their grandeur of style accords with the epic drama of the artist's

ROBERT C. CAFRITZ

subject. Classically structured and thematically elevated, they fulfill the twin aesthetic goals of the ideal style of painting as espoused by Agucchi and by those who followed him in the seventeenth century. In these paintings, Domenichino has presented the pastoral ideal in a manner that conforms completely with the intellectualized aesthetic aspirations of his patrons and their advisors. The narrative interest of these works may, however, obscure Domenichino's appreciation of landscape's self-sufficient expressive potential.

His *Landscape with Fortifications* (Fig. 92) from the 1630s is a more freely invented image, a grand idyllic landscape animated by many scenes of rustic life, including boatmen, shepherds and their flock, and a young couple.[64] The landscape itself "pays direct homage" to the most important example of Annibale's Roman essays in this genre, *Landscape with Flight into Egypt* (Fig. 91), then housed in the Roman palazzo of the Aldobrandini family, to which Domenichino would have had access at this time.[65] In this work, Domenichino combines informal rustic imagery reminiscent, for example, of Annibale's *Hunting* and *Fishing* landscapes in the Louvre (Figs. 84 and 85), with the monumental scale and classical style of landscape Annibale had perfected in his later paintings in Rome. In fact, Domenichino's *Landscape with Fortifications* virtually duplicates the setting of Annibale's *Landscape with Flight into Egypt*. A similar fortified castle dominates the center of both images; in both works, this structure caps the measured ascent of a verdant mountainous terrain watered by a wide stream stretching across the middle of each scene. In appropriating Annibale's natural imagery, Domenichino detached it from the lofty, didactic, and dramatic context in which it had originally appeared. Even the figures, for example, on the left and right of the composition of *Landscape with Fortifications*, serve only as

directionals to focus attention on the natural setting itself. These figures point emphatically and, in effect, recommend the viewer to contemplate Annibale's landscape, which, as the very model of a formalistic "reasoned arrangement of parts," presides as a rhetorical symbol of the Arcadian realm of experience as it was conceived by seventeenth-century Roman adherents of the classical ideal.

While Annibale was effective in making the pictorial expression of the Arcadian ideal conform with the classicizing, hyper idealism of his time, it was his follower, Domenichino, who refined and projected the pastoral tradition well into the first half of the seventeenth century and set the stage for Claude's later success as a specialist in the genre. Domenichino's positive declaration of landscape's worthiness as an aesthetic object made self-evident a truth that before had only been implied in the works by the sixteenth-century Venetians and the Carracci. More than a century of experimentation with landscape as a spiritually or thematically charged motif, grounded in the revival of pastoral poetry and its assumption that human and natural experience were somehow linked if not actually integral to one another, finally brought the patently idealized, speechless drama of nature itself clearly and explicitly into focus as an object of contemplation.

By the middle of the seventeenth century, with Claude Gellée, called Le Lorrain (1600–82), the intellectual legitimacy of the Arcadian experience of nature as a pictorial theme had been affirmed. By this time the pastoral vision of nature, as it was manifested in the form of the ideal or classical style of landscape, had claimed the best efforts of most of the greatest artists in Rome.[66] In the hands of Claude, the Arcadian landscape was most thoroughly and consistently developed as a pictorial theme. Claude fully realized the implications of over a century of Italian exploration of landscape's power of expression. During an unusually long and

brilliantly successful career, Claude, with increasingly urbane virtuosity, brought almost every feature of his natural settings into play as active, expository agents of the implied meaning of his images. Within the relatively limited range of experience encompassed by his essentially pastoral vision of nature, Claude explored virtually every way that the landscape could operate thematically. Marcel Röthlisberger was the first scholar to demonstrate effectively how the mature Claude always composed the landscape in the mode of the subject or theme at hand and did so over the course of his career with increasingly intricate refinement and elaboration.[67] When Claude conceived of landscape as intrinsically symbolic, he was, in essence, the heir to the sixteenth-century Venetian tradition, which had been given a more literary and classical aspect by Annibale Carracci and Domenichino in Rome. Claude's landscape settings function in ways already familiar to us in the works of the sixteenth-century Venetian masters and in those by the Bolognese painters of the early seventeenth century in Rome. These include landscapes styled and furnished after literary subjects, as in *The Judgment of Paris* (Fig. 99);[68] more purely pastoral images, such as *Landscape with Nymph and Satyr Dancing* (Fig. 100),[69] characteristically designed to suggest thoughts about the venerable order of ideas concerning the primordial harmony of the natural world;[70] and, lastly, works such as the drawing *Pastoral Landscape* (Fig. 101),[71] and the painting *View of La Crescenza* (Fig. 102),[72] where the natural setting predominates as a free-floating and "ideal exposition of the totality of nature and light" and where figural elements are only a means to attune the viewer to the pleasure of the landscape itself, the true object of delectation.[73]

Fig. 101 (No. 54)
Claude Gellée, called **Le Lorrain** (1600–82)
Pastoral Landscape 1645
chalk, pen, and brown wash on paper
8½ x 13 inches (21.6 x 33 cm.)
©The Pierpont Morgan Library, New York
III, 82

Fig. 102 (No. 81) (opposite)
Claude Gellée, called **Le Lorrain** (1600–82)
View of La Crescenza c. 1647
oil on canvas
15¼ x 22⅞ inches (38.7 x 58.1 cm.)
The Metropolitan Museum of Art, New York
Purchase, The Annenberg Fund, Inc., Gift, 1978
1978.205

ROBERT C. CAFRITZ

1. Posner 1971 remains the classic study of the leadership of Annibale. The essay by Charles Dempsey, "The Carracci Reform of Painting," pp. 237–55, in *The Age of Correggio* 1986 is an excellent overview of the Carracci family's theory and practice.

2. See Posner 1971, vol. 1, p. 113–22, on the position of landscape in Annibale's work.

3. In addition to work by Posner 1971, cited above Turner 1966 is also indispensable, especially pp. 175–92.

4. For a survey of seventeenth-century Italian landscape painting see the exhibition catalogue, *L'Ideale classico del seicento in Italia* 1962.

5. See Whitfield 1980, p. 50f., on the presumed decorative function of most of Annibale's landscape paintings.

6. See Gombrich 1971, p. 110f., on the historical and literary connections between the rise of landscape in the Renaissance and the emergence of a consciously aesthetic and subjective attitude toward works of art.

7. See Gombrich 1971, p. 112–19, on ancient sources and their importance for the history of Italian Renaissance landscape painting.

8. Lomazzo [1584] 1973–74, book 6, ch. 49, as quoted in Gombrich, 1971, p. 120.

9. They are also discussed in Rosand "Giorgione, Venice, and the Pastoral Landscape," for which see also Alberti's comments as quoted in Gombrich 1971, p. 111.

10. For the Carraccis' annotations of Vasari see Dempsey 1986, pp. 72–76, and on the Carraccis' strong protest against Vasari's bias against Titian and Venetian painting in general, p. 75–76.

11. Gombrich 1971, p. 115–16.

12. See Posner 1971, vol. 1, p. 113, with note 1 and p. 120 with note 28, for the primary sources, e.g.: Bellori 1672; Baglione 1642; Mancini ca. 1620.

13. Posner 1971, vol. 1, p. 113; for a representative selection of landscape drawings by Annibale see Mahon 1963, cat. nos. 235–47; for a large selection of landscape drawings by the Carracci with earlier bibliography, see the sales exhibition catalogue *Catalogue of Ellesmere Collection* 1972; for a survey of seventeenth-century Italian landscape drawings see Chiarini 1972.

14. For example, *Catalogue of Ellesmere Collection* 1972, cat. nos. 43, 56, 57, 58, 117, and 121; see also Agostino Carracci's Titianesque landscape drawings reproduced in cat. nos. 36, 37, 38, 91.

15. Pen and brown ink over red chalk, 11 x 16½ in. (28.4 x 42.6 cm.); *Catalogue of Ellesmere Collection* 1972, cat. no. 57, p. 127, with attribution history; present location unknown.

16. Rosand and Muraro 1976, p. 9.

17. Fig. 83 in this volume; *Age of Correggio* 1986, cat. no. 91, p. 278, with earlier bibliography; Posner 1971, vol. 2, p. 23, cat. no. 50.

18. Rosand and Muraro 1976, p. 138.

19. Posner 1971, vol. 2, p. 20, cat. no. 43 and 44; Turner 1966, p. 179–82.

20. Posner 1971, vol. 1, p. 115; Turner 1966, p. 179–82.

21. Turner 1966, p. 180; Annibale would have most likely known Titian's style and imagery through prints after such Titian drawings as *Landscape with Nymphs and Satyrs*, (Fig. 71), from which Marco Angelo del Moro made a print at the end of the sixteenth century, illustrated in Catelli Isola, 1976, fig. 51.

22. The words of the theologian Gilio da Fabriano, from his *Dialogo degli errori de' pittori circa l'istoria* of 1564 as quoted in Posner 1971, vol. 1, pp. 35–36.

23. For in-depth discussion of these paintings and their place in Annibale's oeuvre and their origination in a scheme of interior decoration see Whitfield 1980, pp. 50–59.

24. *Gemäldegalerie Berlin* 1985, p. 351, cat. no. 372; Posner 1971, vol. 2, p. 32, cat. no. 74.

25. Turner 1966, p. 183.

26. Whitfield 1980, p. 56.

27. Posner 1971, vol. 1, pp. 117–18.

28. Posner 1971, vol. 2, p. 39, cat. no. 91; *Age of Correggio* 1986, cat. no. 96, pp. 287–88.

29. This drawing was originally published and adduced as an advanced preparatory study for the *Landscape with Rest on the Flight into Egypt* by Jaffé 1964, pp. 87–89. More recently (Harris 1985, pp. 114–15) this drawing has been identified as one made after the painting or after studies of the painting by a follower of Annibale. If so, the drawing represents a detailed reading back of the Venetian graphic roots of the style and imagery of the painting to which it is linked.

30. Posner 1971, vol. 1, p. 78.

31. For a sketch of the group of advisors with whom the Carracci and Domenichino were associated see Mahon 1947, p. 144f.

32. That is, after 1602, according to Mahon 1947, pp. 115–16.

33. Mahon 1947, p. 121; for additional assessment of the relationship of Agucchi and Domenichino with respect to the preparation of Agucchi's *Treatise* see Spear 1982, vol. 1, pp. 27–34.

34. Posner 1971, vol. 2, p. 67, cat. no. 145, which contains a review of the dating of this work.

35. Mahon 1947, p. 127.

36. Mahon 1947, pp. 63–64.

37. From Leonardo's *Treatise on Painting* as quoted in Gombrich 1971, pp. 111–12.

38. Mahon 1947, p. 65.

39. Parker 1956, p. 82, cat. no. 165; see also the entry on this work in Mahon 1963, pp. 164–65, cat. no. 244.

40. See Rosand, elsewhere in this volume, "Giorgione, Venice, and the Pastoral Vision," on how the simple compositional distancing of the town from the inhabited natural setting in the foreground defines the escapist character of Giulio Campagnola's work.

41. This drawing was published by Blunt 1979, pp. 55–56, fig. 54.

42. See Posner 1971, vol. 1, p. 113, on how copies by Annibale's followers of his landscape studies especially were the basis for diffusing his vision of nature.

43. Eskridge 1979, pp. 262ff.

44. Agucchi's program for illustrating Erminia and the shepherds was originally published by Whitfield 1973, pp. 217–29.

45. The classic study of Renaissance and Baroque painters' application of the doctrine of *ut pictura poesis* is Lee 1967(b).

46. Lee 1967(b), p. 48. See also Lee 1967(a), p. 42, for several seventeenth-century variations on the theme of Erminia.

47. Whitfield 1973, p. 217.

48. ibid., p. 222.

49. ibid., p. 225.

50. ibid., p. 225.

51. ibid., p. 227.

52. ibid., p. 227.

53. Richard Spear's translation of Agucchi's words, as quoted in *Age of Correggio* 1986, p. 436.

54. For the polemical thrust of the ideal style in which Domenichino and other seventeenth-century Roman painters cast their vision of landscape, see the introduction by Cesare Gnudi to *L'ideale classico del seicento in Italia* 1962, pp. 3–37.

55. *Age of Correggio* 1986, cat. no. 147, p. 431. Spear 1982, vol. 1, pp. 79–80; pp. 172–73, cat. no. 37.

56. The attribution to Domenichino is accepted by the Ashmolean Museum, see Macandrew 1980, p. 257, cat. no. 168, following Borea 1960, p. 14.

57. *Age of Correggio* 1986, p. 433.

58. *Landscape with the Calling of Saints Peter, Andrew and Simon* was recently published, along with its pendant, as a work of Domenichino (Corsini 1986, p. 54; illus. p. 55). It is the kind of landscape with small figures that may also be taken as a work of Giovanni Battista Viola (1576–1622), Annibale's student, who sometimes collaborated with Domenichino and was a specialist in landscape. On Viola, see Spear 1980; Clovis Whitfield in a 1988 article (galleys of which Piero Corsini kindly shared with this author) attributes the Corsini painting to Domenichino, relating it to the Glasgow *Landscape with Saint Jerome* (Fig. 96, this volume).

59. Rosand and Muraro 1976, p. 146, cat. no. 22.

60. For Annibale's characterization, in like manner, of the setting of his painting *Saint John Preaching in the Wilderness*, see Posner 1971, vol. 1, p. 121.

61. Corsini 1986, p. 56.

62. Poggioli 1975, p. 234.

63. Poggioli 1975, p. 121.

64. Spear 1982, vol. 1, p. 302, cat. no. 110.

65. *Age of Correggio* 1986, cat. no. 155, p. 448.

66. See the exhaustive survey of seventeenth-century Roman landscape painting and patronage by Salerno 1977–78.

67. Röthlisberger 1961, vol. 1, p. 23.

68. Röthlisberger 1961, vol. 1, cat. no. LV94, p. 254; see also Russell 1982, cat. no. 34, pp. 155–57.

69. Röthlisberger 1961, vol. 1, cat. no. 55, p. 195–96.

70. For this work's Venetian commissioner and its reflection of paintings by Bellini and Titian, see Russell 1982, cat. no. 28, pp. 142–43.

71. Röthlisberger 1968, vol. 1, cat. no. 592, p. 235; Russell 1982, cat. no. 37, p. 240.

72. Röthlisberger 1961, vol. 1, cat. no. LV118, p. 293; the painting, which was thought to have been lost, was originally published by Röthlisberger 1969, pp. 54–58.

73. Gowing 1974, p. 93.

Netherlandish Reflections of the Venetian Landscape Tradition

Robert C. Cafritz

Before the energetic revival of the Venetian landscape tradition by Rubens during the second quarter of the seventeenth century, that tradition had been reflected only sporadically in Netherlandish art.[1] In the later sixteenth century, most notably in a group of drawings by Pieter Bruegel the Elder, including *Landscape with the Penitence of Saint Jerome* (Fig. 103)[2] from the 1550s and a series of prints by Hendrik Goltzius, among them, *Man and Woman Seated in a Landscape* (Fig. 105) from the 1590s,[3] earlier Netherlandish artists explored Venetian principles of spatial organization and tonal approach to rendering form, but their explorations were couched in an essentially Northern tradition of portraying nature as a remote spectacle. Bruegel and Goltzius appear to have been most deeply affected by those sixteenth-century Venetian landscapes, now ascribed primarily to Domenico Campagnola, that contain extensive, panoramic vistas, those distant views seen from above, which coincide with the "world" type of landscape that was part of a native Netherlandish tradition (for example, Figs. 64 and 104).[4]

The design of the "world" landscape puts the viewer in the position of looking down from outside and far away at an impressive expanse of earth. The sense of a spiritual gap between man and nature, which lingers in such a firmly distanced vision of landscape, was rooted in the belief that the human sphere pertained to a celestial divinity whereas the natural sphere, valued only as the obstacle-ridden setting of man's redemption, stood beneath and apart from God. Relative to Bruegel's conservative response to Venetian models, the gentler, less dramatic vista depicted in Goltzius's

◁ Detail of Fig. 115 **Peter Paul Rubens**
A Shepherd with His Flock in a Woody Landscape

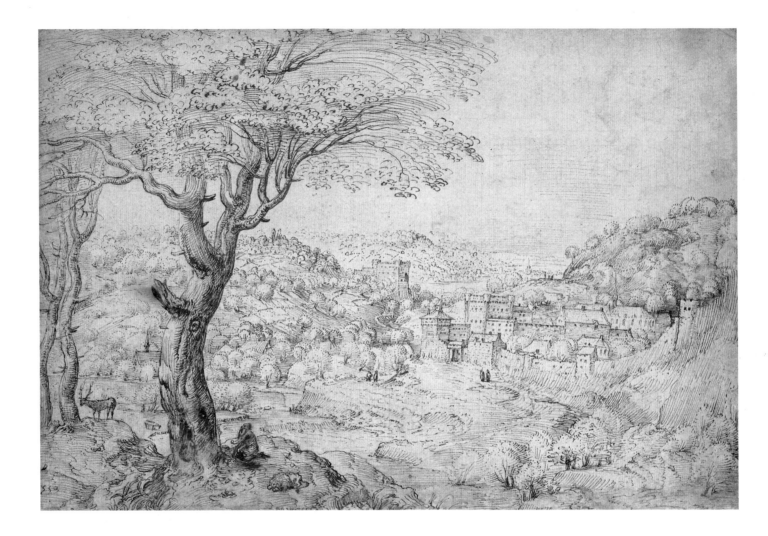

Fig. 103 (No. 47)
Pieter Bruegel the Elder (c. 1525/30–69)
Landscape with the Penitence of Saint Jerome 1553
pen and brown ink on laid paper
9⅛ x 13¼ inches (23.2 x 33.6 cm.)
National Gallery of Art, Washington, D.C.
Ailsa Mellon Bruce Fund
1972.47.1

ROBERT C. CAFRITZ

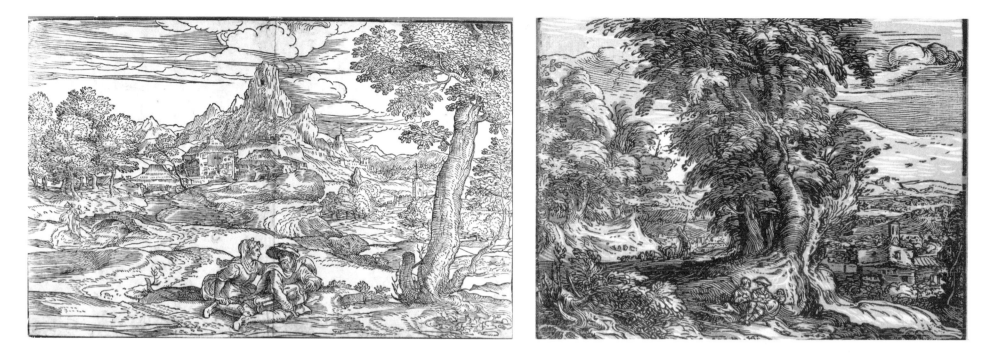

experiment with these sources suggest a new sense of rapport between man and nature. Rubens's adaptions of Venetian models completely superceded those of his predecessors. He put the viewer into direct contact with the landscape and celebrated the ripe harmony of the natural world.

Rubens's exploration of the sixteenth-century Venetian landscape tradition was rooted in a desire to transcend his native tradition and impart to the Northern landscape genre a classical and literary dimension. His efforts were part of a concerted effort among Netherlandish humanists to raise the intellectual level of their native culture in general. Rubens designed his landscapes so that they offered much more than the "mere imitation of nature" that his peers saw as the culturally inferior, intellectually impoverished specialty of their Netherlandish predecessors.[5] Rubens borrowed

compositional ideas and specific motifs from Venetian landscape prints on several occasions. In doing so, he seemed motivated to make landscapes that were poetically significant, essentially from a classical standpoint, and thereby elevate the status of the Northern genre.

By the beginning of the seventeenth century in Flanders, sixteenth-century Venetian landscape designs enjoyed a special status. They were prized as vessels of Latin culture, and they also served as practical studio aids. The superiority of the Venetian achievement in landscape was Carel van Mander's concern when in 1604 he published *Het Schilderboeck*, his important treatise on painting.[6] In his book, van Mander aimed to inspire Northern painters to make landscape convey humanistic themes, based on the classical bucolic poetry and idealizations of rural life in Virgil's *Eclogues* and

Fig. 104 (No. 37) (left)
Domenico Campagnola (1500–64)
Landscape with a Hurdy-gurdy Player and a Girl
c. 1540
chiaroscuro woodcut
9½ x 14¾ inches (24.1 x 37.5 cm.)
Private Collection, Venice

Fig. 105 (No. 48) (right)
Hendrik Goltzius (1558–1617)
Man and Woman Seated in a Landscape c. 1592–95
chiaroscuro woodcut in ochre, sepia, olive, and black ink
4½ x 5¹³⁄₁₆ inches (11.4 x 14.7 cm.)
National Gallery of Art, Washington, D.C.
Rosenwald Collection
1950.1.68, Hirsch./Holl. 379 II/II

Fig. 106 (No. 67)
Anonymous Master
Landscape with Pilgrims, after Domenico Campagnola
c. 1630
etching
10 x 14¾ inches (25.4 x 37.4 cm)
Fondation Custodia, Collection F. Lugt
Institut Néerlandais, Paris
7620/6

Georgics.[7] Significantly, in *Het Schilderboeck*, van Mander also held Titian's landscape woodcuts as valuable models for Northern artists. He wrote that although only a few Italians painted landscape, the landscapes of those who did were virtually unsurpassed, particularly those of "the very gifted Titian, whose woodcuts may instruct us."[8]

Van Mander's recommendations must have spurred Northern artists' collecting of both original Venetian landscape designs and Netherlandish reproductions of them. These were no doubt often assembled into handsome folios like the one preserved in the collection of the Fondation Custodia at the Institut Néerlandais in Paris.[9] In addition to impressions of Cornelis Cort's engravings after well-known paintings and drawings by Titian,[10] the Fondation Custodia's compendium contains two different sets of Netherlandish etchings after Venetian landscape designs, many of which bear ascriptions to Titian but are now given mostly to Domenico Campagnola. One of these sets is composed of the well-known and widely circulated reproductive etchings of Valentin LeFebre, published in Venice in 1682.[11] The other is a consecutively numbered suite of twenty-four impressions, derived from Campagnolesque originals, etched by an anonymous Netherlandish master sometime before 1642.[12] Though less familiar now, the latter series of prints is of particular interest because it documents the literary and classical resonance that Venetian landscapes possessed in the minds of Rubens's contemporaries. These prints bear proverbs in Latin of an admonitory and earthy nature, praising the simple virtues of rural life and harmony with nature, in imitation of classical, georgic sources. That impressions of at least two of these images—with or without the Latin inscriptions—were known to Rubens is reflected in his composition of two late landscapes from the 1630s[13] (cf. Figs. 106 and 121 and cf. Figs. 108 and 109). Some

comments of P. J. Mariette, the distinguished French eighteenth-century connoisseur, are further evidence of the currency of these prints in Rubens's circle. Mariette relates that Schelte a Bolswert, Rubens's friend and one of the engravers on whom he often called to reproduce his paintings (Fig. 107) retouched the second print in the series, the one that reads as *Titianus invenit* ("invented by Titian").[14]

The collector's natural pride of possession—at least a note of self-conscious display—seems to animate the energetic play of Venetian imagery in almost all the pastoral landscapes by Rubens and also in some closely related works by his student, Anthony van Dyck. Many direct quotations and paraphrases from Venetian landscape designs in the work of Rubens and Van Dyck strongly suggest that they had regular access to a collection of prints, perhaps Rubens's own, which was comparable to that at the Fondation Custodia and of which they deliberately availed themselves.

ROBERT C. CAFRITZ

A two-page spread from Van Dyck's *Antwerp Sketchbook* (Fig. 110),[15] contains a collection of pastoral figural vignettes, culled primarily from three of Titian's landscapes. These include the kneeling milkmaid and the shepherd carrying a bucket from the woodcut *Landscape with Milkmaid* (Fig. 54); the shepherd wearing a hat and carrying a staff on his shoulder, from *A Shepherd and his Flock and a Dog in a Landscape with Ruins* (not illustrated), which derived from a Titian drawing in the Louvre; and the flute-playing shepherd and the two perambulating, middleground figures also seen in the famous *Landscape with Flute-playing Shepherd* (Fig. 111).[16] That Van Dyck simply lifted these figures from their original compositions testifies to the status these figural motifs enjoyed, in their own right, as pastoral poetic images in the eyes of Rubens and his contemporaries.[17] Vivid memories of these and other Venetian pastoral figures returned in several works by Rubens and Van Dyck. Moreover, Rubens and Van Dyck usually transposed them to landscape settings derived from yet other originals by Titian or Campagnola. Such was the rich graphic legacy bequeathed to later artists by the sixteenth-century Venetians.

The playful spirit that animates this exploitation of Venetian landscape prints is demonstrated by another Van Dyck drawing, which derives from a print based on Titian's *Landscape with Flute-playing Shepherd* (Fig. 60). Van Dyck's *Landscape in the Manner of Titian* (Fig. 112) contains a relatively faithful and complete reproduction of the landscape setting that appears in, for example, Valentin LeFebre's etching (Fig. 111) derived from Titian's work and also in earlier prints of Titian's frequently reproduced image, which Van Dyck would have known.[18] While Van Dyck retained the landscape setting and the relative positions of the figures seen in the print of *Landscape with Flute-playing Shepherd*, he replaced Titian's flute player

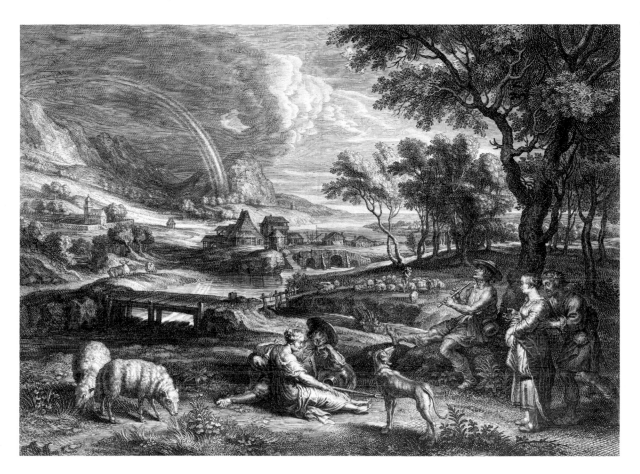

Fig. 107 (No. 51)
Schelte a Bolswert (c. 1581–1659)
Shepherds and Shepherdesses in a Rainbow Landscape
engraving
13⅛ x 17¹¹/₁₆ inches (33.4 x 45 cm.)
The Metropolitan Museum of Art, New York
Elisha Whittelsey Collection
Elisha Whittelsey Fund, 1951
51.501.7727, Holl. 314 (no. 10 in series 305–325)

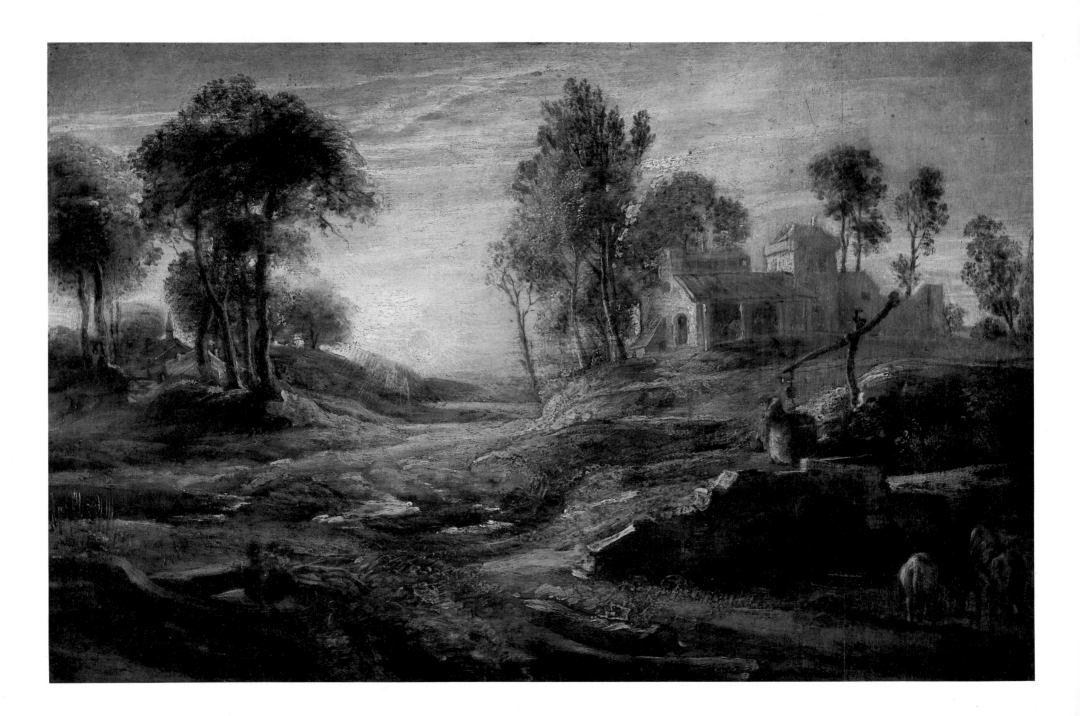

ROBERT C. CAFRITZ

with a load-bearing shepherd and increased from two to three the number of shepherds coming over the hillside in the middleground.

In still another variation by Van Dyck on Titian's *Landscape with Flute-playing Shepherd*, this time, a painting, *Sunset Landscape with a Shepherd and his Flock* (Fig. 113), the flute player returns but as a much smaller figure in a quite different, more open and spacious landscape.[19] The flute player's new landscape setting could be either "a free invention" of the one in which he was originally encountered[20] or it may reflect another, comparable sixteenth-century Venetian landscape design, such as *Landscape with Mill* (Fig. 109). Rubens adapted similar imagery as the setting of his painting *Farm at Sunset* (Fig. 108). Van Dyck's fluid reshuffling and recasting of the figural and natural motifs that he (and Rubens before him) had extracted from Venetian sources and the magnified visual prominence of the original Venetian landscape settings in Van Dyck's works reflect Rubens's own way of manipulating this imagery.[21]

Landscape with Peasant Women and Cows, called hereafter *The Pond*, as it is traditionally known (Fig. 114),[22] is an early Rubens landscape painting of circa 1614, which manifests his characteristic preference for scenes of country life expressed in terms of work rather than relaxation. Similarly Titian's predilection for pastoral in its "harder" and heroic, rather than "softer" and romantic, aspects comes to the fore in his woodcut, *Landscape with Milkmaid* (Fig. 54).[23] In the foreground of *The Pond*, a pair of hearty peasant women unselfconsciously go about their chores, as do the two stolid denizens in Titian's *Landscape with Milkmaid*. In both works, an amusing touch of pictorial conceit is lent by "the games of hide and seek" each artist played out with a series of separate awkward views of the cows.[24] The influence of Titian's woodcut on Rubens was, however,

much more decisive than this play of images. Following the impulse of Titian and through the agency of Rubens, the bird's-eye view of the landscape characteristic of Netherlandish art was finally brought down to earth. As opposed to many of Bruegel's landscapes, including those linked to Venetian sources (for example, Fig. 103), Rubens viewed the landscape directly and from a much closer vantage point, which provides a more intimate experience of the landscape.[25] A sixteenth-century Northern taste for the spectacle of nature still seems to linger in such features of *The Pond* as the exotic-looking tree in the left foreground, dripping with Spanish moss, which is actually a Venetian motif. If indeed appearing somewhat out of

Fig. 109
Anonymous Master, 17th century
Landscape with Mill, after Domenico Campagnola
c. 1630
etching
10 1/16 x 15 inches (25.5 x 38.2 cm.)
Fondation Custodia, Collection F. Lugt
Institut Néerlandais, Paris
7620/7

Fig. 108 (opposite)
Peter Paul Rubens (1577–1640)
Farm at Sunset 1638
oil on panel
11 3/8 x 16 15/16 inches (29 x 43 cm.)
Musée du Louvre, Paris
1816

Fig. 110
Anthony van Dyck (1599–1641)
Two pages from his *Antwerp Sketchbook*
pen and brown ink on white wire-laid paper
each sheet, 8⅛ x 6¼ inches (20.7 x 16 cm.)
The Trustees of the Chatsworth Settlement, Derbyshire

and once again appears to have envisioned his landscape with a Venetian woodcut before him. The landscape setting—from the remarkable trees on the left to the stream coursing down the center of the middleground and the dense screen of trees surmounting the eroded hillside on the right—appears to paraphrase Titian's woodcut *Saint Jerome in the Wilderness* (Fig. 47). In *A Shepherd with his Flock in Woody Landscape*, moreover, the shepherd boy leaning against his staff in front of the eroded bank on the right and his flock of grazing sheep on the left have assumed the relative positions occupied by the saint and lions in Titian's landscape. Rubens spotlights the shepherd to emphasize his presence in the middleground, which might otherwise be overlooked. Titian also used a spotlight to call attention to the figural activity contained in the middleground of his woodcut, the scene of the holy man praying in front of his crucifix.

In adapting Titian's composition to his own expressive aims, Rubens subdued the heroic character of the Venetian master's landscape. Rubens opened up his landscape to include a vista of a distant horizon, and he lowered the sharply changing grade of Titian's terrain. By virtue of these changes, Rubens slowed down and diffused the aggressive pace of Titian's rugged spatial progressions and fostered a more muted and graceful play of light. With these techniques Rubens adapted the heroic style of the Venetian original to the more purely pastoral mode he elected to explore in his own work.[28]

The two versions of *Shepherds and Shepherdesses in a Rainbow Landscape* (Figs. 120 and 121) are among Rubens's last expressions of a pastoral vision.[29] Rubens painted them as a part of the glorious revival of landscape that was a major theme in his late work, executed during his years of his semiretirement as a noble landowner in the

place, Rubens's quotation of the tree from a woodcut by Titian[26] may have been motivated by that tendency to self-conscious display, that pride of possession, which informs some of Rubens's earlier use of Venetian motifs.

For different reasons, the trees in the left foreground of Rubens's *A Shepherd with his Flock in Woody Landscape* (Fig. 115), traditionally dated circa 1618,[27] are also slightly discordant: the branches of a gnarled willow overlaps one of the trees on the left and thereby appears to have shaken two birds from their perch, thus introducing a note of tension into a scene characterized otherwise by the somnolent pastoral calm that overtakes the countryside at sunset. Rubens, in composing *A Shepherd with his Flock in Woody Landscape*, as he had done earlier with *The Pond*, placed the landscape close to and on the same level as the viewer

Flemish countryside.[30] These works suggest again that it was almost impossible for Rubens to visualize the pastoral ideal without being influenced by the ways the Venetians had seen it in the sixteenth century. When Rubens conceived his images of *Shepherds and Shepherdesses in a Rainbow Landscape* in the mid-1630s, he conflated the imagery of two different Campagnolesque designs. He superimposed the foreground of Domenico Campagnola's woodcut, *Landscape with Hurdy-gurdy Player and a Girl* (Fig. 104)—whose impact on Netherlandish art had already been seen in Hendrik Goltzius's print *Man and Woman Seated in a Landscape* (Fig. 105)—onto the background of another Campagnolesque print, *Landscape with Pilgrims* (Fig. 106), an early seventeenth-century Netherlandish impression of which is preserved in the album at the Fondation Custodia.[31]

In *Shepherds and Shepherdesses in a Rainbow Landscape*, Rubens elaborated the theme of amorous pairing suggested by both of the Venetian landscapes he evidently had at hand. When Rubens recycled the image of the interlocked figures in Campagnola's *Landscape with Hurdy-gurdy Player and a Girl*, he portrayed them in the foreground of his paintings as an even more tightly composed unit, and thereby consolidated this motif's status as a "veritable emblem of pastoral love."[32] The theme of coupling is restated throughout the landscape: for example, in the disposition of the sheep in the foreground and in the pair of twin structures with watermills in the middleground, the latter of which are after Campagnola's design (Fig. 106). Finally, the apotheosis of the theme of coupling is the crisscrossed pairs of rainbows in the backgrounds, presumably an image that

Fig. 111 (No. 68) (left)
Valentin LeFebre (c. 1642–80)
Landscape with Flute-playing Shepherd, after Titian, published 1682
etching
12⅛ x 16¹⁵⁄₁₆ inches (30.8 x 43.1 cm.)
Fondation Custodia, Collection F. Lugt
Institut Néerlandais, Paris
7620/26

Fig. 112 (right)
Anthony van Dyck (1599–1641)
Landscape in the Manner of Titian
pen and brush and brown ink on cream paper
13³⁄₁₆ x 21¼ inches (33.5 x 54 cm.)
The Trustees of the Chatsworth Settlement, Derbyshire
959

Fig. 113
Anthony van Dyck (1599–1641)
Sunset Landscape with a Shepherd and his Flock
oil on canvas
42⅜ x 62¼ inches (107.6 x 158.1 cm.)
By Permission of the Governors of Dulwich Picture
Gallery, London
132

Fig. 114
Peter Paul Rubens (1577–1640)
Landscape with Peasant Women and Cows (The Pond)
c. 1610–15
oil on panel
29⅞ x 42⅛ inches (76 x 107 cm.)
Collections of the Prince of Liechtenstein
Vaduz Castle
412

Fig. 115 (opposite)
Peter Paul Rubens (1577–1640)
A Shepherd with his Flock in Woody Landscape
c. 1615–22
oil on panel
25⅛ x 37⅛ inches (63.9 x 94.3 cm.)
The National Gallery, London
2924

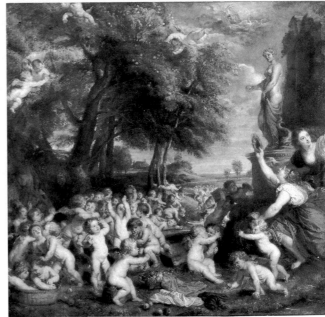

Fig. 116 (left)
Titian (c. 1488–1576)
Worship of Venus 1518–19
oil on canvas
67¾ x 68⅞ inches (172 x 175 cm.)
Museo del Prado, Madrid

Fig. 117 (right)
Peter Paul Rubens (1577–1640)
Worship of Venus, after Titian 1628–29
oil on canvas
76¾ x 82¼ inches (195 x 209 cm.)
Nationalmuseum, Stockholm

Rubens invented. These feats of powerful illusionism challenge nature's own creative powers, a display of painterly prowess characteristic of Rubens's later landscapes.[33] Both versions of this painting—the one in the Hermitage (Fig. 121) and the other, slightly later in the Louvre (Fig. 120)—share most of these features and the general design of the landscape.

In the Louvre version, however, the flute-playing shepherd, who stood alone in the Leningrad version leaning against the tree in the left foreground, has been joined by a female companion seated on the ground next to him. In the Louvre version, Rubens emphasized even more strongly the twin themes of amorous pairing and natural fecundity. In contrast to the Hermitage's version of *Shepherds and Shepherdesses in a Rainbow Landscape*,

in the Louvre's painting, sheep spill across the middle of the landscape. This image recalls the bounty of cupids in a similar arrangement that appears in Titian's *Worship of Venus* (Fig. 116), which Rubens had copied around 1630 (Fig. 117).[34] Rubens naturalized Titian's mythological imagery, adapting it to the earthier poetics of his variation on the theme of fertility. A flock of sheep engulfs the pair of lovers seated in the central foreground of Rubens's painting, and a recumbent pair of sheep in front of the lovers appears to mimic them. This interlaced and mirrored imagery suggests close parallels between the human and natural orders of life, which are both, of course, animated by the reproductive drive, an explicit theme of the painting. In the Louvre version of *Shepherds and Shepherdesses in a Rainbow Landscape*, Rubens

ROBERT C. CAFRITZ

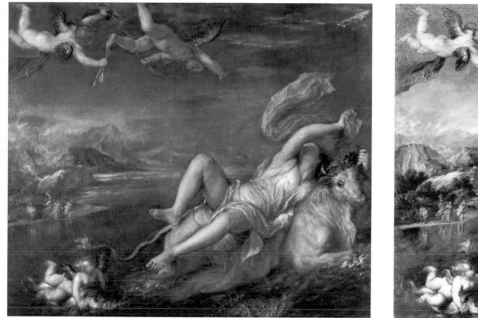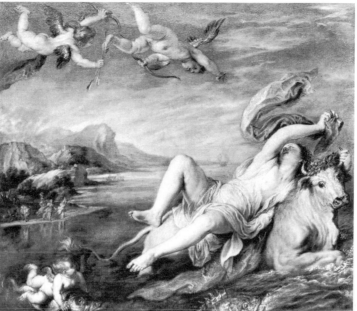

celebrates fertility unabashedly and, in doing so, evoked strongly the model of Titian.[35]

Rubens "carried the image of Titian in his mind just as a lady carried that of her beloved in her heart," Justus Sustermans, a seventeenth-century Flemish artist and connoisseur is reported to have declared,[36] recognizing the warmth and intensity with which Rubens embraced the example of Titian. He copied in oils, in 1628 and 1629, Titian's most painterly and powerfully organic works, the group of mythological landscapes, the *poesie*, that the Venetian master had executed late in his career for the king of Spain (Figs. 118 and 119).[37] From such masterful excercises as these copies, Rubens derived the dazzling coloristic and gestural exuberance of his own mature style, which is most expressively evident in his late landscapes.

The late works, unlike earlier landscapes, show fully the consequences of Rubens's direct, painterly exploration of the Venetian landscape tradition. In addition to a long-standing familiarity with Venetian landscape prints and drawings, Rubens brought the eloquence of a seasoned brush to these late reprisals of the pastoral theme in his work.

Rubens's spirited emulation of Titian's lush and dynamic style of painting gave the mature artist the power to celebrate the ripeness of nature in all its glory. His late landscapes treat this classic theme of plenitude in more than just an emblematic or iconographic way. Whether underscored by the choice of subject matter, as in the amorous couplings in the two versions of the *Shepherds and Shepherdesses in a Rainbow Landscape*, or only

Fig. 118 (left)
Titian (c. 1488–1576)
Rape of Europa 1559–62
oil on canvas
70¹⁄₁₆ x 79 inches (178 x 205 cm.)
Isabella Stewart Gardner Museum, Boston

Fig. 119 (right)
Peter Paul Rubens (1577–1640)
Rape of Europa, after Titian 1628–29
oil on canvas
71¼ x 78¾ inches (181 x 200 cm.)
Museo del Prado, Madrid

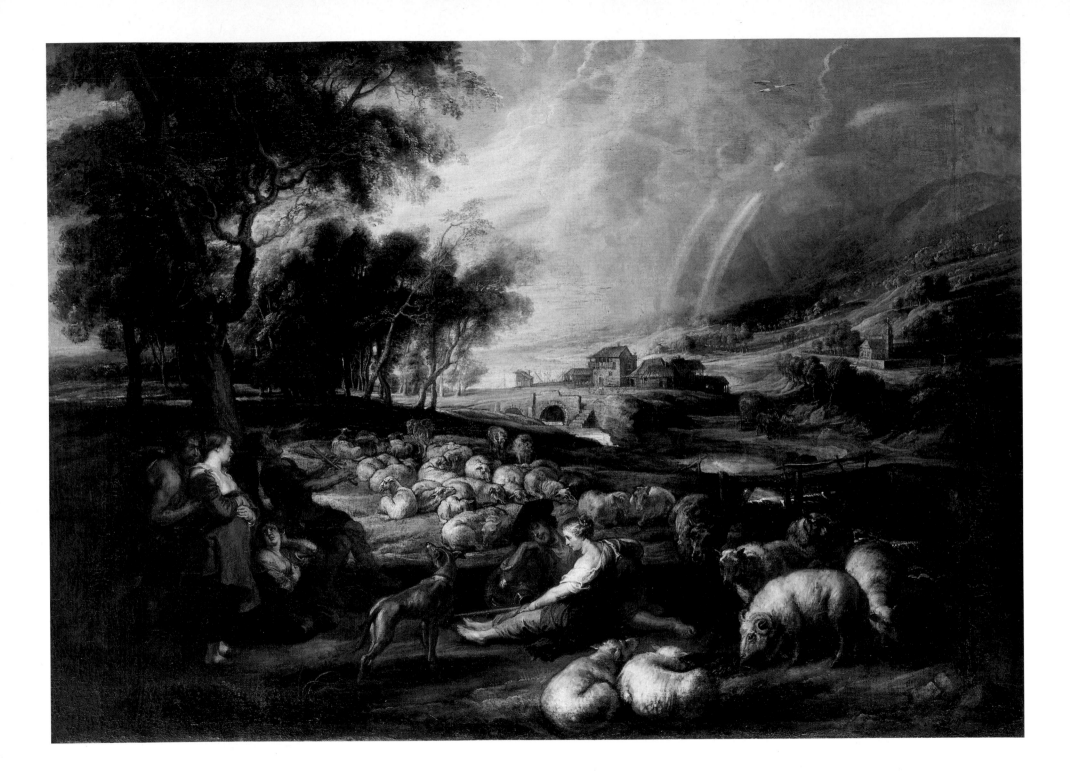

ROBERT C. CAFRITZ

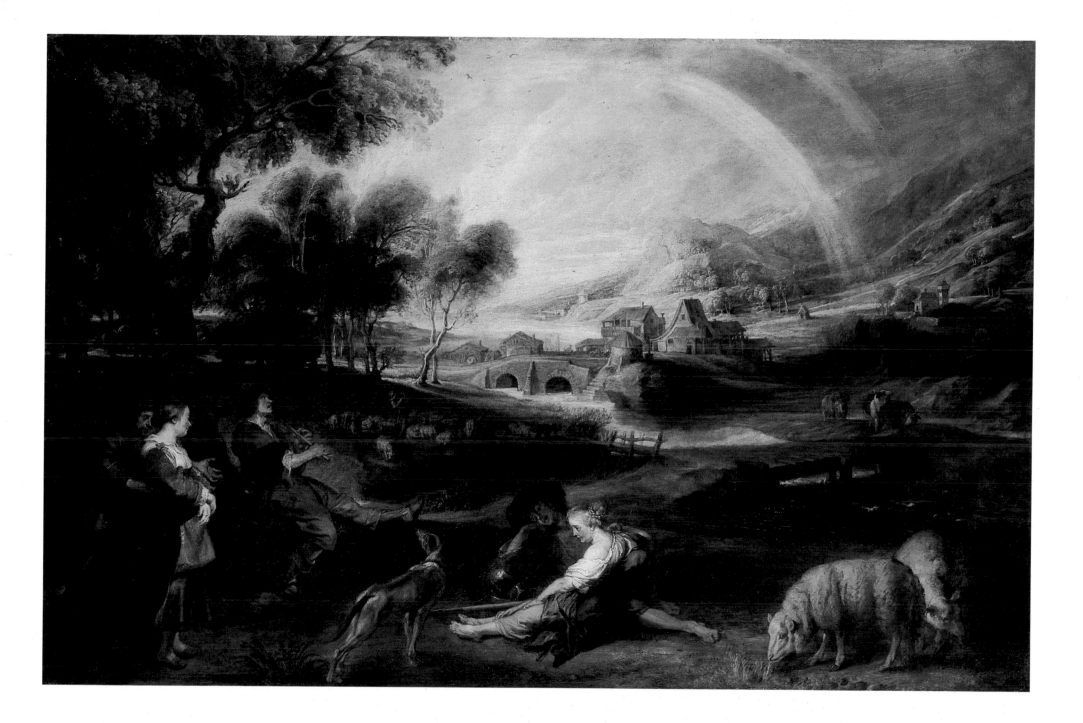

implied, as in the *Farm at Sunset* (Fig. 108), the mature Rubens glorified natural phenomenona with his brush.[38] Earlier in his career, Venetian prints had equipped Rubens with the means by which to structure and detail his humanistic vision of nature. Later, Venetian paintings had quickened his vision on a technical level as well.

NOTES

1. The most recent catalogue raisonné of Rubens's landscape paintings is Adler 1982, vol. 1. An inspiring interpretive model is Vergara 1982.

2. Hand et al. 1986, cat. no. 27 (illus.), p. 99, with earlier bibliography; see also Lugt 1927, p. 116, fig. 4 (illus.); and Brown 1986, pp. 15–17.

3. For a discussion of the Venetian inspiration of Goltzius's print, see Ackley 1980, pp. 27–29.

4. Adler 1982, p. 31f., on the "world" type of landscape.

5. Vergara 1982, pp. 22–23.

6. For a complete English translation with notes of the chapter on landscape in Van Mander's *Het Schilderboeck*, see Brown 1986, pp. 35–43.

7. Vergara 1982, pp. 19ff.

8. From Van Mander, *Het Schilderboeck*, as trans. in Brown 1986, p. 39; for the impact of Van Mander's recommendations of Titian's woodcuts as reflected in drawings by Rubens, Jan Lievens, and Lucas Van Uden, see Dreyer 1985.

9. *Paisages de Titien*, Fondation Custodia (Collection F. Lugt), Institut Néerlandais, Paris, inv. no. 7620; eighteenth-century French leather binding, oblong in folio, 17½ x 23 in. (44.5 x 58.5 cm.), for which, see Meijer 1976, pp. 36–39.

10. For Cort's engravings after Titian, see Mauroner 1943, pp. 58ff., and Bierens de Haan 1948, pp.6ff.

11. For LeFebre, see Rosand, "Giorgione, Venice, and the Pastoral Vision," note 23.

12. *Paisages de Titien*, Fondation Custodia, Institut Néerlandais, inv. no. 7620–1 through 7620–24; see Meijer 1976, pp. 36–37, cat. nos. 22 and 23, for the dating and attribution of these prints and a list of extant sixteenth-century Venetian designs on which they are based.

13. Vergara 1982, p. 57; Kieser 1931, p. 281f. Kieser knew now-lost impressions of these in the Staatliche Grapische

Sammlung, Munich; both Vergara and Kieser reproduced impressions of these prints, which are in the same direction (from left to right) as the landscape settings of the paintings by Rubens that reflect them (Fig. 121 and Fig. 108). The impressions of these prints in the Fondation Custodia's *Paisages de Titien* however, are in the reverse direction (Fig. 106 and Fig. 109). Meijer 1976, pp. 36–37, has identified several extant original sixteenth-century Venetian drawings from which the corresponding prints in the album of *Paisages de Titien* were derived. We would add to Meijer's list the original drawing by Domenico Campagnola on which the etching *Landscape with Mill* (Fig. 109), evidently was based: Domenico Campagnola, *Landscape with Farm Buildings, A Group of Hogs, and a Well at Right*, pen and brown ink, 9⅛ x 14¹⁵⁄₁₆ in. (23.2 x 37.9 cm.), illustrated with notes in Oberhuber and Walker 1973, cat. no. 94, p. 115 (illus., p. 117). The connection between this Venetian drawing and the Netherlandish print was originally made by Vergara 1982, p. 57 with note 96. The landscape in Rubens's painting *Farm at Sunset* (Fig. 108) goes in the same direction as Campagnola's drawing. It is possible that Rubens knew the impressions of this image published by Vergara and Kieser, but this orientation raises the possibility that Rubens knew the original drawing itself. For Rubens's collection of drawings, attributed in the seventeenth-century to Titian, see Jaffé 1964, p. 384, and 1965, p. 29.

14. Meijer 1976, p. 36, mentions Mariette's comments.

15. See Jaffé 1966, vol. 1, p. 25, for evidence of Van Dyck's *Antwerp Sketchbook* as a partial reflection of a lost sketchbook of Rubens.

16. Chatsworth, folio 35 verso-36 recto; see Jaffé 1966, vol. 1, p. 63 and vol. 2, pp. 230–31, for identification of Van Dyck's sources in Titian; and Jaffé 1966, vol. 1, pl. 131 for an illustration of a late-sixteenth-century woodcut derived from Titian's drawing of *A Shepherd and His Flock and a Dog in a Landscape with Ruins*, Cabinet de Dessins, Musée du Louvre, Paris, inv. no. 5528. Titian's drawing is illustrated with notes in Pignatti 1979, pl. 52.; see also Catelli Isola 1976, no. 3 (illus.), no. 69 (illus.), no. 82 (illus.) for other later sixteenth-century prints after this drawing; for a reproduction of a sixteenth-century print after Titian's drawing of a *Landscape with Flute-playing Shepherd*, see Jaffé 1987, p. 144, fig. 88, I.

17. Sewter and White 1972, pp. 88–95, in particular for the adaptation of elements of Titian's *Landscape with Flute-playing Shepherd* in a work by Rembrandt, in addition to the works by Van Dyck discussed here.

18. For Van Dyck's *Landscape in the Manner of Titian* see Jaffé 1987, cat. no. 88, p. 142 (illus. with notes) and again,

Previous page
Fig. 120 (left)
Peter Paul Rubens (1577–1640)
Shepherds and Shepherdesses in a Rainbow Landscape
c. 1635
oil on canvas
48 x 67¾ inches (122 x 172 cm.)
Musée du Louvre, Paris
On loan to the Musée des Beaux-Arts, Valenciennes
1801

Fig. 121 (right)
Peter Paul Rubens (1577–1640)
Shepherds and Shepherdesses in a Rainbow Landscape
1630s
oil on panel, transferred to canvas
31⅞ x 50¾ inches (81 x 129 cm.)
The Hermitage, Leningrad
482

Jaffé 1987, p. 144, fig. 88.1, for a reproduction of a late-sixteenth-century print after Titian's *Landscape with Flute-playing Shepherd* that Van Dyck could have actually known.

19. Jaffé 1966, pp. 410–16, originally linked Van Dyck's painting *Sunset Landscape with a Shepherd and His Flock* at Dulwich to Titian's *Landscape with Flute-playing Shepherd*.

20. Jaffé 1966, p. 414.

21. On the extraordinary degree to which Rubens employed both general and detailed ideas of other artists, sometimes without changes but more often modified or developed (a practice for which some of Rubens's peers criticized him), see White 1987, p. 19.

22. Adler 1982, cat. no. 17, pp. 69–72, "executed circa 1614."

23. Vergara 1982, pp. 30–32, also brought Titian's *Landscape with Milkmaid* to bear on Rubens's *Landscape with Peasant Women and Cows*. The *Landscape with Milkmaid* (Fig. 54) was one of the Titian woodcuts that supplied some of the figural vignettes recorded on the leaf from Van Dyck's *Antwerp Sketchbook* (Fig.110) that possibly reflects a lost sketchbook of Rubens, as mentioned earlier.

24. Vergara 1982, p. 32.

25. See Adler 1982, pp. 27–35, for discussion of the shift in world view implied by Rubens's reorientation of Netherlandish landscape.

26. Rubens's appropriation of the foreground tree from Titian's woodcut, *The Stigmatization of Saint Francis* is noted by Vergara 1982, p. 32, and illustrated (fig. 13); Rosand and Muraro 1976, also illustrate this woodcut with notes, cat. no. 23, pp. 150–51.

27. Adler 1982, cat. no. 23, p. 92, "circa 1618."

28. See Vergara 1982, pp. 66–71 and fig. 39, for Rubens's adaption and enlargement of the design of the landscape *A Shepherd with his Flock in Woody Landscape* in a closely related work, *The Watering Place* (oil on panel, 39 x 53⅛ in.) National Gallery, London, no. 4815 ; Adler 1982, cat. no. 25, pp. 95–98, fig. 71, "circa 1618." Adler adduces a Titianesque landscape drawing from the circle of the Carracci as Rubens's source for the main figures in this painting.

29. *Shepherds and Shepherdesses in a Rainbow Landscape* (Fig. 121) Hermitage no. 482; Adler 1982, cat. no. 39, pp. 131–33, dates "circa 1630"; (Fig. 120) Louvre no. 2118; Ad-

ler 1982, cat. no. 40, pp. 135–38, dates "circa 1635"; Adler 1982, p. 137: both versions as by Rubens himself; Vergera 1982, p. 63: Louvre version as a later product of Rubens's shop.

30. Vergara 1982, pp. 10–14, on Rubens's acquisition in 1635 of the chateau Het Steen in Brabant and its implications for the flowering of landscape as a theme in Rubens's late work.

31. *Landscape with Pilgrims* in *Paisages de Titien*, Fondation Custodia, Institut Néerlandais, Paris, inv. no. 7620-6. See note 13 regarding orientation of prints; Vergara 1982, p. 57 with note 96, which acknowledges Kieset's (1931) original linkage of the Campagnola design to Ruben's paintings.

32. Vergara 1982, pp. 59–60.

33. Vergara 1982, p. 186, on how Van Mander saw a rainbow as a motif that posed a special challenge to an artist's skill.

34. See Held 1982, p. 302f., on Rubens's copies of Titian's *poesie* and the critical significance of Rubens's first-hand study of these works for his later development of landscape as a pictorial theme. See also Adler 1982, p. 25, and Cavalli-Bjorkman 1987.

35. See Vergara 1982, p. 63, for an alternate reading of the Louvre version as "a looser and coarser conception" of Rubens's image of *Shepherds and Shepherdesses in a Rainbow Landscape*, which she attributes to Rubens's workshop; Adler 1982, p. 137, on the other hand, sees the Louvre's painting as the mature version by Rubens himself; Adler finds it particularly compelling because it reflects Rubens's emulation of Titian's late style.

36. As quoted in Held 1982, p. 286.

37. See, in particular, Rosand 1971–72, p. 540, on how Titian's *Rape* has "always appeared a ripe articulation of the Baroque in its openness and, above all, in its shameless naturalism. Here art seems no longer to compete with art but to challenge nature alone, recreating her models but forming them not with ideality but with a superabundance of her own organic stuff."

38. See Adler 1982, p. 30, for Rubens's portrayal in his late landscapes of the forces underlying the visible world of nature, both in the content and in the stylistic structure of his landscapes; see also pp. 34–35 on the link between Rubens's landscapes and the adoption in the seventeenth century of a scientific world view.

Reverberations of Venetian Graphics in Rembrandt's Pastoral Landscapes

Robert C. Cafritz

Whereas Rubens's pastoral vision evolved in paintings, Rembrandt confined his exploration of the pastoral mode of landscape to works on paper, leaving a relatively small quantity of etchings and drawings, mostly executed during the 1640s and 1650s.[1] While Rubens absorbed into his paintings the structure and imagery contained in the Venetian landscape prints he knew so well, his manner of rendering this imagery matured in response to the style of Titian's paintings. Because Rembrandt explored the theme primarily in graphic form, the direct impact of the Venetian style of draftsmanship is much more evident in his work than in paintings by Rubens. In exploring the aesthetics of the Venetian graphic tradition of landscape, Rembrandt sharpened his insight into how the communicative power of landscape depends on composition and style.[2]

Rembrandt's direct contact with the Venetian graphic tradition is dramatically attested by *Mountainous Landscape (with Houses and a Watermill by a Stream)* (Fig. 122), a drawing probably by Domenico Campagnola bearing unmistakable corrections in reed pen by the Dutch master.[3] Rembrandt's bold strokes reinforced the lines of the architecture and, with the added washes, allow the complex of buildings to emerge with more authority from the natural setting. Clarifying the building's structure strengthened the impression of space around it, so that in Rembrandt's version the picturesque farmhouse appears to be firmly planted within the landscape, instead of being superimposed upon the environment, and the house became an organic feature of it. Rembrandt's washes, moreover, introduced a generous play of light and shadow within the landscape, in which the house is central. In comparison to Campagnola's essentially decorative nostalgic work, Rembrandt's more convincing treatment of light and air creates a powerful image that more force-

◁ Detail of Fig. 131 **Rembrandt van Rijn**
Rest on the Flight into Egypt

fully and insistently prompts the viewer's imagination. Rembrandt rejected the essentially decorative, all-over pattern of the Campagnola, a choice that brought the underlying wistfulness of the Venetian original to full force.

Mountainous Landscape evokes the series of idyllic rustic cottages and farmhouses that Rembrandt executed during the 1650s including *A Cottage among Trees* (Fig. 123) in the Metropolitan Museum, which is an exceptionally fine example.[4] *A Cottage among Trees* is sited in the flat Dutch countryside, but by the atmospheric rendering Rembrandt imbued it with the eloquent nostalgia that also characterized his transformation of Campagnola's *Mountainous Landscape*.[5] In both his original work and his reworking of Campagnola, Rembrandt conferred an ideal and poetic character on a prosaic subject by a telling manipulation of compositional and technical features. In his landscapes Rembrandt relied on his drawing style to express the poetic truths of the natural world and man's relationship to it.

Rembrandt's landscapes, whether views of the Dutch countryside or imaginary scenes composed of landscape forms taken from Venetian models, derive their emotional impact from richly accented atmospheric effects. The emotional and thematic chromaticism is particularly compelling in the imagery that evolved in his study of Venetian pastoral landscape prints and drawings. *Three Trees* of 1643 (Fig. 124)[6] is a large panoramic view, unlike most of Rembrandt's treatments of pastoral subject matter, which are significantly smaller and contain intimate scenes of peasant or religious life, viewed from close up. This etching, however, contains several themes that Rembrandt isolated and developed during the 1640s and 1650s, including the erotic life of man and woman, the ways in which the human and the natural spheres are integrated and mirror one another, and how to express different views of these relationships.

One of the least conspicuous but most moving features of Rembrandt's *Three Trees* is the loving couple ensconced in the brambles beneath the trees. This classic pastoral vignette suggests a Titianesque original known to Rembrandt. The lovers motif appears in a Titianesque original, *Landscape with Buildings and Lovers Embracing*, which Rembrandt copied (Figs. 125 and 126).[7] Both the Venetian original and Rembrandt's copy after it are in the collection at Chatsworth. In *Three Trees*, as in the works at Chatsworth, the loving couple is almost completely enmeshed within a veil of deep shadow that enshrouds the hillside. Rembrandt integrated the couple and the hillside with his graphic techniques. The relationship of this unit to the larger pattern of light and shadow that structures the landscape is unusually suggestive: the fertility of the hillside subsumes the amorousness of the loving couple into the sweeping natural rhythms, which is the overriding theme of the etching. Rembrandt's notational style in this etching evokes a pulsating, pantheistic unity of nature in which the realm of man is unselfconsciously and harmoniously melded. The scene represented in *Three Trees* is actually a wide vista of the countryside around Amsterdam, but Rembrandt's technique endows it with a universal quality.[8]

In comparison to the sweeping vista contained in *Three Trees*, the landscapes in the Venetian originals Rembrandt studied—*Mountainous Landscape* at Budapest and his copy of the *Landscape with Buildings and Lovers Embracing* at Chatsworth—were realized from a closer vantage point. They were conceived on a human rather than cosmic scale. This feature must have struck Rembrandt, for his own vision of landscape became increasingly anthropocentric during the 1640s and 1650s.[9] The intimate landscape structures of the Venetians express an essentially pastoral vision of nature, which must have suggested compositional methods that brought Rembrandt's viewpoint

ROBERT C. CAFRITZ

down to earth and narrowed the focus of his landscapes.[10]

The motif of lovers in the shadows is the central theme of *Flute Player* of 1642 (Fig. 127),[11] and one that Rembrandt also examined within the larger landscape context in his copy after *Landscape with Buildings and Lovers Embracing*. In *Flute Player*, Rembrandt is preoccupied with the technical articulation of the links between the natural and human realms. Rembrandt reworked this etching several times until in the third state he obtained a satisfactory impression of the shepherdess enclosed in the bower of foliage in which she is seated—an effect predicated on the tonal relationship between the girl's hat and the bushes behind her.[12] Like the Venetian author of *Landscape with Buildings and Lovers Embracing* Rembrandt did not think of the figures and the natural setting as discrete entities. He conceived them as a single unit of design and a coherent poetic image.

Rembrandt's figures are not the anonymous and pretty shepherds usually represented in Dutch pastoral art. The erotic theme of this image has been given a distinctly earthy, if not crude, coloration especially in comparison to most Dutch variations on the *concert champêtre* theme, which are typically courtly and light-hearted in character.[13] Rembrandt's flute player is a grotesque churl, whose line of sight is trained beneath the shepherdess's skirt. The herdsman's trend of thought is underscored by the alignment of his flute. The tensions of human desire are also reflected in the excitement of the animals scrambling to the right, mirroring the inner state of their owner. Thus, the leering herdsman and his flock of goats, those familiar symbols of sexual ardor, are identified with one another, and the whole landscape becomes erotically charged. By introducing satyric creatures into an otherwise idyllic landscape, Rembrandt tested the limits of the pastoral poetic.[14] This scene passes from the poetic to the plausible: it might depict a situation that could actually have been encountered in the countryside of seventeenth-century Holland.

The dramatic realism of Rembrandt's approach parallels Titian's most characteristic essays in the genre, which tend to the energized and "hard," rather than nostalgically quiescent or "soft," variety of pastoral, that is, georgic rather than idyllic in spirit.[15] Indeed, the single feature that more than any other anchors Rembrandt's image in earthy truth rather than an ideal sphere—the boorish physical appearance of the herdsman—has been identified as one that Rembrandt appropriated from Titian's *Landscape with Flute-playing Shepherd*, which the Dutch master, like Rubens and van Dyck, would have known in the form of any number of prints after the original design (Fig. 111).[16]

In a later etching of about 1644, *The Sleeping Herdsman* (Fig. 128),[17] rustic eroticism returns as a theme. Once again a corner of the landscape comes into close-up view and is revealed as a kind of open-air bedroom. Now the herdsman and the shepherdess act in full complicity. Their physical interaction is of the most unidealized kind. This is illicit sex, as opposed to courtly dalliance or even salacious flirtation. It is made more titillating by the presence of a third party, whose precarious dozing could be construed as guarded voyeurism. The impetuous directness of Rembrandt's draftsmanship accords with the rough-and-ready sexuality of his protagonists. The graphic structure of the sheet situates the scene in the most earthy sector of a "hard" pastoral realm.

The Omval (Fig. 129),[18] an etching of 1645, is a Rembrandt pastoral in a softer mode from both technical and iconographic perspectives. The juxtaposition of an inhabited, woody outcropping in the foreground and a townscape in the background is a scheme typical of early sixteenth-century Venetian pastoral landscapes, including the Campag-

Fig. 122 (No. 58)
Rembrandt van Rijn (1609–69), over **Domenico
Campagnola**(?) (1500–64)
*Mountainous Landscape (with Houses and a Watermill
by a Stream)* c. 1652–54
pen and bistre ink, white body color, on brown paper
6⅜ x 10⅞ inches (16.2 x 27.7 cm.)
The Budapest Museum of Fine Arts
1579

ROBERT C. CAFRITZ

nola print *Shepherds in a Landscape* (Fig. 22).[19] But Rembrandt has recast the contrast of town and country implied in the Venetian originals, making it conform with the realities of Dutch topography.

In *The Omval*, the presence of a loving couple ensconced in the bower only slowly makes itself felt. In contrast to the rugged directness of treatment that characterized *Flute Player* and *The Sleeping Herdsman*, *The Omval* reveals a much enriched, more deliberated technique—evident, in particular, in the suave richness of shadowed tones occupied by the loving couple. Rembrandt used drypoint in addition to etching to establish a mood of special intimacy, as Giulio Campagnola had invented the stippling technique to create on paper the dreamlike atmosphere of Giorgionesque painting (Fig. 20).[20]

In Rembrandt's drawings the blend of wash and pen produces an effect similar to the mixture of drypoint and etching in his prints. The compounded techniques substantially increased Rembrandt's expressive range. The somnolent atmosphere of *The Omval* is shared by the drawing of a *Shepherdess with her Flock* at Besançon (Fig. 130).[21] The balanced alternation of tinted and untinted parts of this sheet endows the scene with a slow rhythm, casting a serene mood that accords with the quiescence of the seated shepherdess and her recumbent flock. Rembrandt selected and used technical options seemingly determined by the emotional requirements of the subject matter.

An emotional modality of style is also apparent in Rembrandt's pastoral interpretation of certain biblical scenes. The composition of *Rest on the Flight into Egypt* (Fig. 131),[22] containing a close-up view of the Holy Family seen against a steep hillside and a distant view of a town, is similar to the scheme in Rembrandt's drawing, *Shepherdess with her Flock*, but its architectural reference to sixteenth-century Venetian models is more explicit. *Rest on the Flight into Egypt* is Rembrandt's personal essay in the type and mood of landscape he explored in such works as his copy (Fig. 132) after a lost original by Titian *Landscape with Bear Attacking a Goat*[23] in the Fondation Custodia. With the open but structured quality of penmanship, telling variations in the stroke weight, and positive activation of the white ground, Rembrandt transposed into the language of the reed pen the more literal, densely accented chromaticism of the sixteenth-century Venetian landscape style.

Landscape with a Resting Shepherd (Fig. 135),[24] a drawing by Rembrandt's colleague Jan Lievens, also recalls the intimate early sixteenth-century Venetian pastoral landscape structure. Also as in Rembrandt's copy of Titian, *Landscape with Bear Attacking a Goat*, Lievens in *Landscape with a Resting Shepherd* kept the focus on the small space in the landscape foreground by closing it off abruptly with a steep bluff rising behind. As in Rembrandt's copy, this scheme precluded a distant view and created a compressed, cloistered space in which a recumbent old shepherd and a lone sheep appear snugly ensconced, much like the pensive old shepherds and saints in landscapes by the Campagnola (Figs. 16 and 134).

Other details in the Lievens drawing evoke Venetian models, such as the leafy plant in the left corner and the feathery transparent foliage of the trees. In *Landscape with a Resting Shepherd*, Lievens sought to capture the luminosity and intimate internal scale of certain Venetian drawings in the manner of Rembrandt's copy *Landscape with Bear Attacking a Goat*, and he used a comparable technique to do so. Lievens's rendering of landscape forms echoes Rembrandt's copy after Titian in many ways: the alternation of passages of long parallel strokes with uninflected passages of the sheet to create a play of light and model the terrain; the curvilinear hatching marks that define tree

Fig. 123
Rembrandt van Rijn (1606–69)
A Cottage among Trees
pen and brown ink, brown wash, on tan paper
6¾ x 10¹³⁄₁₆ in. (17.1 x 27.5 cm.)
The Metropolitan Museum of Art, New York
Bequest of Mrs. H. O. Havemeyer, 1929
H. O. Havemeyer Collection
29.100.939

trunks; and the various acute squiggles that indicate low-growing vegetation in the foreground. The even strokes of Lievens's reed pen denied his drawing the nuanced atmospheric depth that characterizes Rembrandt's comparable essays in a Venetian style of landscape. Whereas Rembrandt's style of reed pen drawing is subtle and intelligent, recalling such drawings by Titian as the one preserved in Rembrandt's copy of *Landscape with Bear Attacking a Goat*, Lievens's style reflects the more limited, economical, and conventional drawing associated with Titian such as that rendered and preserved in the Venetian master's landscape woodcuts. Lievens is known to have studied Titian's *Saint Jerome in the Wilderness* (Fig. 47) and made a copy of its heroic trees (Fig. 133).[25] Lievens's study of Titian's muscular arboreal form affirms van Mander's recommendation that Netherlandish artists study Titian's landscape woodcuts and asserts the continuing significance in Netherlandish art of the Venetian concept of nature as protagonist. Nonetheless, in Lievens's hands the eloquent Venetian language of stroke became a formulaic graphic convention, a reductive variation of Titian's manner applied more or less invariably. In comparison to the psychological and thematic range of Rembrandt's renderings of pastoral, Lievens's bucolic landscape drawings suffer from a recurring flatness (Fig. 136).[26] Evidently Lievens did not share Rembrandt's insight, in part trained by the Venetians, into how to define the affective value of a landscape by the graphic style in which it is rendered.

Rembrandt's greater powers of discrimination are evident in his etching *Saint Jerome Reading in an Italian Landscape* (Fig. 137), executed around 1653,[27] a work in which imagery and style act in perfect accord. The saint's removal from the world of men is expressed by the simple pastoral structure of town vs. country: the contrast between

the shady outcropping that isolates the figure of the saint from human cares and the village seen in the background. The architectural element echoes sixteenth-century Venetian sources, for example, as revealed in *Shepherds in a Landscape* by Giulio and Domenico Campagnola (Fig. 22).[28]

Owing to the broken contours that define it, the figure of the saint only lightly asserts itself within the richly modulated play of light and shadow that animates this sheet. In the contemplative mood induced by the harmonious landscape composition, the viewer tastes the spiritual fruits of the saint's immersion in the natural world—the Book of Nature—and his parallel study of Holy Scripture.

The technical and compositional features that imbue Rembrandt's landscapes with psychological significance cover the emotional spectrum in his varied impressions of *Saint Francis beneath a Tree Praying* (Fig. 138). The tone ranges from the brooding obscurity of the surface-tinted second state on Japanese paper to the visionary purity of the same state on white paper (Fig. 139), as Christopher White has observed.[29] In Rembrandt's pastoral landscapes, every mood depends on a graphic analogue. The artist's awareness of the emotional modality of stroke and the medium's power of communication seems to have been sharpened by his exploration of the relevant sixteenth-century Venetian models. The pastoral landscapes of his Dutch contemporaries often reflected a debt to the Venetians, but usually only in imagery.[30] Rembrandt, above all, recognized and exploited the expressive autonomy of the individual pen stroke and the eloquence of simple compositional structures, as these had been conceived originally in the pastoral landscapes of Titian and his followers. By studying the Venetian originals with such purpose, Rembrandt gave to the Venetian graphic tradition a new momentum.

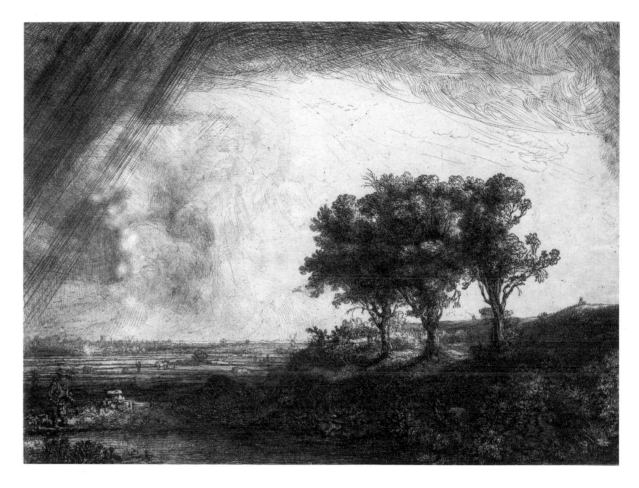

Fig. 124 (No. 60)
Rembrandt van Rijn (1606–69)
The Three Trees 1643
etching with drypoint and burin
8⁵⁄₁₆ x 11 inches (21.2 x 28 cm.)
National Gallery of Art, Washington, D.C.
Rosenwald Collection
1943.3.9119, B.212

Fig. 125
Venetian Follower of Titian, 16th century
Landscape with Buildings and Lovers Embracing,
after Titian
pen and brown ink on paper
5⅞ x 8¼ inches (14.9 x 21 cm.)
The Trustees of the Chatsworth Settlement, Derbyshire
749A

Fig. 126 ▷
Rembrandt van Rijn (1606–69)
Landscape with Buildings and Lovers Embracing,
after Titian
pen and brown ink over slight indications in red chalk
on paper
5½ x 8⁵⁄₁₆ inches (14 x 21.1 cm.)
The Trustees of the Chatsworth Settlement, Derbyshire
749B

Fig. 128 (No. 61)
Rembrandt van Rijn (1606–69)
The Sleeping Herdsman c. 1644
etching and burin
3¹⁄₁₆ x 2¼ inches (7.8 x 5.7 cm.)
National Gallery of Art, Washington, D.C.
Rosenwald Collection
1951.10.482, B.189

Fig. 127 (No. 59)
Rembrandt van Rijn (1606–69)
The Flute Player 1642
etching and drypoint
4⁹⁄₁₆ x 5⅝ inches (11.6 x 14.3 cm.)
Rijksprentenkabinet, Rijksmuseum, Amsterdam
B.188 III

ROBERT C. CAFRITZ

Fig. 129 (No. 62)
Rembrandt van Rijn (1606–69)
The Omval 1645
etching and drypoint
7¼ x 8⅞ inches (18.5 x 22.6 cm.)
National Gallery of Art, Washington, D.C.
Rosenwald Collection
1943.3.7144, B.209 II/II

Fig. 130 (No. 57)
Rembrandt van Rijn (1606–69)
Shepherdess with Her Flock c. 1641–43
pen and bistre ink, white body color on paper
5¾ x 8¼ inches (14.6 x 21 cm.)
Musée des Beaux-Arts et d'Archéologie, Besançon
D.2757

ROBERT C. CAFRITZ

Fig. 132 (No. 55)
Rembrandt van Rijn (1606–69)
Landscape with Bear Attacking a Goat
pen and brown ink on paper
7⅞ x 11½ inches (20.1 x 29.3 cm.)
Fondation Custodia, Collection F. Lugt
Institut Néerlandais, Paris
6584

◁ Fig. 131 (No. 56)
Rembrandt van Rijn (1606–69)
Rest on the Flight into Egypt
reed and quill pen, brown and black ink and wash
on paper
6¹³⁄₁₆ x 9³⁄₁₆ inches (17.3 x 23.3 cm.)
Collection of Mr. and Mrs. Eugene V. Thaw

Fig. 133
Attributed to **Jan Lievens** (1607–74)
Landscape (Study of Trees)
pen and brown ink, brown, grey, green, and greyish blue
wash, some brown and black chalk (?) on paper
10¹³⁄₁₆ x 16⅞ inches (27.5 x 42.8 cm.)
Kupferstichkabinett
Staatliche Museen Preussischer Kulturbesitz,
West Berlin
KdZ 376

Fig. 134
Domenico Campagnola (1500–64)
*Landscape with Saint Jerome Reclining in
Foreground*
pen and ink on paper
9⁷⁄₁₆ x 15¾ inches (24 x 40 cm.)
Gabinetto Disegni e Stampe degli Uffizi, Florence
474P

Fig. 135 (No. 65)
Jan Lievens (1607–74)
Landscape with a Resting Shepherd
pen and ink on paper
9⅞ x 14¼ inches (25.1 x 36.2 cm.)
The Art Institute of Chicago
Leonora Hall Gurley Memorial Collection
1922.1990

Fig. 136
Jan Lievens (1607–74)
Rural Landscape with Milkmaid
reed pen and brown ink on Indian paper
8¹¹⁄₁₆ x 14¹⁄₁₆ inches (22.1 x 35.7 cm.)
The Metropolitan Museum of Art, New York
Rogers Fund, 1961
61.137

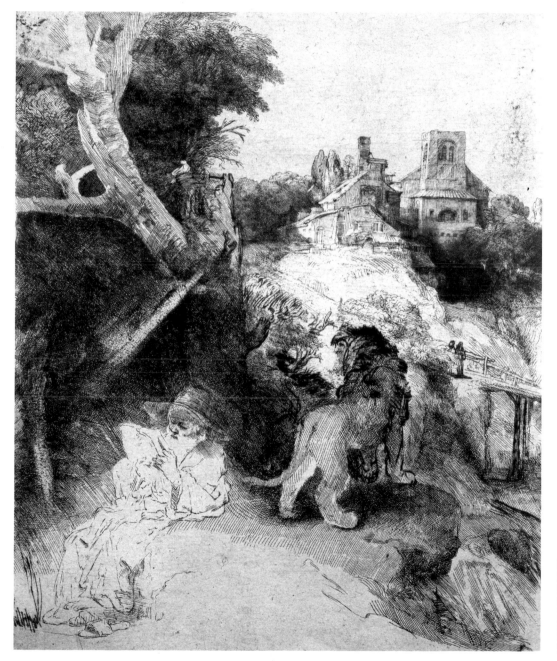

Fig. 137 (No. 63)
Rembrandt van Rijn (1606–69)
Saint Jerome Reading in an Italian Landscape c. 1653
etching, burin, and drypoint
10³⁄₁₆ x 8¼ inches (25.9 x 21 cm.)
National Gallery of Art, Washington, D.C.
Rosenwald Collection
1943.3.7168, B.104 II/II

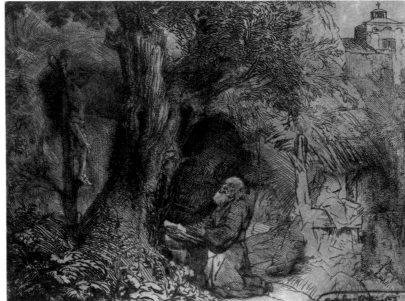

Fig. 138 (No. 64)
Rembrandt van Rijn (1606–69)
Saint Francis Beneath a Tree Praying 1657
drypoint and etching on Japanese paper
7¹/₁₆ x 9⁵/₈ inches (18 x 24.4 cm.)
National Gallery of Art, Washington, D.C.
Rosenwald Collection
1943.3.7156, B.107 II/II

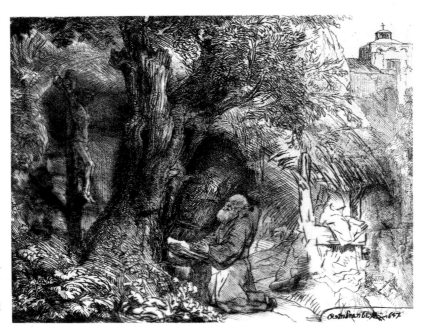

Fig. 139
Rembrandt van Rijn (1606–69)
Saint Francis Beneath a Tree Praying 1657
etching and drypoint on white paper
7¹/₁₆ x 9⁵/₈ inches (18 x 24.4 cm.)
Fitzwilliam Museum, Cambridge, England
B. 107 II/II

NOTES

1. See White 1969, vol. 1, pp. 189–205, on Rembrandt's land-scape etchings and pp. 191 and 205 in particular for the chro-nological pattern of Rembrandt's graphic development of landscape as a theme. In the case of the etchings, produced in two flurries from 1640 to 1645 and again from 1650 to 1653, while making landscape drawings the whole thirteen-year period, see White 1984, p. 99. See Freedberg 1980, pp. 18ff. on the position of Rembrandt's landscape prints within the con-text of seventeenth-century Dutch landscape printmaking. See Kettering 1983, pp. 95–99, on the largely anomalous char-acter of Rembrandt's pastoral images in the context of seven-teenth-century Dutch art, in which a courtly pastoral tradition flourished, only superficially influenced by the sixteenth-century Venetian pastoral landscape tradition. This seems to be true in spite of the popularity of pastoral landscapes by Giorgione and his followers in the northern Netherlands, according to Buckley 1977, pp. 57 and 62. This section of Kettering's work is a condensation of her 1977 article.

2. See Clark 1966, pp. 110–23, generally, on the debt of Rem-brandt to the Venetians as reflected in his landscape etchings and his related landscape drawings.

3. The Budapest Museum of Fine Arts, inv. no. 1579; Fenyó 1965, p. 63; the Budapest drawing is listed as no. 1369 and dated "circa 1652–54" in Benesch 1973. The inventory of 1656, drawn up at Rembrandt's insolvency, lists the albums of prints that he collected. Among these is (item 216): "One [book], very large, with almost all the work of Titian." See Strauss and Meulen 1979, p. 371.

4. The Metropolitan Museum of Art, New York, Bequest of Mrs. H. O. Havemeyer, 1929, H. O. Havemeyer Collection (29.100.939); Benesch 1973, no. 1245, "about 1650-51"; Mules 1985, pp. 30–31 (color illus.).

5. Clark 1966, p. 111; of Rembrandt's transformation of the Campagnola landscape, Clark wrote: "Only a short step in the direction of naturalism separates it from a characteristic Rem-brandt landscape."

6. Bartsch no. 212, in White and Boon 1969. The order of the individual states in this text follows those given in the Hollstein catalogue, with "Bartsch" hereafter abbreviated as "B."

7. Rembrandt, *Landscape with Buildings and Lovers Embrac-ing*, Chatsworth inv. no. 749B, is a copy of the drawing by a Venetian follower of Titian, also entitled *Landscape with Buildings and Lovers Embracing, after Titian*, Chatsworth inv. no. 749A. These works are cat. no. 103 ("Rembrandt in the 1650s") and cat. no. 75 respectively in Jaffé 1987; Byam Shaw

1980, p. 390, also attributes Chatsworth 749B to Rembrandt. This image was also known in the circle of Watteau. The Louvre owns another copy from the circle of the Carracci (inv. no. 5581) and this is the version from which Watteau's friend the Comte de Caylus presumably made his etching of the image. Caylus's etching, inscribed "Cab. du Roy," is reproduced in Catelli Isola 1976, fig. 279.

8. White 1969, vol. 1, p. 199: White's characterization of Rembrandt's *Three Trees* is particularly compelling.

9. On how landscape eventually assumed in Rembrandt's drawings and etchings "the role of mirroring man's thoughts and desires" see White's comments on Rembrandt's etching of *Saint James Reading in an Italian Landscape*, circa 1653, (B. 104) and on the sketch that prepared it, in White 1969, vol. 1, pp. 221 and 224–25.

10. For a definition of Venetian pastoral landscape structures, see Rosand, "Giorgione, Venice, and the Pastoral Vision," elsewhere in this volume.

11. B.188.

12. White 1969, vol. 1, p. 164; see also Freedberg 1980, p. 18, on the extraordinary significance of Rembrandt's successive revisions of his etchings and how the care Rembrandt applied to reworking his etchings set him apart from the majority of seventeenth-century Dutch landscape etchers.

13. Kettering 1983, pp. 96 and 95–99, contains a fuller discussion of the iconography of this image and also its relationship to the seventeenth-century Dutch pastoral tradition in general.

14. For pastoral landscape with a satyric aspect in sixteenth-century Venetian art see Rosand, "Giorgione, Venice, and the Pastoral Vision," elsewhere in this volume.

15. For Titian's development of the "hard" or georgic pastoral mode see Rosand, "Giorgione, Venice, and the Pastoral Vision," elsewhere in this volume.

16. Sewter and White 1972, originally connected Rembrandt's *Flute Player* to Titian's *Landscape with Flute-playing Shepherd*.

17. B. 189, "circa 1644."

18. B. 209.

19. See Rosand, "Giorgione, Venice, and the Pastoral Vision," elsewhere in this volume, on how the simple compositional distancing of the town from the inhabited natural setting in the foreground defines the escapist character of Giulio Campagnola's work.

20. See Rosand, "Giorgione, Venice, and the Pastoral Vision," on Giulio Campagnola's technique as a graphic analogue of Giorgionesque painting.

21. Musée des Beaux-Arts et d'Archeologie, Besançon, D. 2757; Benesch 1973, no. 523, "about 1641–3." Benesch thought it "very probable that the present drawing is an illustration of a biblical scene."

22. Benesch 1973, no. 965, "about 1655"; Denison et al. 1985, cat. no. 7, pp. 28–29; see also Clark 1966, p. 113.

23. For the attribution of our Fig. 132, see White 1975, pp. 375–79; White associates Rembrandt's copy with a number of Rembrandt landscapes of the early 1650s. In addition, he compares Rembrandt's copy with Watteau's copy, presumably after the same Venetian original, which is also at the Fondation Custodia. For both the Rembrandt and Watteau copies, see also cat. no. 18 and cat. no. 19, respectively in Meijer 1976; for Watteau's copy see this author's essay on Watteau and Fig. 144.

24. On Lievens generally see Schneider 1973.

25. On the relationship of this drawing (Fig. 133) to Titian's woodcut, in the context of Van Mander, see Dreyer 1985.

26. Mules 1985, p. 35 (color illus.).

27. B. 104; Kenneth Clark 1966, p. 117; Ackley 1980, pp. 240–42, for a critical history of this etching.

28. White 1969, vol. 1, p. 221 with note 33.

29. White 1969, p. 222.

30. Kettering 1983, p. 92, for sixteenth-century Venetian precedents of "decorative" pastorals by seventeenth-century Dutch artists.

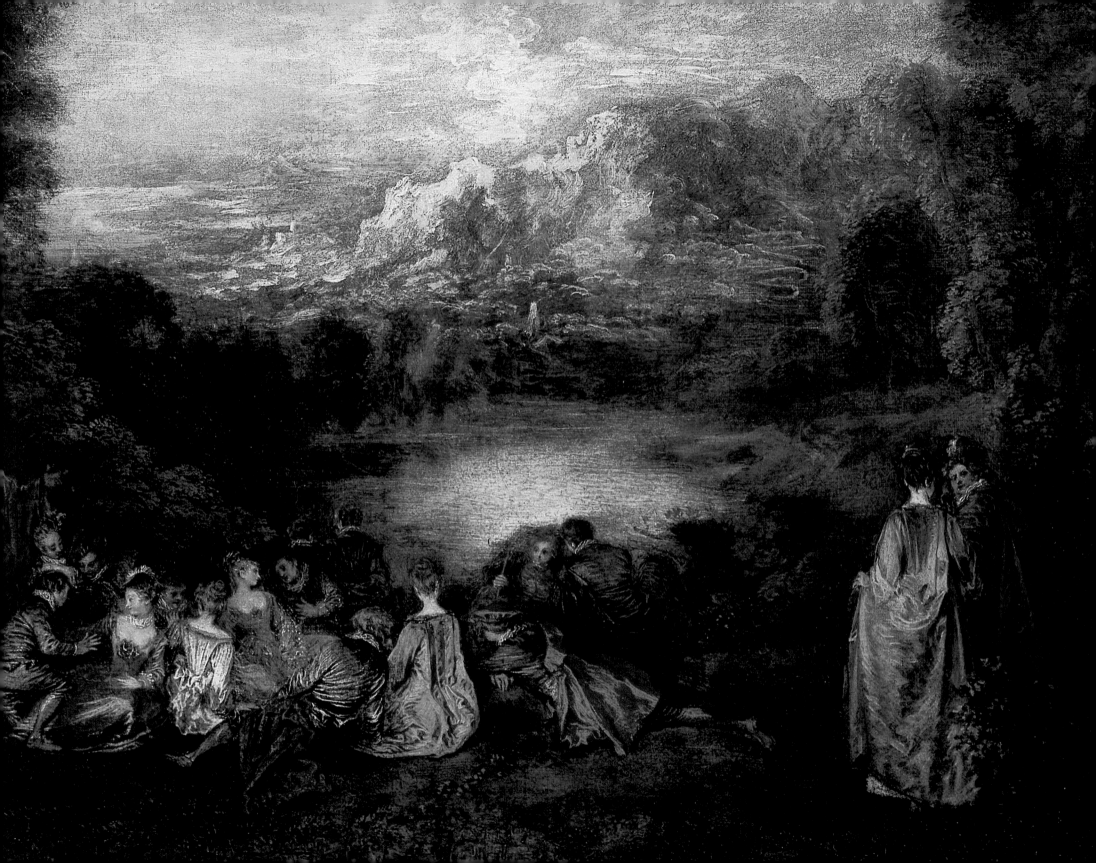

Rococo Restoration
of the Venetian Landscape
and Watteau's Creation
of the Fête Galante

Robert C. Cafritz

Watteau's *fêtes galantes* portray idyllic love scenes, evocative of the formal open-air courtship parties that were a favorite amusement of fashionable Paris during the early eighteenth century.[1] Watteau painted idealized, amorous happenings in parklike settings that contain romantic serenades, exotically costumed personages, symbolic figures, and choreography, borrowed from the theatre and mixed with allusions to contemporary life, just as his most important sponsor, Pierre Crozat, orchestrated flirtatious, stylized gatherings on the grounds of his chateau on the outskirts of Paris.[2] Originally, Watteau drew on the conventions of the stage, decorative design, Northern allegory, and genre painting to forge the language of the fête galante.[3]

The relatively naive illusionism and arrangement of an early work like *La Perspective* [now entitled *View through the Trees in the Park of Pierre Crozat (La Perspective)*] (Fig. 141) of circa 1712–14, which shows an imaginary fête galante set in a park based on the Chateau de Montmorency, Crozat's country manor,[4] made it too easy for critics to dismiss the fête galante as a minor pictorial theme. Subsequently, Watteau began to make definitive elements of the Venetian landscape tradition basic to his imagery, which increased the fête galante's visual and intellectual authority and established its thematic independence. The lofty atmosphere and powerful naturalism of a mature work, Watteau's official masterpiece, *Pilgrimage to the Island of Cythera* (Fig. 157)[5] of 1717, attests to how the Venetian landscape tradition helped Watteau make the fête galante convey universal statements about the nature of love and turn the genre into a high art form.

Watteau created the fête galante in an environment in which the sixteenth-century Venetian

landscape aesthetic had been triumphantly affirmed as an ideal of pictorial imagining and practice. In the early eighteenth century under the aegis of Rubenisme, nature succeeded classicism as the standard against which artistic achievement was measured. Color and the inspired gesture were celebrated as the most effective means by which an illusion of nature could be projected, in contrast to the preceding centuries, which glorified classical draftsmanship. Rubenisme also fostered more informal and hedonistic responses to the sensuous delights of art.[6]

The Rubenistes did not insist exclusively on the iconographic dignity and precision that predominated in the classical view.[7] Their tradition holds the work of Rubens in the seventeenth century as a model, in turn inspired by the work of Titian and his followers in the sixteenth century. Landscape, genre, and still life were by this time firmly established as legitimate categories and, if they did not officially supplant history painting at the top of the academic hierarchy, these more "natural" types of painting conquered public taste, as eighteenth-century Parisian habits of collecting demonstrate.[8] The Rubenistes embraced dynamic naturalism and more freely invented subject matter, eschewing the conceptual and stylistic clarity of painting in the grand manner as practiced by Raphael and Poussin.[9]

In Watteau's time, and especially in connection with the theme of landscape with figures, the sixteenth-century Venetians were seen as the old masters who had exercised most authoritatively the evocative powers of description and more purely formal prerogatives of the painter; who had eschewed the iconographic conventions of history painting; and who had introduced viewers to more subjective varieties of aesthetic experience.

The triumph of Rubenisme created a new intellectual sympathy for the Venetian school and,

in particular, renewed interest in Titian's achievement as a mythological and pastoral landscapist.[10] Study of his works, even more than of nature itself, was believed to hold the secrets of the artful recreation of the natural world.[11] The warmly appreciative collecting, cataloging, and reproduction of sixteenth-century Venetian landscape prints and drawings were conspicuous features of the milieu in which Watteau matured.

From about 1712 until 1719—years that encompass the genesis of the fête galante including Watteau's submission in 1717 of his official masterpiece, *Pilgrimage to the Island of Cythera* (Fig. 157), to the French Academy—Watteau was aligned with the leading Rubeniste salon of Pierre Crozat, and lived sporadically in Crozat's home.[12] Members of Crozat's international artistic coterie included Roger de Piles, Rubenisme's most articulate spokesman; Charles de la Fosse, a venerable academician who had taken a personal interest in Watteau's career and who had himself exchanged a classical for a Titianesque style of painting; and such members of the reinvigorated Venetian school as Rosalba Carriera and Sebastiano Ricci,[13] in whose circle Titianesque designs of pastoral landscapes also enjoyed something of a revival (Fig. 140).[14] In late 1715 Crozat purchased one of the largest and most important collections of sixteenth-century Venetian landscape designs in Europe, many of which may be found today in the Louvre.[15]

Watteau must have been overwhelmed by the profound reflection of his own expressive aims that were mirrored in Crozat's collection of landscapes by Titian and Domenico Campagnola. The examples in Crozat's collection were models for more than one hundred copies of Venetian originals from Watteau's hand known today. As the famous eighteenth-century amateur P. J. Mariette related in his notes on Domenico Campagnola:

ROBERT C. CAFRITZ

Campagnola had a singular talent for drawing landscapes well. There are many by him, woodcuts, which are attributed to Titian, and which are almost as good as that. Monsieur Crozat has a great many of his pen drawings... Watteau copied all of them, when he was with M. Crozat, and he confided that he had profited greatly in doing so.[16]

La Perspective (Fig. 141),[17] which antedates the arrival in Paris of Crozat's new collection, shows the trend of Watteau's thinking during his early years with the Crozat circle and the beginnings of the fête galante, which set the stage for his imminent submission to the Venetian vision of landscape.

In *La Perspective* women wear contemporary costume while the men are dressed in seventeenth-century style, a disjunction that lends an air of unreality to the scene. Nonetheless *La Perspective* is actually one of the few works by Watteau with an identifiable setting.[18] The painting seems to represent an improvised happening rather than a dramatic sequence of events. Separate scenes of amorous pairing appear to be in progress, but little evidence suggests either a dramatic point of origin or outcome to this situation. The absence of a narrative framework is characteristic, as is the way Watteau used the perspectival design of the landscape to visually and emotionally harmonize *La Perspective*, as its title, by which it has been known since the early eighteenth century, suggests.[19] Watteau used the natural setting as an expressive agent, both to site the courtship party, appropriately, in a contemporary version of the pleasance of pastoral poetry and as the primary means by which to unify and coordinate his imagery.

Watteau's poetic use of the landscape as a harmonic structure has precedent in Venetian tradition: the guitarist seated in the left foreground of *La Perspective* was directly inspired by the lute player in the Louvre's *Concert Champêtre* (Fig. 7).[20] Like the author of the *Concert Champêtre*, in

Fig. 140 (No. 79)
Marco Ricci (1676–1729)
Landscape with Peasants and a Mill c. 1725
pen and sepia ink on paper
8⅝ x 9⅜ inches (22 x 23.8 cm.)
Museo Correr, Venice
8220

Fig. 141
Jean Antoine Watteau (1684–1721)
View through the Trees in the Park of Pierre Crozat
(*La Perspective*) c. 1714–15
oil on canvas
18⅜ x 21¾ inches (46.7 x 55.3 cm.)
Maria Antoinette Evans Fund
Courtesy, Museum of Fine Arts, Boston
23.573

Fig. 142 (No. 76) (opposite)
Jean Antoine Watteau (1684–1721)
Two Figures in a Landscape, after Domenico
Campagnola
red chalk on paper
9³⁄₁₆ x 9³⁄₁₆ inches (23.4 x 23.3 cm.)
Musée de Louvre, Paris
Département des Arts Graphiques
33.374

La Perspective Watteau used the landscape setting to unite disjunctive elements into an overall harmony.[21] Here Watteau did not positively declare the Venetian source of his inspiration, but he already revealed an intuitive grasp of the underlying principles of the Venetian landscape tradition. In quoting the motif of the lute player from that tradition's inaugural masterpiece, the Louvre's *Concert Champêtre*, Watteau signaled the concordance of Venetian precedent with his own expressive aims.

Watteau engaged in a kind of picture making different from the classical history painter. Dramatic coherence and explicit characterization of the figure—the essentially literary priorities of the history painter—were irrelevant to Watteau's goals, which emphasized psychologically subtle, nonverbal realities. The compelling visual transmission of mood—the painterly intonation of a fragile emotional climate—depended more on exploiting the poetic resources peculiar to the arts of painting than it did on the narrative methods of the history painters.[22]

The intimate accord between Watteau's aims and the kind of art identified with Giorgione and Titian is also suggested in the ambiguous explanation for Watteau's youthful desire to go to Rome provided by the dealer Edme-François Gersaint, the painter's close friend and early biographer: "Watteau had a strong desire to go to Rome in order to study after the great masters, above all after the Venetians...."[23]

The aristocratic amateur and fellow student at Crozat's salon, the Comte de Caylus (1692–1765),[24] wrote that:

> Watteau was charmed by the fine inventions, the exquisite landscape backgrounds, the foliage, revealing so much taste and understanding, of Titian and Campagnola, whose secrets he was able to explore in these drawings.

Fig. 143 (left)
Jean Antoine Watteau (1684–1721)
Landscape with Infant Saint John the Baptist
red chalk on paper
7¹⁵⁄₁₆ x 13⅛ inches (20.2 x 33.4 cm.)
Present location unknown, formerly Zinser Collection

Fig. 144 (No. 75) (right)
Jean Antoine Watteau (1684–1721)
Landscape with Bear Attacking a Goat
red chalk on paper
7⅞ x 11¹³⁄₁₆ inches (20.1 x 30 cm.)
Fondation Custodia, Collection F. Lugt
Institut Néerlandais, Paris
3803

And, since it is natural to consider things in relation to their possible usefulness, it was to these qualities that he most readily gave attention, rather than to those other qualities of arrangement, composition and expression in the works of the great history painters whose talents and purposes were so remote from his own. These he was content to admire without seeking to adapt himself to them by any special course of study, from which, indeed, he would have derived scant advantage.[25]

Some parallels between his contemporaries' perceptions of the nature of Watteau's achievement and the response with which Giorgione's peers had greeted his paintings also indicate the special affinity between Watteau and the Venetians. The tenor of remarks made by Comte de Caylus shortly after Watteau's death are reminiscent of the bewilderment Vasari expressed at the apparent iconographic imprecision of Giorgione's painting.[26] Caylus, who despite his friendship with the artist, was emerging as one of the leaders of the neoclassical revival of history painting in the grand manner,

complained of Watteau's works that: "In a word, with the exception of one or two of his pictures...his compositions have no precise object. They do not express the activity of any passion, and are thus deprived of one of the most affecting aspects of the art of painting, that is, of action...."[27]

Given the low status of Watteau's subject matter—"*petits sujets galants,*" in a critic's words,[28]—as recognized by even his most admiring and sophisticated peers,[29] historians can allege that the artist suffered isolation and insecurity, in spite of his success and the academy's encouragement, albeit ambivalent. Although Watteau was already familiar with the *Concert champêtre* and other sixteenth-century Venetian pastoral designs, presumably including those well-known reproductions by the seventeenth-century Netherlandish printmaker Valentin LeFebre (cf. Figs. 53 and 143),[30] Crozat's outstanding collection of Venetian originals must have had an impressive, affirmative value for the artist. This authoritative collection

seemed to validate Watteau's natural tendencies as an artist and provide a tradition to orient his invention of the fête galante genre.

The specific character of Watteau's development of the fête galante was influenced by the presence in Crozat's circle of Roger de Piles. In his book *Cours de peinture par principes*, published in 1708, de Piles took pains to define the pastoral as a separate category of landscape and held Titian as the standard-bearer of achievement in this genre. He recommended direct imitation of the Venetian master's prints and drawings as the primary means by which to grasp its expressive potential.[31]

De Piles's views must have directed the intensive study of the Venetian landscape prints and drawings in Crozat's collection by such artists as Watteau and connoisseurs as Caylus and Mariette. Their study yielded new insights into salient differences between Titian and Domenico Campagnola. Amateurs began to recognize Titian's sensitivity and intelligence in contrast to Campa-

gnola's relative flatness of touch and less interesting foregrounds, providing the basis for criteria that still serve connoisseurs of Venetian landscape designs.[32] Watteau actively engaged in this acute probing of the Venetian tradition, which fueled and strongly characterized his definition of the fête galante.

Roger de Piles granted to the theme of landscape innate powers of communication, which he characterized as tending either to the "*héroïque*" or "*pastoral ou champêtre*" in style or spirit. Specifically, the pastoral spirit of landscape was expressed through emphatically picturesque images of nature, rendered with as much verisimilitude and immediacy of effect as possible.[33] For de Piles, among those essential things that gave "soul" or spirit to the landscape are "figures, animals, rivers or streams, trees rustled by the wind, [and] lightness of the brush".[34] De Piles understood the poetics of landscape to be essentially empirical. Not only was the painter expected to create myriad individual "natu-

Fig. 145 (No. 74) (left)
Jean Antoine Watteau (1684–1721)
Concert champêtre (Venetian Landscape) c. 1715
red chalk on laid paper
8¼ x 12 inches (22.3 x 30.4 cm.)
The Fine Arts Museums of San Francisco
Achenbach Foundation for Graphic Arts Purchase
1975.2.14

Fig. 146 (right)
Gérard Jean-Baptiste Scotin II (1698–after 1733)
La Lorgneuse, after Watteau, c. 1727
engraving
13⁷⁄₁₆ x 10⁹⁄₁₆ inches (34.2 x 26.9 cm.)
National Gallery of Art, Washington, D.C.
Widener Collection
1942.9.2092

Fig. 147
Jean Antoine Watteau
(1684–1721)
Diana at her Bath
oil on canvas
31½ x 39¾ inches (80 x
101 cm.)
Musée du Louvre, Paris

ral" motifs, he also had to learn to relate them in compositions that echoed with nature's expressive force and fluid organic integrity.[35] The special delights of the genre hinged on both the painter's descriptive skills and his convincing resolution of problems of scale and formal arrangement.

Landscape, thus, was a subject in which the painter's practical control over the resources peculiar to his art emerged in full glory. In attempting landscape as a theme, the artist could not necessarily rely on the conceptual armature of dramatic subject matter or erudite literary allusion. Indeed, it was considered sufficient that the figural content in landscape paintings represent some "*petit sujet*" that would arouse the attention of the viewer or, at least, give a name to the picture and facilitate differentiation of one work from another.[36] Since landscape was stripped of important subjects, mastery of the fundamentals of picture making was clearly revealed. The artist would do best to absorb himself primarily in the prints and drawings of Titian, afterwards spend a little time with the Venetian master's paintings, and then, finally, with nature itself. According to de Piles, Titian's graphic legacy, above all, offered viable, definitive responses to the special challenges posed by landscape and the pastoral style in particular.[37]

With respect to both spirit of invention and exigencies of realization, the great Venetians were important models for Watteau's expressive aims. His most characteristic works were thought of by his contemporaries as "*petits sujets galants*"[38] or simply as landscape with figures,[39] in spirit reflecting the "tender, agreeable, faintly bucolic"[40] artistic personality of their creator. Watteau's finesse in handling his media and the verisimilitude of his style were the features of his achievement that, in the eyes of his contemporaries, propelled his fêtes galantes above the secondary status to which they would otherwise ultimately be relegated as essays

Fig. 148
Jean Antoine Watteau (1684–1721)
Diana Bathing c. 1716
red chalk on cream paper
6¾ x 6⁷⁄₁₆ inches (17.2 x 16.3 cm.)
Graphische Sammlung Albertina, Vienna
12,008

Fig. 149 (left)
Jean Antoine Watteau (1684–1721)
Landscape with a Castle
red chalk on ivory paper, laid down
8¹³⁄₁₆ x 13⁵⁄₁₆ inches (22.4 x 33.9 cm.)
The Art Institute of Chicago
Helen Regenstein Collection
1964.194

Fig. 150 (right)
François Boucher (1703–70)
An Italian Village in a Mountainous Landscape, after
Domenico Campagnola
red chalk on white paper
8¹¹⁄₁₆ x 13¾ inches (22.2 x 34.9 cm.)
Fitzwilliam Museum, Cambridge, England
PD.106–1961

in mere genre.[41] Moreover, these critical traits of Watteau's art had blossomed, again according to his peers, as a result of his direct study of Crozat's collection of old master drawings.[42]

Watteau's *Two Figures in a Landscape* (Fig. 142),[43] his red chalk copy of Domenico Campagnola's pen-and-ink drawing of *Two Boys Kneeling in a Landscape* (Fig. 25)[44] is a fragmentary pastoral vignette—a "petit sujet"—that may have suggested ideas for a figure grouping in Watteau's own works. *Two Boys Kneeling in a Landscape* appears to be without precise subject matter. Instead it suggests visual poetry of the sort that is only realized fully by the viewer's imagination, which appears to have been a specialty of the Campagnola.[45] This image's power of suggestion resides in the insistent promptings of its compositional soundness and its naturalistic immediacy. It is an essay in how the

visual integrity and wholeness of an image can motivate the imagination, without the support of a full narrative framework. In copying Domenico Campagnola's *Two Boys Kneeling in a Landscape*, Watteau focused on one problem defined by Roger de Piles as a special concern of the landscapist: relating figures to the natural setting. De Piles suggested that in order to avoid any impression that the figures might be artificially superimposed[46] they should be arranged so that their positions echo the design of the landscape,[47] and Watteau's *Two Figures in a Landscape*, his faithful imitation of Campagnola's *Two Boys Kneeling in a Landscape*, could almost serve as an illustration of this point.

Landscape with Bear Attacking a Goat (Fig. 144)[48] is even more enigmatic in subject matter than *Two Boys Kneeling in a Landscape*. This is Watteau's copy after a lost Venetian original evi-

dently known also to Rembrandt.[49] If, as Donald Posner says, Watteau copied some Venetian originals, "not really in order to use them for paintings but to deepen his understanding of the bucolic mode of landscape representation they exemplify,"[50] nonetheless Watteau surely did not fail to recognize that sixteenth-century Venetian landscapes contained many elements that could be useful in shaping his gallant imagery, as Posner says also.[51] Specific impressions of especially romantic Venetian motifs seem to have become embedded in Watteau's mind. When confronted with unusual compositional problems, he drew on these memories to formulate his solutions. Thus, the balletic pose of the little shepherd boy and his position in the landscape seen in *Landscape with Bear Attacking Goat,* may inform the attitude and siting of the sculpture of the plump young nymph in the foreground of his painting *The Love Lesson* (Fig. 154).[52] Once again in the spirit of de Piles's text, a Venetian design offered an effective solution to a compositional problem, such as the figure at rest in the landscape, which could make the image strike a false note if not adroitly handled.[53]

The subject of the drawing *Concert champêtre (Venetian Landscape)* (Fig. 145), presumably after an original by Domenico Campagnola,[54] is closer to the conceptual center of Watteau's pictorial universe. A change in costume would seem enough to transform the Venetian pastoral scene into one of Watteau's earlier fêtes galantes, such as *La Lorgneuse (The Ogler)* (Fig. 146), a now-lost work preserved in the form of an engraving after the original.[55] Both the drawing *Concert champêtre* and *La Lorgneuse* contain close-up, frontal views of interlocked pairs of lovers disposed in unitary triangular arrangements, nestled in the midst of leafy foregrounds, in turn framing distant views of turreted complexes of rustic buildings.

The drama in each work is generated by the intensity of the male figure's aggressive, space-traversing glance firmly fixed on his partner. This evokes one of the most memorable features of the Louvre's *Concert champêtre* (Fig. 7), which must have shared certain features with the now lost Venetian original that Watteau copied. Watteau's dialogue with Venetian models not only fueled his landscape variations on the fête galante theme, it also helped to sharpen his characterizations of human actors. Such otherwise inconspicuous motifs as the space-traversing glance assume a primary significance in the muted sedentary environment of the pastoral landscape.

Watteau's copy illuminates another aspect of his debt to the Venetians: the increasingly vigorous proliferation in his landscapes of variegated, seemingly haphazard vegetative growth. Picturesque bushes and trees catch the viewer's eye and lead him to surrender to the fiction of the image. In de Piles's words, "strongly characterized plants," along with the other natural furnishings typical of the style champêtre, "attract our admiration by their novelty." Especially when they appear in the foreground, "they imprint the first impression of truth and contribute immeasureably to the play of the artifice of the painting."[56] Titian was the unexcelled master of convincing portrayal of arboreal elements, and in particular, the infinite variations of nature that de Piles termed, *"une certaine bizarrerie."* It was through intense study of the Venetian master's designs that artists acquired taste and skill in the picturesque detailing of the landscape.[57]

Watteau evidently shared de Piles's admiration of distinctive vegetation. For example, the sprouting tree trunk in the right foreground of Watteau's drawing *Concert champêtre (Venetian Landscape)* (Fig. 145), is a motif used repeatedly in the sixteenth-century Venetian landscapes he had come to know so well (cf. Figs. 53 and 143). This

ROBERT C. CAFRITZ

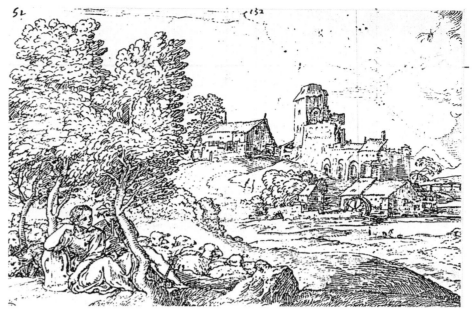

Fig. 151 (No. 71) (opposite)
Jean Antoine Watteau (1684–1721)
Country Amusements (Amusements champêtres) 1716–18
oil on panel
12⅝ x 18½ inches (32 x 47 cm.)
Private Collection

Fig. 152 (No. 73) (top left)
Jean Antoine Watteau (1684–1721)
Musicians Seated under Trees (Italian Landscape)
red chalk on paper
7⅝ x 10¼ inches (19.3 x 26 cm.)
Musée des Beaux-Arts et d'Archéologie, Besançon
D.815

Fig. 153 (top right)
Domenico Campagnola (1500–64)
Musicians Seated under Trees
pen and ink on paper
5¼ x 8⁵⁄₁₆ inches (13.3 x 21.1 cm.)
Musée du Louvre, Paris
Département des Arts Graphiques
4780

◁ Fig. 154
Jean Antoine Watteau (1684–1721)
The Love Lesson (Leçon d'Amour) c. 1716–17
oil on walnut panel
17¼ x 23¹⁵⁄₁₆ inches (43.8 x 60.9 cm.)
Nationalmuseum, Stockholm
NM 5015

vivid motif returns monumentalized, in effect, in Watteau's painting of *Diana at her Bath* (Fig. 147); likewise, the wispy trees and background architecture are typical of Domenico Campagnola's designs.[58]

Roger de Piles had pointedly recommended Titian's woodcuts—in particular those in "which the trees are well-formed"—as the principal models above all else, in any media, for that humble imitation of the great master's touch by which the secrets of his powers of description could be learned.[59] It is the distinctive stroke-for-stroke faithfulness of Watteau's imitations of Venetian designs that sets them apart from comparable essays by other eighteenth-century French artists, for example, a characteristically more decorative revision of a Campagnola landscape by François Boucher (Fig. 150).[60]

In contrast to Boucher, Watteau emulated the Venetians in style as well as imagery. For example, the assorted short curves with which he modeled the foliage, branches, and tree trunk in *Diana at her Bath* quite clearly echo corresponding passages in Campagnola. Moreover, Watteau's imitation of the Venetian style of drawing is equally explicit in his paintings and works on paper. When the arboreal motifs in the detailed preliminary red chalk study for *Diana at her Bath* (Fig. 148)[61] are compared to the corresponding passages in his painting, Watteau's literal transposition into paint of the Venetian graphic technique becomes apparent. "According to Gersaint," Posner writes, "Watteau himself was happier drawing than painting, the brush slowed his hand, and the full palette delayed and made more difficult the formation of the image he was creating. But it is one of the secrets of his painting, that in their rendition of figures and landscape, they show the same aims and means as his sketches. They are drawn, too, only with brush and oil paints."[62]

This equation of the aims and means of Watteau's drawings with the spirit and technique of his paintings holds true for the relationship between those few extant copies by Watteau after Venetian landscape designs that can be directly linked to existing paintings. In his drawing of a *Landscape with a Castle* (Fig. 149),[63] presumably a copy after a lost work by Domenico Campagnola, Watteau reproduced, but in the softer medium of red chalk, the Venetian style of incisive pen strokes and carefully calculated passages from densely to lightly woven areas of landscape. These techniques lend the copy its spacious effects of light and vaporous atmosphere. Moreover, Watteau effectively recreated the graphic structure of his copy when he transposed it as the background of the painting *The Love Lesson* (Fig. 154).[64] In the painting, tone and brushwork assume the functions of the chalk strokes in the drawing.

A fluid translation, from one medium to another, also characterizes the relationship between a Venetian landscape in the Louvre, a pen-and-ink drawing originally from Crozat's collection, Domenico Campagnola's *Musicians Seated under Trees* (Fig. 153)[65] and Watteau's red chalk copy of it in Besançon (Fig. 152).[66] Watteau again faithfully transposed both the style and the imagery of the Venetian drawing when he adapted it in a painting. In the background of *Country Amusements* (Fig. 151), specific reflections of the undulating terrain, turreted, arcaded structure, and watermill, all seen in the drawings, are found.[67]

The Love Lesson, Country Amusements, and *Prelude to a Concert* (Fig. 155)[68] were all executed around 1716–17, and they are closely related in technique and subject. In each, small groups of figures close to the frontal plane are contained by shady outcroppings of trees, and the distance is viewed through an opening in the foreground. This structure focuses attention on the figures whose characterization differentiates images that otherwise are largely formal variations.[69]

ROBERT C. CAFRITZ

The general setting of these works, the intimate watered landscape, the shady trees that accommodate the ease of the figures, and, by way of emphasizing the theme of leisured retreat, the suggestion of a town at a safe distance on the horizon, evokes the *locus amoenus*, the "place of delight," of classical tradition. But, in contrast to the Venetian designs that inspired it, which were original visualizations from literary models,[70] Watteau's pastoral vision of landscape emerged from a rich pictorial legacy. In Watteau's imagination, Titian and Domenico Campagnola took the place of Theocritus and Virgil.

Watteau's understanding of the Venetian vision of landscape was critical to his establishment of the fête galante as an independent genre. Northern European settings, like the one seen in *La Perspective* (Fig. 141), were supplanted by the spectacle of exotic, cloud-filled mountainous vistas in most of the paintings Watteau executed between about 1716 and 1718.[71] This new exaltation of the fête galante's setting transported its inhabitants to an unequivocally idealized realm and undermined the genre's original links to traditions of representing scenes from the theatre and daily life.[72] In the social milieu that hosted Watteau's creation of the fête galante—the circle of Crozat—this ideal realm was probably appreciated as more compelling and authoritative in its poetic and natural, as well as art-historical, frame of reference[73] than the familiar Northern settings that had formerly located Watteau's imagery. Comments by Watteau's peers imply an increase in the prestige of his work after he engaged the Venetian tradition. Watteau's peers attributed his new brilliance to study of the old master drawings in Crozat's house.[74]

The new visual authority of Watteau's fête galante, however, was not enough to win him the official status of history painter he sought on submitting *Pilgrimage to the Island of Cythera* (Fig. 157)[75] as his reception-piece to the French

Academy in August 1717. Once again, the iconographic ambiguity of his imagery—Watteau's failure, as in the case of Giorgione before him, to base a work of art on the narrative poetics of classical drama—seems to have been the problem. The academy's records of Watteau's reception show that the original title of the painting, "*Le pelerinage a l'isle de Cithère*" was crossed out and replaced by the phrase "*une feste galante*."[76] This implies confusion on the academy's part about the narrative of this work, which persists to this day. Opposing views suggest that Watteau intended, on the one hand, to represent a departure for the symbolic island of love and, on the other, a leave-taking of it.[77] In any event, the fête galante received official recognition as a pictorial theme and Watteau was admitted to the upper ranks of the academy, but only in the secondary category of genre painter.[78]

In spite of its official failure as a piece of history painting, *Pilgrimage to the Island of Cythera* represents a triumph. Compared to the intimate bucolic settings of the group of paintings considered above, the landscape in *Pilgrimage to the Island of Cythera* is monumental. No longer merely functioning as expressive backdrop, it fills the pictorial field, which now includes an opened-up middleground and a greater vista in the distance, crowned by rocky peaks rather than hilltop towns, creating an expansive setting for the figures. In this newly invigorated sweep of landscape, the trees in the foreground now loom over the figures, in contrast to the low, supportive clumps of trees seen in Watteau's more conventional variations on the pastoral landscape theme. A new intensity of vision pervades Watteau's dramatic landscape. The rendering of the heroic foreground trees evoke, in configuration and in their higher degree of surface articulation, Titian's heroic trees (Fig. 47), rather than the more flaccid, loosely described Campagnolesque copses that furnish the foregrounds

Fig. 155
Jean Antoine Watteau (1684–1721)
Prelude to a Concert c. 1716
oil on canvas
26 x 35⅞ inches (66 x 91 cm.)
Schloss Charlottenburg
Staatliche Schlösser und Gärten, West Berlin

Fig. 156
Jean Antoine Watteau (1684–1721)
Peaceful Love 1718
oil on canvas
22¹/₁₆ x 31⅞ inches (56 x 81 cm.)
Schloss Charlottenburg
Staatliche Schlösser und Gärten, West Berlin

Fig. 157 (opposite)
Jean Antoine Watteau (1684–1721)
Pilgrimage to the Island of Cythera 1717
oil on canvas
50¾ x 76⅜ inches (129 x 194 cm.)
Musée du Louvre, Paris
MI 8525

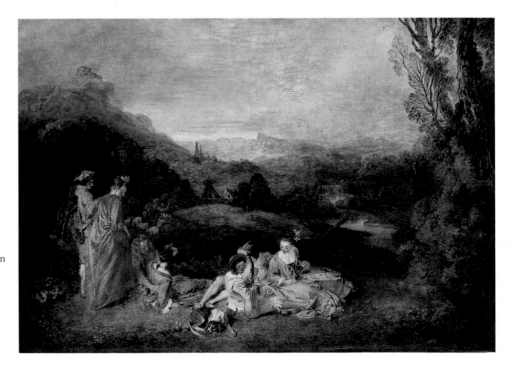

ROBERT C. CAFRITZ

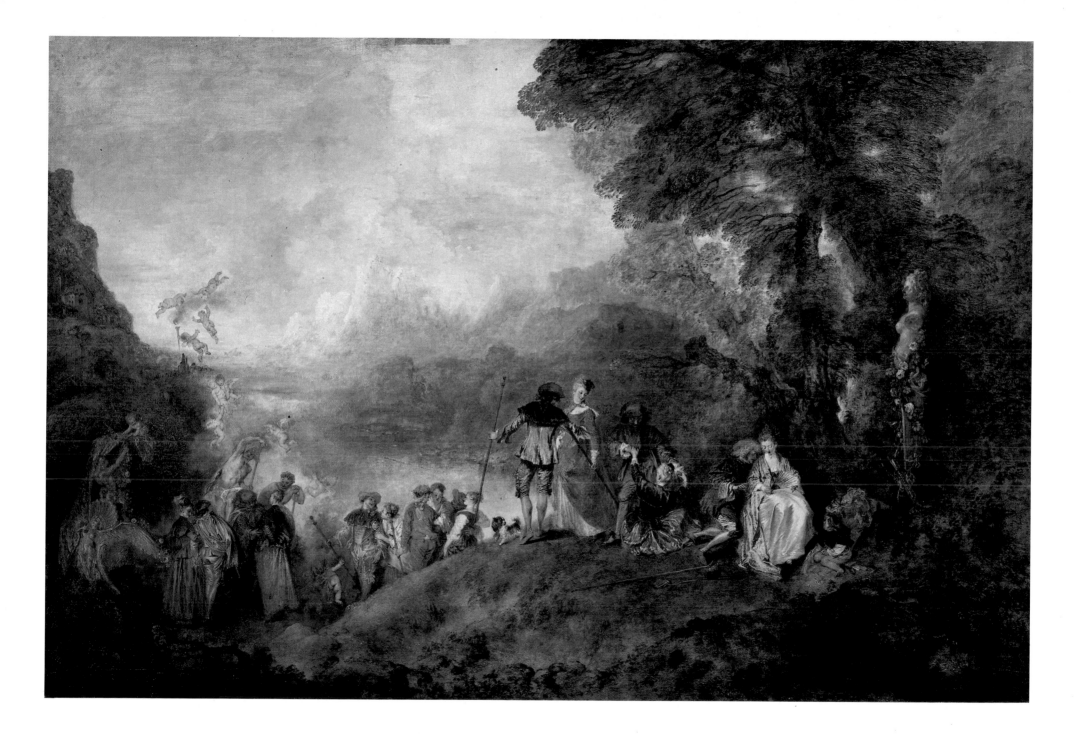

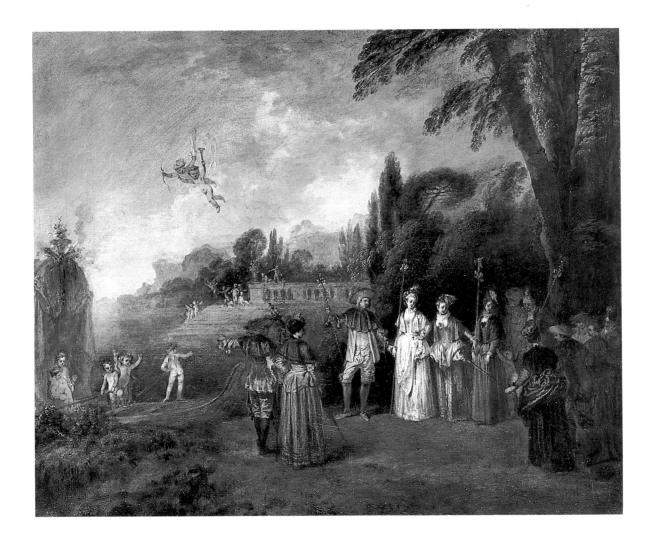

Fig. 158
Jean Antoine Watteau (1684–1721)
The Island of Cythera c. 1709–10
oil on canvas
17 x 21 inches (43.1 x 53.3 cm.)
Städelsches Kunstinstitut, Frankfurt

ROBERT C. CAFRITZ

in other paintings by Watteau.[79]

The prominence of the natural world in *Pilgrimage to the Island of Cythera* is enhanced by the arabesque arrangement of the group of humans. This dynamic grouping and the rear view of the central figure encourage the viewer's active exploration of the landscape, in contrast to the more passive response solicited by the landscape in *The Love Lesson* and the works associated with it.

In *Pilgrimage to the Island of Cythera*, Watteau abandoned the sedentary mode that characterized those works and introduced a dynamic impulse into his concept of pastoral. With the implied movement of the crowd of figures, he activated the expansive, universalizing kind of landscape that he also explored, with less dramatic thrust, in such paintings as *The Enchanted Isle* (Fig. 159), *Peaceful Love* (Fig. 156), and *Landscape with a River* (Fig. 162).[80] These paintings also bear witness to Watteau's intensive study of sixteenth-century Venetian drawings and prints.[81]

The specific Venetian sources of *Pilgrimage to the Island of Cythera*, include Domenico Campagnola's panoramic landscapes in which the pilgrim or wanderer is a kind of leitmotif.[82] It is difficult to imagine Watteau visualizing *Pilgrimage to the Island of Cythera* without referring to his own copy of Domenico Campagnola's drawing, *Landscape with Setting Sun* (cf. Figs. 160 and 161),[83] and to the Venetian master's *Landscape with Wandering Family* (Fig. 64),[84] etchings after both of which were made by the Comte de Caylus, Watteau's sometime critic and his fellow student of Crozat's collection and evidently of the Venetian landscape designs in the French Royal Collection as well.[85] The impact of these works seems to be strongly reflected in both the general disposition and the detailing of Watteau's great masterpiece and in his other panoramic fêtes galantes.[86]

Watteau's enlargement and recharacterization of the landscape structure of the fête galante along the lines suggested by the panoramic vistas of Domenico Campagnola, projected the human search for love into a cosmic or "Olympian" perspective, to use the Goncourt brothers' words. Watteau's imagery evoked Elysian fields, again in the Goncourts' words, in which "sight and thought languish into a vague, vanishing distance, like the deep floating backgrounds that are the frontiers of Titian's pictorial world."[87] In *Pilgrimage to the Island of Cythera*, the human inhabitants are virtually dwarfed and completely enveloped by the natural setting rather than encamped before it. As the grand sweep of the landscape absorbs the organic chain of amorous men and women, the search for love finds a graceful status within the natural order. Nature is affirmed as dynamic and creative, not just a muted backdrop for human affairs. Watteau's juvenile essay on the theme of the land of love, *The Island of Cythera* (Fig. 158) painted around 1710, for which the visual sources were largely Northern European and theatrical in origin,[88] indicates that there were virtually no precedents in French painting for Watteau's improvisation of his increasingly dynamic and exalted vision of the natural world and the organic position within it of man and woman. It was the Venetian landscape, as Roger de Piles had defined it, that Watteau embraced as the source of the authority, inspiration, and practice that brought his modern restatement of the pastoral vision of nature to pictorial fruition.

Watteau, on the eve of his death in 1721, acknowledged the centrality of the Venetian experience of landscape in the maturation of his own vision when he produced a painted rendition of Titian's famous woodcut, *Landscape with Milkmaid* (Fig. 54), in *The Shopsign* (Fig. 163), which he made for his friend, the Parisian art dealer Gersaint.[89] Watteau significantly positioned his

Overleaf
Fig. 159 (No. 72) (left)
Jean Antoine Watteau (1684–1721)
The Enchanted Isle 1716–18
oil on canvas
18⅛ x 22³⁄₁₆ inches (46 x 56.3 cm.)
Private Collection, Switzerland

Fig. 160 (No. 77) (right)
Attributed to **Jean Antoine Watteau**
Landscape with Setting Sun, after Domenico Campagnola
red chalk on paper
15⅝ x 23⅝ inches (39.7 x 60 cm.)
Musée du Louvre, Paris
Département des Arts Graphiques
5577

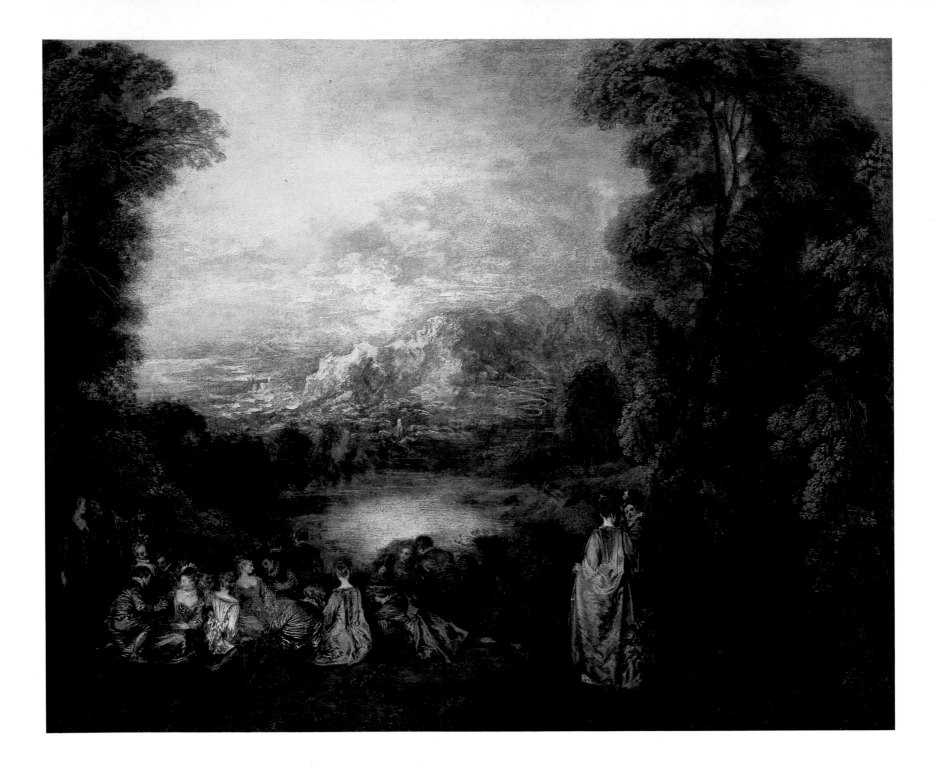

ROBERT C. CAFRITZ

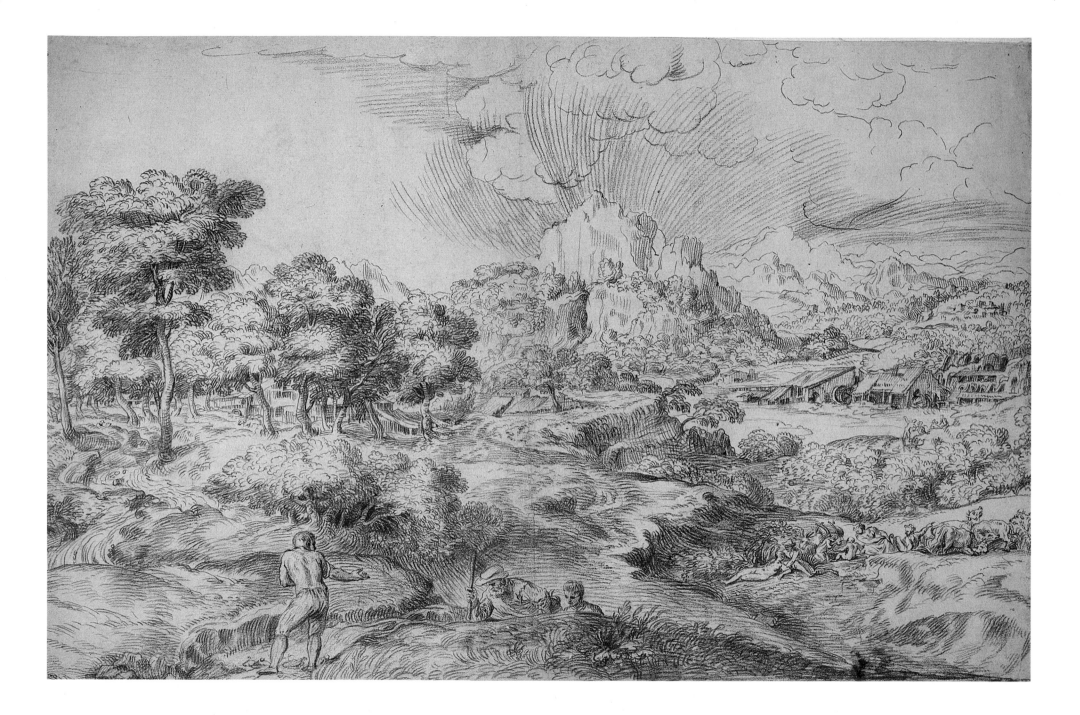

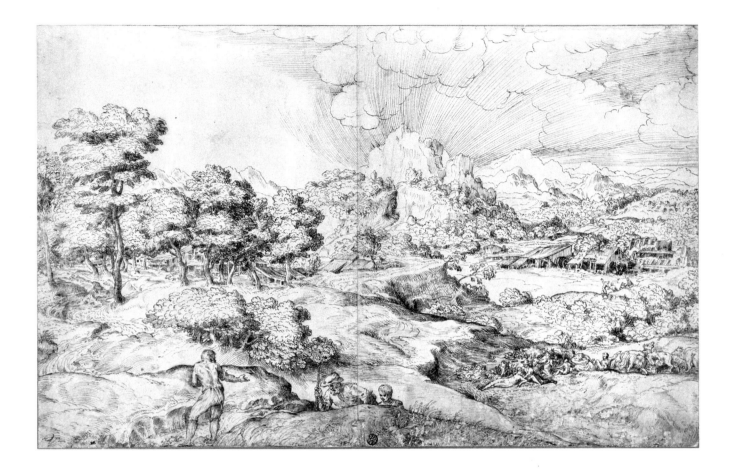

Fig. 161 (No. 35)
Domenico Campagnola (1500–64)
Landscape with Setting Sun
pen and brown ink on paper
14¹³⁄₁₆ x 23¹³⁄₁₆ inches (37.7 x. 60.5 cm.)
Musée du Louvre, Paris
Département des Arts Graphiques
5550

ROBERT C. CAFRITZ

rendition of the Titian uppermost and right of center on the facing wall of his imaginary installation (Fig. 163, detail), which contains evocations of the old masters that are generally taken in sum to be the painter's symbolic testament to the sources of his inspiration.[90] Watteau's choice of the woodcut also signaled the practical means by which he made the Venetian experience part of his own. It evokes Roger de Piles's emphasis on the specific value of Titian's graphic legacy as the unexcelled resource for those who aspired to succeed, in any media, to the great Venetian's pictorial mastery of the natural world.

Gersaint's *Shopsign* not only advertises the sources from which Watteau forged his personal vision, it also displays the currency of Watteau's sources among his contemporaries in the form of a large selection of then fashionable Venetian and Rubensian mythological and pastoral landscapes.[91]

The commercial success of Watteau's own work is the best witness to the appeal of his vision to his contemporaries. They launched a concerted effort, led by the wealthy businessman, Jean de Jullienne, to disseminate Watteau's work posthumously through engravings of both his paintings and his drawings.[92] The *Recueil Jullienne*, presented in four volumes to the French Academy in 1739, illustrates several now lost works by Watteau.[93] These last provide even more evidence of his reliance on Venetian models as do a few of the early paintings of idyllic peasant scenes by François Boucher (1707–70), one of the artists involved in this project (Fig. 164).[94] Meanwhile, late into the eighteenth century, Jean Honoré Fragonard (1732–1806) above all would airily expand on Watteau's nostalgic portrayal of the sweeping up of human desires into nature's continuum of superabundant energy (Fig. 165),[95] a vision in which Watteau had been closely trained by the sixteenth-century Venetians.

Fig. 162
Jean Antoine Watteau (1684–1721)
Landscape with a River c. 1715
oil on canvas (transferred from panel to canvas in 1883)
27⁹/₁₆ x 41¹¹/₁₆ inches (70 x 106 cm.)
The Hermitage, Leningrad

Fig. 163 (detail)

Fig. 163
Jean Antoine Watteau (1684–1721)
The Shopsign 1721
oil on canvas
65¼ x 120 inches (166 x 306 cm.)
Schloss Charlottenburg
Staatliche Schlösser und Gärten, West Berlin

ROBERT C. CAFRITZ

173

Fig. 164 (No. 78)
François Boucher (1703–70)
Le Repos des fermiers (*The Farmers' Rest*)
oil on canvas
34¼ x 53½ inches (87 x 136 cm.)
Collection of Jeffrey and Linda Horvitz

Fig. 165 (No. 80)
Jean Honoré Fragonard (1732–1806)
The Swing c. 1765
oil on canvas
85 x 73 inches (215.9 x 185.5 cm.)
National Gallery of Art, Washington, D.C.
Samuel H. Kress Collection
1961.9.17

1. Posner 1984, p. 151.

2. Crow 1985, p. 56.

3. Posner 1984, p. 128f., contains a review of the genesis of the fête galante; Crow 1985, pp. 55–74, emphasizes more than Posner the links between contemporary theater, the ethos of the aristocracy, and traditions of decorative painting in Watteau's original vision of the fête galante.

4. Grasselli and Rosenberg 1984, cat. no. P 25, pp. 300–4.

5. See notes 75–87 and related text for more discussion of *Pilgrimage to the Island of Cythera*.

6. Kalnein and Levey 1972, part 1, "Painting and Sculpture," by Michael Levey, pp. 3–6, for a brief introduction to Rubenisme. See Stuffmann 1968, p. 36, on the special position of landscape in Roger de Piles's authoritative Rubeniste criticism and de Piles's influence on Crozat's habits as a collector; p. 43, on Roger de Piles's high esteem for Titian's landscapes; and pp. 36ff., for emergence of critical criteria in the circle of Crozat based on the pleasure of connoisseurship rather than on academic considerations of subject matter. For an illustrated inventory of Crozat's collection, see *Recueil d'estampes* 1729–42; Crow 1985, p. 44, for how Watteau's own work "encouraged a reorientation of painting toward the provision of sensual pleasure at the expense of moral and intellectual edification" and in this connection how "the preponderance of Venetians among the Italian artists who were guests in the Crozat household and the implicit favor thus given to coloristic and gestural facility, remind us that this was also the forcing house of the Rococo style in painting."

7. Bryson 1981, pp. 58–63, on the Rubenistes' anti-academic "attack on the classicizing discursive image."

8. Kalnein and Levey 1972, p. 4; Stuffmann 1968, p. 36, on the popularity of landscape in particular; on the vogue for genre painting, landscape, and northern European cabinet pictures among early eighteenth-century Parisian collectors in general, see, in addition to Stuffmann, Lefrançois 1981, pp. 36–40; Pomian 1979, 23–36; Scott 1973, 42–53; Duverger 1967, pp. 77ff. and 82; Watson 1963; Posner 1984, p. 122, on relationship of commercial success of Watteau's fête galantes to taste for Netherlandish genre paintings.

9. Kalnein and Levey 1972, p. 4, and, with respect to Watteau's position in this context in particular, see p. 16; Teyssèdre 1965, for a comprehensive account of the debate between the proponents of the draftsmanly style of painting, identified in France in the seventeenth and eighteenth centuries with Raphael and Poussin, and the advocates of northern Italian and Flemish painterly principles.

10. Stuffmann 1968, pp. 39–40, as reflected in early eighteenth-century painting sales catalogues; Levey 1980, pp. 4–6, on rediscovery of Venetian art by late seventeenth-century France; Posner 1984, p. 109, with respect to Watteau's personal interest in the landscapes of Titian and Domenico Campagnola, and p. 273, about vogue for Venetian mythological landscapes and pastorals that emerged in the early eighteenth century, as reflected in *The Shopsign for Gersaint* by Watteau; see also, note 91 below.

11. De Piles 1969, pp. 239 and 242.

12. For a chronology of Watteau's active association with Crozat, see Grasselli and Rosenberg 1984, p. 34; for this chronology with respect to Watteau's development of the fête galante, see Posner 1984, pp. 116–17; for the relationship of Watteau and Crozat's circle see Crow 1985, pp. 72–73.

13. Scott 1973, 11–19; see also Crow 1985, pp. 39–44, on the composition and activities of Crozat's circle, including its Venetian members; on the relationship between Watteau and Charles de La Fosse, see also Posner 1984, pp. 64–76.

14. Ricci, *Landscape with Peasants and a Mill* (Fig. 140), is discussed and illustrated in Pignatti and Romanelli 1985, p. 102, "a brilliant sketch which illustrates Ricci's Titianesque manner, probably after 1720"; Marco Ricci was the nephew of Sebastiano Ricci, who was one of the Venetian artists in the circle of Crozat; on Marco Ricci's Titianesque landscape drawings, see Pignatti and Romanelli 1985, pp. 42–43; on the position of Marco Ricci's Titianesque landscape drawings in the context of eighteenth-century drawings, see *Eighteenth-Century Venetian Drawings from the Correr Museum* 1963, pp. 13, 43–44, including cat. no. 59 and 60; on Marco Ricci as a draftsman, Blunt and Croft-Murray 1957, pp. 30–45 and 39–49 for Ricci's late landscape drawings in the manner of Titian and Domenico Campagnola.

15. On the chronology of the arrival in Paris of Crozat's collection of Venetian landscape drawings and Watteau's exposure to them, see Grasselli and Rosenberg 1984, p. 221.

16. Mariette in Chennevières and Montaiglon 1966, vol. 1, p. 294; For recent revisions of Parker and Mathey's original 1957 list of Watteau landscape drawings after Titian and Campagnola, see Posner 1984, p. 107–8, and Grasselli and Rosenberg 1984, p. 220. For evidence that Watteau was not the only eighteenth-century French artist to copy sixteenth-century Venetian landscape drawings, see Jacoby 1979; and for Boucher, see also notes 60 and 94.

17. See again, Grasselli and Rosenberg 1984, cat. no. P 25, pp. 300–4.

18. Posner 1984, p. 148.

19. For example, this was the title by which Mariette referred to the work or a second version of it, see Chennevières and Montaiglon 1966, vol. 6, notes on Watteau, p. 110; see Grasselli and Rosenberg 1984, p. 300, for the possibility that the eighteenth-century print of *La Perspective*, referred to by Mariette, reflects a second version of the painting, as distinguished from the painting in Boston.

20. Grasselli and Rosenberg 1984, p. 302.

21. Rosand, "Giorgione, Venice, and the Pastoral Vision," elsewhere in this volume, for this characterization of the Louvre's *Concert Champêtre*.

22. On the Rubeniste critical and theoretical context of Watteau's nonnarrative subject matter, of the more purely pictorial means by which he brought his subject matter to life, and of the divergence of Watteau's imagery and of his visual "strategies" from the classical canon of history painting, see Bryson 1981.

23. Edme-François Gersaint in Chennevières and Montaiglon 1966, vol. 6, p. 129.

24. Rocheblave 1889, and Zadoks-Josephus Jitta 1948, remain the most complete biographies of the Comte de Caylus, but for a partial account, see also Gaehtgens 1985. For Caylus as a printmaker after Venetian landscape drawings in collaboration with Watteau, see note 85 below.

25. Monsieur le Comte de Caylus, "The Life of Antoine Watteau, Painter of Figures and Landscape and of Romantic and Contemporary Subjects," read at the Académie Royale de Peinture et de Sculpture on 3 February 1748, as published in Goncourt 1981. The main sources for the life of Watteau are notes by his friends, Jean de Jullienne and the art dealer Gersaint; by P. J. Mariette; by the publisher of the *Mercure de France*, Antoine de la Roque; and by the connoisseur Dezallier d'Argenville; they have been collected and edited by Champion 1921; the same group of notices, except those of d'Argenville, are published with notes in Chennevières and Montaiglon 1966, vol. 6, pp. 104–36. For brief but informative biographical sketches of Watteau's acquaintances and professional colleagues, see Nicole Parmantier, "The Friends of Watteau," in Grasselli and Rosenberg 1984, pp. 31–50.

26. See Rosand 1985, for interpretation of Vasari's remarks on Giorgione's façade decorations of the Fondaco dei Tedeschi in Venice, pp. 26–27.

27. Caylus in Goncourt 1981, p. 26.

28. Antoine de la Roque's words in Chennevières and Montaiglon 1966, Marriette's notes on Watteau, vol. 6, p. 112.

29. On Mariette, see Scott 1973, 54–59; and *Le Cabinet d'un Grand Amateur* 1967.

30. As far as the present writer knows, Watteau's red chalk drawing (Parker and Mathey 1957, no. 428) after a print of Domenico Campagnola's copy (?) of Titian's lost drawing *Landscape with Infant Saint John the Baptist* (Fig. 52) was last seen in the collection of the late Richard Zinser (deceased 1984) of Forest Hills, New York; Watteau's drawing of the *Landscape with Infant Saint John the Baptist* (Fig. 143) was presumably based on a print derived from the original Venetian drawing, perhaps a counterproof of Valentin LeFebre's print published in 1682 (Fig. 53); Watteau's *Landscape with Infant Saint John* goes in the opposite direction to the print by LeFebre. For LeFebre's etchings after designs that LeFebre himself attributed to Titian, but which are now regarded as mostly by Domenico Campagnola, see Rosand, "Giorgione, Venice, and the Pastoral Vision," note 23. For the attribution of the original Venetian drawing in the Uffizi, see Oberhuber 1976. For evidence of familiarity with LeFebre's prints after sixteenth-century Venetian landscape designs in the circle of Watteau, see Chennevières and Montaiglon 1966, vol. 5, notes on Titian, pp. 332–40 and also Rosand 1981, p. 301; Jacoby 1979, p. 264, notes that François Boucher owned a suite of LeFebre's etchings after Titian.

31. On de Piles's definition of pastoral mode of landscape, see de Piles 1969, pp. 202–25; on supremacy of Titian's contributions to the genre, p. 205; on primacy, in de Piles's view, of Titian's prints and drawings as models, pp. 240–41. See Posner 1984, p. 109, on relevance of Roger de Piles's definition of "le style champêtre" to Watteau's conception of landscape, of which, in de Pile's eyes, Titian was the greatest exponent. For de Piles, the expressiveness of "le style champêtre," as explained in the chapter on landscape in his *Cours de peinture par principes* (1969; pp. 200–259), depends largely on the artist's telling manipulation of purely aesthetic effects, for which, in de Piles's view, Titian's landscapes offered the supreme models. On the subjectivity of de Piles's response to the sensuous effects of painting and, in particular, his recognition of the affective significance of form and color and how de Piles's focus on the purely aesthetic elements of a work of art fueled the development of connoisseurship, see Puttfarken 1985 and review of same in Masheck 1987. For the formalistic subjectivity of de Piles's response to Giorgionesque and Titianesque landscapes and the great esteem in which he held these works, see Stuffmann 1968, pp. 42–43.

32. See, for example, Chennevières and Montaiglon 1966, vol. 1, notes on Domenico Campagnola, p. 294, for that distinguished connoisseur's penetrating summation of the dif-

ferences between Campagnola's draftsmanship and Titian's; for which, see also Rosand 1981, p. 301.

33. De Piles 1969, p. 203.

34. ibid., p. 254.

35. ibid., pp. 200–01.

36. ibid., p. 230.

37. ibid., pp. 239–42.

38. Antoine de la Roque, publisher of *Mercure de France*, in Chennevières and Montaiglon 1966, vol. 6, notes on Watteau, p. 112.

39. Posner 1984, p. 114.

40. Caylus in Goncourt 1981, p. 22.

41. Caylus in Goncourt 1981, p. 24; Chennevières and Montaiglon 1966, vol. 6, notes on Watteau, p. 112.

42. See remarks of Caylus in Goncourt 1981, p. 27; of Jean de Jullienne in Chennevières and Montaiglon 1966, vol. 6, notes on Watteau, pp. 117–18; and of Gersaint, in Chennevières and Montaiglon 1966, vol. 6, notes on Watteau, pp. 128–29.

43. Watteau, *Two Figures in a Landscape* (Fig. 142), Parker and Mathey 1957, no. 438; As noted in Bacou 1977, no. 19, pp. 26–27, this work, like the Venetian original (Fig. 25) now in the Albertina (no. 24364) that served as Watteau's model, was in P. J. Mariette's collection; meanwhile, the Venetian original probably had been in Crozat's collection before it was acquired by Mariette.

44. Campagnola, *Two Boys Kneeling in a Landscape* (Fig. 25): For attribution of this work to Campagnola (formerly given to Titian) see, in particular, Oberhuber 1976, cat. no. 67, pp. 122–23; Rosand, "Giorgione, Venice, and the Pastoral Vision," elsewhere in this volume; Borenius 1924, pp. 279–80, originally adduced the Campagnola in the Albertina as the model for the Louvre's copy after the latter by Watteau; see also Jacoby 1979, p. 261, on Watteau's copy.

45. See Rosand on Giulo Campagnola's designs in "Giorgione, Venice, and the Pastoral Vision," elsewhere in this volume.

46. De Piles 1969, p. 230.

47. De Piles 1969, p. 229.

48. Watteau, *Landscape with Bear Attacking Goat* (Fig. 144), Parker and Mathey 1957, no. 437, is discussed in Meijer 1976, cat. no. 19, pp. 33–34; Bacou 1977, cat. no. 20, p. 27, "a copy by Watteau of a [now-lost] Venetian landscape drawing, which he probably knew when in the Crozat collection." White 1975, p. 377 (with illustration, fig. 2) adduced a Titian drawing in the Louvre, inv. no. 5539, as a model of what the original of Watteau's copy after Titian of *Landscape with Bear Attacking Goat* must have looked like; this drawing, as noted by Oberhuber 1976, p. 68, no. 19, was etched by Watteau's fellow copyist of sixteenth-century Venetian landscape designs, the Comte de Caylus. Caylus's etching of this drawing, which was then in the French Royal Collection, is illustrated in Catelli Isola 1976, fig. 280. See also remarks about Watteau's *Landscape with Bear Attacking Goat* (after Titian) in Jacoby 1979, pp. 261–67.

49. For Rembrandt's copy (Fig. 132), see especially White 1975, pp. 375–79, and Cafritz, "Reverberations of Venetian Graphics in Rembrandt's Pastoral Landscapes," elsewhere in this volume.

50. Posner 1984, p. 107.

51. Posner 1984, p. 109.

52. Watteau, *The Love Lesson* (*Leçon d'amour*), (Fig. 154), see Grasselli and Rosenberg 1984, cat. no. P55, pp. 381–84; p. 382: "c. 1716–17"; for the relationship of the landscape setting of *The Love Lesson* to an extant Watteau copy after a sixteenth-century Venetian landscape design, see note 64 and related text, p. 162.

53. De Piles 1969, p. 229.

54. Watteau, *Concert champêtre (Venetian Landscape)*, (Fig. 145), Parker and Mathey 1957, no. 436; Johnson and Goldyne 1985, cat. no. 49, p. 114–15 (with color illus.): "ca. 1715"; Johnson and Goldyne suggest that the engraving of c. 1517 by Giulio and Domenico Campagnola *Shepherds in a Landscape* (Fig. 22) "may be the main source" for Watteau's *Concert champêtre (Venetian Landscape)*; i.e., one of "many possible sources for the artist's inspiration" among extant sixteenth-century Venetian landscape designs.

55. Posner 1984, pp. 154–55; Mirimonde 1961, p. 270 and illus. p. 276, fig. 22.

56. De Piles 1969, p. 226.

57. De Piles 1969, pp. 256–57.

58. Watteau, *Diana at Her Bath* (*Diane au bain*), oil on canvas, 31½ x 39¾ in. (80 x 101 cm.), Paris, Musée du Louvre; Grasselli and Rosenberg 1984, cat. no. P28, pp. 308–10 (with color illustration), with reference to the dating of this work: "the landscape with its neo-Venetian constructions presages the works of the year 1715–16."

59. De Piles 1969, p. 240.

60. Attributed to François Boucher, (formerly Watteau), *An Italian Village in a Mountainous Landscape* (Fig. 150), Parker and Mathey 1957, no. 443; Jaffé 1976, no. 120, pp. 75–76; the attribution of this drawing to Boucher was proposed by Jacoby 1979, pp. 261–72, on the basis of stylistic comparison

with more securely attributed copies after sixteenth-century Venetian landscapes by Watteau and by the appearance of a detail from *Italian Village* as part of the background in one of Boucher's early landscape pastoral paintings entitled *Le Moineau apprivoisé* after the reproductive engraving of that name (Jacoby 1979, p. 262, illus. p. 263, fig. 1); Boucher derived the Fitzwilliam drawing from an etching by Caylus (illus., Jacoby 1979, p. 265, fig. 5) after Domenico Campagnola's landscape design, then in the French Royal Collection and now in the Louvre (inv. no. 5536); illus., Jacoby 1979, p. 265, fig. 4.

61. Watteau, *Diana Bathing* (Fig. 148), Grasselli and Rosenberg 1984, cat. no. D66, pp. 134–35.

62. Posner 1984, p. 71.

63. Watteau, *Landscape with a Castle* (Fig. 149), Parker and Mathey 1957, no. 427; Grasselli and Rosenberg 1984, cat. no. D141, p. 223: "1716–18"; Edwards 1966, pp. 9–10.

64. Watteau's *Landscape with a Castle* was originally linked to his painting of *The Love Lesson* by Eidelberg 1967, p. 176. See p. 159 herein for other Venetian featues of this image.

65. Campagnola, *Musicians Seated under Trees* (Fig. 153), see Grasselli and Rosenberg 1984, p. 373.

66. Watteau, *Musicians Seated under Trees (Italian Landscape)* (Fig. 152), Parker and Mathey 1957, no. 435; Grasselli and Rosenberg 1984, D139, pp. 220–21: p. 221, "as late as 1717–18."

67. Watteau, *Country Amusements* (*Amusements champêtres*) (Fig. 151), Grasselli and Rosenberg 1984, cat. no. P52, pp. 373–75: p. 374, "1716–18."

68. Watteau, *Prelude to a Concert*, formerly *Le Concert*, (Fig. 155), Grasselli and Rosenberg 1984, cat. no. P48, p. 358–62: p. 358 "1716."

69. Posner 1984, pp. 154–60 for comparative interpretation of this group of works.

70. Rosand, "Giorgione, Venice, and the Pastoral Vision," elsewhere in this volume.

71. Grasselli and Rosenberg 1984, p. 221.

72. Posner 1984, pp. 150–51, on the Netherlandish and French traditions of genre painting from which the language of Watteau's fête galante evolved; and p. 154, on how the mountainous vistas of Watteau's mature fête galantes, which he had derived from the Venetian landscape designs, transported his protagonists to "an ideal land of love."

73. Crow 1985, p. 72, on the "advanced art-historical awareness" of Crozat's circle.

74. On the recognition by his peers of the benefits Watteau derived from his study of Crozat's collection, see notes 41–42 above, and pp. 157–58.

75. Watteau, *Pilgrimage to the Island of Cythera* (Fig. 157), Grasselli and Rosenberg 1984, cat. no. P61, pp. 396–406.

76. Grasselli and Rosenberg 1984, p. 396, fig. 1, contains a reproduction of the official manuscript that bears the academy's amended record of Watteau's submission of *Pilgrimage* on 28 August 1717.

77. Posner 1984, pp. 192–95, on the implications of the Academy's change in registration of the picture; Grasselli and Rosenberg 1984, p. 400–1, for summary of different interpretations of *Pilgrimage*.

78. Posner 1984, p. 194.

79. See Mariette in Chennevières and Montaiglon 1966, notes on Titian, vol. 5, pp. 336–37, on Titian's *Saint Jerome* woodcut; Mariette thought that Titian's woodcut of *Saint Jerome in the Wilderness* could not be admired enough. He felt Titian's touch could not have been rendered better than it was by the cutter of the original woodcut of Titian's *Saint Jerome*. Mariette did not fail to single out the beautiful but now-lost study of trees, which Mariette knew from Crozat's collection, that Titian made to prepare the foreground trees of the *Saint Jerome* woodcut. The now-lost study of trees by Titian is illustrated in Rosand and Muraro 1976, p. 143, fig. III-2.

80. Watteau, *The Enchanted Isle* (Fig. 159), Grasselli and Rosenberg 1984, cat. no. P60: pp. 393–95: p. 393: "1716–18"; Watteau, *Peaceful Love* (Fig. 156), Grasselli and Rosenberg 1984, cat. no. P66, pp. 422–24, p. 422: "1718"; Watteau, *Landscape with a River* (Fig. 162), Grasselli and Rosenberg 1984, cat. no. P33, pp. 322–23: p. 323, "after 1715."

81. Grasselli and Rosenberg 1984, p. 323.

82. Rosand, "Giorgione, Venice, and the Pastoral Vision," elsewhere in this volume, on Domenico Campagnola's pilgrimage landscapes.

83. Campagnola, *Landscape with Setting Sun* (Fig. 161): Bacou 1977, p. 27, points out that this drawing was acquired by Louis XIV in 1671 as part of the Jabach collection. Caylus's etching of Campagnola's drawing is inscribed "Cab. du Roy." (an impression of which is reproduced in Catelli Isola 1976, fig. 274), to which Watteau would have had access through its curator, his friend, the painter Antoine Coypel. Domenico Campagnola's study for the left half of the *Landscape with Setting Sun* (Chantilly, Musée Condé, *Etude de paysage*, pen and brown ink with brown wash on paper, 8¾ x 14¾ in. (22.4 x 37.8 cm.), inv. no. 116) was also in the Royal Collection and later belonged to Mariette. This study is illustrated in Albert Chatelet's article, "Domenico Campagnola et la naissance du

paysage ordonné," in Rosand 1984, pp. 331–43: p. 338, figure 13; for provenance of this work, see p. 336 with notes. For visual documentation of the many Venetian landscape designs then in the French Royal Collection, see the etched reproductions of Italian landscape drawings attributed to Titian, Campagnola, and Annibale Carracci, in *Recueil de 238 estampes gravées* 1754. Watteau, *Landscape with Setting Sun* (Fig. 160), was originally attributed to Watteau by Jaffé, contained in Bacou 1977, p. 27.

84. See Rosand, "Giorgione, Venice, and The Pastoral Vision," elsewhere in this volume, note 52, on Domenico Campagnola's woodcut, *Landscape with Wandering Family*; Caylus's etching of *Landscape with Wandering Family*, inscribed "Cab. du Roy." is reproduced in Catelli Isola 1976, fig. 275.

85. Caylus's etchings after the Venetian works mentioned here in notes 83 and 84. On the collaboration of Caylus and Watteau in the preparation of copies of Venetian landscape drawings in Crozat's collection, see Caylus's own account in Goncourt 1981, p. 24; on Caylus as a printmaker see Jacoby 1979, pp. 264–68; also, Roux 1940, p. 53f.; and Dacier 1926, 161–69; 1927, 1–10, 52–58, 69–77.

86. Other Watteau copies after panoramic Campagnolesque landscapes are in the Metropolitan Museum of Art, New York: Watteau, *Landscape with an Old Woman Holding a Spindle,* after Domenico Campagnola, red chalk, 8⅛ x 12⁹/₁₆ in. (20.6 x 31.9 cm.)inv. no. 1972.118.237, Parker and Mathey 1957, no. 439; illus. with bibliography in Bean and Turčić 1986, no. 334, p. 298; and Grasselli and Rosenberg 1984, no. 140, p. 222, along with Campagnola drawing probably copied by Watteau, which is also in the Metropolitan: Domenico Campagnola, *Landscape with Old Woman Holding Spindle*, pen and brown ink, 10¹/₁₆ x 14⁹/₁₆ in. (25.5 x 37 cm.), inv. no. 1972.118.243., with bibliography in: Bean and Turčić 1982, no. 40., pp. 54–55. A seventeenth-century anonymous Netherlandish print after Campagnola's design is contained in *Paisages de Titien*, (Fondation Custodia, Institut Neerlandais, Paris, inv. no. 7620) a volume that contains a suite of twenty-four Netherlandish seventeenth-century prints after Campagnola, impressions of which were evidently known to Rubens. *Landscape with Old Woman Holding a Spindle* is numbered 19 in the series. On the album and the print's relationship to the Metropolitan's Campagnola landscape drawing, see Meijer 1976, pp. 36–37, with note 7. On the album in the Fondation Custodia and Rubens's absorption of sixteenth-century Venetian landscape imagery derived from a similar corpus of prints after Campagnola, see Cafritz, "Netherlandish Reflections of the Venetian Landscape Tradition," elsewhere in this volume. Additional drawings, which appear to be Watteau copies after

now-lost panoramic Campagnola landscapes, are in the Ashmolean Museum, Oxford: Watteau, *Pastoral Landscape*, red chalk, 12 x 17 in. (31 x 44 cm.), cat. no. P. and M. 441; Parker and Mathey 1957, no. 441 (illus.); and at Didier Aaron, Inc., New York, N.Y., Watteau, *Mountainous Landscape*, red chalk on cream laid paper, 12¾ x 18 in. (32.9 x 46.4 cm.); Parker and Mathey 1957, no. 434 (illus.); and catalogued and reproduced in Salz 1984, cat. no. 47 and fig. 1. For evidence of the existence of a now-lost Watteau copy of a Campagnolesque landscape design and his adaptation of it in a painting, *La Chute d'eau*, see Eidelberg 1967, pp. 177–79, for which see also Posner 1984, pp. 108–9, illus., p. 108, fig. 87. Another painting, *Landscape with a Goat (Paysage à la chevre)*, oil on resinous panel, 10⁷/₁₆ x 7¹⁵/₁₆ in. (26.5 x 18.5 cm.), Musée du Louvre, Paris, appears to reflect Watteau's reliance on a Campagnolesque landscape design similar to the one that allegedly stands behind his painting *La chute d'eau*. Grasselli and Rosenberg date *Landscape with a Goat* after 1716, stressing its Venetian aspects and comparing it with the drawings of Titian and Campagnola, which Watteau liked to copy at Crozat's after 1716, in Grasselli and Rosenberg 1984, cat. no. P41, p. 344, color illus. Grasselli and Rosenberg also note the similarity of *Landscape with a Goat* to the middleground of Watteau's *Peaceful Love* (Fig. 156) and the upper left part of the *Pilgrimage to the Island of Cythera* (Fig. 157). They also point out that *Landscape with a Goat*, like the Hermitage's *Landscape with a River* (Fig. 162) is conspicuous in the context of Watteau's work for the predominance of the landscape itself. Evidently Watteau's more overt explorations of landscape as a subject in its own right were motivated and shaped by his study of Domenico Campagnola's panoramic vistas, just as Campagnola's designs had directed his elaboration of the genre of the fête galante.

87. Goncourt 1981, p. 6.

88. Watteau, *The Island of Cythera* (Fig. 158), Grasselli and Rosenberg 1984, cat. no. P9, pp. 261–64, p. 261: "c. 1709–10" (Rosenberg) or "1712–13" (Grasselli); Posner 1984, p. 187.

89. Watteau, *Shopsign* (Fig. 163), Grasselli and Rosenberg 1984, cat. no. P73, pp. 446–58. On Titian's *Landscape with a Milkmaid*, see Rosand, "Giorgione, Venice, and the Pastoral Vision," elsewhere in this volume. For Watteau's adoption of the design in *Shopsign*, see Dreyer 1976, p. 271, and Dreyer 1979, p. 375. Mariette in Chennevières and Montaiglon 1966, notes on Titian, vol. 5, p. 336, owned an impression of the original woodcut of Titian's *Landscape with Milkmaid* and also Titian's study for the background of it, the *Landscape with a Castle*, now in the Musée Bonnat, Bayonne (inv. no.

1323; illus. p. 142, fig. III-1, Rosand and Muraro 1976). They were among Mariette's most prized possessions.

90. Posner 1984, p. 273, for *Shopsign* as Watteau's hommage to his sources of inspiration.

91. Posner 1984, p. 273, on *Shopsign*'s reflection of this vogue.

92. Crow 1985, p. 73, on the Crozat circle's exceptionally sophisticated and energetic organization and stimulation of the wide, international demand for the fête galante as a genre and particularly for those by and after Watteau in the years immediately following the death of the artist.

93. On the compilation of the *Recueil Jullienne*, see the chronology in Grasselli and Rosenberg 1984, p. 28, and Parmantier's notes on Jullienne, pp. 38–39; see also Dacier et al. 1921–29.

94. Boucher, *Le Repos des fermiers* (Fig. 164): For the echoes of Campagnola landscapes in the left-hand side of the background of this painting, see Laing et al. 1986, cat. no. 20, p. 143; Laing (p. 143) implies a date of around 1729 for this painting. For the ramifications of Boucher's involvement in the production of the *Recueil Jullienne* with respect to the develop-ment of the artist's youthful pastoral landscape paintings, including *Le Repos des fermiers*, see Voss 1953, p. 82f. For evidence of Boucher's direct copying of Venetian landscape designs and his absorption of such a design into a painting, see note 60 above and related text with Fig. 150 including references in Jacoby 1979; reflections of Boucher's familiarity with Campagnolesque designs, directly or through the medium of Watteau, are also contained in his early painting, *Les oies de Frère Philippe*, gouache on taffeta, 8¼ x 16½ in. (21 x 42 cm.), Musée des Beaux-Arts et d'Archeologie, Besançon, inv. no. 848.7.1, as noted and illus. in color by Laing et al. 1986, cat. no. 7, pp. 105–8. For Boucher's involvement in the production of the *Recueil Jullienne* beginning in the mid-1720s see Jacoby 1979, p. 266, and chronology in Laing et al. 1986, p. 16f.

95. Fragonard, *The Swing* (Fig. 165), was most recently published with earlier bibliography in Rosenberg 1988, cat. no. 162, pp. 344–49. For the relationship of Watteau's vision of nature to that of Fragonard, see Rosenberg 1988, p. 346. For the reflection in the paintings of Watteau and Fragonard of an evolving affirmation during the eighteenth century in France of a vitalist conception of nature, see Charlton 1984, p. 29.

The Modern Vision

Lawrence Gowing

The parts of this story coexist; they are present together in the galleries and in our minds. The whole pastoral tradition from Bellini to Avery is simultaneously active in the current understanding of painting. Just to list the contributors to the modern vision from the pastoral tradition is a parlor game or studio game, too delightful to resist, never played without enlightenment. Of course, the list begins with that immovable masterpiece on which pastoral painting was founded, which hangs in the French National Collection under the name of the almost omnipotent master Titian, whose only failing was never to paint anything quite like the *Concert champêtre* (Fig. 7).

The ages have associated the *Concert champêtre*, as we do, with the name of Giorgione, who was and is known for the major innovations of which this was the product. These innovations were in both the matter and manner of painting. They are not entirely understood in either respect, but the aspects of them that were comprehensible proved perennially influential and durable.

The matter of painting was transformed when the spirit of the Arcadian subject, which had been conveyed by Signorelli, Botticelli, and Mantegna by figures, human or divine, was made manifest by landscape in itself and in the relationship of figures to it. In the manner of painting this change involved not only the fluent transitions of the oil medium, which had been brought to Venice a quarter-century before, but an enveloping softness of color and tone, which were seen to bathe the

◁ Detail of Fig. 172 **Samuel Palmer** *The Harvest Moon: Drawing for 'A Pastoral Scene'*

figures in natural light. Alignments, which had been the armatures of both drawing and expression since Giotto, were now given an intimate significance of their own.

The absence of evident interpretation from Giorgione's essential works is not their only surprise. Aside from the assortment of costumes and conditions in the *Concert champêtre* there is a decided strangeness in the representation of living flesh, which must have been altogether new to experience in 1510. An image with this circumstantial naturalness had never been seen. In the pictorial world everything had possessed its own separate identity. It was strange that the left and right legs of the seated woman in the *Concert champêtre* joined to form a continuous edge slanting up in a single pronounced alignment from the left ankle to the right knee, where it supported the left arm in a similar slant, supporting in its turn the right hand, which holds a flute à bec, reinforcing the dominant direction from ankle to knee.

We can imagine the surprise to Giorgione's contemporaries, unprepared except by the similarly provocative alignments of limbs in the poses of the allegories that he had painted on the Fondaco dei Tedeschi. Searching the picture for another such governing slant, we notice the same angle, again catching the light, in the upper arm of the woman turning to the well. These two angles are keyed into the picture by shapes that meet them at right angles, the leg of the young dandy in parti-colored hose and the triangle of bright hill in the middle distance behind him. These tapering shapes are parts of a system of forms, alternately in light and shadow from the foreground bank up into the sky, pointed strips that wedge the image together.

Is it possible that the acute Venetian before 1510 simply lacked the conceptual terms of reference to notice these improbable alignments? Do we *notice* them now? The significance of such alignments in Western painting is an open secret, which historical propriety forbids us to mention. That the formalism of the early twentieth century was a continual circumstance of Western painting is a possibility supposedly considered and discarded. The question is quite relevant to a history that has by no means ended.

The Phillips Collection, in which the latter part of this exhibition is shown, together with the most informative copy of the *Concert champêtre* (Fig. 210), was founded by Duncan Phillips, who was not only a collector but a critic with a special interest in the sources of modernism and in the traditionalism of modern art. These naturally led him to Giorgione; he wrote a book called *The Leadership of Giorgione* (which the present writer has used with gratitude for many years) and bought for the collection, which was intended from the beginning for the public, a naively beautiful panel in the manner of Giorgione, *The Hour Glass* (Fig. 32).

The enthusiasm that Giorgione has attracted since his own time has given an unbroken momentum to interpretations. Critics emphasized the mastery of nature achieved by melting color or, later, the idyllic and lyrical spirit that conveys the union of nature and man. Many found in Giorgione the free play of fantasy and imagination dear to the Romantic movement. In the later nineteenth century he was thought to exemplify the art that aspired continually towards the condition of music, in fact towards a degree of abstraction. In the twentieth century Giorgione's works have been believed to conceal esoteric secrets. Few critical appreciations can be, or perhaps should be, unconnected with the art of the critic's own time, and the present writer's interest in the alignments that govern figuration in Giorgione is perhaps inseparable from the existential realism noticed by contemporaries of Giacometti.

LAWRENCE GOWING

Are we discussing a painter, however innovative and "great," or a distillation of aesthetic habit over four centuries? The legacy of Giorgione is such that he can quite well appear to be the creator of the sensuous beauty of painting in the modern world. Each critic who looks closely at him comes to regard him as the source of whatever he values most. Duncan Phillips considered him the inventor of Romantic originality, which was a myth as enchanting as any but not quite the real man. Giorgione's figurative style married Giovanni Bellini's Orpheus to the structure of his lady dressing her hair in two mirrors (Fig. 207), which hangs in Vienna and was the single parallel to the power and grace with which Giorgione aligned the naked limbs of the women in the *Concert champêtre*. Bellini exemplified figurative purpose as an autonomous direction of thought—demonstrating that the innate evocative power of the human body could be used to fulfill wholly new aspirations—to intimacy, reverie, and visual music.

Perhaps all of this was discoverable, at least as implicit potentialities, among the beauties that Bellini created in the later phases of his long development: the reasoned space, the fullness of drapery, the atmospheric envelopment, the lute music, the candor and roundness of the nudes, and even the structure of parallel alignments observed in the lady at her toilet. But critics have held that the melting color must have been Giorgione's invention, as it certainly seemed to his public.

Pastoral painting in the melting color that Giorgione invented was a figurative potential that he left for the future, when it would put the sensuous poetry back into classicism and provide a formal frame for the Romantic movement. Perhaps the women in the *Concert champêtre* really are a uniquely invisible species of nymph.[1] All one can be sure of is that the "drawing" (or whatever term describes this far-from-linear realization through

color) was galvanized by a new kind of figurative structure, the alignments that were so important for the future of pictorial art and the origin, more than three hundred years later, of the painting that we know as modern.

The seated woman from the *Concert champêtre* seems to have taken possession of the destiny of figure painting in Western art through the continuities that are a part of her nature. The standing woman has an analogous structure—a turning movement about a vertical axis—which it owes to an engraving by Marcantonio Raimondi after Raphael.

At first painters seem to have regarded such figures as embodiments of sentiment, melancholy, and melody, but eventually their strucure was adopted nonetheless. The rectilinear alignments were imparted to landscape and converted into pictorial schemes like Annibale Carracci's boldly rectilinear *Landscape* (Fig. 83). They provided the essential spine for French classicism, down to David and Ingres. The strength of classic landscape, as Cézanne rediscovered it, is inseparable from this ordering of shape. The composition of *Fishing in Saint-Ouen, near Paris* (Fig. 206) owes its plan to Carracci's *Fishing* (Fig. 85), and the scheme that Manet derived from the *Concert champêtre* for his *Déjeuner sur l'herbe* (Fig. 208) again combined elements from both Raphael and Venice and assimilated them to the modern imperative. Seeing some women bathers on a Sunday at Argenteuil, Manet was forcibly reminded of his studies from the *Concert champêtre* and abruptly agreed to paint a picture of nudes.[2]

In historical criticism, hindsight is a legitimate and invaluable instrument. Returning to the *Concert champêtre* to remind ourselves what we mean by pastoral and be refreshed by the reminder, can Titian be wholly out of mind? Of course not, however foreign to the spirit of the *Concert* the

Fig. 166
Claude Gellée, called **Le Lorrain** (1600–82)
Landscape with a Goatherd and Goats c. 1636
oil on canvas
20¼ x 16¼ inches (51.4 x 41.3 cm.)
The National Gallery, London
Sir George Beaumont Gift, 1823/8
58

Fig. 167 (No. 82) (opposite)
Thomas Gainsborough (1727–88)
*A Pastoral Landscape (Rocky Mountain Valley with
Shepherd, Sheep and Goats)* c. 1783
oil on canvas
40⅜ x 50⅜ inches (102.5 x 127.9 cm.)
Philadelphia Museum of Art
The John H. McFadden Collection
M28–1–9

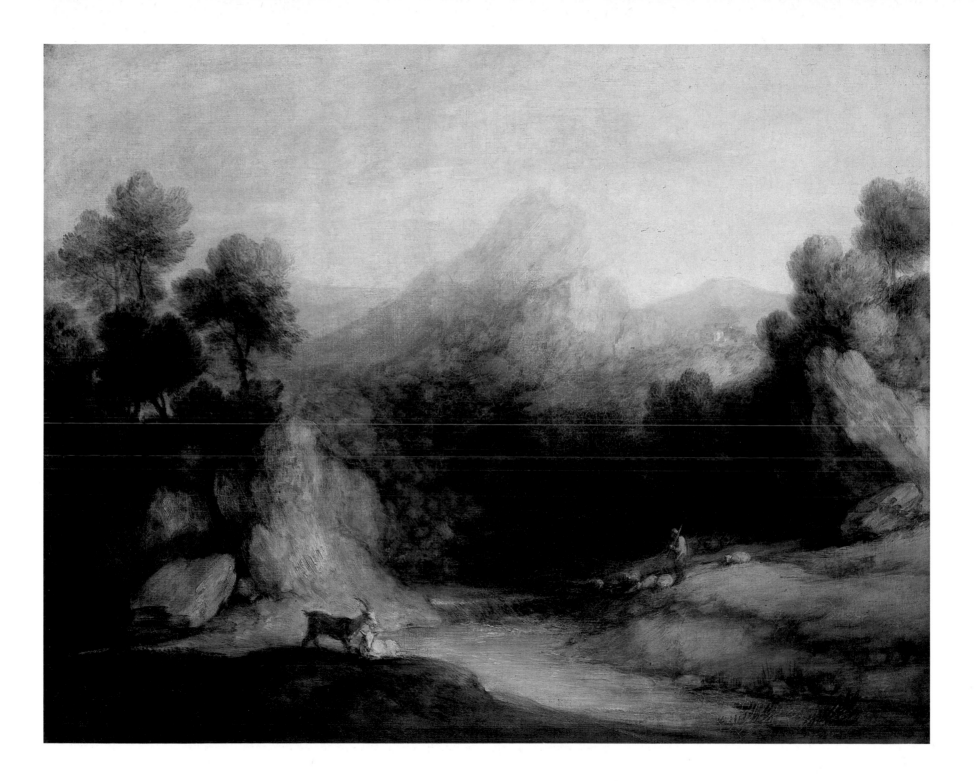

Fig. 168 (No. 83)
William Blake (1757–1827)
The Pastorals of Virgil 1821
4 proofs on uncut sheet
wood engravings
sheet, 6¼ x 3¹¹⁄₁₆ inches (15.9 x 9.3 cm.)
National Gallery of Art, Washington, D.C.
Rosenwald Collection
1943.3.1867, Bindman 603–606

indubitable Titian called *Sacred and Profane Love* (Fig. 5) is seen to be. And if Titian, can we see the *Concert* without remembering Manet and over-hearing his confidence to his friend Antonin Proust, which led to *Le Déjeuner sur l'herbe* (Fig. 208)? If Manet, can we forget Cézanne and his watercolour hardly ten years later of the *Concert*? The twentieth century and its wholesome fear of historicism were founded on Cézanne's witness. Without this hind-sight we are blinded. Cézanne assured Emile Bernard in 1904 that when he discovered his own style he would find it to be "the means employed by the four or five great ones of Venice."[3] Why the uncertainty of the number? Perhaps because Cézanne was no more certain than we are whether to credit the *Concert champêtre* to one painter or two.

We have to exhibit pastoral landscape through the ages, down to the transforming modern vision of it, in the absence of the single indispensable picture that engendered the idea, the *Concert champêtre*. We show one of the two resplendent drawings by Jàn de Bisschop (Fig. 209),[4] which records the *Concert champêtre* in pen and bistre wash in a style that is actually rather foreign to the Veneto; it is native rather to the Roman Campagna and those who followed B. Breenbergh and Claude Gellée. There is still more of the *Concert champêtre* in the full color of an oil copy made in the Louvre by William Etty in the midst of the revolution in July 1830 (Fig. 210). Etty's usual productions were adaptations of the richness of Titian to Romantic narrative; the single defect of his *Concert champêtre* was a certain limpness in the draperies of the standing woman, which conveniently demonstrates the rectilinear tension in the original.

The miraculous invention of a natural sensuousness of style with which to paint a sensual subject did not exhaust the lessons to be drawn from the example of the *Concert champêtre*. Paris Bordone, born in 1500 when Giorgione was about

twenty-three years old—and when Leonardo's visit to Venice inspired him with the poetry of light—must have been haunted by the landscape of the *Concert champêtre*. He adapted it for a *Mystic Marriage of Saint Catherine* and borrowed it again as a setting for *Saint Jerome in the Desert* (Fig. 48). In a drier devotional climate Giorgione had painted *The Adoration of the Shepherds* (Fig. 43) in which landscape is depicted as a reasoned continuity expressed in a receding series of wide parabolas. This formulation waited for another century and the intellectual art of Nicolas Poussin to discover its potential.

Both Giorgione and Poussin loaded these linked curves with a spatial implication. Cézanne drew the same kind of space from a carafe, a glass, and a plate on his uncleared dinner table.[5] Such a tenuous train of stylistic development fills a temperate historian with trepidation if not horror. Giorgione painted a pastoral *Adoration of the Shepherds* (Fig. 43). His shepherds are close relatives of the young men who attend to the last notes of the lute in the *Concert*. Before toil wore out his clothes one of them may have been as fashionable as the dandy in the *Concert* but in a different world. The boy with the cropped hair is as sincerely devoted as his counterpart. Conceivably the painting of shepherds inaugurated the sentimental consensus which persists in pastoral painting as in the literary genre. "Pastoral landscape" denotes exactly this dimension, this art that is in many ways more than landscape. Pastoral is the art of relationship, the art both of the human relationship, which the subjects discover, and the interrelation of visual elements, which was to be the essence of the modern vision and the modern creation in painting. The meaning of pastoral landscape resides in the human reference, but not necessarily on the presence of the figures. In one of the most recent pictures in this exhibition, *The Shower* by Georges Braque (Fig.

Fig. 169 (No. 84)
William Blake (1757–1827)
The Pastorals of Virgil 1821
4 proofs on uncut sheet
wood engravings
sheet, 6³/₁₆ x 4³/₁₆ inches (15.6 x 10.5 cm.)
National Gallery of Art, Washington, D.C.
Rosenwald Collection
1943.3.1868, Bindman 607–610

Fig. 170 (No. 85)
William Blake (1757–1827)
Album containing 17 wood engravings for Thornton's
Pastorals of Virgil 1821
wood engravings, each trimmed and mounted one to a page
album, 5¹³⁄₁₆ x 7⅞ inches (14.7 x 19.9 cm.)
1st image (largest), 2⁷⁄₁₆ x 3⁵⁄₁₆ inches (6.2 x 8.4 cm.)
other images average, 1⁵⁄₁₆ x 2¹⁵⁄₁₆ inches (3.4 x 7.4 cm.)
National Gallery of Art, Washington, D.C.
Rosenwald Collection
1943.3.1850–1866, Bindman 602–618

Fig. 171 (No. 98)
Samuel Palmer (1805–81)
The Valley of Vision c. 1829
brush and brown ink, brown and grey wash, heightened
with white body color over pencil on brown wove paper
(wrapper for Creswick crayon paper)
11⅛ x 17½ inches (28.2 x 44.5 cm.)
Yale Center for British Art, New Haven
Paul Mellon Collection
B1975.4.1835

235), the quality of leisure and caprice, the with-drawal and disengagement, which are inseparable from pastoral, are as clear as anywhere. We may even equate the showery weather on some allegorical level with Fortune, as in Giorgione's *Tempest* (Fig. 4).[6] Although there is no figure in *The Shower*, the human role is amply conveyed by a bicycle leant carefully against a tree.

The intimacy in the *Concert champêtre* has an ancient narrative reference. It may be that the men, so negligent if not unaware of the presence of women, carry overtones of Orpheus and Calais, but it does not seem likely that the women will beat the well-dressed *compagno* to death.[7] The role of the turning woman at the well is strangely like the half-turned soldier in the *Tempest*, as a detached spectator of the scene. A degree of detachment or a suspension of determined purpose is an essence of pastoral. Its subject is, at most, a state of being or an implicitly intimate exchange.

Giorgione's intimacy with the environment became in Titian's hands a robust and compelling formulation of the abundance of nature. Titian was the first great landscape painter, yet he hardly painted a single landscape as such and nothing in the mood of sentient seclusion that always marked the harmonies of Giorgione. The popular appeal of landscape was Titian's creation, as the mysterious richness of the forest was his unique intuition—the opposite extreme to the alien, even sinister proliferation that enraptured the Danube painters.

The essence of pastoral, as it has sustained what is persistent and vital in the modern vision, is most obvious in the great woodcuts signed by Domenico Campagnola or attributable to him (Figs. 64, 79), or traceable to an education in landscape that was gained by learning to cut Titian's drawings on a wide plank. It is as if the lines of landscape and the grain of timber worked directly on us, and worked together. As if the breadth of the

country and the expanse of natural space were themselves alive in the "long, slightly curved, parallel strokes" shading the pool of shadow cast by a great tree or marking the dark current of a river. Titian and Domenico, with their printers and their copyists, seem to have borrowed from the woodcut medium a momentum like that of nature. Or else they shared a communal energy observed in the picaresque life lived in the valleys through which Alpine rivers tumbled. Milkmaids, farmboys, a flute-playing shepherd, and a wandering hurdy-gurdy player (who was also a scabrous seducer), were all "afforded a foothold by the graphically busy rock formation."[8]

In the next century the fertility that Rubens bestowed was still recognizable as the estate that Titian had marked as his own. Another century later, and again by way of the Titianesque virility in Rubens, Watteau inflected his woodlands with the same delicate pulse. The same spirit informed his verdant countryside, the symbolic isle of love, and equally the relationship of the inhabitants to them, a relationship that from the time of the *Concert champêtre* had been the essence of the pastoral spirit. It was all incorporated in the legacy of Venice and in the tree trunks as Titian first drew them.

Meditating on the character of the landscape legacy that Venice conferred on the West, we are still perhaps not quite at its heart, the aesthetic outcome in the first decade of the sixteenth century, which was unparalleled in any tradition or at any juncture before. Conceivably, to call it *pastoral* landscape misleads us, although the shepherds and flocks that mark these new tracts of country are as characteristic of them as anything in the habitual subject matter. But to think of them—the paintings with their generous sensuousness and the herculean graphics of the circle of Titian—as in any way analogous to a literary genre is to overlook a distinction that was vital to the renascence or rebirth

Fig. 172 (No. 99)
Samuel Palmer (1805–81)
The Harvest Moon: Drawing for 'A Pastoral Scene'
c. 1831–32
sepia drawing on paper
6 x 7¼ inches (15.2 x 18.4 cm.)
The Trustees of the Tate Gallery, London
N 03699

Fig. 173 (No. 97)
Samuel Palmer (1805–81)
A Shepherd and His Flock under the Moon and Stars c. 1827
pen and brown ink with brown and grey wash,
heightened with white on paper
4⅜ x 5⅛ inches (11.1 x 13.1 cm.)
Yale Center for British Art, New Haven
Paul Mellon Collection
B1981.25.2655

of the visual arts. Until Giorgione, there was no true pastoral genre in art, any more than there had been in poetry until Theocritus invented it. Venice conceived the essence of landscape as a separate emotional liberation, one that was quite unprecedented.

Giorgione was so innovative that understanding by the contemporary public, when he died at about thirty-three in 1510, was limited. But one artist, then in his eighties, understood and was inspired. Bellini rediscovered the naturalness of ancient rusticity from Giorgione and within a few years the perfect patrons, the Este of Ferrara, were ready for it. What Bellini produced was a kind of divine discord in the traditional imagining of the gods. He conceived and painted the actuality of the gods with an unprecedented vividness. *Feast of the Gods* (Fig. 38) modernized the painterly faculty by combining imagination and observation in a coherent creation, which was immediately recognizable as the ordained destination of fifteenth-century painting.

These gods, who receive us as if into an artist's festival, are endowed with no more or less than the customary amount of erotic delight, and the predicted seductions are at once fancifully imagined and, to an exactly balancing degree, matter-of-factly represented. It is a still life of sexuality, depicted with the most exquisite decency. In due course the native pastoral, which is the primal art of landscape, became the modern vision. These terms jointly connote whatever it is in art we natively and naturally enjoy. The visual poetry of the *Feast of the Gods* is quite prosaic: a burnished kitchen bowl makes an unheroic helmet. But from this domestic naturalness we trace a peculiar strain of realism that, rather than any artifice, was at the heart of pastoral landscape.

The commonness of the humanity exhibited in the *Feast of the Gods* threatens to descend with

laborious banality into that area in which Bellini's tread was most delicate, yet most sure and fearless. Bellini judged precisely his alternative to grandeur or nobility, and we must value the rarity and preciousness of such a standpoint to antiquity distinguished by a near-comic incongruity. Bellini is innocent of anything facetious. He was protected from it by a growing reliance on painting from observation, which guided him in the custom of painting his habitual and, one must guess, affectionate model dressing her back-hair in two mirrors (Fig. 207). In deciding how to interpret to ourselves the spirit of antinobility in which he imagined and portrayed a mythology that was everything but ancient, we must recognize his fond delight in incongruity. In later years he moved beyond that mood, as if seeking a way out of this almost sardonic delight and eventually finding the way in an attentive observation, which had no parallel before those first decades of the sixteenth century. We are not wrong to detect in the elderly man with the thin, fragile face and the steady belief in a standpoint of his own, whom we know in Bellini's self-portraits, a uniquely modern spirit.

Giovanni Bellini balanced deliberately and precisely on the antiheroic edge. The helmet worn by his Mars suggested both the wear of an ordinary member of the military proletariat and an equally common kitchen bowl. The scoured and burnished gloss of it and the ostentatiously ordinary shape must always have attracted a painter. Looking at the charming maid of the household, the uncouth groom and the Priapus from the nether gardens of some Este property, the artist picked his way through awkward incongruities by painting from nature. Thus he fostered in himself the observant genius and directness of painterly habit, which were the new recourse for art. The spirit of pastoral resided in the commonness of a shepherd's condition and the ordinariness of observation as a fu-

Fig. 174 (No. 100)
Samuel Palmer (1805–81)
Moonlight: A Landscape with Sheep c. 1831–33
sepia drawing on paper
6 x 7¼ inches (15.2 x 18.4 cm.)
The Trustees of the Tate Gallery, London
N 03700

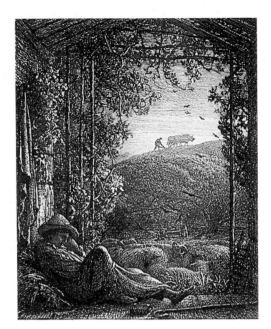 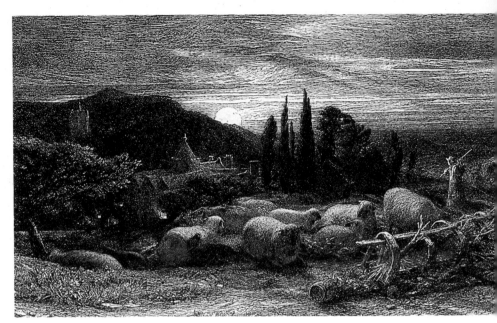

Fig. 175 (No. 101) (left)
Samuel Palmer (1805–81)
The Sleeping Shepherd; Early Morning 1857
etching on chine collé
image, 3¾ x 3¹⁄₁₆ inches (9.5 x 7.8 cm.)
plate, 4⅞ x 4¹⁄₁₆ inches (12.4 x 10.4 cm.)
National Gallery of Art, Washington, D.C.
Ailsa Mellon Bruce Fund
1982.21.1, Lister 1969, 6 IV/IV

Fig. 176 (No. 102) (right)
Samuel Palmer (1805–81)
The Rising Moon or *An English Pastoral* 1857
etching on chine collé
image, 4⅝ x 7⁹⁄₁₆ inches (11.7 x 19.3 cm.)
plate, 7 x 9¹⁵⁄₁₆ inches (17.8 x 25.3 cm.)
National Gallery of Art, Washington, D.C.
Rosenwald Collection
1947.7.91, Lister 1969, 7 V/IX

ture for painting.

Rudolf Wittkower in a seminal lecture on Giorgione as the discoverer of the pastoral Arcadia pointed out that Giorgione's true successor was Claude Gellée, "who with his bucolic landscape peopled with the gods and heroes of antiquity soothes the beholder into the peacefulness of Virgil's Golden Age."[9] Wittkower did not notice that it was the element of realism in Claude, as in Giorgione and Bellini themselves, that qualified them to play a significant part in the artistic development that followed. Fritz Saxl, discussing *Feast of the Gods* (Fig. 38), spoke acutely of the prosaic naturalness that the pastoral tradition contributed to the nineteenth century—the durable factual information that early modern painting needed. Saxl remarked that, "It was with great wisdom that the old Bellini avoided straining the classical element in the *Feast of the Gods* and thus preserved a

wonderful unity." The unity that is documented and substantiated by Bellini's observation both in the *Feast of the Gods* and *Young Woman Arranging Her Hair* (Fig. 207) (which was perhaps a toilet of Venus) marked his ability to understand the realism of Giorgione and interpret it to the future. Bellini inaugurated the modernity of pastoral painting. It is likely that all the models who populated the *Feast of the Gods* were recruited from the household of some Este property in the Ferrarese countryside.

The virtue of the pastoral form as an imaginative vessel for the meaning of a human environment unfolded gradually but continually. It repeatedly revealed itself to hold within it a different content and a deeper order of contentment. During the sixteenth century both formulas—the bliss and melancholy of pastoral sentiment and the hackneyed framework of the Arcadian mise-en-scène—

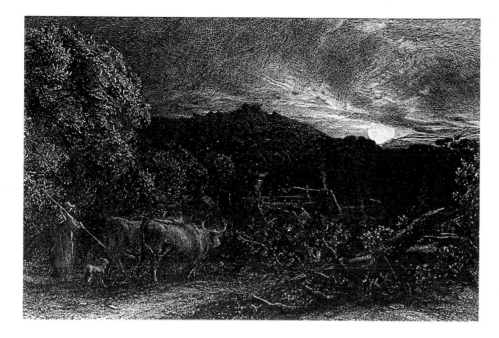

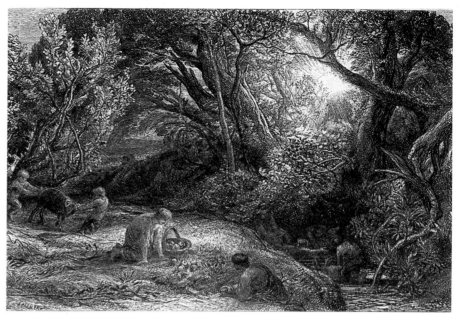

Fig. 177 (No. 103) (left)
Samuel Palmer (1805–81)
The Weary Ploughman 1858
etching on chine collé
image, 5³⁄₁₆ x 7¹⁵⁄₁₆ inches (13.2 x 20.2 cm.)
plate, 7⁹⁄₁₆ x 10⁷⁄₁₆ (19.3 x 26.4 cm.)
Collection of Ruth and Jacob Kainen
Lister 1969, 8 VIII/VIII

Fig. 178 (No. 104) (right)
Samuel Palmer (1805–81)
Morning of Life 1860–61
etching
image, 5³⁄₈ x 8³⁄₁₆ inches (13.7 x 20.7 cm.)
National Gallery of Art, Washington, D.C.
Rosenwald Collection
1943.3.6712, Lister 1969, 10 VI/VII

Fig. 179 (No. 106)
Welby Sherman (active 1827–36)
Moonlight: The Shepherd and His Flock, after
Palmer, 1834
mezzotint engraving
5⁷⁄₈ x 7 inches (14.9 x 17.8 cm.)
The Board of Trustees of the Victoria and Albert Museum, London
E3451–1923
By courtesy of the Trustees of the Victoria and Albert Museum

were mechanically repeated. Yet within each the spirit of the landscape and the visible life-style identified with pastoral were being liberated from their familiar subjects. In the hands of the Carracci, landscape evolved an austere intellectual architecture. The convention of pastoral seduction prompted Rembrandt to tell graphic tales of real sexuality that unfolded against the stunted but indubitably natural hedgerows along the waterways east of Amsterdam.

Could Claude have ranked, as he certainly did, as the inventor of modern landscape without understanding the visual authenticity that placed him in the true succession of Giorgione? The means by which he encompassed it were recorded by Sandrart, who intended to establish Claude's position as a nature painter in the tradition of Caravaggio. Sandrart described how Claude would go into the fields at dawn or sunset and mix a series of tones to render the receding colors "from the foreground to the greatest distance," then take the progression back to his studio and insert it into appropriate areas of the picture he had in mind. The story has been told before,[10] but we are still not much closer to seeing how this incomparably specific habit of observation was part of the very literal thought characteristic of this painter, who conceived almost naively symmetrical pastoral illustrations and set the scene not only for decorative landscape in the century to come but for the realism of the Romantic movement.

Sandrart had a vested interest in an idea of Claude painting from nature, which in fact he only did on uncommon and particular occasions. He did something much more interesting, influential, and unparalleled. He abstracted the tonal match, which was the essence of his observation of light and space, in a graduated series of mixtures that compounded information about local color and about light in a single scale of chromatic intervals. This

Fig. 180 (No. 86)
John Constable (1776–1837)
A Lane near Flatford(?) c. 1810–11
oil on paper mounted on canvas
8 x 12 inches (20.3 x 30.5 cm.)
The Trustees of the Tate Gallery, London
N 01821

Fig. 181 (No. 87) (opposite)
John Constable (1776–1837)
On the River Stour c. 1834–37
oil on canvas
24 x 31 inches (60.9 x 78.7 cm.)
The Phillips Collection, Washington, D.C.

Fig. 182
John Constable (1776–1837)
Landscape with a Goatherd and Goats, after Claude,
1823
oil on canvas
21 x 17½ inches (53.3 x 44.5 cm.)
Art Gallery of New South Wales, Sydney

Overleaf
Fig. 184 (No. 107) (left)
Jean-Baptiste Camille Corot (1796–1875)
Genzano 1843
oil on canvas
14⅛ x 22½ inches (35.8 x 57.1 cm.)
The Phillips Collection, Washington, D.C.

Fig. 185 (No. 108) (right)
Jean-Baptiste Camille Corot (1796–1895)
Ville d'Avray c. 1867–70
oil on canvas
19⅜ x 25⅝ inches (49.2 x 65.1 cm.)
National Gallery of Art, Washington, D.C.
Gift of Count Cecil Pecchi-Blunt
1955.9.1

process was unprecedented in his time, but it is evident in the newly detached attitude to observation and description.

Among the pictures that Claude did paint from nature, the best documented is *Landscape with a Goatherd and Goats* (Fig. 166). He could not part with this picture because the animated herbage and foliage, which direct observation had inspired, suggested an inimitable freshness of reaction that he referred to whenever he needed to paint such a passage again. Another picture that reveals the poetic prose directness of observation can engender within the pastoral tradition, the painting of the mansion at La Crescenza, was also surely painted straight from nature (Fig. 102). In this case, the directness must have been animated by a regard for the spirit of place and for Claude's patron, Cardinal Massimi. The unavailability of *Landscape with a Goatherd and Goats* annoyed his patron, so Claude eventually copied it to pacify him. That picture remained in the Rospigliosi family. The earlier version, which came to the National Gallery in London from Sir George Beaumont, was immediately recognized by Constable when he stayed at Coleorton as having been painted from nature. That recognition shows the English master to have been more perceptive on such matters than most art historians. Constable celebrated his sympathy for the directness of reaction and for "the animated pencil that landscape demands" by copying it (Fig. 182) with miraculous fidelity, which still did not quite command the magic balance of attachment and detachment that defines the pastoral realist's poetics.

The all-too-solid flesh of Dutch pastoral portraiture is not the most fruitful instance of Dutch engagement with the Venetian tradition. From the sexuality of the Venetian example Rembrandt developed the emotional humanity of his pastoral, a more moving, more bodily expression of

Fig. 183 (No. 88)
John Constable (1776–1837)
Landscape with Trees and Deer,
after Claude, 1825
pen and brown ink with grey
and brown wash on off-
white laid paper
11⅜ x 7⅞ inches (29 x 20 cm.)
Yale Center for British Art
New Haven
Paul Mellon Collection
B1977.14.5223

LAWRENCE GOWING

Fig. 186 (No. 109)
Charles-Emile Jacque (1813–94)
Landscape with Sheep
oil on canvas
26¼ x 32½ inches (67 x 82 cm.)
The Montreal Museum of Fine Arts
Gift of Colin W. Webster

fleshly attachment than anything else of its kind in art. The shaded couple who embrace under the bushes on the Omval engage sympathy yet insist on the privacy of their emotional situation (Fig. 129). The flute-playing shepherd, borrowed from Titian with his virulent masculinity intact, gazes and whistles his way up the skirts of his bucolic girlfriend (Fig. 127); nothing in all the relationships that pastoral, the art of relationship, uncovers for us is more exciting than Rembrandt's lovers. Their carnal beauty is vividly apparent in the wind-blown resilience of the trees along the banks of the canals.

The cursive elegance of Gainsborough's line served a conception of rural life that had peculiarly melancholy overtones (Fig. 167).[11] Like so many exponents of early Romantic landscape he was a man of earnest evangelical piety, and his contemporaries understood that the cottagers who inhabited the elegaic settings of his later landscapes were contemplating the fallen state of mankind. Even the fidelity of the representation and the painterly sleight-of-hand involved a dilemma that was at root moral. As the Reverend Graves wrote in a poetic eulogy:

> We find the pleasing cheat so well sustained
> Each landskip seems a paradise regained.[12]

It was, in fact, a serious problem how man could live a productive and virtuous life in an unredeemed world; the dilemma was the theme for meditations of delicate solemnity.

Gainsborough was certainly aware that virtue of the women he painted rarely could be described as anything but easy, while in the subjects commissioned from his French contemporaries any sign of virtue was to seek. We are inclined to overlook that the issues addressed in Diderot's Salon reviews presented genuine difficulty to serious painters in both France and England. The lyricism of style that came easily to Gainsborough's hand

LAWRENCE GOWING

Fig. 187 (No. 111)
Jean-François Millet (1814–75)
The Shepherd 1872–74
conté crayon on paper
11⅝ x 14⅞ inches (29.5 x 37.7 cm.)
The Phillips Collection, Washington, D.C.

Fig. 188 (No. 110)
Jean-François Millet (1814–75)
Falling Leaves 1866–67
pastel and black pencil on buff-colored paper
14½ x 17 inches (36.8 x 43.2 cm.)
The Corcoran Gallery of Art, Washington, D.C.
William A. Clark Collection, 1926

Fig. 189 (No. 91)
Edward Calvert (1799–1883)
Ideal Pastoral Life 1829
lithograph
1⅝ x 3¹⁄₁₆ inches (4.2 x 7.8 cm.)
The Art Institute of Chicago
Gift of the Print and Drawing Club
1930.169

Fig. 190 (No. 92) (top)
Edward Calvert (1799–1883)
The Goatherd's Tent/Study for Pastoral
oil on paper
5¼ x 10⅜ inches (13.3 x 26.3 cm.)
Trustees of the British Museum, London

Fig. 191 (No. 93) (bottom)
Edward Calvert (1799–1883)
Amphion with the Flocks of his Brother Zethus
oil on paper
6¼ x 13½ inches (15.9 x 34.3 cm.)
Trustees of the British Museum, London

Fig. 194 (No. 96)
Edward Calvert (1799–1883)
A Primitive City 1822
watercolor with pen and ink on paper
2¹¹⁄₁₆ x 4 inches (6.8 x 10.2 cm.)
Trustees of the British Museum, London

Fig. 192 (No. 94) (top)
Edward Calvert (1799–1883)
A Pastoral
oil on paper
5½ x 10 inches (14 x 25.4 cm.)
Trustees of the British Museum, London

Fig. 193 (No. 95) (bottom)
Edward Calvert (1799–1883)
The Lesson on the Reeds
oil on paper
7 x 12½ inches (17.8 x 31.8 cm.)
Trustees of the British Museum, London

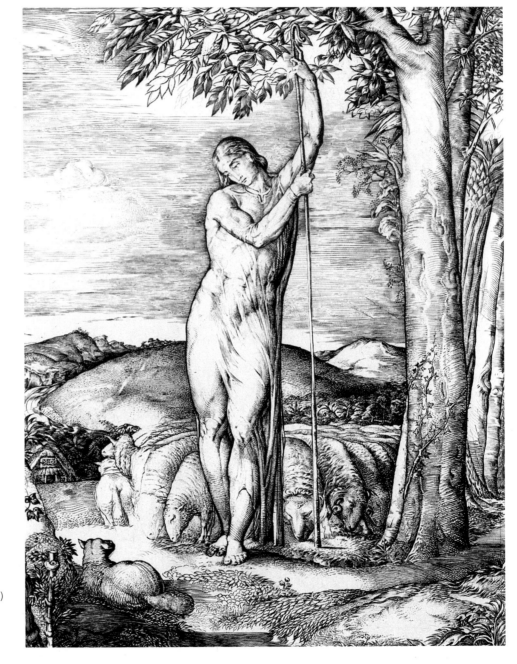

Fig. 195 (No. 105)
George Richmond (1809–96)
The Shepherd 1828
chine collé engraving with etching
plate, 6¼ x 4⁷⁄₁₆ inches (15.4 x 11.3 cm.)
sheet, 7 x 4⁷⁄₁₆ inches (17.8 x 11.3 cm.)
Yale Center for British Art, New Haven
Paul Mellon Collection
B1977.14.12816

commanded a restrained solemnity, which could be described as moral pastoral. Its innocence was by no means falsified by the studied earnestness of its expression.

 The literary pastoral of Augustan and Georgian England seemed in its time to have evoked no echoes of equivalent quality in the visual arts: we do not know if the paradox of the Caroline, in fact papist, origin in Van Dyck of the style on which Gainsborough openly modeled his fluent grace ever disturbed him. Probably his constitutional geniality and tolerance saved him from any such worries. On his death bed he envisaged painters all going to heaven together and added that Van Dyck was one of the company.

 The only parallel to Virgilian pastoral in British art came at the very end of the period, and it

was a surprising one. The benevolent busybody John Linnell (Fig. 196) persuaded Dr. R. J. Thornton, a botanist and physician, to support William Blake, the venerated visionary master to whom the classical and medieval past were equally radiant presences. Thornton commissioned Blake in 1821 to make seventeen wood engravings (Fig. 170a-g) to illustrate an eclogue written by Ambrose Philips, an eighteenth-century poet who had been a protegé of Addison.[13] The poetic dialogue was a fairly unremarkable introduction to the manner of Virgil, intended as a theme for school-room translations into Latin. But Blake's illustrations, which pictured the conversation of two shepherds, Thenot and Colinet, respectively patriarchal and melancholic, display a diminutive monumentality hardly paralleled in art. They were cut with a

Fig. 196 (No. 90)
John Linnell (1792–1882)
Sheep at Noon 1818
etching on very thin India-type paper
5⁹⁄₁₆ x 9¹⁄₁₆ inches (14.1 x 23 cm.)
Collection of Robert N. Essick

Fig. 197 (No. 112) (opposite)
Pierre Cecile Puvis de Chavannes (1824–98)
Massilia, Greek Colony 1868
oil on canvas
38⅝ x 57⅝ inches (98.1 x 146.3 cm.)
The Phillips Collection, Washington, D.C.

Fig. 198 (No. 114)
Pierre Cecile Puvis de Chavannes (1824–98)
Sacred Grove after 1884
watercolor and gouache on paper
7⅝ x 7⅝ inches (19.3 x 19.3 cm.)
The Phillips Collection, Washington, D.C.

Fig. 199 (No. 113)
Pierre Cecile Puvis de Chavannes (1824–98)
Doux Pays (Pleasant Land) 1882
oil on canvas
10⅛ x 18⅝ inches (25.8 x 47.3 cm.)
Yale University Art Gallery, New Haven
The Mary Gertrude Abbey Fund

minute, rough-hewn vigour, which understandably perplexed Dr. Thornton. He was dissuaded from having them recut but inserted this apology: "The illustrations of this English pastoral are by the famous Blake, the illustrator of Young's *Night Thoughts* and Blair's *Grave* who designed and engraved them himself. This is mentioned, as they display less of art than of genius and are much admired by some eminent painters."

Samuel Palmer's reactions three years later were recounted in one of his notebooks:

> I sat down with Mr. Blake's Thornton's Virgil woodcuts before me, thinking to give to their merits my feeble testimony. . . . They are visions of little dells, and nooks, and corners of paradise; models of the exquisitest pitch of intense poetry. I thought of their light and shade, and looking upon them found no word to describe it. Intense depth, solemnity and vivid brilliancy only coldly and partially describe them. There is in all such a mystic and dreamy glimmer as penetrates and kindles the inmost soul, and gives complete and unreserved delight, unlike the gaudy daylight of this world.

Palmer's son, his biographer, reported that "These in my father's opinion were perhaps the most intense gems of bucolic sentiment in the whole range of art" and "utterly unique."[14] (He spoke of them as his "heart's delight. . .") The Virgil wood engravings were, in fact, a chief source of Palmer's own style and the object of close imitation in the Linnell circle.

Blake's idea of country life was possibly formed during his three years (1800–03) in the employment of William Hayley at Felpham, a downland village by the sea in West Sussex, which the present writer remembers from a childhood summer to have a particularly beautiful light, in which tiny things glistened bright and clear.

The intention in the designs, which imagined the conversation of the two shepherds, was perhaps to epitomize the cheerlessness of the human condition and divine charity in the face of it. The designs are filled with a fateful sense of natural drama. Colinet sees his piteous plight reflected in a blasted tree, which is riven by the blast and abandoned, just as he is (VI). The poet Swinburne described it in his critical essay on Blake in 1868:

> …splendour of sweet and turbulent moonlight falls across blown bowed hedgerows, over the gnarled and laboring branches of a tough tortuous oak, upon soft ears of laid corn like long low waves without ripple or roll; every bruised blade distinct and patient, every leaf quivering and straightened out in the hard wind. The stormy beauty of this design, the noble motion and passion in all parts of it, are as noticeable as its tender sense of detail and grace in effect of light. Not a star shows about the moon; and the dark hollow half of her glimmering shell, emptied and eclipsed, is faint upon the deep air.[15]

The subjects include a Palladian manor house (X) where a stone roller is pulled across the lawn and the Lord and Lady, who are "good to all, who Good deserve," hold a party sparkling with light (XIII) "which shall curb the malice of unbridled tongues, and bounteously reward thy rural songs." There is a profound nocturne in which the new moon gleams on the river and a reclining shepherd bemoans an unjust fate: "Neither want nor pinching cold is hard, to blasting storms of calumny compared" (XI). Others make music "[i]n the cool shade to sing the pains of love" (XII). The fairly elementary vicissitudes that mankind suffers, according to the poet, gives the painter a foothold from which the downland community is seen, by day and night and the radiant dawn, to assume an old-testament dignity. Apart from the benevolent Thenot, Blake's shepherds are mercurial, aerial sprites. We never think of Blake as a realist, yet he was the first artist to gain from the pastoral myth any understanding that the man who confronts nature lives under duress.

Samuel Palmer, who was nineteen in 1824

Overleaf
Fig. 200 (No. 129) (left)
George Inness (1825–94)
A Bit of the Roman Aqueduct 1852
oil on canvas
39 x 53¼ inches (99 x 135.2 cm.)
Lent by the High Museum of Art, Atlanta
Purchased with funds from the Members Guild and through exchange
69.42

Fig. 201 (No. 130) (right)
George Inness (1825–94)
The Lackawanna Valley 1855
oil on canvas
33⅞ x 50¼ inches (86 x 127.6 cm.)
National Gallery of Art, Washington, D.C.
Gift of Mrs. Huttleston Rogers
1945.4.1

LAWRENCE GOWING

LAWRENCE GOWING

when he met Blake, wrote that the Virgil engravings were "like all that wonderful artist's works, the drawing aside of a fleshly curtain, and the glimpse, which all the most holy, studious saints and sages have enjoyed, of that rest which remaineth to the people of God. The figures of Mr. Blake have that intense soul-evidencing attitude and action, and that elastic nervous spring which belongs to the uncaged immortal spirits."[16] Blake's natural vision in these works was the culminating experience in the artistic formation that was inspired by his own intensely visionary and deep-feeling nature. Blake taught him, Palmer said, to perceive the soul of beauty through the forms of matter, but that perception was already far advanced by his childhood awareness both of nature and faith. When he was three years old his perceptive nurse had held him up to see the shifting, wind-blown shadows of an elm tree cast by the moon on a white wall opposite his window and repeated a couplet from the poet Young's *Night Thoughts*:

> Fond man, the vision of a moment made,
> Dream of a dream, and shadow of a shade.[17]

It is a telling example of how much imaginative upbringing can contribute to the inspiration of a deeply Romantic nature because, as Palmer told, he never forgot those shadows and seventy years later was still trying to paint them.

The ingredients of poetic verbalisation, a knowledge of Dürer and other northern prints as well as of early music, his constitutional piety, and, not least, a precocious talent—he was being exhibited and sold at the Royal Academy when he was thirteen—all contributed to his rapid development. Probably as valuable to his make-up as any of these was a lively sense of place, which was stimulated when he moved to Shoreham in Kent when he was twenty-two. He called it the *Valley of Vision* (Fig. 171), and the secluded, concentrated life he lived there for seven years of Episcopal Anglican piety (which had replaced the evangelical faith in which he was raised) and his close observation proved the material of the little masterpieces for which he is known. A group of followers, including Welby Sherman (Fig. 179) and Edward Calvert (Figs. 189–194), united in admiration for Blake, assembled round Palmer at Shoreham. They called themselves the Ancients and their medievalizing version of pastoral was avowedly English and gothic in its picturesqueness. Blake's inspiring example had been rooted in an eighteenth-century imitation of Virgil, but after seven years at Shoreham, Palmer began to hanker for a more truly Virgilian version of pastoral. He traveled to Italy and set to work at the classic sites. But classical convention, in particular the influence of Claude, denied his native inspiration. The image of nature in British art rarely survives transfiguration by the ideal vision, which Palmer came to hold the highest form of art, although he had earlier reacted strongly against anything grand or heroic. "Whatever you do," he told himself in his sketchbook, "guard against bleakness and grandeur—and try for the primitive cottage feeling." That feeling was not so easy to recapture in the Italian context, and the intensity of the work at Shoreham was never regained in the generalities of his later works.

The achievement of Blake's followers, and in particular of the Shoreham school, was considerable and undiminished by the atmosphere of pedantry and disappointment in which it expired. Its effect was to naturalize the pastoral tradition in the British context, where it was primarily interpreted in the graphic media.

The manner of Claude was the only historical style that ever took root in Britain. It was an essential element in the resources of both Turner and Constable, and it contributed eventually to

Fig. 202 (No. 132) (opposite)
George Inness (1825–94)
Etretat 1875
oil on canvas
29⅞ x 44¹⁵⁄₁₆ inches (75.9 x 114.2 cm.)
Wadsworth Atheneum, Hartford, Connecticut
The Ella Gallup Sumner and Mary Catlin Sumner Collection

Overleaf
Fig. 203 (No. 131) (left)
George Inness (1825–94)
Lake Albano 1869
oil on canvas
30⅜ x 45⅜ inches (77.1 x 115.2 cm.)
The Phillips Collection, Washington, D.C.

Fig. 204 (No. 133) (right)
Frederick Church (1826–1900)
Italian Coastal Scene 1882
oil on canvas
14¹⁵⁄₁₆ x 22¹⁄₁₆ inches (38 x 56 cm.)
Private Collection

LAWRENCE GOWING

their mature achievements in which no other shade of Italianate convention was apparent. But the achievement in graphic pastoral, which Blake and Palmer shared, and the drama of their formulations of nature and country life—by turns gaunt or harsh and richly poetic—have lent a fulfilled romanticism to the native landscape and to British art in the twentieth century.

The Shoreham circle established a new pattern of personal originality in British art, an example almost comparable with the idiosyncratic innovations that led the way to modern art. Palmer had more sense of the recklessness of personal commitment, which opens the way to individual style, than has been general among British painters, and he communicated it. "Excess," he exclaimed, "is the essential vivifying spirit, vital spark, embalming sprite . . . of the finest art." "Only by excess," his biographer explains, "could the work be made to leave the earth and soar upwards into celestial air."[18]

The most remarkable of the Ancients was Edward Calvert, the oldest of them and the only one who devoted himself deliberately and exclusively to cultivating a recognizable pastoral style (Figs. 190–193).[19] He began as a naval officer and while in the Navy paid a visit to Greece, which left him with a lasting sense of the appropriate Arcadian setting. Under Palmer's influence he exchanged Arcadia for Eden, but his passionate subject matter remained consistently innocent, even when he reverted to paganism and installed an altar to Pan in his garden.

Calvert intelligently considered and reconsidered the context for the pastoral tradition that attracted his loyalty, and the pastoral paintings of his later years were among the most sensitive pictures of his time. But they lacked something in urgency. He was the only one of the Ancients who possessed an independent income. This circumstance had no necessary connection with the fact that he appeared to the rest of the circle as a dilettante, an earnest one, who did not like being teased about his conventional family and the white trousers that he still affected. A comparison of Blake's Virgil engravings (Figs. 168, 169) with a lithograph by Calvert (Fig. 189) is instructive: Calvert's print seems, by contrast, elegant. They appeal particularly to print collectors, who have had a long-standing influence on British art.

Constable's conviction of the rarity of "a true pastoral feel" and of his own exclusive grasp of it, speak for the momentum of nineteenth-century landscape. The original impetus of the century, as strong in its last years as its first, was observation, noting the specific as distinct from the ideal, the strand in the Venetian tradition that was due to Giorgione and Bellini.

Naturalness is not in itself an artistic programme. The support for a natural style of painting that Constable eventually secured was hard fought. To convey the totality of his contribution is beyond the range of this essay, but an understanding of one or two aspects of his actual innovation may contrast simplifications of the Constable myth. The freshness and animation of Constable's oil sketches, for example, is so compelling that it is sometimes surprising to find how inventive many of them were. The well-known *A Lane Near Flatford* (Fig. 180) seems to be an endeavor to evoke painting from nature in the studio with his memory and encyclopaedic knowledge of pastoral convention for guides. The image is nonetheless magnificent. Very possibly it was painted in the course of evolving the design that became *The Cornfield*, the famous and conventional pastoral composition into which, in his desperate need for a sale, Constable incorporated "more eye-salve" than he usually condescended to. His reward was that the rather disastrous picture was bought for

Fig. 205 (No. 134) (opposite)
Thomas Eakins (1844–1916)
Arcadia c. 1883
oil on canvas
38⅝ x 45 inches (98.1 x 114.3 cm.)
The Metropolitan Museum of Art, New York
Bequest of Miss Adelaide Milton de Groot, 1967
67.187.125

Fig. 206
Edouard Manet (1832–83)
Fishing in Saint-Ouen, near Paris 1860–61
oil on canvas
30¼ x 48½ inches (76.8 x 123.2 cm.)
The Metropolitan Museum of Art, New York
Purchase, 1957, Mr. and Mrs. Richard J. Bernhard Fund
57.10

LAWRENCE GOWING

the nation by public subscription. The sketch of *A Lane Near Flatford*, like *The Cornfield*,[20] contains the motif of a boy lying to drink from the stream, which any connoisseur of Constable's time would have recognized as a reference to the story of Diogenes and the ideal of Stoic naturalness. It is indeed very possible that the disposition of masses in *A Lane Near Flatford* was derived from an engraving in reverse of Poussin's *Landscape with Diogenes*, the most famous and influential of Stoic landscapes.[21] If the kind of effort represented by *A Lane Near Flatford* had been successful and Constable had been able to turn the flank of conservative opposition to his uncompromisingly natural style with sketch-type pictures painted out of his head, the whole story of nineteenth-century painting and Constable's own sad life would have been different. The gap between philosophical picture-construction and painting from observation was eventually closed by Cézanne. Constable's later, triumphant elaboration of a style in which the scattered accents of light have a symbolic reference to abstracted naturalness—which seems a logical conclusion of pastoral—is represented in this exhibition by *On the River Stour* (Fig. 181), an example of the masterly style of studio sketch towards which *A Lane Near Flatford* was pointing.

In pastoral landscape from the sixteenth century onwards, the purposes of everyday life were held in suspense. Real observation was used to represent an imaginary way of life in which there was time for dreaming and loving and the making of amorous music. The herdsman's business was not pressing; his herds prospered without much attention. Unhurried dalliance or prolonged melancholy or the involved heroics of romance were the accepted motivations in the pastoral subject. It was in reaction to this fantasy that landscape figuration in itself became the justifying purpose of nineteenth-century painting. The virtue implied in *la*

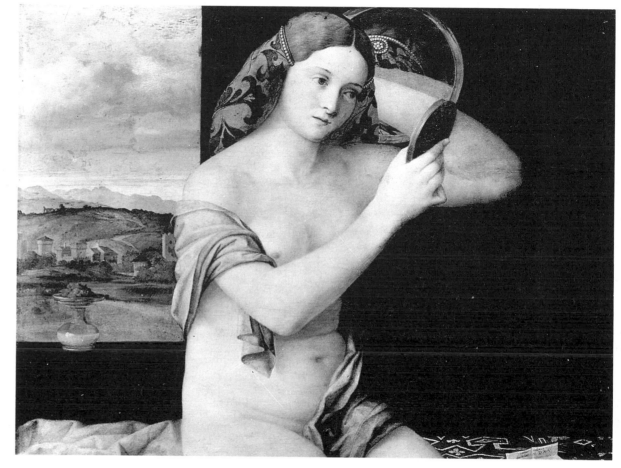

Fig. 207
Giovanni Bellini (c. 1433–1516)
Young Woman Arranging Her Hair 1515
oil on wood
24⅜ x 31 1/16 inches (62 x 79 cm)
Kunsthistorisches Museum, Vienna

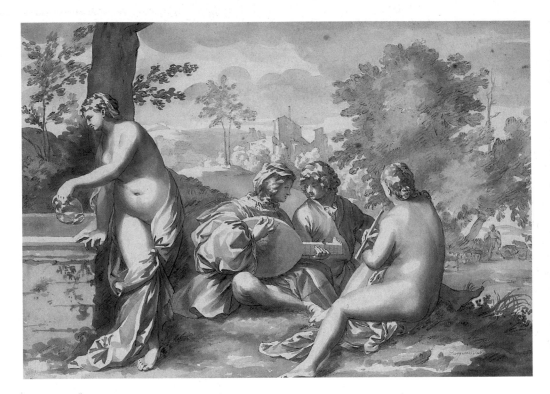

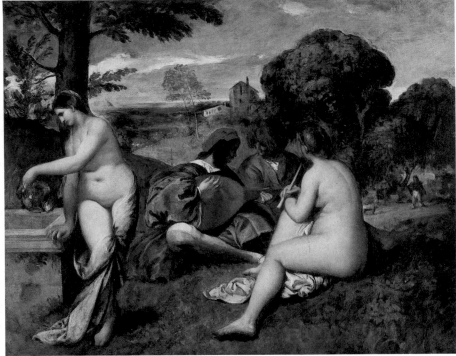

Fig. 208 ▷
Edouard Manet (1832−83)
Le Déjeuner sur l'herbe 1863
oil on canvas
81⅞ x 103¹⁵⁄₁₆ inches (208 x 264 cm.)
Musée d'Orsay, Paris

Fig. 210 (No. 89)
William Etty (1787−1849)
Concert champêtre 1830
oil on canvas
28¾ x 36¼ inches (73 x 92 cm.)
Private Collection, England

Fig. 209 (No. 66)
Jan de Bisschop (1628−71)
Concert champêtre 1668
black chalk, brush in brown wash on paper
10⁵⁄₁₆ x 14⁵⁄₁₆ inches (26.2 x 36.3 cm.)
Prentenkabinet der Rijksuniversiteit, Leiden

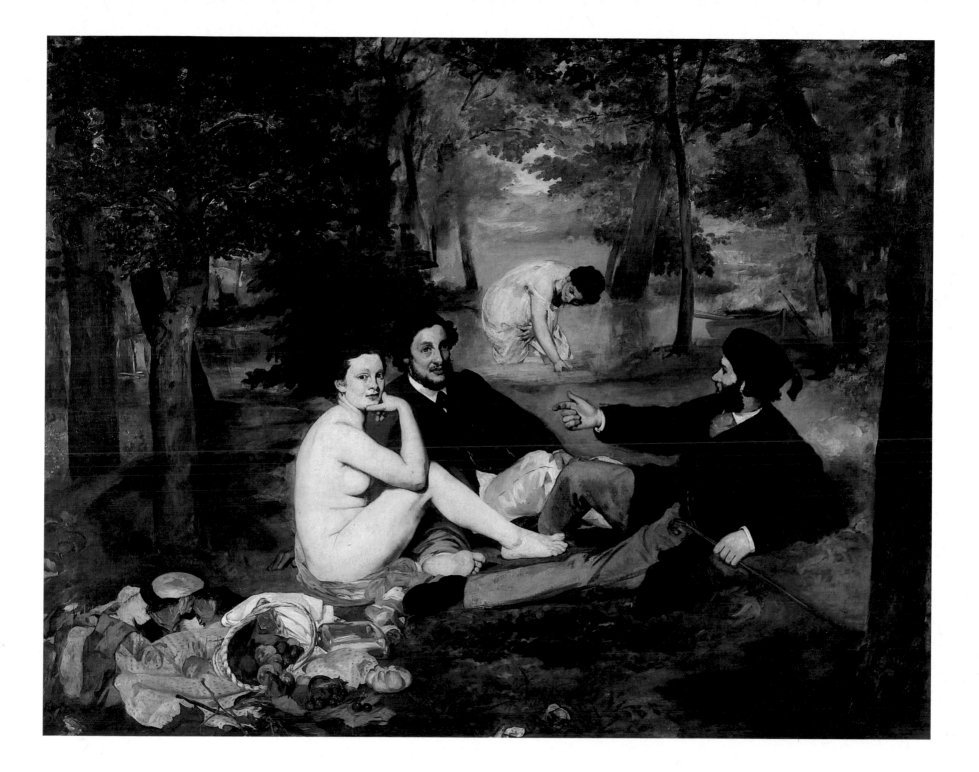

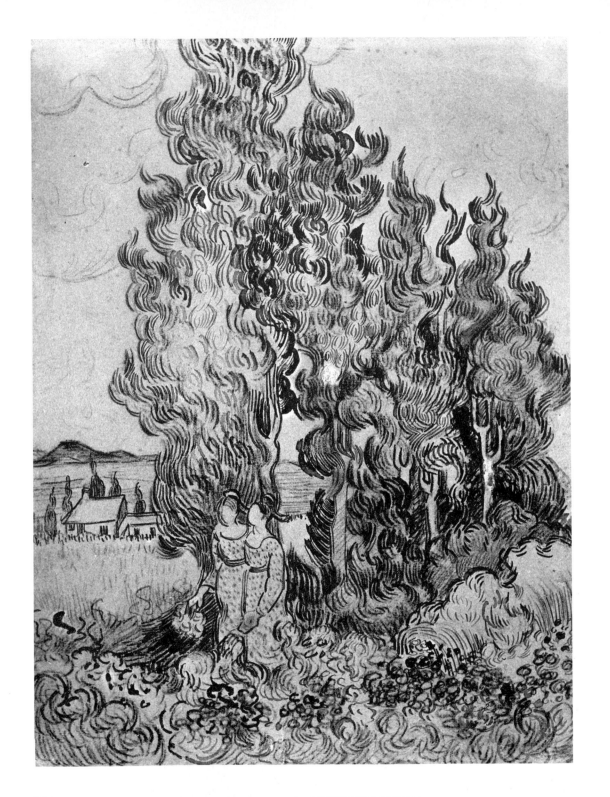

bonne peinture is analogous to the values of metaphoric agriculture, which the ideal painter chose to depict. In this context the component of realism in Arcadian and Olympian painting alike from Bellini onwards became the element that supplied the motivation and justification of the whole.

The idea that the condition of the agricultural proletariat was the fundamental value in eighteenth-century landscape painting has impoverished the vocation of art history with a tendency to falsehood. The element of naturalness in Constable's style was an emotional involvement, supported by a degree of sheer fetishistic excitement with the freshness of nature and an infatuation with shiny things along the water's edge of which he spoke continually. It is the momentum of the real in the apparent detachment of pastoral painting that liberates the greatness of nineteenth-century art.

Constable made oil paint the masterly instrument of the art that was "another word for feeling." In his hands it became an organ of imaginative realization in itself. Constable asked himself the question that was and is at the root of figurative painting, "What is painting but an imitative art?" But if he had any idea that in force would be merely rhetorical, that idea was immediately corrected by the corollary that occurred to him: "An art that is to realize not to feign." The phrase, which was found among his papers, became as well known in France as in England. In France its effect was more potent: it laid down what was to be the implicit program of nineteenth-century painting.

In the initial stages of developing his later works Constable joined this realization with a pictorial fabric that scorned to pretend to be anything but paint. It amounted to a confession of the substance that painting was made of, and a withdrawal from the imitative sleight of hand, which pretended that landscape painting consisted of

leaves. The picture entitled *On the River Stour* (Fig. 181) requires a spectator to recognize that the vision of landscape consists in acts of strictly visual differentiation. If it differentiates light from dark, shine from shadow, dryness from dew, all in terms of the color that is quite clearly nothing but paint, then that paint is the material of analogy and allegory. Painting makes its subject real by means that are figurative in both senses. Realized in paint, the likeness is as metaphorical, as imaginative, as it would be in a figure of speech.

In Constable's works the likeness to country and weather was accompanied, as his contemporaries complained, by an even more striking likeness to paint. In this tradition of landscape, paint became during the nineteenth century the means of an essential detachment. The condition of real-seeming and the grammar of pictorial poetry were a withdrawal from imitative description and the recognition in its place of the metaphoric likeness that painterly vitality conjured out of the pigment and the justness of its strictly visual distinctions. This was the vividness that Delacroix recognized in the English pictures presented at the Salon of 1824.

Yet there remained a parallel with the Venetian innovation of three centuries before. The country trades, herding and husbandry, were still the sufficient representatives of the actuality of life within the landscape. The nineteenth century inaugurated the *pastoral of paint*.

Self-committed *plein-airiste* painters sedulously cultivated the inseparable involvement of images with paint marks, patches of tone that divided into multiple brush strokes. In fact, they engendered the involvement of nature with the nature of paint. The crusty *taches*, in which paint was most itself, became the visible sign of commitment to the reality of the subject and eventually to the real significance of nature in itself. In the hands of an observant painter the tonal crust of painting was

capable of conveying a vision in serenely visual terms that were in its way a veritable ideal. Painting outdoors in the face of the subject, realizing what was strictly visible, Corot (Fig. 184) released French landscape painting from the habit of categorical description into a world of simplicity and directness. His vision embraced just what a loaded brush could match. His example testified to his faith in the grandeur that the visual report in itself could possess.

In general the landscape painting of mid-century in France remained descriptive. Charles-Emile Jacque's *Landscape with Sheep* (Fig. 186) demonstrates that a pastoral subject does not ensure any other quality of pastoral. Only J. F. Millet, in the most delicate, least rhetorical mood of *Falling Leaves* (Fig. 188), found some of the original poetry of pastoral in the abstracted role of a shepherdess who watches her flock as if in a dream, exactly poised to guard a screen of trees and pensively to punctuate the space, as if no other reason for existence was imaginable.

For the long-standing, delicate solemnity of the French imagining, the later nineteenth century looked to Puvis de Chavannes. He alone preserved a quality of classicism that retained an aloofness akin to pastoral. The view of Marseilles in terms of Greek antiquity (Fig. 197), as seen by Levantine immigrants from an arriving ship, is indeed a considerable (and unfamiliar) inspiration. Without his instinctive dignity, the mix of sources available to modern painting would have been very different, and it may be doubted if either Gauguin (Fig. 217) or Seurat (Fig. 223) would have commanded the monumentality that we know.

The central event of nineteenth-century art in France was Edouard Manet's painting of *Le Déjeuner sur l'herbe* (Fig. 208) in 1863. This work demonstrated the continued relevance of the Venetian pastoral tradition, and in doing so showed in-

Fig. 211 (opposite)
Vincent van Gogh (1853–90)
Cypresses 1887
black chalk and reed pen on paper
12³⁄₁₆ x 9¹⁄₁₆ inches (31 x 23 cm.)
Rijksmuseum Kröller-Müller, Otterlo

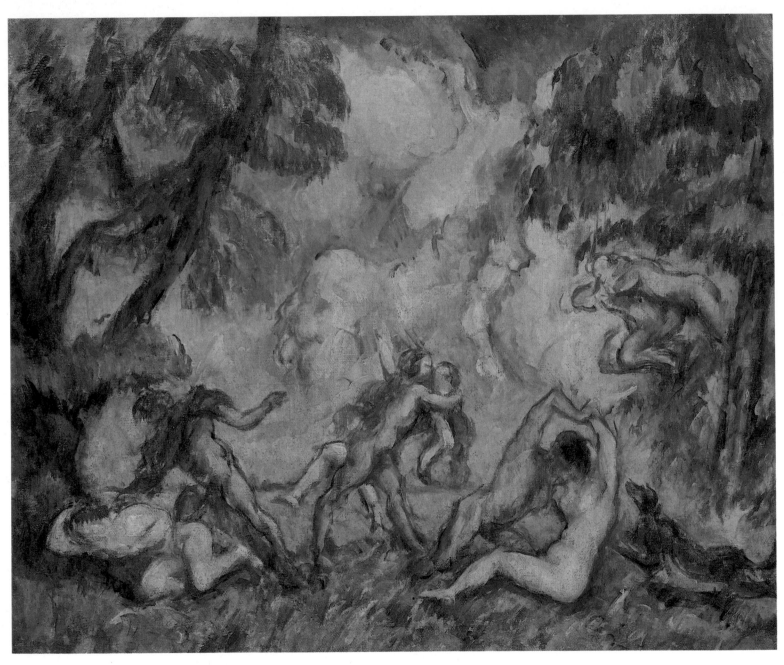

Fig. 213 (No. 116)
Paul Cézanne (1839–1906)
The Battle of Love c. 1880
oil on canvas
14⅞ x 18¼ inches (37.8 x 46.3 cm.)
National Gallery of Art, Washington, D.C.
Gift of the W. Averell Harriman Foundation
in memory of Marie W. Harriman
1972.9.2

LAWRENCE GOWING

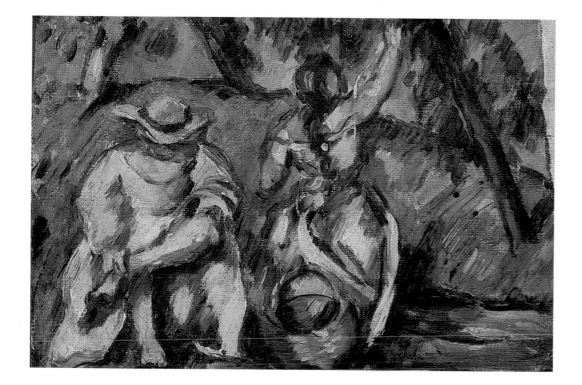

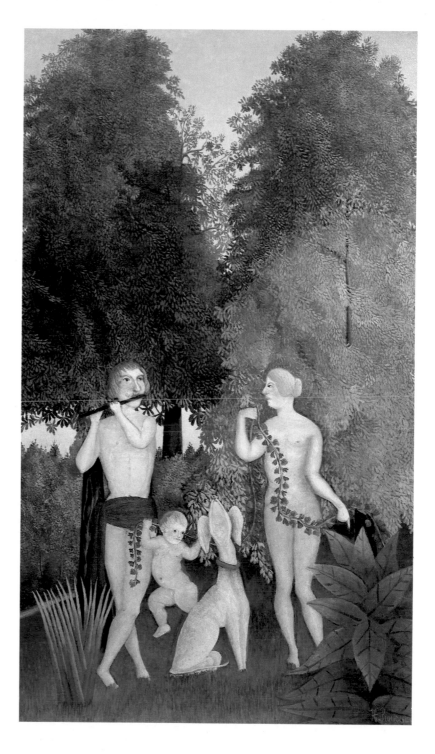

Fig. 212 (No. 115)
Paul Cézanne (1839–1906)
Women Picking Fruit 1876–77
oil on canvas
6⅛ x 8⅞ inches (15.5 x 22.5 cm.)
Private Collection

Fig. 214 (No. 117)
Henri Rousseau (1844–1910)
The Happy Quartet 1902
oil on canvas
37 x 22½ inches (94 x 57.1 cm.)
Collection of Mrs. John Hay Whitney

cidentally, with debonair cavalierness, that the artist in the new age had exchanged his role for a more complex and sophisticated, indeed ironical, one that examined critically not only current experience but the long-standing definition of art itself.

Manet's friend, the critic Antonin Proust, remembered an incident that revealed the challenge that Manet felt of bringing past and present together.

> We were at Argenteuil one Sunday . . . some women were bathing. Manet's eye was fixed on the flesh of the women leaving the water. 'I'm told,' he said to me, that I must do a nude. All right, I will. Back in our student days, I copied Giorgione's women, the women with the musicians. That's a dark picture. The background is gone (*repoussé*). I am going to do it over again and do it in the transparency of the atmosphere, with figures like those you see over there.'[22]

He went on to grumble that he would doubtless be blamed for his imitativeness as usual.

There was a sardonic note in Manet's compliance with expectations. He supposed, again more than half ironically, that the memory of the *Concert champêtre*, which he would apparently feel compelled to make evident, would expose him to the customary criticism, if not of plagiarism, of borrowing his whole definition of painting from one or other historic period. Yet he was not free to adopt any simpler, less vulnerable course. The sophisticated allusion to an historical definition was for Manet an inseparable constituent of his art. It was perhaps his real invention, more original than anything he could borrow from Giorgione or Raphael—that Manet grafted his student memory of the Venetian picture onto the design for a Judgment of Paris engraved by Marcantonio after Raphael perhaps in order to complicate and justify his critical position. He used them together as a joint key to recapturing not only the experience at Argenteuil, but the historical standpoint from which

he necessarily saw it. If his sense of painterly observation was, as it seems, compounded by his inescapable sense of the historical context, there was a still further complexity in his mask of impersonality and withdrawal. Portraying a new yet ancient and significantly hackneyed definition of the artist's role, he was engaged in a pastoral of plagiarism.

Landscape painting in America, moved by the sheer magnificence before the painter's eyes, developed an ideally heroic style of topography to express a pride that was new to art. American painters who traveled occasionally betrayed a certain complacency. In Italy they exploited the ideal option (Fig. 204) and imitated Claude (Fig. 203) with a confidence that verged on bombast, but at home their achievement was incomparable. George Inness's *Lackawanna Valley* (Fig. 201) is surely one of the masterpieces of the century because the "momentous and prophetic meeting of man and machine"[23] was painted with such honorable simplicity and directness. An image was, for once, conceived in a spirit wholly worthy of that in which the enterprise was carried out. The first president of the Delaware, Lackawanna and Western Railroad, from whom the commission originated, received better than he ever knew. The picture eventually came to light in a job lot of surplus office equipment in Mexico City.

The breadth with which Inness painted usually escaped the temptations of miscellaneous description that lay in wait for the nineteenth-century painter. His surety of touch and taste clears him in picture after picture of the sentiment that he perhaps intended. The integrity of Thomas Eakins is, by contrast, beyond any doubt. It is clear that he aimed in the picture now called *Arcadia* (Fig. 205) to merge the knowledge on which he reasonably held that classicism depended with the most efficient pictorial technology that was to hand. He

Opposite
Fig. 215 (No. 120) (top)
Ker Xavier Roussel (1867–1944)
Faun and Nymph under a Tree
oil on canvas
17 x 23 inches (43.1 x 58.4 cm.)
The Phillips Collection, Washington, D.C.

Fig. 216 (No. 121) (bottom)
Ker Xavier Roussel (1867–1944)
Mediterranean
oil on academy board
10¼ x 15¼ inches (26 x 38.7 cm.)
The Phillips Collection, Washington, D.C.

Overleaf
Fig. 217 (No. 118) (left)
Paul Gauguin (1848–1903)
Breton Girls Dancing, Pont Aven 1888
oil on canvas
28¾ x 36½ inches (73 x 92.7 cm.)
National Gallery of Art, Washington, D.C.
Collection of Mr. and Mrs. Paul Mellon
1983.1.19

Fig. 218 (right)
Paul Gauguin (1848–1903)
Haystacks in Brittany 1890
oil on canvas
29¼ x 36⅞ inches (74.3 x 93.6 cm.)
National Gallery of Art, Washington, D.C.
Gift of the W. Averell Harriman Foundation
in memory of Marie N. Harriman
1972.9.11

painted it from photographs of his willing models, a nephew and a student, posed on his sister's farm at Avondale, Pennsylvania. The thoroughness and devotion and the classical judgment are all beyond question, but it is not quite certain that the visual knowledge, on which Eakins rightly held he depended, was ever as complete as when he won it by eye. The title of the picture was due to his widow, but he would surely have approved it. It was a marginal addition to the achievements of his genius to have added to the classical tradition a pastoral of photography.

Looking back to Manet's observation at Argenteuil, which resulted in *Le Déjeuner sur l'herbe*, it is apparent that when the bathers renewed his interest in the pastoral ideal inherited from Venice, he was on the verge of a conception of the artist of unprecedented sophistication. Yet the realization was in essence a simple one. Bodies in the open air called for paint in its simplest state, demanded the intrinsic beauty of paint as a visual tone. So the realistic but improper recognition that the primal state of paint could resemble the society that undressed to bathe, in fact, the demi-monde, was the manifesto of a new art. Manet seemed deliberately to provoke moral shock; he was really intent on the simple beauty of pastoral.

This was the newly active tradition that Cézanne inherited. The style that emerged towards 1880 was based on coincident directions and alignments that Cézanne may conceivably never have noticed were inseparable from the Venetian revolution in the *Concert champêtre*, which he had copied in the Louvre. The structural rhythms and organized parallels of Cézanne's *Battle of Love* (Fig. 213) galvanized a pastoral of intense Baroque-Romantic sophistication, but it is exceptional in his mature art. His classically bucolic simplicity is more evident in the little picture *Women Picking Fruit* (Fig. 212). He may possibly have read the

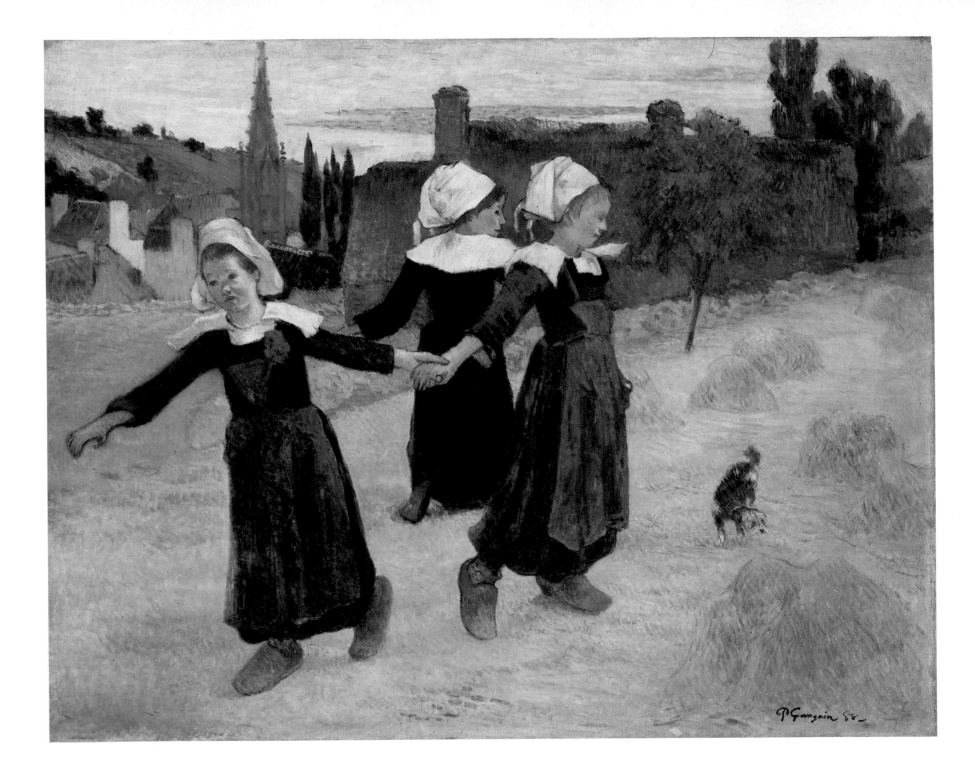

LAWRENCE GOWING

LAWRENCE GOWING

Fig. 219 (opposite)
Paul Gauguin (1848–1903)
The Bathers 1898
oil on canvas
23¾ x 36¾ inches (60.4 x 93.4 cm.)
National Gallery of Art, Washington, D.C.
Gift of Sam A. Lewisohn
1951.5.1

Fig. 220
Paul Gauguin (1848–1903)
Breton Shepherdess with Flock 1886
oil on canvas
23⅝ x 28¾ inches (60 x 73 cm.)
Laing Art Gallery, Newcastle upon Tyne
Reproduced by permission of Tyne
and Wear Museums Service

Overleaf
Fig. 221 (left)
Pierre Bonnard (1867–1947)
La Symphonie pastorale
or *Campagne* 1916–20
oil on canvas
51¼ x 63 inches (130 x 160 cm.)
Bernheim-Jeune, Paris
Photo Bernheim-Jeune

Fig. 222 (right)
Pierre Bonnard (1867–1947)
L'Eté 1917
oil on canvas
102⅜ x 133⅞ inches (250 x 340 cm.)
Collection Fondation Maeght, Saint Paul

LAWRENCE GOWING

fragment from Sappho that describes the same subject.

This bucolic pastoral is the same tradition that claimed Gauguin's allegiance when he went to paint in Brittany (Figs. 217, 218, 220). His art was never independent of it again and through him the same tradition is the source of the pastoral of the primitive, which became in the twentieth century a pastoral simplicity that can be studied in a specific primitive place.

It is significant that the aspiration to an Arcadian ideal remained unexpended through the nineteenth century. The option remained on offer to the nonconforming talents that sought an enterprising alternative to the relics of Impressionist realism in the 1880s. It was in store for the first post-modern avant-garde under the label of neo-Impressionism, which one could as well denominate neo-Pastoral. The indispensable pastoral "cool," or control, was supplied by the new and excessively theoretical analysis of visual means, which was extracted from Seurat's inspired practice. It was this originally Arcadian, ideally beautiful option that saved Matisse's turgid "proto-Fauvism," his agitated sub-Impressionism of the 1890s, from turning into a thoroughly muddled proto-expressionism—saved it for the deliberation and control that were indispensable for modern art and for the "madly anxious" Matisse, as he was described by H. E. Cross, his neo-Impressionist mentor. The residual ideal of the 1890s, the ideal that descended to Bonnard (Figs. 221, 222), was thus Arcadian in the original sense, full of intrinsic delight in the truth of life and love, while the ideal of the 1900s was arcadian in the new, more strenuous and intended sense. These two options left us with the two great modern exponents of those beauties that are fundamentally and irreducibly pastoral in landscape painting.

The nineteenth century with its trium-

Opposite
Fig. 224 (No. 126) (left)
Henri Matisse (1869–1954)
Nude in a Landscape 1906
oil on canvas
15¾ x 12⅝ inches (40 x 32 cm.)
Wally Findlay Collection, Chicago

Fig. 225 (No. 125) (right)
Henri Matisse (1869–1954)
Woman by a Stream 1906
oil on canvas
13½ x 11 inches (34.3 x 28 cm.)
Galerie Jan Krugier, Geneva

Fig. 223 (No. 119)
Georges Seurat (1859–91)
Study for *La Grande Jatte* 1884–85
oil on panel
6¼ x 9⅞ inches (15.9 x 25 cm.)
National Gallery of Art, Washington, D.C.
Ailsa Mellon Bruce Collection
1970.17.81

LAWRENCE GOWING

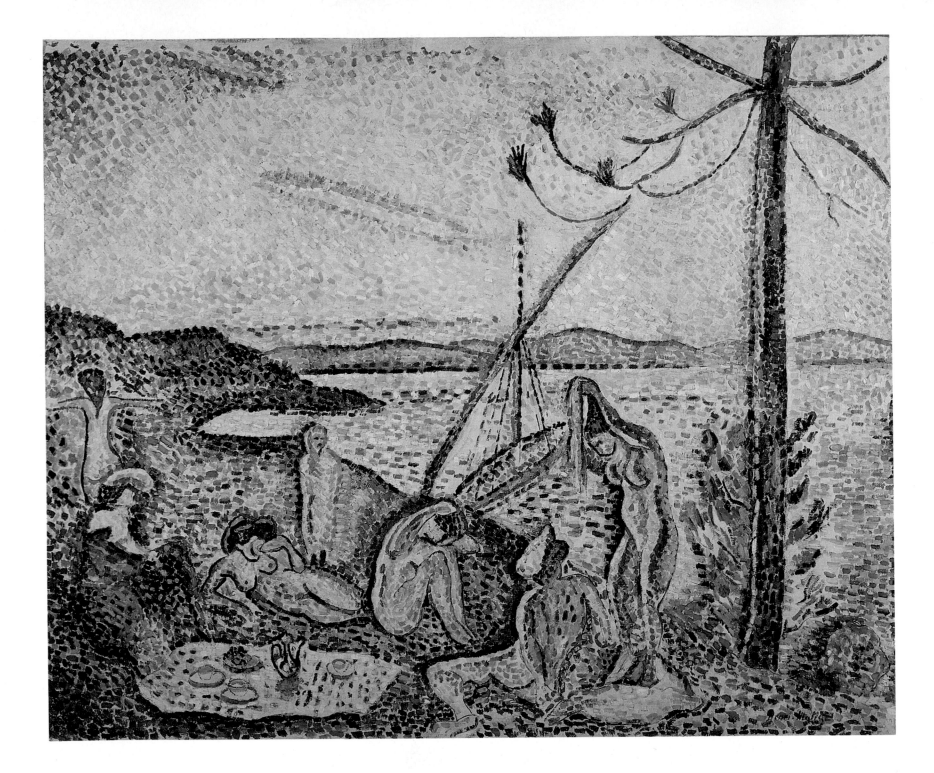

LAWRENCE GOWING

Fig. 228 (No. 122)
Henri Matisse (1869–1954)
Study for *Luxe, calme et volupté* 1904
oil on canvas
15 x 21½ inches (38.1 x 54.6 cm.)
Collection of Mrs. John Hay Whitney

Fig. 226 (opposite)
Henri Matisse (1869–1954)
Luxe, calme et volupté 1904–05
oil on canvas
33⅞ x 45⅝ inches (86 x 116 cm.)
Musée d'Orsay, Paris
DO 1985–1

Fig. 227 (No. 123)
Henri Matisse (1869–1954)
By the Sea (Golfe de Saint-Tropez) 1904
oil on canvas
25⁹⁄₁₆ x 19⅞ inches (65 x 50.5 cm.)
Kunstsammlungen Nordrhein-Westfalen, Düsseldorf

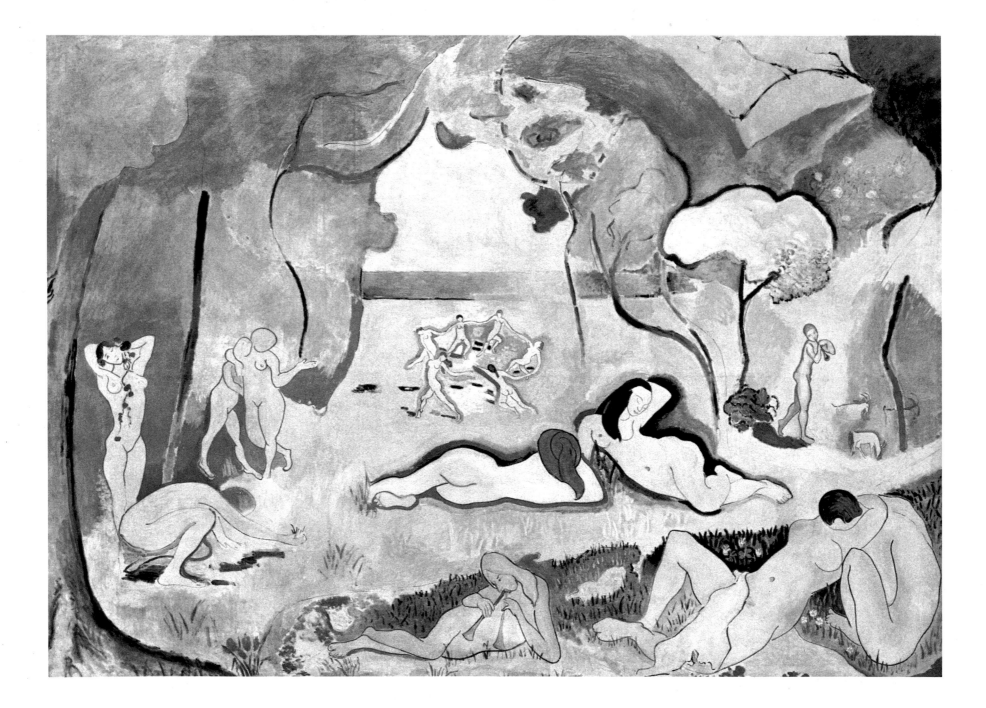

LAWRENCE GOWING

phantly intelligent readings of history qualifies the twentieth to inherit both aspects of a single tradition, the pastoral of primitiveness and the pastoral of sophistication. The apparent dichotomy in this single tradition accounts for the richness that has been open to modern painters, as well as the puzzlement.

The whole tradition was received intact by Matisse and progressively recognized by him as transmitting through the Impressionist brightness of color not merely the effect of light but the flat crust of color in itself. We can follow the stages of Matisse's recognition in the neo-Impressionist analysis of the means to a brilliant pastoral of prismatic color. All its stages are evident in the simple beauty of his sketches—a beauty that (in the paradoxical language that Manet taught modern pastoral to speak) means the most sophisticated beauty there is. They were the stages in Matisse's identification of Arcadia in *Luxe, calme et volupté* (Figs. 226, 227, 228) and then in *Bonheur de vivre* (Figs. 229, 230). In 1906 the Arcadian pattern was identified in the dance of *Bonheur de vivre*, which Matisse could trace back to Agostino Carracci. By 1911 Arcadia was recognized as a real place to which Matisse could book a ticket—Seville, or Morocco, or, finally, the shocking beauty of the banality of the demi-monde at Nice.

Finally, the twentieth century, like the nineteenth, enchants us with these painters who preserve a simplistic trust in the elemental verities of color and surface. Henri Rousseau (Fig. 214) and Milton Avery (Fig. 236), in their respective generations, were not in any way alike or parallel. Like the original and natural pastoral painters, each is enjoyed on his own terms, which he salvaged from the inherent nature of the art. Meanwhile, the pastoral purpose continues. Howard Hodgkin is as inextricably involved as ever in the brush marks and paint patches with which he improvises a pastoral as sophisticated as any (Fig. 234).

Fig. 229 (opposite)
Henri Matisse (1869–1954)
Le Bonheur de vivre 1905–06
oil on canvas
68½ x 93¾ inches (174 x 238.1 cm.)
The Barnes Foundation, Merion, Pennsylvania

Fig. 230
Henri Matisse (1869–1954)
Study for *Le Bonheur de vivre* 1905
oil on canvas
16⅛ x 21⅝ inches (41 x 54.9 cm.)
Private Collection

243

Fig. 231
Henri Matisse (1869–1954)
Pastorale, Collioure 1906
oil on canvas
18⅛ x 21¾ inches (46 x 55.2 cm.)
Musée d'Art Moderne de la Ville de Paris

Fig. 232 (No. 124)
Henri Matisse (1869–1954)
Nude in a Wood 1905
oil on panel
15¹⁵⁄₁₆ x 12¹³⁄₁₆ inches (40.5 x 32.5 cm.)
The Brooklyn Museum
Gift of George F. Of
52.150

Fig. 233 (No. 127)
Henri Matisse (1869–1954)
Nymph in the Forest (La Verdure) 1935–42/43(?)
oil on canvas
95¼ x 76¾ inches (242 x 195 cm.)
Musée Matisse, Nice

Fig. 234 (No. 136)
Howard Hodgkin (b. 1932)
In the Public Garden, Naples 1981–82
oil on panel
32 x 36¼ inches (81.3 x 92.1 cm.)
Private Collection, New York

Fig. 235 (No. 128) (opposite)
Georges Braque (1882–1963)
The Shower 1952
oil on canvas
13¾ x 21½ inches (34.9 x 54.6 cm.)
The Phillips Collection, Washington, D.C.

Fig. 236 (No. 135)
Milton Avery (1893–1965)
Sheep 1952
oil on canvas
30 x 40 inches (76.2 x 101.6 cm.)
Milton and Sally Avery Arts Foundation, New York

NOTES

1. Fehl 1957.

2. Antonin Proust, *Edouard Manet, Souvenirs* (Paris: H. Laurens, 1913).

3. Letter to Emile Bernard, 23 December 1904, from *Correspondance* (Paris: Grasset, 1978), p. 308.

4. Haskell 1971.

5. Lawrence Gowing, *Paul Cézanne: The Basel Sketchbooks*, exhibition catalogue (New York: Museum of Modern Art, 1988), p. 25. Adrien Chappuis, *The Drawings of Paul Cézanne. A Catalogue Raisonné*, (Greenwich, CT: New York Graphic Society, Ltd., 1973), vol. 2, pl. 554.

6. Wind 1969, pp. 3–4.

7. Fischer 1974, pp. 71–74.

8. Rosand and Muraro 1976, p. 162.

9. Wittkower 1978, pp. 161–73.

10. Gowing 1974.

11. Pointon 1979.

12. In Shenstone's *Miscellany*, 1759–63. Quoted by Pointon 1979, p. 450.

13. Bindman 1982, p. 168. Thornton's publication, incorrectly described by Bindman, was reproduced and published in full by Thomas B. Mosher (*XVII Designs to Thornton's Virgil*, 1899). Catalogue raisonné (Bindman 1978) nos. 602–18. Thornton engravings recently reprinted in Iain Bain and William Chambers, *The Wood Engravings of William Blake for Thornton's Virgil* (London: British Museum, 1977).

14. A. H. Palmer, *The Life and Letters of Samuel Palmer, Painter and Etcher* (London: Seeley & Co., 1892), pp. 15–16.

15. Quoted in *XVII Designs to Thornton's Virgil*, 1899, p. 56.

16. Palmer 1892, pp. 15–16.

17. Cecil 1969, p. 10.

18. Palmer 1892, pp. 17–19.

19. Lister 1962. Best illustrations in Lawrence Binyon, *The Followers of William Blake* (New York and London, 1925).

20. Cormack 1986, pl. 169.

21. Blunt 1966, *Landscape with Diogenes*, no. 150, p. 108.

22. Antonin Proust, *Edouard Manet, Souvenirs* (Paris: H. Laurens, 1913).

23. Cikovsky and Quick 1985, p. 74.

Bibliography

Ackley, Clifford S. *Printmaking in the Age of Rembrandt.* Exhibition catalogue. Boston: Museum of Fine Arts and Saint Louis: The Saint Louis Art Museum, 1980.

Adam Elsheimer: Werk, künstlerisches Herkunft und Nachfolge. Exhibition catalogue. Frankfurt: Städelsches Kunstinstitut, 1966.

Adhémar, Hélène. *Watteau: Embarkation for Cythera.* London: Max Parrish, 1947.

Adler, Wolfgang. *Landscapes and Hunting Scenes.* Corpus Rubenianum Ludwig Burchard, no. 18. 2 vols. Translated by P. S. Falla. New York: Oxford University Press and London: Harvey Miller, 1982–86.

The Age of Correggio and the Carracci: Emilian Paintings of the Sixteenth and Seventeenth Centuries. Exhibition catalogue. Washington, D.C.: National Gallery of Art, 1986.

Aikema, Bernard, and Bert W. Meijer. *Disegni veneti di collezioni olandesi.* Exhibition catalogue. Venice: Fondazione Giorgio Cini and Florence: Istituto Universitario Olandese. Vicenza: Neri Pozza Editore, 1985.

Alberti, Leon Battista. *The Ten Books of Architecture: The 1755 Leoni Edition, Leon Battista Alberti.* Originally published as *The Architecture of Leon Batista [sic] Alberti in Ten Books.* Translation of Alberti's *De re aedificatoria* by James Leoni. London: R. Alfray, 1755. Reprint. New York: Dover Publications, 1986.

Alpers, Paul. *The Singer of the Eclogues: A Study of Virgilian Pastoral.* Berkeley and Los Angeles: University of California Press, 1979.

Anderson, Jaynie. "A Further Inventory of Gabriel Vendramin's Collection." *Burlington Magazine* 121 (October 1979): 639–48.

———. "Giorgione, Titian and the Sleeping Venus." In *Tiziano e Venezia: Convegno internazionale di studi, Venezia, 1976,* 337–42. Vicenza: Neri Pozza Editore, 1980.

Argan, Giulio Carlo. "La 'rettorica' e l'arte barocca." In *Atti del III congresso internazionale di studi umanistici,* 9–14. Rome: Fratelli Boca, 1955.

Arndt, Karl. "Pieter Bruegel d. A. und die Geschichte der 'Waldlandschaft.'" *Jahrbuch de Berliner Museen* 14 (1972): 69–121.

Askew, Pamela, ed. *Claude Lorrain 1600-1682: A Symposium.* Studies in the History of Art, vol. 14. Washington, D.C.: National Gallery of Art, 1984. Distributed by Hanover, NH and London: University Press of New England.

Bacou, Roseline. *French Landscape Drawings and Sketches of the Eighteenth Century.* Exhibition catalogue. London: British Museum, 1977.

Baglione, Giovanni. *Le vite de' pittori, scultori, architetti.* Rome: 1642.

Bailey, Colin B., ed. *The First Painters of the King: French Royal Taste from Louis XIV to the Revolution.* Exhibition catalogue. New York: Stair Sainty Matthiesen, 1985.

Baldass, Ludwig. "Les tableaux champêtres des Bassano et la peinture réaliste des Pays-Bas au XVIᵉ siècle." *Gazette des Beaux-Arts* 45 (March 1955): 143–60.

Banks, Oliver T. *Watteau and the North: Studies in the Dutch and Flemish Baroque Influences on French Rococo Painting.* New York and London: Garland, 1977.

Barolsky, Paul, and Norman E. Land. "The 'Meaning' of Giorgione's *Tempesta.*" *Studies in Iconography* 9 (1983): 57–65.

Bartsch, Adam. *Le peintre-graveur.* 21 vols. Vienna: J. V. Degen, 1803–21.

Battisti, Eugenio. "Le origini religiose del paesaggio veneto." *Archivio di filosofia* 1 (1980): 227–46.

Batz, George de, and George M. Richter. *Giorgione and His Circle.* Exhibition catalogue. Baltimore: Johns Hopkins University, 1942.

Bauer, Hermann. "Wo liegt Kythera?" In *Wandlungen des Paradiesischen und Utopischen,* 251–78. Probleme der Kunstwissenschaft, no. 2. Berlin: Walter de Gruyter, 1966.

Baxandall, Michael. *Giotto and the Orators: Humanist Observers of Painting in Italy and the Discovery of Pictorial Composition, 1350–1450.* Oxford: Clarendon Press, 1971.

Bean, Jacob, and Lawrence Turčić. *15th and 16th Century Italian Drawings in The Metropolitan Museum of Art.* New York: The Metropolitan Museum of Art, 1982.

———. *Fifteenth–Eighteenth Century French Drawings in The Metropolitan Museum of Art.* New York: The Metropolitan Museum of Art, 1986.

Bellori, Giovanni Pietro. *Le vite de' pittori, scultori ed architetti moderni.* Rome: 1672.

Bembo, Pietro. *Gli Asolani.* 1505. Translated by Rudolf B. Gottfried. Bloomington: Indiana University Press, 1954. Reprint. Freeport, NY: Books for Libraries Press, 1971.

Benesch, Otto. *Rembrandt.* Translated by James Emmons. Geneva: Skira, 1957.

———. *The Drawings of Rembrandt.* Edited by Eva Benesch. 6 vols. London: Phaidon, 1954–57. Rev. ed. London: Phaidon, 1973.

Bialostocki, Jan. "Le 'Baroque': style, époque, attitude." *L'Information d'Histoire de l'Art* 7 (January-February 1962): 20–33.

———. "The Renaissance Concept of Nature and Antiquity." In *Studies in Western Art: The Renaissance and Mannerism,* 19–30. Vol. 2 of *Acts of the Twentieth International Congress of the History of Art.* Princeton, NJ: Princeton University Press, 1963.

———. "Das Modusproblem in den bildenden Kunsten." In *Stil und Ikonographie.* Studien zur Kunstwissenschaft. Dresden: Veb Verlag der Kunst, 1966.

Bierens de Haan, Johan Catherinus Justus. *L'oeuvre gravé de Cornelis Cort, graveur hollandais.* The Hague: M. Nijhoff, 1948.

Bilder vom irdischen Glück: Giorgione—Titian—Rubens—Watteau—Fragonard. Exhibition catalogue. Berlin: Schloss Charlottenburg, 1983.

Bindman, David. *William Blake: His Art and Times.* Exhibition catalogue. New Haven: Yale Center for British Art and Toronto: Art Gallery of Ontario, 1982.

Bindman, David, with the assistance of Deirdre Toomey. *The Complete Graphic Works of William Blake.* New York: Putnam and London: Thames and Hudson, 1978.

Blunt, Anthony. "The Heroic and the Ideal Landscape in the Work of Nicolas Poussin." *Journal of the Warburg and Courtauld Institutes* 7 (1944): 209–29.

———. *Nicolas Poussin.* Bollingen Series, no. 7, 1958. New York: Bollingen Foundation, 1967. Distributed by New York: Pantheon Books.

———. *Nicolas Poussin: A Critical Catalogue.* London: Phaidon, 1966.

———. *The Drawings of Poussin.* New Haven and London: Yale University Press, 1979.

Blunt, Anthony, and Edward Croft-Murray. *Venetian Drawings of the XVII & XVIII Centuries in the Collection of Her Majesty the Queen at Windsor Castle.* London: Phaidon, 1957.

Bodelsen, Merete. "Gauguin's Cézannes." *Burlington Magazine* 104 (May 1962): 204–11.

Bohlin, Diane DeGrazia. *Prints and Related Drawings by the Carracci Family: A Catalogue Raisonné.* Exhibition catalogue. Washington, D.C.: National Gallery of Art, 1979.

Bonnard: The Late Paintings. Exhibition catalogue. Washington, D.C.: The Phillips Collection and Dallas: Dallas Museum of Art, 1984. Originally published as *Bonnard*. Paris: Musée National d'Art Moderne, Centre Georges Pompidou, 1984.

Bordeaux, Jean-Luc. "The Epitome of the Pastoral Genre in Boucher's Oeuvre: *The Fountain of Love* and *The Bird Catcher* from *The Noble Pastoral*." *The J. Paul Getty Museum Journal* 3 (1976): 75–101.

Borea, Evelina. "Aspetti del Domenichino paesista." *Paragone* 11 (March 1960): 8–16.

———. "Due momenti del Domenichino paesista: Le 'Mitologie' di Palazzo Farnese e della Villa Aldobrandini." *Paragone* 14 (November 1963): 22–33.

Borenius, Tancred. "A Propos de quelques dessins du Louvre: Watteau et Titien." *Beaux-Arts* 2 (1 November 1924): 279–80.

Boschloo, A[nton] W[illem] A[driaan]. *Annibale Carracci in Bologna: Visible Reality in Art after the Council of Trent*. Translated by R. R. Symonds. 2 vols. Kunsthistorische Studien van het Nederlands Instituut te Rome. The Hague: Government Publishing Office, 1974.

Bouret, Jean. *The Barbizon School and 19th-Century French Landscape Painting*. Greenwich, CT: New York Graphic Society, 1973. Originally published as *L'Ecole de Barbizon*. Neuchâtel: Editions Ides et Calendes, 1972.

Brettell, Richard et al. *A Day in the Country: Impressionism and the French Landscape*. Exhibition catalogue. Los Angeles: Los Angeles County Museum of Art and New York: Harry N. Abrams, 1984.

Brown, Christopher. *Dutch Landscape: The Early Years: Haarlem and Amsterdam 1590–1650*. Exhibition catalogue. London: National Gallery, 1986.

Brown, David Blayley. *Samuel Palmer 1805–1881: Loan Exhibition from the Ashmolean Museum, Oxford*. Exhibition catalogue. London: Hazlitt, Gooden and Fox and Edinburgh: National Gallery of Scotland, 1982. Reprint, as *Samuel Palmer 1805–1881: Catalogue Raisonné of the Paintings and Drawings, and a Selection of the Prints in the Ashmolean Museum*. Oxford: Ashmolean Museum, 1983.

Bryson, Norman. "Watteau and reverie." In *Word and Image: French Painting of the Ancien Regime*, 58–88. Cambridge and New York: Cambridge University Press, 1981.

Buckley, Elizabeth Trimble. *Poesia Muta: Allegory and Pastoral in the Early Paintings of Titian*. Ann Arbor, MI: University Microfilms International, 1978.

Burckhardt, Jakob. *The Civilization of the Renaissance in Italy*. Translated by S.G.C. Middlemore. 1860. Reprint. London: Phaidon, 1965.

Byam Shaw, James. "Titian's Drawings: A Summing Up." *Apollo* 112 (December 1980): 386–91.

———. *The Italian Drawings of the Frits Lugt Collection*. 3 vols. Paris: Institut Néerlandais, 1983.

Le Cabinet d'un Grand Amateur P. J. Mariette 1694–1774: Dessins du XVᵉ siècle au XVIIIᵉ siècle. Exhibition catalogue. Introduction by Maurice Sérullaz. Texts by Frits Lugt, Roseline Bacou, and Françoise Viatte. Paris: Musée du Louvre, 1967.

Calvesi, Maurizio, ed. *Giorgione e la cultura veneta tra '400 e '500: mito, allegoria, analisi iconologica: Atti del convegno*. Rome: De Luca Editore, 1981.

Carezzolo, S. et al. "Castel S. Zeno di Montagnana in un disegno attribuito a Giorgione." *Antichità viva* 17 (July–October 1978): 40–52.

Cast, David. "The Stork and the Serpent: A New Interpretation of the *Madonna of the Meadow* by Bellini." *Art Quarterly* 32 (Autumn 1969): 247–57.

Catalogue of the Ellesmere Collection of Drawings by the Carracci and other Bolognese Masters Collected by Sir Thomas Lawrence. Sale catalogue. London: Sotheby, 11 July 1972.

Catelli Isola, Maria. *Immagini da Tiziano: Stampe dal sec. XVI al sec. XIX dalle collezioni del Gabinetto Nazionale delle Stampe*. Exhibition catalogue. Rome: De Luca Editore, 1976.

Cavalli-Bjorkman, Gorel, ed. *Bacchanals by Titians and Rubens*. Stockholm: Nationalmuseum, 1987.

Cecil, David. *Visionary and Dreamer, Two Poetic Painters: Samuel Palmer and Edward Burne-Jones*. Bollingen Series, no. 15, 1966. Princeton, NJ: Princeton University Press, 1969.

Champion, Pierre Honoré, ed. *Notes critiques sur les vies anciennes d'Antoine Watteau*. Paris: E. Champion, 1921.

Charlton, D. G. *New Images of the Natural in France: A Study in European Cultural History 1750–1800*. New York and Cambridge: Cambridge University Press, 1984.

Chastel, André. "L'ardita capra." *Arte veneta* 29 (1975): 146–49. Reprinted in *Fables, formes, figures*, vol. 2, 121–27. 2 vols. Paris: Flammarion, 1978.

Chatelet, Albert. "Les dessins et gravures de paysage de Domenico Campagnola." *Venezia e l'Europa: Atti del XVIII congresso internazionale di storia dell'arte*, 258–59. Venice: Casa Editrice Arte Veneta, 1956.

Chennevières, Ph. de, and A. de Montaiglon. *Abecedario de P. J. Mariette et autres notes inédites de cet amateur sur les arts et les artistes....* 6 vols. Paris: J. B. Dumoulin, 1851/53–1859/60. Reprint. Paris: F. de Nobèle, 1966.

Chiari, Maria Agnese. *Incisioni da Tiziano: Catalogo del fondo grafico a stampa del Museo Correr*. Venice: La Stamperia di Venezia, 1982.

Chiarini, Marco. "Alcuni quadri di paesaggio nel Museo di Belle Arti di Budapest." *Bulletin du Musée Hongrois des Beaux-Arts* nos. 32–33 (1969): 123–29.

———. *I Disegni italiani di paesaggio dal 1600 al 1750*. Treviso: Libreria Editrice Canova, 1972.

Christiansen, Keith. "Titianus (Per)fecit." *Apollo* 125 (March 1987): 190–96.

Cikovsky, Nicolai, Jr., and Michael Quick. *George Inness*. Exhibition catalogue. Los Angeles: Los Angeles County Museum of Art and New York: Harper and Row, 1985.

Clark, Kenneth. "Four Giorgionesque Panels." *Burlington Magazine* 71 (November 1937): 199–206.

———. *Landscape into Art*. London: John Murray, 1949. Rev. ed. New York: Harper and Row, 1976.

———. *Rembrandt and the Italian Renaissance*. New York: New York University Press, 1966.

Como, Ugo da. *Girolamo Muziano 1528-1592: note e documenti*. Bergamo: Istituto italiano d'arti graphiche, 1930.

Conisbee, Philip. *Painting in Eighteenth-Century France*. Ithaca, NY: Cornell University Press and Oxford: Phaidon, 1981.

Cormack, Malcolm. *Constable*. New York and Cambridge: Cambridge University Press, 1986.

Corsini, Piero. *Important Old Master Paintings and Discoveries of the Past Year*. Exhibition catalogue. New York: Piero Corsini, 1986.

Crow, Thomas E. *Painters and Public Life in Eighteenth-Century Paris*. New Haven and London: Yale University Press, 1985.

Cuno, James B. "Matisse and Agostino Carracci: A source for the 'Bonheur de vivre.'" *Burlington Magazine* 122 (July 1980): 503–5.

Curtius, Ernst Robert. *European Literature and the Latin Middle Ages*. Translated by Willard R. Trask. Bollingen Series, no. 35. New York: Pantheon Books, 1953.

Dacier, Emile. "Caylus, Graveur de Watteau." *L'Amateur d'Estampes* 5 (December 1926): 161–69; 6 (January 1927): 1–10; 6 (March 1927): 52–58; 6 (May 1927): 69–77.

Dacier, Emile, Jacques Hérold, and Albert Vuaflart. *Jean de Jullienne et les graveurs de Watteau au XVIIIᵉ siècle.* 4 vols. Paris: Pour les Membres de la Société [pour l'Etude de la Gravure française], 1921–29.

Davies, Martin. *The Earlier Italian Schools.* Rev. ed. London: National Gallery, 1961.

Démoris, Réné. "Les fêtes galantes chez Watteau et dans le roman contemporain." *Dix-huitième siècle* (1971): 337–57.

Dempsey, Charles. *Annibale Carracci and the Beginnings of Baroque Style.* Villa I Tatti, Harvard University Center for Italian Renaissance Studies. Gluckstadt: J. J. Augustin Verlag, 1977.

———. "Some Observations on the Education of Artists in Florence and Bologna during the Later Sixteenth Century." *Art Bulletin* 62 (December 1980): 552–69.

———. "The Carracci *Postile* to Vasari's *Lives.*" *Art Bulletin* 68 (March 1986): 72–76.

Denison, Cara D. et al. *Drawings from the Collection of Mr. & Mrs. Eugene Victor Thaw.* Part 2. Exhibition catalogue. Introductions by Eugene Victor Thaw and Charles Ryskamp. New York: The Pierpont Morgan Library and Richmond: Virginia Museum of Fine Arts, 1985.

Dickey, Stephanie S. "'Judicious Negligence': Rembrandt Transforms an Emblematic Convention." *Art Bulletin* 68 (June 1986): 253–62.

Dolce, Lodovico. *Dialogo di M. Lodovico Dolce, nel qvale si ragiona delle qualita, diuersita, et proprieta de i colori.* Venice: Appresso G.B., et M. Sessa fratelli, 1565.

Dopo Mantegna: Arte a Padova e nel territorio nei secoli XV e XVI. Exhibition catalogue. Padua: Palazzo della ragione and Milan: Electa Editore, 1976.

Dorment, Richard. *British Painting in the Philadelphia Museum of Art from the Seventeenth through the Nineteenth Century.* Philadelphia: Philadelphia Museum of Art, 1986.

Dresdner, Albert. "Von Giorgione zum Rokoko." *Preussische Jahrbücher* 140 (April 1910): 22–47.

Dreyer, Peter. "Xilografie di Tiziano a Venezia." *Arte veneta* 30 (1976): 271–72.

———. "Tizianfälschungen des sechzehnten Jahrhunderts: Korrekturen zur Definition der Delineatio bei Tizian und Anmerkungen zur Datierung seiner Holzschnitte." *Pantheon* 37 (October-December 1979): 365–75.

———. "A woodcut by Titian as a model for Netherlandish landscape drawings in the Kupferstichkabinett, Berlin." *Burlington Magazine* 127 (November 1985): 766–67.

Duncan, Carol. *The Pursuit of Pleasure: The Rococo Revival in French Romantic Art.* New York and London: Garland, 1976.

Duverger, Erik. "Réflexions sur le commerce d'art au XVIIIᵉ siècle." In *Stil und Überlieferung in der Kunst des Abendlandes,* 65–88. Vol. 3 of *Akten des 21. Internationalen Kongresses für Kunstgeschichte in Bonn 1964.* Berlin: Gebr. Mann, 1967.

Edwards, Hugh. "Two Drawings by Antoine Watteau." *Museum Studies* 7 (1966): 9–10.

Egan, Patricia. "*Poesia* and the *Fête Champêtre.*" *Art Bulletin* 41 (December 1959): 303–13.

Ehrard, Jean. *L'Idée de nature en France dans la première moitié du XVIIIᵉ siècle.* Paris, 1963. Reprint. Geneva: Slatkine, 1981.

Eidelberg, Martin P. "Watteau's Use of Landscape Drawings." *Master Drawings* 5 (November 1967): 173–82.

———. *Watteau's Drawings: Their Use and Significance.* New York and London: Garland, 1977.

Eighteenth-Century Venetian Drawings from the Correr Museum. Exhibition catalogue. Introduction by Terisio Pignatti. Washington, D.C.: National Gallery of Art, 1963.

Elderfield, John. "The Pastoral, the Primitive, and the Ideal." In *The "Wild Beasts": Fauvism and Its Affinities,* 97–139. New York: Museum of Modern Art, 1976.

The Ellesmere Collection of Drawings by the Carracci and Other Bolognese Masters, Part 1. London: Sotheby, 1972.

Emison, Patricia. "Invention and the Italian Renaissance Print." Ph.D. diss., Columbia University, 1985.

Eskridge, Robert William. "Attitude toward Seventeenth-Century Landscape Painting in Rome." Master's thesis, Oberlin College, 1979.

Farr, Dennis, and William Bradford. *The Northern Landscape: Flemish, Dutch and British Drawings from the Courtauld Collections.* Exhibition catalogue. New York: The Drawing Center and London: The Courtauld Institute Galleries. London: Trefoil Books, 1986.

Fasolo, Ugo. *Titian.* Translated by Patrick Creagh. Florence and New York: Scala Books, 1980.

Fehl, Philipp. "The Hidden Genre: A Study of the *Concert Champêtre* in the Louvre." *Journal of Aesthetics and Art Criticism* 16 (December 1957): 153–68.

Fenyő, Iván. *North Italian Drawings from the Collection of the Budapest Museum of Fine Arts.* Budapest: Corvina Press, 1965.

Fischer, Erik. "Orpheus and Calais on the Subject of Giorgione's *Concert Champêtre.*" In *Liber Amicorum Karel G. Boon,* 71–74. Amsterdam: Swets & Zeithuger BV, 1974.

Flam, Jack. *Matisse: The Man and his Art 1869–1918.* Ithaca, NY and London: Cornell University Press, 1986.

Fleming, John V. *From Bonaventure to Bellini: An Essay in Franciscan Exegesis.* Princeton, NJ: Princeton University Press, 1982.

François Boucher: 1703–1770. Exhibition catalogue. New York: The Metropolitan Museum of Art, 1986.

Freedberg, David. *Dutch Landscape Prints of the Seventeenth Century.* British Museum Prints and Drawings Series. London: British Museum Publications, Colonnade Books, 1980.

Freedberg, Sydney J. *Painting in Italy 1500 to 1600.* Baltimore and Harmondsworth: Penguin Books, 1971. 2d rev. ed., 1975.

———. *Circa 1600: A Revolution of Style in Italian Painting.* Cambridge and London: Harvard University Press, 1983.

Freedman, Luba. "The Pastoral Theme in the Visual Arts of the Renaissance, Baroque and Rococo." Ph.D. diss., Hebrew University, Jerusalem, 1983.

Gaehtgens, Thomas. "Archaeology and Enlightenment: The Comte de Caylus and French Neo-Classicism." Translated by Sheldon Cheek. In *The First Painters of the King: French Royal Taste from Louis XIV to the Revolution,* 37–45. Exhibition catalogue. New York: Stair Sainty Matthiesen, 1985.

Gelder, J. G. van. "Episcopius (Jan de Bisschop) after Venetian Paintings." In *Venezia e l'Europa: Atti del XVIII congresso internazionale di storia dell'arte,* 335–36. Venice: Casa Editrice Arte Veneta, 1956.

———. "Jan de Bisschop 1628–1671." *Oud-Holland* 86 (1971): 201–88.

Gemäldegalerie Berlin: Geschichte der Sammlung und ausgewahlte Meisterwerke. Texts by Henning Bock et al. Berlin: Staatliche Museen Preussischer Kulturbesitz, 1985.

Gerstenberg, Kurt. *Die ideale Landschaftsmalerei: Ihre begründung und vollendung in Rom.* Halle: Max Niemeyer, 1923.

Giamatti, A. Bartlett. *The Earthly Paradise and the Renaissance Epic.* Princeton, NJ: Princeton University Press, 1966.

Gilbert, Creighton. "On Subject and Not-Subject in Italian Renaissance Pictures." *Art Bulletin* 34 (September 1952): 202–16.

Gilchrist, Alexander. *Life of William Blake.* New York: E. P. Dutton and London: J. M. Dent and Sons, 1942.

Giorgione: Atti del convegno internazionale di studio per il 5° centenario della nascita. Castelfranco Veneto: Commune di Castelfranco Veneto, 1979.

Gleeson, Larry, ed. *Followers of Blake.* Exhibition catalogue. Santa Barbara: Santa Barbara Museum of Art, 1976.

Glück, Gustav. *Die Landschaften von Peter Paul Rubens.* Vienna: Anton Schroll, 1945.

Goldfarb, Hilliard T. "Boucher's *Pastoral Scene with Family at Rest* and the Image of the Pastoral in Eighteenth-Century France." *Bulletin of The Cleveland Museum of Art* 71 (March 1984): 82–89.

_____. "An Early Masterpiece by Titian Rediscovered, and its Stylistic Implications." *Burlington Magazine* 126 (July 1984): 419–23.

Gombrich, E. H. "The Renaissance Theory of Art and the Rise of Landscape." In *Norm and Form: Studies in the Art of the Renaissance,* 107–21. London: Phaidon, 1966. 2d. ed. New York and London: Phaidon, 1971.

Goncourt, Edmond and Jules de. *French Eighteenth-Century Painters: Watteau, Boucher, Chardin, La Tour, Greuze and Fragonard.* Translated with an introduction by Robin Ironside. London: Phaidon, 1948. Reprint, with corrections. Ithaca, NY: Cornell University Press, 1981.

Gould, Cecil. *The Sixteenth-Century Venetian School.* London: National Gallery, 1959.

_____. "Sebastiano Serlio and Venetian Painting." *Journal of the Warburg and Courtauld Institutes* 25 (1962): 56–64.

Gowing, Lawrence. "Nature and the Ideal in the Art of Claude." Review of *Claude Lorrain: The Drawings* by Marcel Röthlisberger. *Art Quarterly* 37 (Spring 1974): 91–97.

Grad, Bonnie Lee. *Milton Avery.* Foreword by Sally Michel Avery. Royal Oak, MI: Strathcona, 1981.

Grasselli, Margaret Morgan, and Pierre Rosenberg, with the assistance of Nicole Parmantier. *Watteau 1684–1721.* Exhibition catalogue. Washington, D.C.: National Gallery of Art, 1984.

Hand, John Oliver et al. *The Age of Bruegel: Netherlandish Drawings in the Sixteenth Century.* Exhibition cata-logue. Washington, D.C.: National Gallery of Art and New York: The Pierpont Morgan Library. Cambridge: Cambridge University Press, 1986.

Harris, Ann Sutherland. *Landscape Painting in Rome: 1595–1675.* Exhibition catalogue. Contributions by Marcel Röthlisberger and Kahren Hellerstedt. New York: Richard L. Feigen, 1985.

Haskell, Francis. "Giorgione's *Concert Champêtre* and its Admirers." *Journal of the Royal Society of Arts* 119 (July 1971): 543-55. Reprinted in *Past and Present in Art and Taste: Selected Essays,* 141–53. New Haven and London: Yale University Press, 1987.

_____. *Patrons and Painters: A Study in the Relations between Italian Art and Society in the Age of the Baroque.* New York: Alfred A. Knopf, 1963. Reprint. New York: Harper & Row, 1971.

Held, Julius S. "Rubens and Titian." In *Titian: His World and his Legacy,* 283–339. Edited by David Rosand. New York: Columbia University Press, 1982.

Herbert, Robert L. *Jean-François Millet.* Exhibition cata-logue. Translated by Marie-Geneviève de la Coste-Messelière. Paris: Grand Palais and London: Hayward Gallery, 1975.

Hind, Arthur M. "Adam Elsheimer II—His Original Etch-ings." *Print Collector's Quarterly* 13 (February 1926): 8–29.

_____. *Early Italian Engraving.* 7 vols. London: Bernard Quaritch, published for the National Gallery of Art, Washington, D.C., 1948.

Hirschmann, Otto. *Verzeichnis des graphischen Werks von Hendrik Goltzius 1558–1617.* Braunschweig: Klinkhardt & Biermann, 1976.

Hodge, Rupert. "A Carracci Drawing in the Studio of Rubens." *Master Drawings* 15 (Autumn 1977): 268–69.

Hofmann, Werner. *The Earthly Paradise: Art in the Nine-teenth Century.* Translated by Brian Battershaw. New York: George Braziller, 1961.

Hollstein, F.W.H. *Dutch and Flemish Etchings, Engravings and Woodcuts ca. 1450–1700.* Amsterdam: Menno Hertzberger, 1949–.

Horace. *Odes and Epodes.* Translated by Charles Edwin Bennett. Cambridge: Loeb Classical Library, 1927.

Howard, Deborah. "Giorgione's *Tempesta* and Titian's *Assunta* in the Context of the Cambrai Wars." *Art His-tory* 8 (September 1985): 271–89.

Howard Hodgkin: Forty Paintings 1973–84. Exhibition catalogue. London: Whitechapel Art Gallery, 1984.

L'Ideale classico del seicento in Italia e la pittura di paesaggio: V Mostra biennale d'arte antica. Exhibition catalogue. Preface by Germain Bazin and introduction by Cesare Gnudi. Texts by Francesco Arcangeli et al. Bolo-gna: Edizioni Alfa, 1962.

Jacoby, Beverly Schreiber. "A Landscape Drawing by Fran-çois Boucher after Domenico Campagnola." *Master Drawings* 17 (Autumn 1979): 261–72.

Jaffé, Michael. "The Interest of Rubens in Annibale and Agostino Carracci: further notes." *Burlington Magazine* 99 (November 1957): 375–79.

_____. "The Second Sketch Book by Van Dyck." *Burlington Magazine* 101 (September-October 1959): 317–21.

_____. "Some Pen Drawings of Landscape with Figures by Annibale Carracci." *Bulletin du Musée Hongrois des Beaux-Arts* (1964): 87–97.

_____. "Rubens as a Collector of Drawings." Parts 1, 2. *Master Drawings* 2 (1964): 383–97; 3 (1965): 21–35.

_____. *Van Dyck's Antwerp Sketchbook.* 2 vols. London: Macdonald, 1966.

_____. "A Landscape by Rubens, and another by Van Dyck." *Burlington Magazine* 108 (August 1966): 410, 413–16.

_____. *European Drawings from the Fitzwilliam.* Wash-ington, D.C.: International Exhibitions Foundation, 1976.

_____. *Rubens and Italy.* Oxford: Phaidon, 1977.

_____. *Old Master Drawings from Chatsworth: A Loan Exhibition from the Devonshire Collection.* Exhibition catalogue. Pittsburgh: The Frick Art Museum and Al-exandria, VA: International Exhibitions Foundation, 1987.

Jean-Richard, Pierrette. *Musée du Louvre, Cabinet des Dessins, Collection Edmond de Rothschild. Inventaire générale des gravures, Ecole française.* Vol. 1. *L'oeuvre gravé de François Boucher dans la Collection Edmond de Rothschild,* 33–61. Paris: Editions des musées nationaux, 1978.

Johnson, Robert Flynn, and Joseph R. Goldyne. *Master Drawings from the Achenbach Foundation for Graphic Arts, The Fine Arts Museums of San Francisco.* Geneva: Richard Burton and San Francisco: California Palace of the Legion of Honor, 1985.

Kalnein, Wend, and Michael Levey. *Art and Architecture of the Eighteenth Century in France.* Baltimore and Harmondsworth: Penguin Books, 1972.

Kaplan, Paul H.D. "The Storm of War: The Paduan Key to Giorgione's *Tempesta*." *Art History* 9 (December 1986): 405–27.

Kennedy, I. G. "Claude and Architecture." *Journal of the Warburg and Courtauld Institutes* 35 (1972): 260–83.

Kennedy, William J. *Jacobo Sannazaro and the Uses of Pastoral*. Hanover, NH and London: University Press of New England, 1983.

Kettering, Alison McNeil. "Rembrandt's *Flute player*: A unique treatment of pastoral." *Simiolus* 9 (1977): 19–44.

———. *The Dutch Arcadia: Pastoral Art and its Audience in the Golden Age*. Totowa and Montclair, N.J.: Allanheld and Schraam; Woodbridge, Suffolk: Boydell Press, 1983.

Kettering, A[lison] McNeil, and P.E.L. Verkuyl. *La Pastorale olandese nel seicento: L'ispirazione poetica della pittura nel secolo d'oro*. Exhibition catalogue. Rome: Istituto Olandese, 1983.

Kieser, E[mil]. "Tizians und Spaniens Ein-wirkungen auf die Spateren Landschaften des Rubens." *Münchner Jahrbuch der bildenden Kunst* n.s. 8 (1931): 281–91.

Kitson, Michael. "The 'Altieri Claudes' and Virgil." *Burlington Magazine* 102 (July 1960): 312–18.

———. "The Place of Drawings in the Art of Claude Lorrain." In *Studies in Western Art: Latin American Art, and the Baroque Period*, Vol. 3 of *Acts of the Twentieth International Congress of the History of Art*, 96–112. Princeton, NJ: Princeton University Press, 1963.

Knab, Eckhart. "Appreciation of Michael Kitson's Paper: Stylistic Problems of Claude's Draftsmanship." In *Studies in Western Art: Latin American Art, and the Baroque Period in Europe*, Vol. 3 of *Acts of the Twentieth International Congress of the History of Art*, 113–17. Princeton, NJ: Princeton University Press, 1963.

Krautheimer, Richard. "The Tragic and Comic Scene of the Renaissance: The Baltimore and Urbino Panels." In *Studies in Early Christian, Medieval, and Renaissance Art*, 345–59. New York: New York University Press and London: University of London Press, 1969.

Kuretsky, Susan Donahue. "Rembrandt's Tree Stump: An Iconographic Attribute of St. Jerome." *Art Bulletin* 56 (December 1974): 571–80.

Labrot, Gérard. "Conservatisme plastique et expression rhétorique: réflexions sur le developpement de l'academisme en Italie centrale (Rome et Florence) (1550 env.–1620 env.)." *Mélanges d'archéologie et d'histoire* 76 (1964): 555–624.

Laing, Alastair. "Boucher et la pastorale peinte." *Revue de l'art* (1986): 55–64.

Laing, Alastair et al. *François Boucher 1703–1770*. Exhibition catalogue. New York: The Metropolitan Museum of Art, 1986.

Lee, Rensselaer W. Review of *Studies in Seicento Art and Theory* by Denis Mahon. *Art Bulletin* 33 (September 1951): 204–12.

———. "Erminia in Minneapolis." In *Studies in Criticism and Aesthetics, 1660-1800: Essays in Honor of Samuel Holt Monk*, 36–57. Edited by Howard Anderson and John S. Shea. Minneapolis: University of Minnesota Press, 1967(a).

———. *Ut Pictor Poesis: The Humantistic Theory of Painting*. New York: W. W. Norton, 1967(b). Originally published in *Art Bulletin* 22 (December 1940): 197–269.

LeFebre, Valentin. *Opera selectioria quae Titianus Vecellius Cadubriensis et Paulus Calliari Veronensis inventarunt ac pinxerunt quaeque Valentinus le Febre Bruxellensis delineavit et sculpsit*. Venice: Jan van Campen, 1682.

Lefrançois, Thierry. *Nicolas Bertin (1668–1736): Peintre d'Histoire*. Neuilly-sur-Seine: Arthena, 1981.

Lemonnier, Henri. "A propos des 'Pastorales' de Boucher." In *L'Art Moderne (1500–1800): Essais et Esquisses*. Paris: Librairie Hachette, 1912.

Levenson, Jay A., Konrad Oberhuber, and Jacquelyn L. Sheehan. *Early Italian Engravings from the National Gallery of Art*. Washington, D.C.: National Gallery of Art, 1973.

Levey, Michael. "The Real Theme of Watteau's *Embarcation for Cythera*." *Burlington Magazine* 103 (1961): 180ff.

———. *Painting in Eighteenth-Century Venice*. London, 1959. 2d rev. ed. Ithaca, NY: Cornell University Press, 1980.

Levy, Jean. "Une vie inconnue d'Antoine Watteau." *Bulletin de la Société de l'Histoire de l'Art français* (1957): 175-203.

Lister, Raymond. *Edward Calvert*. London: G. Bell and Sons, 1962.

———. *Samuel Palmer and his Etchings*. New York: Watson-Guptill and London: Faber and Faber, 1969.

———. *Samuel Palmer and "The Ancients."* Exhibition catalogue. New York and Cambridge: Cambridge University Press, 1984.

Lomazzo, Giovan Paolo. *Trattato dell'arte della pittura, scoltura, et architettura*. Milan: P.G. Pontio, 1584. Reprinted in *Scritti sulle arti*. Edited by Roberto Paolo Ciardi. 2 vols. Florence: Marchi & Bertolli, 1973–74.

Lugt, Frits. "Pieter Bruegel und Italien." In *Festschrift für Max J. Friedlander zum 60. Geburtstage*, 111–29. Leipzig: E. A. Seemann, 1927.

Macandrew, Hugh. *Italian Schools: Supplement*, Vol. 3., *Catalogue of the Collection of Drawings in the Ashmolean Museum*. Oxford: Clarendon Press, 1980.

Magnuson, Torgil. *Rome in the Age of Bernini*. Translated by Nancy Adler. 2 vols. New Jersey: Humanities Press and Stockholm: Almqvist & Wiksell, 1982.

Mahon, Denis. *Studies in Seicento Art and Theory*. London: Warburg Institute, University of London, 1947.

———. "Art Theory and Artistic Practice in the Early Seicento: Some Clarifications." *Art Bulletin* 35 (September 1953): 226–32.

———. "Eclecticism and the Carracci: Further Reflections on the Validity of a Label." *Journal of the Warburg and Courtauld Institutes* 16 (July-December 1953): 303–41.

———. *Mostra dei Carracci: Catalogo critico dei disegni*. Exhibition catalogue. Translated from English by Maurizio Calvesi. Bologna: Palazzo dell'Archiginnasio, 1956. 2d rev. ed. Bologna: Edizioni Alfa, 1963.

Mancini, Giulio. *Considerazione sulla pittura*. Rome: 1614–21 with additions until 1630. Reprint. A. Marucchi and L. Salerno, eds. Rome, 1956–57.

Mander, Carel van. *Het Schilderboeck*. Haarlem: Paschier van Westbusch, 1604. Reprint, in facsimile. Utrecht: Davaco Publishers, 1969. 2d ed., 1618. Translated, with an introduction by Constant van de Wall, under the title *Carel van Mander. Dutch and Flemish Painters*. New York: McFarlane, Warde, McFarlane, 1936.

Marinelli, Peter V. *Pastoral*. The Critical Idiom, edited by John D. Jump, vol. 15. London: Methuen, 1971.

Martin, Gregory. "Two closely related Landscapes by Rubens." *Burlington Magazine* 108 (April 1966): 180–84.

Martineau, Jane, and Charles Hope, eds. *The Genius of Venice 1500–1600*. Exhibition catalogue. London: Royal Academy of Arts and Weidenfeld and Nicolson, 1983.

Masheck, Joseph. "Art Theory." Review of *Roger de Piles' Theory of Art* by Thomas Puttfarken. *Art in America* 75 (February 1987): 29.

M[atthiesen], P[atrick] D. *From Borso to Cesare d'Este: The School of Ferrara 1450–1628*. Exhibition catalogue. London: Matthiesen Fine Art, 1984.

Mauroner, Fabio. *Le incisioni di Tiziano*. 2d ed. Padua: Le Tre Venezie, 1943.

Mauzi, Robert. *L'idée de bonheur dans la littérature et la pensée françaises au XVIIIᵉ siècle*. 4th ed. Paris: Librairie Armand Colin, 1960.

Meijer, Bert W. *Hommage à Titien, vers 1490–1576: Dessins, gravures et lettres autographés de Titien et d'artistes du nord*. Exhibition catalogue. Paris: Institut Néerlandais and Florence: Istituto Universitario Olandese, as *Omaggio a Tiziano: Mostra di disegni, lettere et stampe di Tiziano e artisti nordici*, 1976.

Meiss, Millard. *Giovanni Bellini's St. Francis in the Frick Collection*. Princeton, NJ: Princeton University Press, 1964.

———. "Sleep in Venice: Ancient Myths and Renaissance Proclivities." In *The Painter's Choice: Problems in the Interpretation of Renaissance Art*, 212–39. New York: Harper and Row, 1976.

Michel, Edouard, Robert Aulanier, and Hélène de Vallée. *Watteau: L'Embarquement pour l'île de Cythère*. Monographies des peintures du Musée du Louvre, no. 2. Tours: Editions des musées nationaux, 1939.

Middledorf, Ulrich. "Eine Zeichnung von Giulio Campagnola?" In *Festschrift Martin Wackernagel zum 75. Geburtstag*, 141–52. Cologne: Bohlau Verlag, 1958.

Mirimonde, A.-P. de. "Les sujets musicaux chez Antoine Watteau." *Gazette des Beaux-Arts* 58 (November 1961): 249–88.

Il Mito del classicismo nel seicento. Introduction by Stefano Bottari. Texts by L. Anceschi et al. Messina and Florence: Casa Editrice G. d'Anna, 1964.

Mongan, Agnes. "European Landscape Drawing 1400–1900: A Brief Survey." *Daedalus* 92 (Summer 1963): 581–635.

Morassi, Antonio. "Esordi di Tiziano." *Arte veneta* 8 (1954): 178–98.

Mucchi, Ludovico. "Caratteri radiografici della pittura di Giorgione." In *I Tempi di Giorgione*, 3. Exhibition catalogue. Florence: Fratelli Alinari, 1978.

Mules, Helen Bobritzsky. *Dutch Drawings of the Seventeenth Century in The Metropolitan Museum of Art*. New York: The Metropolitan Museum of Art, 1985. Reprinted from *Metropolitan Museum of Art Bulletin* (Spring 1985).

Münz, Ludwig. *Rembrandt's Etchings: Reproductions of the Whole Original Etched Work*. 2 vols. London: Phaidon, 1952.

———. *Bruegel: The Drawings*. London: Phaidon, 1961.

Muraro, Michelangelo. "The Political Interpretation of Giorgine's Frescoes on the Fondaco dei Tedeschi." *Gazette des Beaux-Arts* 86 (December 1975): 177–84.

———. *Pittura e società: Il Libro dei Conti e la bottega dei Bassano*. Dispense universitarie. Padua: Università di Padova, 1982–1983.

———. *Civiltà delle ville venete*. Udine: Magnus, 1986.

Oberhuber, Konrad. "Hieronymous Cock, Battista Pittoni und Paolo Veronese in Villa Maser." In *Munuscula Discipulorum: Kunsthistorische Studien, Hans Kauffmann zum 70 Geburtstag, 1966*, 207–24. Berlin Bruno Hessling, 1968.

———. *Zwischen Renaissance und Barock: Das Zeitalter von Bruegel und Bellange. Die Kunst der Graphik, IV. Werke aus dem Besitz der Albertina*. Exhibition catalogue. Vienna: Albertina, 1967. Reprint. New York: Arno/Worldwide, 1968.

———. "Gli affreschi di Paolo Veronese nella Villa Barbaro." *Bollettino del Centro Internazionale di Studi di Architettura Andrea Palladio* 10 (1968): 188–202.

———. "Tiziano disegnatore di paesaggi." In *Tiziano e il manierismo europeo: Corso internazionale di alta cultura, 18th, Venice 1976*. Exhibition catalogue. Edited by Rodolfo Pallucchini. Florence: Leo S. Olschki, 1978.

———. "Bruegel's Early Landscape Drawings." *Master Drawings* 19 (Summer 1981): 146–56.

Oberhuber, Konrad, and Dean Walker. *Sixteenth-Century Italian Drawings from the Collection of Janos Scholz*. Exhibition catalogue. Washington, D.C.: National Gallery of Art and New York: The Pierpont Morgan Library, 1973.

Oberhuber, Konrad, with the assistance of Hilliard Goldfarb. *Disegni di Tiziano e della sua cerchia*. Exhibition catalogue. Vicenza: Neri Pozza Editore, 1976.

Pallucchini, Rodolfo. *Tiziano*. 2 vols. Florence: G. C. Sansoni Editore, 1969.

———, ed. *Giorgione e l'umanesimo veneziano: Corso internazionale di alta cultura*. 2 vols. Florence: Leo S. Olschki, 1981.

———. *Veronese*. Milan: Arnoldo Mondadori, 1984.

Panofsky, Erwin. "Et in Arcadia Ego: On the Conception of Transience in Poussin and Watteau." In *Philosophy and History: Essays Presented to Ernst Cassirer*. Oxford: Clarendon Press, 1936. Reprint, edited by Raymond Klibansky and H. J. Paton. New York: Harper and Row, 1963.

———. *Problems in Titian, Mostly Iconographic*. New York: New York University Press, 1969.

Parker, K.T. *Italian Schools*, Vol. 2, *Catalogue of the Collection of Drawings in the Ashmolean Museum*. Oxford: Clarendon Press, 1956.

———. *The Drawings of Antoine Watteau*. London: B. T. Batsford, 1931. Reprint. New York: Hacker Art Books, 1970.

Parker, K. T., and J. Mathey. *Antoine Watteau: Catalogue complet de son oeuvre-dessiné*. 2 vols. Paris: F. de Nobèle, 1957.

Pater, Walter. *The Renaissance: Studies in Art and Poetry*. Edited by Donald L. Hill. Berkeley and Los Angeles: University of California Press, 1980.

Paulson, Ronald. *Emblem and Expression: Meaning in English Art of the Eighteenth Century*. Cambridge: Harvard University Press and London: Thames and Hudson, 1975.

———. *Literary Landscape: Turner and Constable*. New Haven and London: Yale University Press, 1982.

Peck, Robert McCracken. "Thomas Eakins and Photography: The Means to an End." *Arts Magazine* 53 (May 1979): 113–17.

Phillips, Duncan. *The Leadership of Giorgione*. Washington, D.C.: The American Federation of Arts, 1937.

Pignatti, Terisio. *Giorgione*. Venice: Alfieri, 1969. 2d ed. Milan: Alfieri, 1978. English translation by Clovis Whitfield. New York and London: Phaidon, 1971.

———. *Tiziano: Disegni*. Florence: La Nuova Italia, 1979.

———. *Five Centuries of Italian Painting 1300–1800 from the Collection of The Sarah Campbell Blaffer Foundation*. Houston: The Sarah Campbell Blaffer Foundation, 1985.

Pignatti, Terisio, and Giandomenico Romanelli. *Drawings from Venice: Masterworks from the Museo Correr, Venice*. Exhibition catalogue. New York: The Drawing Center and London: Trefoil Books, 1985.

Piles, Roger de. *Cours de peinture par principes*. Paris: Jacques Estienne, 1708. Reprint. Geneva: Slatkine Reprints, 1969.

Pirrotta, Nino. "Musiche intorno a Giorgione." In *Giorgione: Atti del convegno internazionale di studio per il 5° centenario della nascita*, 41–45. Castelfranco Veneto: Commune di Castelfranco Veneto, 1979.

Pochat, Götz. *Figur und Landschaft: Eine historische Interpretation der Landschaftsmalerei von der Antik bis zur Renaissance*. Berlin and New York: De Gruyter, 1973.

Poggioli, Renato. *The Oaten Flute: Essays on Pastoral Poetry and the Pastoral Ideal*. Cambridge: Harvard University Press, 1975.

Pointon, Marcia. "Gainsborough and the Landscape of Retirement." *Art History* 2 (December 1979): 441–55.

Pomian, Krzystof. "Marchands, connaisseurs, curieux à Paris au XVIIIᵉ siècle." *Revue de l'art* (1979): 23–36.

Pope-Hennessy, John. *The Drawings of Domenichino in the Collection of His Majesty the King at Windsor Castle*. London: Phaidon, 1948.

Posner, Donald. *Annibale Carraccci: A Study in the Reform of Italian Painting around 1590*. 2 vols. National Gallery of Art, Kress Foundation Studies in the History of Art, no. 5. New York and London: Phaidon, 1971.

_____. "The Swinging Women of Watteau and Fragonard." *Art Bulletin* 64 (March 1982): 75–88.

_____. *Antoine Watteau*. Ithaca, NY: Cornell University Press, 1984.

Procacci, Ugo. "Una 'Vita' inedita del Muziano." *Arte veneta* 8 (1954): 242–64.

Puttfarken, Thomas. *Roger de Piles' Theory of Art*. New Haven and London: Yale University Press, 1985.

Ragghianti, Carlo L. "Classicismo e paesaggio nel seicento." *Critica d'Arte* 10 (January-February 1963): 1–51.

Rearick, W. R. "Jacopo Bassano's Later Genre Paintings." *Burlington Magazine* 110 (May 1968): 241–49.

_____. *Tiziano e il disegno veneziano del suo tempo*. Exhibition catalogue. Translated by Anna Maria Petrioli Tofani. Florence: Gabinetto Disegni e Stampe degli Uffizi and Leo S. Olschki, 1976.

Recueil d'estampes d'après les plus beaux tableaux et d'après les plus beaux desseins, qui sont en France dans le cabinet du Roy, dans celuy de monseigneur le duc d'Orleans, & dans autres cabinets. 2 vols. Paris: De l'imprimerie royale, 1729–42.

Recueil de 283 estampes gravées à l'eau forte par les plus habiles peintres du tems, d'après les desseins de grands maîtres, que possedoit autrefois M. Jabach, et qui depuis ont passé au cabinet du Roy. Paris: Joullain, 1754.

Reist, Inge Jackson. "Renaissance Harmony: The Villa Barbaro at Maser." Ph.D. diss., Columbia University, 1985.

Rembrandt and His Century: Dutch Drawings of the Seventeenth Century from the Collection of Frits Lugt, Institut Néerlandais, Paris. Exhibition catalogue. New York: The Pierpont Morgan Library and Paris: Institut Néerlandais, 1977.

Rewald, John. *The John Hay Whitney Collection*. Exhibition catalogue. Washington, D.C.: National Gallery of Art, 1983.

Reznicek, E.K.J. *Die Zeichnungen von Hendrick Goltzius*. 2 vols. Utrecht: Haentjens Dekker & Gumbert, 1961.

Rice, Eugene F., Jr. *Saint Jerome in the Renaissance*. Baltimore and London: Johns Hopkins University Press, 1985.

Richter, George Martin. *Giorgio da Castelfranco, called Giorgione*. Chicago: University of Chicago Press, 1937.

Ridolfi, Carlo. *Le maraviglie dell'arte: Ovvero Le vite degli illvstri pittori Veneti e dello stato*. 1648. Reprint, edited by Detlev von Hadeln. 2 vols. Berlin: G. Grote, 1914–24.

Riflettoscopia all'infrarosso computerizzata. Quaderni della Soprintendenza ai Beni Artistici e Storici di Venezia 6 (1984): 48–53.

Riggs, Timothy A. *Hieronymus Cock: Printmaker and Publisher*. New York and London: Garland, 1977.

Rigon, Fernando. *Gli animali di Jacopo Bassano*. Bassano del Grappa: G.B. Verci, 1983.

Roberts, Keith. *Art into Art: Works of Art as a Source of Inspiration*. Exhibition catalogue. Presented by *Burlington Magazine*. London: Sotheby & Co, 1971.

_____. *Rembrandt: Master Drawings*. New York: E. P. Dutton and Oxford: Phaidon, 1976.

Rocheblave, Samuel. *Essai sur le comte de Caylus, l'homme, l'artiste, l'antiquaire*. Paris: Hachette, 1889.

Rosand, David. "*Ut Pictor Poeta*: Meaning in Titian's *Poesie*." *New Literary History* 3 (1971–72): 527–46.

_____. *Titian*. New York: Harry N. Abrams, 1978.

_____. "Titian Drawings: A Crisis of Connoisseurship?" *Master Drawings* 19 (Autumn 1981): 300–08.

_____, ed. *Titian: His World and his Legacy*. New York: Columbia University Press, 1982.

_____, ed. *Interpretazioni veneziane: Studi di storia dell'arte in onore di Michelangelo Muraro*. Itinerari di Storia e arte, no. 5. Venice: Arsenale Editrice, 1984.

_____. *Painting in Cinquecento Venice: Titian, Veronese, Tintoretto*. New Haven and London: Yale University Press, 1982. 2d ed., 1985.

Rosand, David, and Michelangelo Muraro. *Titian and the Venetian Woodcut*. Exhibition catalogue. Washington, D.C.: National Gallery of Art and International Exhibitions Foundation, 1976.

Rosenberg, Pierre. *Fragonard*. Exhibition catalogue. New York: The Metropolitan Museum of Art, distributed by Harry N. Abrams, 1988.

Rosenmeyer, Thomas G. *The Green Cabinet: Theocritus and the European Pastoral Lyric*. Berkeley and Los Angeles: University of California Press, 1969.

Röthlisberger, Marcel. "New Light on Claude Lorrain." *Connoisseur* 145 (March 1960): 57–63.

_____. "The Subjects of Claude Lorrain's Paintings." *Gazette des Beaux-Arts* 55 (April 1960): 209–24.

_____. *Claude Lorrain: The Paintings*. 2 vols. Yale Publications in the History of Art, edited by George Kubler, no. 13. New Haven: Yale University Press, 1961.

_____. "Les dessins de Claude Lorrain à sujets rares." *Gazette des Beaux-Arts* 59 (March 1962): 153–64.

_____. "The Judgement of Paris by Claude." *Burlington Magazine* 108 (June 1966): 316–17.

_____. *Claude Lorrain: The Drawings*. 2 vols. Berkeley and Los Angeles: University of California Press, 1968.

_____. "Aggiunte a Claude." *Paragone* 20 (July 1969): 54–58.

_____. "Claude Lorrain in the National Gallery of Art." *Report and Studies in the History of Art* 1969, 34–57. Washington, D.C.: National Gallery of Art, 1970.

_____. *Im Licht von Claude Lorrain: Landschaftsmalerei aus drei Jahrhunderten*. Exhibition catalogue. Munich: Haus der Kunst, 1983.

Roux, Marcel. *Bibliothèque Nationale. Département des Estampes. Inventaire du fonds français. Graveurs du XVIIIᵉ siècle*. Vol. 4. Paris: Bibliothèque Nationale, 1940.

Russell, H. Diane. *Claude Lorrain 1600–1682*. Exhibition catalogue. Washington, D.C.: National Gallery of Art, 1982.

Saccomani, Elisabetta. "Domenico Campagnola disegnatore di 'paesi': dagli esordi alla prima maturita." *Arte veneta* 36 (1982): 81–99.

Saint Jerome, Selected Letters. Translated by Frederick Adam Wright. Cambridge: Loeb Classical Library, 1933.

Salerno, Luigi. "La pittura di paesaggio." *Storia dell'arte* 24/25 (May-December 1975): 111–24.

Salerno, Luigi. *Pittori di paesaggio del seicento a Roma: Landscape Painters of the Seventeenth Century in Rome*. Translated by Clovis Whitfield and Catherine Enggass. 3 vols. Rome: Ugo Bozzi Editore, 1977–78.

Salz, Alan E. *French Master Drawings*. Exhibition catalogue. New York: Didier Aaron, 1984.

Sannazaro, Jacopo. *L'Arcadia & Piscatorial Eclogues.* Edited and translated by Ralph Nash. Detroit: Wayne State University Press, 1966.

_____. *Opere di Jacopo Sannazaro.* Edited by Enrico Carrara. Turin: Unione Tipografico-Editrice Torinese, 1952. Reprint, 1967.

Santini, Pier Carlo. *Modern Landscape Painting.* Translated by P. S. Falla. London: Phaidon, 1972. Originally published as *Il paesaggio nella pittura contemporanea,* Venice: Electa Editrice, 1971.

Sargeaunt, George Montague. "The Classical Pastoral and Giorgione." In *Classical Studies,* 164–86. London: Chatto and Windus, 1929.

Saxl, Fritz. "Elsheimer and Italy." In *Lectures,* vol. 1, 286–97. 2 vols. London: Warburg Institute, University of London, 1957.

_____. "Titian and Pietro Aretino." In *Lectures,* vol. 1, 161–73. 2 vols. London: Warburg Institute, University of London, 1957. Reprinted in *A Heritage of Images: A Selection of Lectures by Fritz Saxl,* 71–87. Edited by Hugh Honour and John Fleming. Baltimore and Harmondsworth: Penguin Books, 1970.

_____. "A Humanist Dreamland." In *Lectures,* vol. 1, 215–27. 2 vols. London: The Warburg Institute, University of London, 1957. Reprinted in *A Heritage of Images: A Selection of Lectures by Fritz Saxl,* 89–104. Edited by Hugh Honour and John Fleming. Baltimore and Harmondsworth: Penguin Books, 1970.

Schneider, Hans. *Jan Lievens: Sein Leben und seine Werke.* Haarlem, 1932. Reprint, with supplement by R.E.O. Ekkart. Amsterdam: Nico Israel, 1973.

Schwartz, Gary. *Rembrandt: His Life, His Paintings.* New York and Harmondsworth: Viking, 1985. Originally published as *Rembrandt, zijn leven, zijn schilderijen: een nieuwe biografie, met alle beschikbare schilderijen in kleur afgebeeld* (1984).

Scott, Barbara. "Pierre Crozat: A Maecenas of the Regence"; "The Duc de Choiseul: A Minister in the Grand Manner"; and "Pierre-Jean Mariette: Scholar and Connoisseur." *Apollo* 97 (January 1973): 11–19; 42–53; 54–59.

Seerveld, Calvin. "Telltale Statues in Watteau's Painting." *Eighteenth-Century Studies* 14 (Winter 1980): 151–80.

Settis, Salvatore. *La "Tempesta" interpretata: Giorgione, i committenti, il soggetto.* Turin: Giulio Einaudi, 1978.

_____. "Giorgione e i suoi committenti." In *Giorgione e l'umanesimo veneziano: Corso internazionale di alta cultura,* vol. 1, 373–98. 2 vols. Florence: Leo S. Olschki, 1981.

XVII Designs to Thornton's Virgil Reproduced from the Original Woodcuts [of William Blake]. Portland, ME: Thomas B. Mosher, 1899.

Sewter, A. C., and D. Maxwell White. "Variations on a Theme of Titian." *Apollo* 95 (February 1972): 88–95.

Shapley, Fern Rusk. *Catalogue of the Italian Paintings.* 2 vols. Washington, D.C.: National Gallery of Art, 1979.

Slatkin, Regina Shoolman. *François Boucher: His Circle and Influence.* Exhibition catalogue. New York: Stair Sainty Matthiesen, 1987.

Spassky, Natalie et al. *American Paintings in the Metropolitan Museum of Art.* Vol. 2. *A Catalogue of Works by Artists Born between 1816 and 1845.* Edited by Kathleen Luhrs, assisted by Jacolyn A. Mott. New York: The Metropolitan Museum of Art, 1985.

Spear, Richard E. "The Early Drawings of Domenichino at Windsor Castle and Some Drawings by the Carracci." *Art Bulletin* 49 (March 1967): 52–57.

_____. "A forgotten landscape painter: Giovanni Battista Viola." *Burlington Magazine* 122 (May 1980): 298–315.

_____. *Domenichino.* 2 vols. New Haven and London: Yale University Press, 1982.

Stainton, Lindsay. *British Landscape Watercolours 1600–1800.* New York and London: Cambridge University Press, 1985.

Stechow, Wolfgang. *Dutch Landscape Painting of the Seventeenth Century.* National Gallery of Art, Kress Foundation Studies in the History of European Art. Oxford: Phaidon, 1966. Reprint, with corrections. Oxford: Phaidon, 1968, 1981.

Strauss, Walter L., ed. *Hendrik Goltzius 1558–1617: The Complete Engravings and Woodcuts.* 2 vols. New York: Abaris Books, 1977.

Strauss, Walter, and Marjon van der Meulen. *The Rembrandt Documents.* New York: Abaris Books, 1979.

Stuffmann, Margaret. "Les tableaux de la collection de Pierre Crozat." *Gazette des Beaux-Arts* 72 (July-September 1968): 11–144.

Sutton, Denys. "Giorgione and Walter Pater." In *Giorgione: Atti del convegno internazionale di studio per il 5° centenario della nascita,* 339–42. Castelfranco Veneto: Commune di Castelfranco Veneto, 1979.

Sweeny, Barbara. *John G. Johnson Collection: Catalogue of Italian Paintings.* Philadelphia: John G. Johnson Collection, 1966.

Tanner, Marie. "'Ubi sunt': An Elegiac Topos in the 'Fête Champêtre.'" In *Giorgione: Atti del convegno internazionale di studio per il 5° centenario della nascita,* 61–66. Castelfranco Veneto: Commune di Castelfranco Veneto, 1979.

Teyssèdre, Bernard. *Roger de Piles et les débats sur le coloris au siècle de Louis XIV.* Paris: La Bibliothèque des Arts, vol. 13, 1957. Lausanne: Les Presses de l'imprimerie centrale, 1965.

Thornton, Robert John. *The Pastorals of Virgil, with a course of English reading adapted for schools; in which all the proper facilities are given, enabling youtm[!] to acquire the Latin language, in the shortest period of time.* 3d ed. 2 vols. London: F. C. and J. Rivingtons, 1821. Vol. 1 contains seventeen wood engravings by William Blake.

Tietze, Hans, and E. Tietze-Conrat. "Domenico Campagnola's Graphic Art." Parts 1, 2. *Print Collector's Quarterly* 26 (October, December 1939): 310–33; 445–69.

_____. *The Drawings of the Venetian Painters in the 15th and 16th Centuries.* New York, 1944. Reprint. New York: Hacker Art Books, 1979.

Tietze-Conrat, E. "Titian as a Landscape Painter." *Gazette des Beaux-Arts* 45 (January 1955): 11–20.

Turner, A. Richard. "The Genesis of a Carracci Landscape." *Art Quarterly* 24 (Autumn 1961): 249–57.

_____. *The Vision of Landscape in Renaissance Italy.* Princeton, NJ: Princeton University Press, 1966.

Ulrich, Christoffel. *Italienische Kunst die Pastorale.* Vienna: Bergland Verlag, 1952.

Vasari, Giorgio. *Le vite de' più eccellenti pittori, scultori ed architettori.* 1568. Reprint, edited by Gaetano Milanesi. Florence: G. C. Sansoni Editore, 1906.

Vergara, Lisa. *Rubens and the Poetics of Landscape.* New Haven and London: Yale University Press, 1982.

Viatte, Françoise, Roseline Bacou, and Guiseppina delle Piane Perugini. *Il Paesaggio nel disegno del cinquecento europeo.* Exhibition catalogue. Translated by Maria Teresa Caracciolo di Vietri. Rome: Accademia di Francia, Villa Medici and De Luca Editore, 1972.

Virgil. *Georgics.* Translated by H. Rushton Fairclough. Cambridge: Loeb Classical Library, 1978.

Vitruvius. *The Ten Books on Architecture*. Translated by
Morris Hicky Morgan. 1914. Reprint. New York: Dover
Publications, 1960.

Voss, Hermann. "François Boucher's Early Development."
Translated by Ilse Barea. *Burlington Magazine* 95
(March 1953): 81–93.

Waddingham, Malcolm. "Elsheimer Revised." *Burlington
Magazine* 114 (September 1972): 600–11.

Watson, F[rancis] J[ohn] B[agott]. *The Choiseul Box*. Lon-
don: Oxford University Press, 1963.

Wethey, Harold E. *The Paintings of Titian*. Vol. 3, *The
Mythological and Historical Paintings*. London:
Phaidon, 1975.

White, Christopher. *Rembrandt as an Etcher: A Study of
the Artist at Work*. 2 vols. London: A. Zwemmer, 1969.

————. "A Rembrandt Copy after a Titian Landscape."
Master Drawings 13 (Winter 1975): 375–79.

————. *Rembrandt*. New York and London: Thames and
Hudson, 1984.

————. *Peter Paul Rubens: Man & Artist*. New Haven and
London: Yale University Press, 1987.

White, Christopher, and Karel G. Boon, comps. *Hollstein's
Dutch and Flemish Etchings, Engravings and Woodcuts*.
Vols. 18 and 19, *Rembrandt van Rijn*. Amsterdam:
Vangendt, 1969.

Whitfield, Clovis. "A Programme for 'Erminia and the
Shepherds' by G. B. Agucchi." *Storia dell'arte* 19
(September-December 1973): 217–29.

————. "Early Landscapes by Annibale Carracci." *Pan-
theon* 38 (January-March 1980): 50–58.

————. "Les Paysages du Dominiquin et de Viola." *Monu-
ments et mémoires. Academie des inscriptions et belles-
lettres, Fondation Eugène Piot* 69 (1988): 61–127.

Whittingham, Selby. "From the Regence to the Regency:
Watteau's *L'Ile enchantée*." *Pantheon* 42 (October–
December 1984): 339–47.

————. "Watteau and Watteaus in Britain, c. 1780–1851."
In *Antonin Watteau (1684–1721): The Painter, His Age,
His Legend*. François Moreau and Margaret Morgan
Grasselli, eds. Paris: Champion and Geneva: Slatkine,
1987.

————. "What You Will: Or Some Notes Regarding the
Influence of Watteau on Turner and Other British
Artists." *Turner Studies* 5 (Summer 1985).

Wilkinson, L. P. *The Georgics of Virgil: A Critical Survey*.
Cambridge: Cambridge University Press, 1969.

Wind, Edgar. *Giorgione's Tempesta with Comments on
Giorgione's Poetic Allegories*. Oxford: Clarendon Press,
1969.

Wittkower, Rudolf. *Art and Architecture in Italy 1600 to
1750*. Baltimore and Harmondsworth: Penguin Books,
1958. 2d rev. ed., 1965. 3d rev. ed., 1973.

————. "L'Arcadia e il Giorgionismo." In *Umanesimo
europeo e umanesimo veneziano: Il secondo corso
internazionale di alta cultura*, 473–84. Edited by Vittore
Branca. Florence: G. C. Sansoni Editore, 1963. Reprinted
in *Idea and Image: Studies in the Italian Renaissance*,
161–73. Edited by Margot Wittkower. London: Thames
and Hudson, 1978.

Zadoks-Josephus Jitta, A. N. "De Comte de Caylus als
Archeoloog." *Tijdschrift voor Geschiedenis* 61 (1948):
290–97.

Zafran, Eric M. *Master Drawings from Titian to Picasso:
The Curtis O. Baer Collection*. Exhibition catalogue.
Washington, D.C.: National Gallery of Art and Atlanta:
High Museum of Art, 1985.

Zampetti, Pietro, ed. *Giorgione e i Giorgioneschi*. Exhibi-
tion catalogue. Venice: Palazzo Ducale and Casa Editrice
Arte Veneta, 1955.

Zeri, Federico, and Elizabeth E. Gardner. *Italian Paintings:
Venetian School: A Catalogue of the Collection of The
Metropolitan Museum of Art*. New York: The Metro-
politan Museum of Art, 1973.

————. *Italian Paintings: North Italian School: A Cata-
logue of the Collection of The Metropolitan Museum of
Art*. New York: The Metropolitan Museum of Art, 1986.

Checklist of the Exhibition

The Pastoral Landscape is an exhibition jointly presented by The Phillips Collection and the National Gallery of Art and on view simultaneously at the two institutions from November 6, 1988 to January 22, 1989. "The Legacy of Venice" includes cat. nos. 1–80, exhibited at the National Gallery of Art. "The Modern Vision" includes cat. nos. 81–136, exhibited at The Phillips Collection.

 Without the generous cooperation of the lenders this joint exhibition would not have been possible. The directors and curators of both institutions acknowledge their sincere appreciation to the lenders.

1. **Giovanni Bellini** (c. 1433–1516)
 Orpheus c. 1515
 oil on canvas, transferred from panel
 18⅝ x 32 inches (39.5 x 81 cm.)
 National Gallery of Art, Washington, D.C.
 Widener Collection
 1942.9.2

2. **Andrea Previtali** (c. 1470–1528)
 David the Shepherd c. 1500
 oil on canvas
 26 x 19⅝ inches (66 x 49.9 cm.)
 Gift of Michael Straight
 Herbert F. Johnson Museum of Art
 Cornell University, Ithaca, New York

3. **Giorgione**(?) (c. 1477/78–1510)
 The Adoration of the Shepherds c. 1505–10
 oil on wood panel
 35¾ x 43½ inches (91 x 111 cm.)
 National Gallery of Art, Washington, D.C.
 Samuel H. Kress Collection
 1939.1.289

4. **Giorgione** (c.1477/78–1510)
 Castel San Zeno di Montagnana (formerly *View of Castelfranco*)
 red chalk on paper
 8 x 11⅜ inches (20.3 x 29 cm.)
 Museum Boymans-van Beuningen, Rotterdam

5. Attributed to **Giorgione**
 Saint John the Baptist Preaching in the Wilderness c. 1510
 oil on wood panel
 13½ x 10¹⁵⁄₁₆ inches (34.3 x 27.9 cm.)
 Piero Corsini, New York

6. **Circle of Giorgione**
 The Hour Glass
 oil on wood panel
 4¾ x 7½ inches (12 x 19 cm.)
 The Phillips Collection, Washington, D.C.

7. **Circle of Giorgione**
 Venus and Cupid in a Landscape
 oil on wood panel
 4⅜ x 8 inches (11 x 20 cm.)
 National Gallery of Art, Washington, D.C.
 Samuel H. Kress Collection
 1939.1.142

8. **Circle of Giorgione**
 Paris Exposed on Mount Ida
 oil on wood panel
 14¹⁵⁄₁₆ x 22⁷⁄₁₆ inches (38 x 57 cm.)
 The Art Museum, Princeton University
 Gift of Frank Jewett Mather, Jr.

9. **Circle of Giorgione**
 Saint Theodore about to Slay the Dragon
 oil on canvas
 29½ x 33¾ inches (75 x 85.7 cm.)
 Private Collection

10. **Circle of Giorgione**
 Allegory c. 1506–10
 oil on wood panel
 17 x 27½ inches (43.1 x 69.8 cm.)
 Sarah Campbell Blaffer Foundation
 Houston

11. **Circle of Giorgione**
 Landscape with an Old Nude Man Seated (Saint Jerome?) c. 1505
 pen and brown ink and wash on brownish paper
 7⁷⁄₁₆ x 10⅛ inches (18.9 x 25.8 cm.)
 The Ian Woodner Family Collection, Inc., New York

12. **Anonymous Parmesan**(?) **Artist**, 16th century
 Mythological Scene c. 1520–30
 red chalk on yellowish paper
 5½ x 7½ inches (13.9 x 19.1 cm.)
 Hessisches Landesmuseum, Darmstadt

13. **Giovanni de Lutero**, called **Dosso Dossi** (c. 1479–1542)
 The Three Ages of Man c. 1520–25
 oil on canvas
 30½ x 44 inches (77.5 x 111.8 cm.)
 The Metropolitan Musuem of Art, New York
 Maria DeWitt Jesup Fund, 1926
 26.83

14. **Lorenzo Lotto** (c. 1480–1556)
 A Maiden's Dream c. 1505
 oil on wood panel
 16⅞ x 13¼ inches (43 x 34 cm.)
 National Gallery of Art, Washington, D.C.
 Samuel H. Kress Collection
 1939.1.147

15. **Lorenzo Lotto** (c. 1480–1556)
 Allegory 1505
 oil on wood panel
 22¼ x 16⅝ inches (56.5 x 42.2 cm.)
 National Gallery of Art, Washington, D.C.
 Samuel H. Kress Collection
 1939.1.156

16. Attributed to **Titian**
 An Idyll: A Mother and a Halberdier in a Wooded Landscape
 oil on wood panel
 18¼ x 17¼ inches (46.4 x 43.8 cm.)
 Private Collection, New York

17. **Titian** (c. 1488–1576)
Two Satyrs in a Landscape
pen and bistre ink on paper
8½ x 5¹⁵⁄₁₆ inches (21.6 x 15.2 cm.)
Private Collection

18. **Titian** (c. 1488–1576)
Landscape with Milkmaid
pen and brush and brown ink, washed, on faded,
 brownish paper
14⁹⁄₁₆ x 20¹³⁄₁₆ inches (37 x 52.8 cm.)
Musée du Louvre, Paris
Département des Arts Graphiques
5573

19. **Titian** (c. 1488–1576)
Landscape with Flute-playing Shepherd
pen and brown ink on yellowed paper
11⅞ x 17¹⁄₁₆ inches (30.2 x 43.4 cm.)
Graphische Sammlung Albertina, Vienna
1477

20. **Titian** (c. 1488–1576)
Group of Trees c. 1514
pen and brown ink, traces of grey printer's ink at
 lower right, on beige paper
8⁹⁄₁₆ x 12⁹⁄₁₆ inches (21.8 x 31.9 cm.)
The Metropolitan Museum of Art, New York
Rogers Fund, 1908
08.227.38

21. **Titian** (c. 1488–1576)
Group of Trees
pen and brown ink on paper
9⁹⁄₁₆ x 8⅛ inches (24.3 x 20.7 cm.)
Private Collection

22. After **Titian**
Landscape with Milkmaid c. 1520–25
woodcut
14¹³⁄₁₆ x 17¹⁄₁₆ inches (37.6 x 43.3 cm.)
National Gallery of Art, Washington, D.C.
Rosenwald Collection
1964.8.372

23. After **Titian**
St. Jerome in the Wilderness c. 1525–30
woodcut
15⅛ x 20⅝ inches (38.5 x 52.5 cm.)
National Gallery of Art, Washington, D.C.
Rosenwald Collection
1964.8.373

24. **Giulio Campagnola** (c. 1482–after 1515)
Landscape with Two Philosophers
pen and brown ink on paper, partially pricked for transfer
5¼ x 10⅛ inches (13.3 x 25.7 cm.)
Musée du Louvre, Paris
Département des Arts Graphiques
4868

25. **Giulio Campagnola** (c. 1482–after 1515)
*Three Philosophers Consulting a Globe in a
 Landscape*
pen and brown ink on brownish toned paper
7³⁄₁₆ x 10¹³⁄₁₆ inches (18.3 x 27.4 cm.)
Fondation Custodia, Collection F. Lugt
Institut Néerlandais, Paris
1978–T.21

26. **Giulio Campagnola** (c. 1482–after 1515)
Venus Reclining in a Landscape c. 1508–09
engraving
4¹¹⁄₁₆ x 7³⁄₁₆ inches (11.9 x 18.3 cm.)
The Cleveland Museum of Art
Gift of the Print Club of Cleveland
31.205, Hind 5, no. 13

27. **Giulio Campagnola** (c. 1482–after 1515)
The Young Shepherd c. 1509
engraving
5³⁄₁₆ x 3¹⁄₁₆ inches (13.2 x 7.8 cm.)
Cincinnati Art Museum
Bequest of Herbert Greer French
1943.88, Hind 5, no. 10 II

28. **Giulio Campagnola** (c. 1482–after 1515)
The Old Shepherd
engraving
plate, 3⅛ x 5⁵⁄₁₆ inches (7.9 x 13.5 cm.)
The Metropolitan Museum of Art, New York
Harris Brisbane Dick Fund, 1937
37.3.11, Hind 5, no. 8 II

29. **Giulio Campagnola** (c. 1482–after 1515)
The Astrologer c. 1509
engraving
3¾ x 6¹⁄₁₆ inches (9.6 x 15.4 cm.)
Cincinnati Art Museum
Bequest of Herbert Greer French
1943.90, Hind 5, no. 9 II

30. **Giulio** (c. 1482–after 1515) and **Domenico
 Campagnola** (1500–64)
Shepherds in a Landscape c. 1517
engraving
5¼ x 10¹⁄₁₆ inches (13.3 x 25.5 cm.)
National Gallery of Art, Washington, D.C.
Rosenwald Collection
1943.3.2697, Hind 5, no. 6

31. **Domenico Campagnola** (1500–64)
Two Boys Kneeling in a Landscape
pen and brown ink on paper
9⁵⁄₁₆ x 8⅜ inches (23.6 x 21.3 cm.)
Graphische Sammlung Albertina, Vienna
24364

32. **Domenico Campagnola** (1500–64)
Landscape with Infant Saint John the Baptist c. 1530
pen and brown ink with traces of black chalk on
 paper
9 x 14⅝ inches (22.8 x 37.1 cm.)
Gabinetto Disegni e Stampe degli Uffizi, Florence
1405E

33. **Domenico Campagnola** (1500–64)
Landscape with Wooded Slope and Buildings
pen and brown ink on paper
8⅞ x 13¾ inches (22.5 x 35 cm.)
Gabinetto Disegni e Stampe degli Uffizi, Florence
1406E

34. **Domenico Campagnola** (1500–64)
Landscape with Boy Fishing c. 1520
pen and brown ink on laid paper
6⁷⁄₁₆ x 9¾ inches (16.4 x 24.7 cm.)
National Gallery of Art, Washington, D.C.
Rosenwald Collection
1950.20.1

35. **Domenico Campagnola** (1500–64)
Landscape with Setting Sun
pen and brown ink on paper
14¹³⁄₁₆ x 23¹³⁄₁₆ inches (37.7 x. 60.5 cm.)
Musée du Louvre, Paris
Département des Arts Graphiques
5550

36. **Domenico Campagnola** (1500–64)
Saint Jerome with the Fighting Lions c. 1530–35
woodcut
11⁵⁄₁₆ x 16⁷⁄₁₆ inches (28.7 x 41.8 cm.)
The Cleveland Museum of Art
Dudley P. Allen Fund
52.271

37. **Domenico Campagnola** (1500–64)
Landscape with a Hurdy-gurdy Player and a Girl
 c. 1540
chiaroscuro woodcut
9½ x 14¾ inches (24.1 x 37.5 cm.)
Private Collection, Venice

38. **Paris Bordone** (1500–71)
Saint Jerome in the Desert c. 1535–40
oil on canvas
27⅝ x 34¼ inches (70.2 x 87 cm.)
John G. Johnson Collection of Philadelphia

39. **Polidoro Lanzani** (1515–65)
*Madonna and Child and the Infant Saint John in
 a Landscape* c. 1540–50
oil on canvas
11 x 22¾ inches (27.9 x 57.8 cm.)
National Gallery of Art, Washington, D.C.
Andrew W. Mellon Collection
1937.1.36

40. Attributed to **Pietro degli Ingannati** (mentioned 1529–48)
Allegory c. 1530
oil on wood panel
17 x 15⅜ inches (43 x 39.2 cm.)
National Gallery of Art, Washington, D.C.
Gift of Dr. and Mrs. G. H. Alexander Clowes
1948.17.1

41. **Girolamo Muziano** (1532–92)
Landscape with Saint Giving a Sermon
pen and black pencil on paper
19¼ x 14⅜ inches (49 x 36.5 cm.)
Gabinetto Disegni e Stampe degli Uffizi, Florence
522P

42. **Annibale Carracci** (1560–1609)
Landscape c. 1590
oil on canvas
34¾ x 58¼ inches (88.5 x 148.2 cm.)
National Gallery of Art, Washington, D.C.
Samuel H. Kress Collection
1952.5.58

43. **Annibale Carracci** (1560–1609)
Pastoral Landscape with Three Figures c. 1600
pen and brown ink on paper
9⅝ x 7³⁄₁₆ inches (24.4 x 18.3 cm.)
The Visitors of the Ashmolean Museum, Oxford
PII.165

44. **Domenico Zampieri**, called **Domenichino**
(1581–1641)
*Landscape with the Calling of Saints Peter,
Andrew and Simon* c. 1603–04
oil on canvas
14¼ x 21 inches (36.2 x 53.3 cm.)
Piero Corsini, New York

45. **Domenico Zampieri**, called **Domenichino**
(1581–1641)
Landscape with Two Boys
pen and brown ink on paper
10⅜ x 8¹⁄₁₆ inches (26.3 x 20.4 cm.)
The Trustees of the Chatsworth Settlement,
Derbyshire

46. **Domenico Zampieri**, called **Domenichino**
(1581–1641)
Landscape with Saint Jerome
pen and brown ink on paper
7¹³⁄₁₆ x 10⁹⁄₁₆ inches (19.9 x 26.9 cm.)
The Visitors of the Ashmolean Museum, Oxford
PII.168

47. **Pieter Bruegel the Elder** (c. 1525/30–69)
Landscape with the Penitence of Saint Jerome
1553
pen and brown ink on laid paper
9⅛ x 13¼ inches (23.2 x 33.6 cm.)
National Gallery of Art, Washington, D.C.
Ailsa Mellon Bruce Fund
1972.47.1

48. **Hendrik Goltzius** (1558–1617)
Man and Woman Seated in a Landscape c. 1592–95
chiaroscuro woodcut in ochre, sepia, olive, and
black ink
4½ x 5¹³⁄₁₆ inches (11.4 x 14.7 cm.)
National Gallery of Art, Washington, D.C.
Rosenwald Collection
1950.1.68, Hirsch./Holl. 379 II/II

49. **Adam Elsheimer** (1578–1610)
*Satyr Playing the Flute, Surrounded by Other
Satyrs*
etching
3⁵⁄₁₆ x 4¼ inches (8.4 x 10.8 cm.)
The Trustees of the Chatsworth Settlement,
Derbyshire
Hind 1926, no. 11

50. **Adam Elsheimer** (1578–1610)
*Landscape with Flute-playing Satyr and Two
Nymphs*
etching
2⅜ x 3¹⁵⁄₁₆ inches (6.1 x 10 cm.)
The Trustees of the Chatsworth Settlement,
Derbyshire
Hind 1926, no. 12

51. **Schelte a Bolswert** (c. 1581–1659)
*Shepherds and Shepherdesses in a Rainbow
Landscape*
engraving
13⅛ x 17¹¹⁄₁₆ inches (33.4 x 45 cm.)
The Metropolitan Museum of Art, New York
Elisha Whittelsey Collection
Elisha Whittelsey Fund, 1951
51.501.7727, Holl. 314 (no. 10 in series
305–325)

52. **Claude Gellée**, called **Le Lorrain** (1600–82)
Landscape with Nymph and Satyr Dancing 1641
oil on canvas
39¼ x 52⅜ inches (99.7 x 133 cm.)
The Toledo Museum of Art
Gift of Edward Drummond Libbey

53. **Claude Gellée**, called **Le Lorrain** (1600–82)
The Judgment of Paris 1645–46
oil on canvas
44¼ x 58⅞ inches (112.3 x 149.5 cm.)
National Gallery of Art, Washington, D.C.
Ailsa Mellon Bruce Fund
1969.1.1

54. **Claude Gellée**, called **Le Lorrain** (1600–82)
Pastoral Landscape 1645
chalk, pen, and brown wash on paper
8½ x 13 inches (21.6 x 33 cm.)
The Pierpont Morgan Library, New York
III, 82

55. **Rembrandt van Rijn** (1606–69)
Landscape with Bear Attacking a Goat
pen and brown ink on paper
7⅞ x 11½ inches (20.1 x 29.3 cm.)
Fondation Custodia Collection F. Lugt
Institut Néerlandais, Paris
6584

56. **Rembrandt van Rijn** (1606–69)
Rest on the Flight into Egypt
reed and quill pen, brown and black ink, and
wash on paper
6¹³⁄₁₆ x 9³⁄₁₆ inches (17.3 x 23.3 cm.)
Collection of Mr. and Mrs. Eugene V. Thaw

57. **Rembrandt van Rijn** (1606–69)
Shepherdess with Her Flock c. 1641–43
pen and bistre ink, white body color on paper
5¾ x 8¼ inches (14.6 x 21 cm.)
Musée des Beaux-Arts et d'Archéologie,
Besançon
D.2757

58. **Rembrandt van Rijn** (1609–69), over **Domenico
Campagnola**(?), (1500–64)
*Mountainous Landscape (with Houses and a
Watermill by a Stream)* c. 1652–54
pen and bistre ink, white body color on yellowish
brown paper
6⅜ x 10⅞ inches (16.2 x 27.7 cm.)
The Budapest Museum of Fine Arts
1579

59. **Rembrandt van Rijn** (1606–69)
The Flute Player 1642
etching and drypoint
4⁹⁄₁₆ x 5⅝ inches (11.6 x 14.3 cm.)
Rijksprentenkabinet, Rijksmuseum, Amsterdam
B.188 III

60. **Rembrandt van Rijn** (1606–69)
The Three Trees 1643
etching with drypoint and burin
8⁵⁄₁₆ x 11 inches (21.2 x 28 cm.)
National Gallery of Art, Washington, D.C.
Rosenwald Collection
1943.3.9119, B.212

61. **Rembrandt van Rijn** (1606–69)
The Sleeping Herdsman c. 1644
etching and burin
3¹⁄₁₆ x 2¼ inches (7.8 x 5.7 cm.)
National Gallery of Art, Washington, D.C.
Rosenwald Collection
1951.10.482, B.189

62. **Rembrandt van Rijn** (1606–69)
The Omval 1645
etching and drypoint
7¼ x 8⅞ inches (18.5 x 22.6 cm.)
National Gallery of Art, Washington, D.C.
Rosenwald Collection
1943.3.7144, B.209 II/II

63. **Rembrandt van Rijn** (1606–69)
Saint Jerome Reading in an Italian Landscape
c. 1653
etching, burin, and drypoint
10³⁄₁₆ x 8¼ inches (25.9 x 21 cm.)
National Gallery of Art, Washington, D.C.
Rosenwald Collection
1943.3.7168, B.104 II/II

64. **Rembrandt van Rijn** (1606–69)
Saint Francis Beneath a Tree Praying 1657
drypoint and etching on Japanese paper
7¹⁄₁₆ x 9⅝ inches (18 x 24.4 cm.)
National Gallery of Art, Washington, D.C.
Rosenwald Collection
1943.3.7156, B.107 II/II

65. **Jan Lievens** (1607–74)
Landscape with a Resting Shepherd
pen and ink on paper
9⅞ x 14¼ inches (25.1 x 36.2 cm.)
The Art Institute of Chicago
Leonora Hall Gurley Memorial Collection
1922.1990

66. **Jan de Bisschop** (1628–71)
Concert champêtre 1668
black chalk, brush in brown wash on paper
10⁵⁄₁₆ x 14⁵⁄₁₆ inches (26.2 x 36.3 cm.)
Prentenkabinet der Rijksuniversiteit, Leiden

67. **Anonymous Master**, 17th century
Landscape with Pilgrims, after Domenico
 Campagnola, c. 1630
etching
10 x 14¾ inches (25.4 x 37.4 cm.)
Fondation Custodia, Collection F. Lugt
Institut Néerlandais, Paris
7620/6

68. **Valentin LeFebre** (c. 1642–80)
Landscape with Flute-playing Shepherd, after
 Titian, published 1682
etching
12⅛ x 16¹⁵⁄₁₆ inches (30.8 x 43.1 cm)
Fondation Custodia, Collection F. Lugt
Institut Néerlandais, Paris
7620/26

69. **Valentin LeFebre** (c. 1642–80)
Landscape with Infant Saint John the Baptist,
 after Titian, published 1682
etching
11⁹⁄₁₆ x 15¹¹⁄₁₆ inches (29.3 x 39.8 cm.)
Fondation Custodia, Collection F. Lugt
Institut Néerlandais, Paris
7620/27

70. **Valentin LeFebre** (c. 1642–80)
Sleeping Shepherd with Flock, after Titian,
 published 1682
etching
8 x 12⁹⁄₁₆ inches (20.4 x 31.9 cm.)
Fondation Custodia, Collection F. Lugt
Institut Néerlandais, Paris
7620/30

71. **Jean Antoine Watteau** (1684–1721)
Country Amusements (Amusements champêtres)
 c. 1716–18
oil on panel
12⅝ x 18½ inches (32 x 47 cm.)
Private Collection

72. **Jean Antoine Watteau** (1684–1721)
The Enchanted Isle 1716–18
oil on canvas
18⅛ x 22³⁄₁₆ inches (46 x 56.3 cm.)
Private Collection, Switzerland

73. **Jean Antoine Watteau** (1684–1721)
Musicians Seated under Trees (Italian Landscape)
red chalk on paper
7⅝ x 10¼ inches (19.3 x 26 cm.)
Musée des Beaux-Arts et d'Archéologie,
 Besançon
D.815

74. **Jean Antoine Watteau** (1684–1721)
Concert champêtre (Venetian Landscape) c. 1715
red chalk on laid paper
8¼ x 12 inches (22.3 x 30.4 cm.)
The Fine Arts Museums of San Francisco
Achenbach Foundation for Graphic Arts
 Purchase
1975.2.14

75. **Jean Antoine Watteau** (1684–1721)
Landscape with Bear Attacking a Goat
red chalk on paper
7⅞ x 11¹³⁄₁₆ inches (20.1 x 30 cm.)
Fondation Custodia, Collection F. Lugt
Institut Néerlandais, Paris
3803

76. **Jean Antoine Watteau** (1684–1721)
Two Figures in a Landscape, after Domenico
 Campagnola
red chalk on paper
9³⁄₁₆ x 9³⁄₁₆ inches (23.4 x 23.3 cm.)
Musée de Louvre, Paris
Département des Arts Graphiques
33.374

77. Attributed to **Jean Antoine Watteau**
Landscape with Setting Sun, after Domenico
 Campagnola
red chalk on paper
15⅝ x 23⅝ inches (39.7 x 60 cm.)
Musée du Louvre, Paris
Département des Arts Graphiques
5577

78. **François Boucher** (1703–70)
Le Repos des fermiers (The Farmers' Rest)
oil on canvas
34¼ x 53½ inches (87 x 136 cm.)
Collection of Jeffrey and Linda Horvitz

79. **Marco Ricci** (1676–1729)
Landscape with Peasants and a Mill c. 1725
pen and sepia ink on paper
8⅝ x 9⅜ inches (22 x 23.8 cm.)
Museo Correr, Venice
8220

80. **Jean Honoré Fragonard** (1732–1806)
The Swing c. 1765
oil on canvas
85 x 73 inches (215.9 x 185.5 cm.)
National Gallery of Art, Washington, D.C.
Samuel H. Kress Collection
1961.9.17

81. **Claude Gellée, called Le Lorrain** (1600–82)
View of La Crescenza c. 1647
oil on canvas
15¼ x 22⅞ inches (38.7 x 58.1 cm.)
The Metropolitan Museum of Art, New York
Purchase, The Annenberg Fund, Inc., Gift, 1978
1978.205

82. **Thomas Gainsborough** (1727–88)
*A Pastoral Landscape (Rocky Mountain Valley
 with Shepherd, Sheep and Goats)* c. 1783
oil on canvas
40⅜ x 50⅜ inches (102.5 x 127.9 cm.)
Philadelphia Museum of Art
The John H. McFadden Collection
M28–1–9

83. **William Blake** (1757–1827)
The Pastorals of Virgil 1821
4 proofs on uncut sheet
wood engravings
sheet, 6¼ x 3¹¹⁄₁₆ inches (15.9 x 9.3 cm.)
National Gallery of Art, Washington, D.C.
Rosenwald Collection
1943.3.1867, Bindman 603–606

84. **William Blake** (1757–1827)
The Pastorals of Virgil 1821
4 proofs on uncut paper
wood engravings
sheet, 6³⁄₁₆ x 4³⁄₁₆ inches (15.6 x 10.5 cm.)
National Gallery of Art, Washington, D.C.
Rosenwald Collection
1943.3.1868, Bindman 607–610

85. **William Blake** (1757–1827)
Album containing 17 wood engravings for
 Thornton's *Pastorals of Virgil* 1821
wood engravings, each trimmed and mounted
 one to a page
album, 5¹³⁄₁₆ x 7⅞ inches (14.7 x 19.9 cm.)
1st image (largest), 2⁷⁄₁₆ x 3⁵⁄₁₆ inches (6.2 x 8.4
 cm.)
other images average, 1⁵⁄₁₆ x 2¹⁵⁄₁₆ inches (3.4 x
 7.4 cm.)
National Gallery of Art, Washington, D.C.
Rosenwald Collection
1943.3.1850–1866, Bindman 602–618

86. **John Constable** (1776–1837)
A Lane near Flatford(?) c. 1810–11
oil on paper mounted on canvas
8 x 12 inches (20.3 x 30.5 cm.)
The Trustees of the Tate Gallery, London
N 01821

87. **John Constable** (1776–1837)
On the River Stour c. 1834–37
oil on canvas
24 x 31 inches (60.9 x 78.7 cm.)
The Phillips Collection, Washington, D.C.

88. **John Constable** (1776–1837)
Landscape with Trees and Deer, after Claude,
 1825
pen and brown ink with grey and brown wash on
 off-white laid paper
11⅜ x 7⅞ inches (29 x 20 cm.)
Yale Center for British Art, New Haven
Paul Mellon Collection
B1977.14.5223

89. **William Etty** (1787–1849)
Concert champêtre 1830
oil on canvas
28¾ x 36¼ inches (73 x 92 cm.)
Private Collection, England

90. **John Linnell** (1792–1882)
Sheep at Noon 1818
etching on very thin, India-type paper
5⁹⁄₁₆ x 9¹⁄₁₆ inches (14.1 x 23 cm.)
Collection of Robert N. Essick

91. **Edward Calvert** (1799–1883)
Ideal Pastoral Life 1829
lithograph
1⅝ x 3¹⁄₁₆ inches (4.2 x 7.8 cm.)
The Art Institute of Chicago
Gift of the Print and Drawing Club
1930.169

92. **Edward Calvert** (1799–1883)
The Goatherd's Tent/Study for Pastoral
oil on paper
5¼ x 10⅜ inches (13.3 x 26.3 cm.)
Trustees of the British Museum, London

93. **Edward Calvert** (1799–1883)
Amphion with the Flocks of his Brother Zethus
oil on paper
6¼ x 13½ inches (15.9 x 34.3 cm.)
Trustees of the British Museum, London

94. **Edward Calvert** (1799–1883)
A Pastoral
oil on paper
5½ x 10 inches (14 x 25.4 cm.)
Trustees of the British Museum, London

95. **Edward Calvert** (1799–1883)
The Lesson on the Reeds
oil on paper
7 x 12½ inches (17.8 x 31.8 cm.)
Trustees of the British Museum, London

96. **Edward Calvert** (1799–1883)
A Primitive City 1822
watercolor with pen and ink on paper
2¹¹⁄₁₆ x 4 inches (6.8 x 10.2 cm.)
Trustees of the British Museum, London

97. **Samuel Palmer** (1805–81)
*A Shepherd and His Flock under the Moon and
 Stars* c. 1827
pen and brown ink with brown and grey wash,
 heightened with white on paper
4⅜ x 5⅛ inches (11.1 x 13.1 cm.)
Yale Center for British Art, New Haven
Paul Mellon Collection
B1981.25.2655

98. **Samuel Palmer** (1805–81)
The Valley of Vision c. 1829
brush and brown ink, brown and grey wash,
 heightened with white body color over pencil on
 brown wove paper (wrapper for Creswick
 crayon paper)
11⅛ x 17½ inches (28.2 x 44.5 cm.)
Yale Center for British Art, New Haven
Paul Mellon Collection
B1975.4.1835

99. **Samuel Palmer** (1805–81)
*The Harvest Moon: Drawing for 'A Pastoral
 Scene'* c. 1831–1832
sepia drawing on paper
6 x 7¼ inches (15.2 x 18.4 cm.)
The Trustees of the Tate Gallery, London
N 03699

100. **Samuel Palmer** (1805–81)
Moonlight: A Landscape with Sheep
 c. 1831–1833
sepia drawing on paper
6 x 7¼ inches (15.2 x 18.4 cm.)
The Trustees of the Tate Gallery, London
N 03700

101. **Samuel Palmer** (1805–1881)
The Sleeping Shepherd; Early Morning 1857
etching on chine collé
image, 3¾ x 3¹⁄₁₆ inches (9.5 x 7.8 cm.)
plate, 4⅞ x 4¹⁄₁₆ inches (12.4 x 10.4 cm.)
National Gallery of Art, Washington, D.C.
Ailsa Mellon Bruce Fund
1982.21.1, Lister 1969, 6 IV/IV

102. **Samuel Palmer** (1805–81)
The Rising Moon or *An English Pastoral* 1857
etching on chine collé
image, 4⅝ x 7⁹⁄₁₆ inches (11.7 x 19.3 cm.)
plate, 7 x 9¹⁵⁄₁₆ inches (17.8 x 25.3 cm.)
National Gallery of Art, Washington, D.C.
Rosenwald Collection
1947.7.91, Lister 1969, 7 V/IX

103. **Samuel Palmer** (1805–81)
The Weary Ploughman 1858
etching on chine collé
image, 5³⁄₁₆ x 7¹⁵⁄₁₆ inches (13.2 x 20.2 cm.)
plate, 7⁹⁄₁₆ x 10⁷⁄₁₆ inches (19.3 x 26.4 cm.)
Collection of Ruth and Jacob Kainen
Lister 1969, 8 VIII/VIII

104. **Samuel Palmer** (1805–81)
Morning of Life 1860–61
etching
image, 5³⁄₈ x 8³⁄₁₆ inches (13.7 x 20.7 cm.)
National Gallery of Art, Washington, D.C.
Rosenwald Collection
1943.3.6712, Lister 1969, 10 VI/VII

105. **George Richmond** (1809–96)
The Shepherd 1828
chine collé engraving with etching
plate, 6¼ x 4⁷⁄₁₆ inches (15.4 x 11.3 cm.)
sheet, 7 x 4⁷⁄₁₆ inches (17.8 x 11.3 cm.)
Yale Center for British Art, New Haven
Paul Mellon Collection
B1977.14.12816

106. **Welby Sherman** (active 1827–36)
Moonlight: The Shepherd and his Flock, after
 Palmer, 1834
mezzotint engraving
5⁷⁄₈ x 7 inches (14.9 x 17.8 cm.)
The Board of Trustees of the Victoria and Albert
 Museum, London
E3451–1923

107. **Jean-Baptiste Camille Corot** (1796–1875)
Genzano 1843
oil on canvas
14⅛ x 22½ inches (35.8 x 57.1 cm.)
The Phillips Collection, Washington, D.C.

108. **Jean-Baptiste Camille Corot** (1796–1895)
Ville d'Avray c. 1867–70
oil on canvas
19⅜ x 25⅝ inches (49.2 x 65.1 cm.)
National Gallery of Art, Washington, D.C.
Gift of Count Cecil Pecchi-Blunt
1955.9.1

109. **Charles-Emile Jacque** (1813–94)
Landscape with Sheep
oil on canvas
26¼ x 32½ inches (67 x 82 cm.)
The Montreal Museum of Fine Arts
Gift of Mr. Colin W. Webster

110. **Jean-François Millet** (1814–75)
Falling Leaves 1866–67
pastel and black pencil on buff-colored paper
14½ x 17 inches (36.8 x 43.2 cm.)
The Corcoran Gallery of Art, Washington, D.C.
William A. Clark Collection, 1926

111. **Jean-François Millet** (1814–75)
The Shepherd 1872–74
conté crayon on paper
11⅝ x 14⅞ inches (29.5 x 37.7 cm.)
The Phillips Collection, Washington, D.C.

112. **Pierre Cecile Puvis de Chavannes** (1824–98)
Massilia, Greek Colony 1868
oil on canvas
38⅝ x 57⅝ inches (98.1 x 146.3 cm.)
The Phillips Collection, Washington, D.C.

113. **Pierre Cecile Puvis de Chavannes** (1824–98)
Doux Pays (Pleasant Land) 1882
oil on canvas
10⅛ x 18⅝ inches (25.8 x 47.3 cm.)
Yale University Art Gallery, New Haven
The Mary Gertrude Abbey Fund

114. **Pierre Cecile Puvis de Chavannes** (1824–98)
Sacred Grove after 1884
watercolor and gouache on paper
7⅝ x 7⅝ inches (19.3 x 19.3 cm.)
The Phillips Collection, Washington, D.C.

115. **Paul Cézanne** (1839–1906)
Women Picking Fruit 1876–77
oil on canvas
6⅛ x 8⅞ inches (15.5 x 22.5 cm.)
Private Collection

116. **Paul Cézanne** (1839–1906)
The Battle of Love c. 1880
oil on canvas
14⅞ x 18¼ inches (37.8 x 46.3 cm.)
National Gallery of Art, Washington, D.C.
Gift of the W. Averell Harriman Foundation in
 memory of Marie W. Harriman
1972.9.2

117. **Henri Rousseau** (1844–1910)
The Happy Quartet 1902
oil on canvas
37 x 22½ inches (94 x 57.1 cm.)
Collection of Mrs. John Hay Whitney

118. **Paul Gauguin** (1848–1903)
Breton Girls Dancing, Pont Aven 1888
oil on canvas
28¾ x 36½ inches (73 x 92.7 cm.)
National Gallery of Art, Washington, D.C.
Collection of Mr. and Mrs. Paul Mellon
1983.1.19

119. **Georges Seurat** (1859–91)
Study for *La Grande Jatte* 1884–85
oil on panel
6¼ x 9⅞ inches (15.9 x 25 cm.)
National Gallery of Art, Washington, D.C.
Ailsa Mellon Bruce Collection
1970.17.81

120. **Ker Xavier Roussel** (1867–1944)
Faun and Nymph under a Tree
oil on canvas
17 x 23 inches (43.1 x 58.4 cm.)
The Phillips Collection, Washington, D.C.

121. **Ker Xavier Roussel** (1867–1944)
Mediterranean
oil on academy board
10¼ x 15¼ inches (26 x 38.7 cm.)
The Phillips Collection, Washington, D.C.

122. **Henri Matisse** (1869–1954)
Study for *Luxe, calme et volupté* 1904
oil on canvas
15 x 21½ inches (38.1 x 54.6 cm.)
Collection of Mrs. John Hay Whitney

123. **Henri Matisse** (1869–1954)
By the Sea (Golfe de Saint-Tropez) 1904
oil on canvas
25⁹⁄₁₆ x 19⅞ inches (65 x 50.5 cm.)
Kunstsammlungen Nordrhein-Westfalen,
 Düsseldorf

124. **Henri Matisse** (1869–1954)
Nude in a Wood 1905
oil on panel
15¹⁵⁄₁₆ x 12¹³⁄₁₆ inches (40.5 x 32.5 cm.)
The Brooklyn Museum
Gift of George F. Of
52.150

125. **Henri Matisse** (1869–1954)
Woman by a Stream 1906
oil on canvas
13½ x 11 inches (34.3 x 28 cm.)
Galerie Jan Krugier, Geneva

126. **Henri Matisse** (1869–1954)
Nude in a Landscape 1906
oil on canvas
15¾ x 12⅝ inches (40 x 32 cm.)
Wally Findlay Collection, Chicago

127. **Henri Matisse** (1869–1954)
Nymph in the Forest (La Verdure)
 1935–42/43(?)
oil on canvas
95¼ x 76¾ inches (242 x 195 cm.)
Musée Matisse, Nice

128. **Georges Braque** (1882–1963)
 The Shower 1952
 oil on canvas
 13¾ x 21½ inches (34.9 x 54.6 cm.)
 The Phillips Collection, Washington, D.C.

129. **George Inness** (1825–94)
 A Bit of the Roman Aqueduct 1852
 oil on canvas
 39 x 53¼ inches (99 x 135.2 cm.)
 Lent by the High Museum of Art, Atlanta
 Purchased with funds from the Members Guild
 and through exchange
 69.42

130. **George Inness** (1825–94)
 The Lackawanna Valley 1855
 oil on canvas
 33⅞ x 50¼ inches (86 x 127.6 cm.)
 National Gallery of Art, Washington, D.C.
 Gift of Mrs. Huttleston Rogers
 1945.4.1

131. **George Inness** (1825–94)
 Lake Albano 1869
 oil on canvas
 30⅜ x 45⅜ inches (77.1 x 115.2 cm.)
 The Phillips Collection, Washington, D.C.

132. **George Inness** (1825–94)
 Etretat 1875
 oil on canvas
 29⅞ x 44¹⁵⁄₁₆ inches (75.9 x 114.2 cm.)
 Wadsworth Atheneum, Hartford, Connecticut
 The Ella Gallup Sumner and Mary Catlin Sumner
 Collection

133. **Frederick Church** (1826–1900)
 Italian Coastal Scene 1882
 oil on canvas
 14¹⁵⁄₁₆ x 22¹⁄₁₆ inches (38 x 56 cm.)
 Private Collection

134. **Thomas Eakins** (1844–1916)
 Arcadia c. 1883
 oil on canvas
 38⅝ x 45 inches (98.1 x 114.3 cm.)
 The Metropolitan Museum of Art, New York
 Bequest of Miss Adelaide Milton de Groot, 1967
 67.187.125

135. **Milton Avery** (1893–1965)
 Sheep 1952
 oil on canvas
 30 x 40 inches (76.2 x 101.6 cm.)
 Milton and Sally Avery Arts Foundation, New
 York

136. **Howard Hodgkin** (b. 1932)
 In the Public Garden, Naples 1981–82
 oil on panel
 32 x 36¼ inches (81.3 x 92.1 cm.)
 Private Collection, New York

Acknowledgments

During the preparation of this book and its accompanying exhibitions, we have incurred the debt of many colleagues and friends. We gratefully acknowledge the contributions of Patrice Bachelard, Roseline Bacou, Beatrice de Boisseson, David B. Brown, Anna Ottani Cavina, Piero Corsini, Peter Day, Jonathan Feld, Jack Flam, Peter Galassi, George Goldner, Robert Guthrie, Francis Haskell, Carlos van Hasselt, Howard Hodgkin, Henry Hopkins, Philip M. Jelley, Jacob and Ruth Kainen, Michael Laclotte, Gloria C. Lancaster, Hubert Landais, Dana Levy, Shelley Longmuir, Judith K. Lyon, A. W. F. Meij, Agnes Mongan, Letitia O'Connor, Edward Owen, Joseph Rishel, Pierre Rosenberg, Suzanne Royce, Lawrence Rubin, Janos Scholz, Melvin Seiden, Charles F. Stuckey, Eugene Thaw, Marie-Louise van der Pol, George Wachter, and John Walsh, Jr.

At the National Gallery of Art a number of staff members have assisted with the mechanics of organizing both halves of the two-part exhibition. For their unrelenting good nature and help we thank Barbara Bernard, Ann Bigley Robertson, Rita Cacas, Janice Collins, Lamia Doumato, Margaret Morgan Grasselli, Carlotta Owens, Andrew Robison, Frances P. Smyth, Jane Sweeney, D. Dodge Thompson, Elizabeth Weil, and Arthur Wheelock.

The staff of The Phillips Collection was no less cheerful and able. We would like particularly to thank Lillian Blacken, M. Leigh Bullard, Rima Calderon, Rebecca Dodson, Vivien M. Greene, Elizabeth A. Griffith, Barbara Grupe, Lillian Hannapel, Joseph P. Holbach, Linda L. Johnson, Laura Lester, Willem De Looper, Sarah J. Martin, Patricia Nicholls, Erika D. Passantino, Penelope deB. Saffer, Marcia Schifanelli, Karen Schneider, David Shive, Virginia L. Speer, and Louise A. Steffens.

Finally, we are especially grateful to Jan Lancaster for her extraordinary dedication to the publication of this book and the preparation of both parts of the exhibition.

Beverly Louise Brown
National Gallery of Art

Robert C. Cafritz
The Phillips Collection

Coordinators of the exhibition

Photography Credits

Photographs have been supplied by the owners and by the museums or collections in which a work is housed, as noted in the figure captions. In addition, special acknowledgment is due to the following people and institutions.

Alinari/Art Resource, NY: Figs. 2, 4, 5, 116, 119

Jörg P. Anders, West Berlin: Figs. 88, 133, 163 detail

Copyright © ARS, NY/SPADEM, 1988: Figs. 215, 216

Copyright © ARS, NY/SPADEM ADAGP, 1988: Fig. 221, 222, 235

Copyright © ARS/Succession H. Matisse, 1988: Figs. 224, 225, 226, 227, 228, 229, 230, 231, 232, 233

Copyright © 1988 The Art Institute of Chicago. All rights reserved: Figs. 135, 149, 189

Photo courtesy of Grace Borgenicht Gallery, NY: Fig. 236

Arte Fotografica, Rome: Fig. 91

ARTOTHEK, Planegg: Figs. 86, 87

Photograph copyright © 1988 by The Barnes Foundation: Figs. 33, 229

Photo M. Bérard, Nice: Fig. 233

Michael Bodycomb, Fort Worth: Figs. 125, 126

O. Böhm, Venice: Fig. 41

Reproduced by courtesy of the Board of Directors of the Budapest Museum of Fine Arts: Figs. 90, 122

Richard W. Caspole: Figs. 173, 183

Charles Choffet, Besançon: Figs. 130, 152

Ken Cohen, New York: Fig. 204

Michael Dudley: Fig. 210

Ursula Edelmann, Frankfurt: Fig. 158

Claude Gaspari: Fig. 222

Gianni Giacomelli, Venice: Fig. 63

Photo courtesy of Harvard University Art Museums, photo Rick Stafford: Fig. 28

E. Heuker, Hoek: Fig. 211

Lichtbildwerkstätte "Alpenland," Vienna: Figs. 25, 58, 60, 148

Marburg/Art Resource, NY: Fig. 207

Michael Marsland: Fig. 195

All rights reserved, The Metropolitan Museum of Art: Figs. 16, 64, 107, 123, 136, 206

Copyright © 1979 by The Metropolitan Museum of Art: Figs. 21, 205

Copyright © 1981 by The Metropolitan Museum of Art: Fig. 102

Copyright © 1984 by The Metropolitan Museum of Art: Fig. 27

Cliché: Musées de la Ville de Paris: Fig. 231

Cliché des Musées Nationaux, Paris: Figs. 7, 20, 56, 74, 85, 95, 108, 120, 142, 147, 153, 157, 160, 161, 208, 226

Reproduced by courtesy of the Trustees, The National Gallery, London: Figs. 1, 7, 14, 45, 46, 115, 166

Edward Owen, Washington, D.C.: Figs. 32, 198, 203, 235

PHOTOBUSINESS/Meyer, Leopoldsdorf bei Wein: Fig. 78

Eric Pollitzer, New York: Fig. 228

Scala/Art Resource, NY: Fig. 84

Index

Places of Delight: The Pastoral Landscape
was produced for
The Phillips Collection
by Perpetua Press, Los Angeles
Editor: Letitia Burns O'Connor
Book Designer: Dana Levy
Production artist: D. J. Choi
Typeset in Sabon by Continental Typographics
Printed and bound in Italy by Amilcare Pizzi, S.p.A., Milano